ASIAN ART

ASIAN ART

MUSEUM AND UNIVERSITY COLLECTIONS IN THE SAN FRANCISCO BAY AREA

Edited, with an introduction by René-Yvon Lefebvre d'Argencé

ALLANHELD & SCHRAM
MONTCLAIR
DISTRIBUTION:
UNIVERSE BOOKS, NEW YORK

Designed by Horst Erich Wolter, Leipzig

Copyright © 1978 by Edition Leipzig

Published in the United States of America in 1978
by Abner Schram, Montclair, N.J.,
and Allanheld, Osmun & Co., Montclair, N.J.
Abner Schram (Schram Enterprises Ltd.)
36 Park Street, Montclair, N.J. 07042

Allanheld, Osmun & Co. Publishers, Inc.
19 Brunswick Road, Montclair, N.J. 07042
Distributed by Universe Books
381 Park Avenue South, New York, N.Y. 10016

An *Allanheld & Schram* Imprint

Library of Congress Catalog Card Number: LC 77-78737
ISBN: 08390-0199-1

Printed in the German Democratic Republic

*The present volume is the joint work of museums
and universities in the San Francisco Bay Area.
Contributions were made as follows:*

General Editor	René-Yvon Lefebvre d'Argencé Director and Chief Curator, Asian Art Museum of San Francisco
Editor	Diana Turner Curator of Education Asian Art Museum of San Francisco
Asian Art Museum of San Francisco, *The Avery Brundage Collection*	René-Yvon Lefebvre d'Argencé
Japanese Colored Woodblock Prints *in the Achenbach Foundation for Graphic Arts*	Fenton Kastner Yoshiko Kakudo
The University Art Museum, Berkeley	James Cahill Howard Rogers
The Stanford University Museum	John La Plante

CONTENTS

ASIAN ART MUSEUM OF SAN FRANCISCO: THE AVERY BRUNDAGE COLLECTION

The Asian Art Museum is a relatively recent institution, and yet its history goes back to the mid-thirties, when Avery Brundage fell in love with Asian art. This momentous event coincided with the celebrated exhibition of Chinese art which was held at Burlington House in London during 1935 and 1936. Avery Brundage applied to his new passion his usual athletic and systematic style. Unlike most art collectors, who try to domesticate their craving for beauty by channeling it into one area or another where they can develop a highly specialized taste and knowledge, Avery Brundage did not attempt to tame his gargantuan appetite. On the contrary, his essentially humanistic approach ignored all chronological and spatial barriers. His only criteria were diversity and quality.

His timing, too, was unusually fortunate. He appeared on the scene precisely at the time when, as a result of major archaeological discoveries not just in China but also in Japan, Korea, Vietnam, Cambodia, Thailand, Indonesia, India, and Iran, the true nature and significance of early Asian artistic productions were beginning to be appreciated in the West, which had never known them, and simultaneously, reappreciated in the East, where they had been for the most part long-forgotten.

The first three decades of this century had been eventful and exciting years for Orientalists. The discovery of the dead cities of the Indus Valley in Northwest India, of the Kansu, Honan, and Shantung complexes in North China, of the Jōmon shell mounds in Japan or again of the Hoà-binh settlements in North Vietnam had established the existence of rich and varied neolithic cultures throughout Asia. Other sites, such as those of An-yang and of the Huai Valley in China, of the Yayoi and Kofunjidai cultures in Japan, and of Dongson, near Thánh-hoà, in North Vietnam had also yielded a wealth of material revealing that in China and peripheral countries the Bronze Age had reached an unparalleled degree of sophistication. Yet, other discoveries or rediscoveries such as those of a large number of Buddhist temples, cave-temples, or monasteries, sometimes city-size agglomerations, from Bamiyan to Tun-huang and from Lung-men to Borobudur, had brought to light some of the most spectacular achievements of one of the most inspired religious movements this world has ever known.

By 1959 Avery Brundage had amassed a collection of such magnitude that he felt the urge to share his treasures and their tremendous educational value with the public. The collection was donated to the city of San Francisco, which with its traditional interest in the arts, its dynamic Oriental communities and its close links with all cities of the Pacific Basin, was a logical choice. The city responded to this magnificent gesture by creating in Golden Gate Park a museum especially designed for the preservation and display of Asian art objects. Special attention was paid to the creation of a fully equipped Conservation Laboratory, the first one of its kind in the Western United States. A three-storied building with 40,000 square feet of display space, the museum was formally opened in 1966 as part of the M. H. de Young Memorial Museum, and the occasion was marked by an international symposium attended by more than two hundred and fifty scholars, collectors, and dealers from all over the world.

As one specialist put it at the time of the opening, "Acquisition of the collection gave San Francisco at one stroke international distinction in the museum world and a rich and varied source for research, study, and appreciation of Oriental civilization."

Since then, the holdings of the museum have more than doubled, owing to the enduring generosity of Avery Brundage and to that of various citizens or groups of citizens of San Francisco. To recognize some outstanding contributions, galleries in the museum were named after Adrian Gruhn, T. A. Soong, Osgood Hooker, Babette G. Lurie, Lenette and Willard Caro, Fredrick Faudé and the Cyril Magnin family, whose members funded the installation of a special Jade Room. In addition, display labels bear the names of generous donors such as the Asian Art Foundation, the Atholl McBean Foundation, the de Young Museum Endowment Fund, the de Young Museum Society, the Society for Asian Art, and many dedicated citizens. The pre-1959 collection was particularly noted for its Chinese department which, with its ancient bronzes, ceramics, jades, and sculpture, ranked even fifteen years ago among the most important of its kind. The post-1959 holdings, which were also donated to the city of San Francisco in 1969, are the result of Avery Brundage's eagerness to round out the collection while forming a well-balanced museum series. They consist essentially of major Korean, Japanese, Indian, and Southeast Asian acquisitions, as well as of Chinese painting and calligraphy.

It was also in 1969 that the city and county of San Francisco formally placed the museum under a separate administration, whose governing body is known as the Asian Art Commission of San Francisco; subsequently the museum assumed its present name.

The first floor of the museum is entirely devoted to China and its artistic productions; these represent about half of the holdings. The second floor contains selections from Iran, Korea, Japan, India, and all Southeast Asian countries. On both floors displays are continuous, without architectural barriers of any kind, so that the visitor can move freely from one area to another and absorb transitions quite naturally. With the exception of those dealing with large objects such as sculptures or paintings, individual labels are confined to basic data—type, date, provenance, in order to eliminate unnecessary visual distractions. On the other hand, long explanatory labels as well as maps and charts are located in places where they can be studied conveniently without encroaching on the display proper. In addition, daily tours of the museum are conducted by trained volunteer guides, known as docents.

Today the ideal pursued by Avery Brundage for more than forty years, and enthusiastically endorsed by the citizens of San Francisco, has largely materialized. The Asian Art Museum is not just the only one of its kind in the United States, it has also become a major center for the study and appreciation of the arts and cultures of Asia. In July and August of 1975 the museum set a new attendance record when over 835,000 people came to view "The Exhibition of Archaeological Finds of the People's Republic of China". Taken as a whole, the ten thousand or so sculptures, architectural elements, paintings, bronzes, ceramics, jades and decorative objects, which the museum contains, illustrate all the major periods and stylistic developments of the arts of Asia from Iran to Japan and from Mongolia to Indonesia.

As stated above, China comes first with about 4,500 items. In terms of bulk the ceramic section of the Chinese department is by far the most voluminous, with approximately 2,000 pieces of earthenware, stoneware, and porcelain. From the Neolithic period to the end of the Ch'ing dynasty (1644 to 1912 A.D.), every period, practically every style, and starting from the Ming dynasty (1368—1644 A.D.), every reign is illustrated by at least a few outstanding examples. Particularly noteworthy are the series of Han and Wei *ming-ch'i*, T'ang three-color wares, Sung monochromes, and Ming and Ch'ing blue-and-white and enameled porcelains.

The jade section consists of more than 1,200 items. Well-distributed over some thirty centuries, from the Neolithic period to modern times, it constitutes one of the most comprehensive collections of Chinese jades in the world. One of its main attractions may well rest with the unusually large number of carved animals it contains, including a substantial group of figurines of the so-called medieval period (3rd to 14th century A.D.)

The bronze section had already attained international fame many years ago: specialists would come from all over the world to see some of its most spectacular specimens when they were still housed in the various mansions Avery Brundage owned in Chicago and Santa Barbara. This group of about 750 vessels, bells, weapons, chariot fittings, and mirrors present an unusually well-balanced selection from the best Shang (ca. 1523—1028 B.C.) and Chou (1027—221 B.C.) workshops. It contains many unique

items such as the Rhinoceros (Pl. 9) which has become the emblem of the museum.

The sculpture section (about 250 items) consists essentially of stone and gilt bronze effigies of Buddhist inspiration, dating from the 4th to the 18th centuries. Particularly well-represented are those centuries when Buddhist art was at its height, during the Wei, Northern Ch'i, Northern Chou, Sui, and T'ang dynasties (approximately from the 4th through the 9th centuries). The gilt bronze Buddha bearing a date corresponding to 338 A.D. (Pl. 59) is probably the best-known item in this series. It is in any case the one that has been the most extensively publicized.

The section of painting and calligraphy which has increased considerably in the course of the last decade, consists of about 150 works ranging from the 10th to the 20th century. It is particularly strong in paintings by Ming and Ch'ing masters of all schools.

To wind up the Chinese department, one must also mention a group of about 300 pieces of lacquer, cloisonné, ivory, bamboo, tortoise-shell, rhinoceros horn, and other more or less exotic materials which add colorful touches to our displays.

With its 350 objects, the Korean department is relatively small. Its strength lies primarily with a large group of Silla pottery, Koryŏ celadons and Yi porcelains, but it also includes at least a few examples of all the main Korean art forms throughout the ages.

The Japanese department, which had grown spectacularly since the museum opened, now contains approximately 1,600 items. *Netsuke* and *inrō* constitute the most numerous series, with close to 1,000 pieces. Next comes the painting section, which numbers about 230 screens and scrolls dating from the Kamakura through the Edo periods. The section of ceramics (150 vessels and figurines) covers the entire span of the evolution of Japanese pottery, but outstanding groups are probably those of the earliest periods, Jōmon, Yayoi and Kofunjidai, and those of the Momoyama and Edo periods namely Oribe, Shino, Kutani, Kakiemon, Nabeshima, and Imari wares. Sculpture, which is mainly of Buddhist inspiration, is represented by some 70 pieces in dry lacquer, wood, and bronze. Among other major statues, a dry-lacquer pair of Bonten and Tai-shaku-ten (Pls. 103, 104) may well be the earliest Japanese statues in any collection outside of Japan.

Another substantial group is that of Muromachi, Momoyama, and Edo lacquers (about 70 items).

The sculpture of India and Indianized countries (Burma, Thailand, Laos, Cambodia, and Indonesia) occupies half the second floor and, in addition, much space in storage. These 450 or so pieces of temple sculptures, reliefs, steles, bronze effigies and wood carvings come from the great workshops of the subcontinent and Southeast Asia. Ranging from over life-size to diminutive items, they illustrate most of the main trends in Buddhist, Jain, and Hindu statuaries over a period of about 2,000 years. Particularly rich and diversified are the Kushān and medieval series for India proper and the pre-Khmer and Khmer sequences for Southeast Asia.

Lamaism, i.e. that special form of Tantric Buddhism which was conceived in Tibet and from there spread to Ladakh, Nepal, Bhutan, Sikkim, and Mongolia, is illustrated in its pictorial, sculptural and decorative aspects by over 260 items with special emphasis on gilt bronze statuettes and temple banners *(tankas)* dating from the 17th and 18th centuries.

Finally, the arts of Iran are represented by a group of over 300 pieces of pottery ranging from the Neolithic period to the end of the Islamic period and by another group of about 130 so-called Luristān bronzes.

Since the collection has more than doubled in about ten years, the museum has to cope with serious space limitations. An energetic policy of gallery rotations helps to solve part of the problem, at least temporarily. These rotations often require major structural changes, but in any case the exhibits are displayed in historical sequences and grouped in a manner that stresses stylistic evolution as well as socio-political background. The year 1969 marked the beginning of the transfer of the collection of Asian art housed in another city museum, the M.H. de Young Memorial Museum, to the Asian Art Museum. This transfer included a remarkable group of Chinese blue-and-white porcelains dating from the 14th to the 18th century, which San Francisco collector Roy Leventritt had acquired and donated to the city.

While this volume is the first one to attempt to give a bird's-eye view of the museum's collections, numerous books, catalogues, brochures, and articles have been published which deal with various aspects of them. The museum also has a fast-growing

library of approximately twelve thousand volumes, many of which were acquired as a result of a continuous fund-raising campaign sponsored by The Society for Asian Art.

In the winter of 1972 the museum, inspired by dedicated leaders of the Japanese community, opened an extension in the newly constructed Japan Center. This close collaboration between a city museum and a community center is a vivid illustration of the ever-increasing importance played by the arts of Asia in the cultural life of San Francisco and the Bay Area.

DESCRIPTION OF ILLUSTRATIONS

China

Ancient Bronzes

1 *Li-ho, ceremonial wine vessel.* Middle Shang dynasty (16th to 14th century B.C.). Bronze, height 9 in.

The top of this tripod with hollow and pointed legs suggests a human mask with a mouth wide open and two bulging eyes. The conical spout also serves as an elongated, almost clownish nasal appendage. Vessels of this period, which corresponds to the first phase of the Bronze Age, are very rare. Thin-walled, equipped with primitive handles and showing quite a few casting imperfections, they illustrate the very beginnings of metallurgy in China. The majority were discovered in the vicinity of Cheng-chou in Honan province. (B60 B53)

2 *Li-ting, ceremonial food vessel.* Late Shang dynasty, An-yang style (ca. 1300—1028 B.C.). Bronze, inscribed, height 8 in.

The most sophisticated vessels of the entire Chinese Bronze Age were discovered at An-yang in the northern tip of Honan. An-yang was the last capital of the Shang state. Its workshops developed an iconography which relied heavily on zoomorphic and geometric motifs, a style which combined massiveness with linear clarity, and casting techniques that have remained unsurpassed. The decoration of this unusually fine vessel consists of a band of whorl circles alternating with "squares and crescents" on the neck and a large monster's mask of the bovine type on each of the lobes. All these motifs stand out in relief against a background of rounded spirals. (B60 B1030)

3 *Chia, ceremonial wine vessel.* Late Shang dynasty (13th to 11th century B.C.). Bronze, inscribed, height 29⅝ in.

Very few king-size vessels were ever made, and fewer have survived. This tripod is a monumental example of the classical, or second, phase of the Bronze Age. It is covered from the top of the spool-shaped uprights to the tip of the splayed feet with a variety of zoomorphic motifs which stand out in fairly high relief against a meander background. (B61 B11+)

4 *Chüeh, ceremonial wine vessel.* Latter part of late Shang dynasty (12th to 11th century B.C.). Bronze, inscribed, height 9¼ in.

With their three legs, two uprights, spout, tail, and single handle, vessels of the *chüeh* group are the only asymmetrical ones in the Shang repertoire. This intriguing shape poses many problems which are still awaiting definitive answers. Most, if not all, *chüeh* were probably made with covers, yet very few covers have survived. Besides having a cover, this vessel has other unique features: the caps of the uprights shaped like coiling snakes, the cicada incised behind the handle, the inscriptions that are cast inside the body and on the verso of the lid rather than behind the handle or on the pillars of the uprights, and finally the curious ridges that frame the central design. (B60 B1049)

5 *Ku, ceremonial wine vessel.* Late Shang dynasty, An-yang style (ca. 1300—1028 B.C.). Bronze, inscribed, height 11¾ in.

Chüeh and *ku* have often been found together in tombs, which seems to denote some sort of close ritual connection between these two categories of vessels. In addition, both shapes ceased to be made shortly after the downfall of the Shang dynasty. This elegant beaker, which can be regarded as a very typical example of the *ku* category in its mature phase, consists essentially of components flowing smoothly into one another: the trumpet, the bulging central part that marks the bottom of the receptacle and the hollow foot. The vessel is covered with the usual zoomorphic decoration in which large monsters' masks (*t'ao-t'ieh*) are prominent, while rising blades, snakes, and cicadas appear respectively on the trumpet and on the narrow intermediate belts. (B60 B777)

6 *Fang I, ceremonial wine vessel.* Late Shang dynasty (13th to 11th century B.C.). Bronze, height 7½ in.

Square ore squarish shapes which reflect a gradual emancipation from the ceramic origins of bronze metallurgy in China were produced as early as the Middle Shang period (16th—14th century B.C.). The proliferation of such shapes, however, takes place toward the end of the Shang dynasty. Typically, this *fang i* consists of a square box and a roof-shaped cover topped by a knob that looks like a diminutive version of the cover. The base is hollow and perforated on each side with large semicircular notches. Large monsters' masks (*t'ao-t'ieh*) adorn each face of the cover and of the main zone of the body, while secondary zones are decorated with various types of dragons. All these motifs stand out in relief against a fine meander background. (B60 B997) *10*

7 *Yu, ceremonial wine vessel*. Late Shang dynasty, An-yang style (ca. 1300—1028 B.C.). Bronze, height 14³/₄ in.

The most remarkable features of this vessel are its lid and swing handle. Linked together by means of a chain consisting of two plain rings, a free-sculpted cicada with bat's wings, and a dragon biting its tail, they contrast vividly with the simple flowing contours of the container itself. The profile of the massive, bow-shaped handle is accentuated by a scored flange which looks like the spinal cord of two beasts with bovine heads. The knob of the lid is a small bird, sculpted in the round and sporting a very powerful beak. The main decorative motifs of the vessel proper consist of finely incised monsters' masks *(t'ao-t'ieh)* alternating with narrow and somewhat unusual spiral bands. A similar vessel was excavated at An-yang, Honan in 1950. (B60 B1008)

8 *Kuang, ceremonial wine vessel*. Latter part of late Shang dynasty (12th to 11th century B.C.). Bronze, height 9 in.

This type of syncretic vessel was produced toward the end of the Shang dynasty and for not much more than about a century. It seems to provide a fascinating, if slightly puzzling, answer to a need for a container that would stand as a microcosm of the Shang pantheon. It combines quadrupeds with birds, reptiles, and mythological animals such as dragons and *t'ao-t'ieh*. Some vessels even include parts of the human body. This *kuang* is an example of the most conservative and possibly earliest vessels in this group, as the belly and foot zones make no concession to the new spirit. (B60 B1032)

9 *Rhinoceros-shaped tsun, ceremonial wine vessel*. Latter part of late Shang dynasty (ca. 11th century B.C.). Bronze, inscribed, length 13 in.

According to tradition, this unique vessel was unearthed in 1843 in Shou-chang, Shantung, not far from Confucius' home town, and remained in the possession of the sage's descendants for a few generations. Probably modeled after a two-horned Southeast Asian rhinoceros, this powerful beast contrasts with all other zoomorphic vessels of the period in that it is completely free of any kind of surface ornamentation. A twenty-seven-character inscription cast on the bottom explains that the vessel was paid for with cowries donated to a high official by a king returning from a successful punitive expedition. (B60 B1+)

10 *Fang Ting, ceremonial food vessel*. Early Western Chou dynasty (ca. 1024—1005 B.C.). Bronze, inscribed, height 10 in.

This sturdy vessel of the third phase of the Bronze Age exemplifies magnificently the early Chou predilection for the bird motif. The *fang ting* can be dated with unusual precision due to the presence of a thirty-three-character inscription cast on one of the long walls and part of the bottom. This inscription refers to one of the numerous military expeditions that marked the beginning of the Chou hegemony and specifies that the vessel had been paid for with a hundred pair of cowries. This *fang ting* was discovered in 1924 in a royal tomb near Feng-hsiang, Shensi. (B60 B2+)

11 *Liang Ch'i Hu, ceremonial wine vessel*. Late Western Chou dynasty (9th to 8th century B.C.). Bronze, inscribed, height 13¹/₂ in.

The sagging body is covered by a network of flat bands and conical projections suggestive of leather trappings held in place by rivets. The grotesque silhouette of the vessel is typical of a period (the fourth phase of the Bronze Age) in which free-sculptured innovations are accompanied by a serious impoverishment of decorative motifs. Simultaneously a new rhythm emerges. At first this is a slow and then increasingly swift movement in which highly conventionalized animal shapes are rendered calligraphically. Here the animal shapes are dissolved and gyrate in antithetical motion around central eyes. This vessel is known as the *Liang Ch'i Hu*. Liang Ch'i, the name of the donor, appears in the forty-three-character inscription incised on the lid, mouth, rim and neck. (B60 B1012)

12 *Chien, ceremonial basin*. Ch'un-ch'iu period (late 6th to early 5th century B.C.). Bronze, width 29³/₄ in.

This monumental basin is a product of the fifth phase of the Bronze Age and is characteristic of a period which delighted in associating loud and frequently openwork features with serpentine or vermiculous shapes in flat relief and continuous intertwining schemes. This type of oppressively dense decoration brings the calligraphic trend noted earlier to a climax and may well reflect the political turbulence of the period. A similar, although less elaborate, basin was excavated in 1961 at Hou-ma, Shansi. Antiquarians have theorized that such basins served as reflectors, but there is little doubt that they were used for a variety of purposes, including ritual ablution.

(B69 B3; Gift of the Asian Art Foundation)

13 *Hu, ceremonial wine vessel*. Mid Warring States period (5th to 4th century B.C.). Bronze, height 15¹/₂ in.

The sixth and last phase of the Chinese Bronze Age was marked by a number of important technical and thematic changes. Casters resorted more and more to repetitive techniques such as stamping. Traditional motifs were gradually replaced by mythological scenes in which men or semi-human creatures played an increasingly significant part. On this unusually fine vessel, hunting and fighting scenes alternate with conventionalized animal shapes which constitute a traditional, hence conservative, element in the decoration. All the motifs appear in flat relief, and the intervals were originally filled with a perishable and colored substance, probably applied to a lacquer base.

(B60 B1075)

14 *Ts'ung*, Chou dynasty (10th to 3rd century B.C.). Jade, light green with black markings, height 6 in., and amber with brown markings, diameter 3⁵/₈ in.

The *ts'ung*, a religious symbol, has been aptly described as a "tube within a cube". In the remarkably well-preserved squat example, the cube is split in four segments which take the form of abstracted human masks with all features rendered geometrically. Such objects are particularly difficult to date with precision, as so far none

of them has appeared in a scientifically controlled excavation. In Han times, yellow *ts'ung* were specifically referred to as symbols of Earth, and it is very likely that this interpretation reflected a tradition of long standing. *Ts'ung* were produced in various sizes throughout the Shang, Chou, and Han dynasties, and some of them rank among the bulkiest items produced by ancient jade carvers.

(B60 J20+ and 603)

15 *Pi*. Warring States period (5th to 3rd century B.C.). Jade, mottled green altered in parts, diameter $8^5/_{16}$ in.

Together with *ts'ung* (see Pl. 14), perforated discs known as *pi* formed one of the most important groups of religious symbols in ancient China. Han texts recording much older traditions specify that when blue or azure blue, *pi* symbolized Heaven. Both sides of this example are identical. Ornamental schemes, divided into two main concentric zones, include an inner field of hexagonal grain pattern and an outer one with four bovine masks in axial positions. The inner zone is framed by incised rope bands. A similar object was found in a Western Han tomb near Hsü-chou, Kiangsu province. (B60 J156)

16 *Pinhead, pendant, pi with rampant dragons and fitting*. Warring States or Western Han dynasty (ca. 3rd century B.C.). Respectively, green jade with patches of brown, height $1^1/_2$ in.; ivory-colored calcified jade, length $3^3/_4$ in.; light green jade altered in parts, width $2^1/_4$ in.; and ivory-colored partly calcified jade, length $1^1/_8$ in.

Warring States and Western Han jade carvers are noted for daring experimentations and high technical achievements. Some of their creations remained models of excellence for all generations to come. This climax of the Chinese glyptic art is characterized by ebullient calligraphic rhythms and close-knit ornamental schemes. Artisans were keen on putting an impeccable finish to their products. This is best seen in the manner in which they reserved some areas in their ornamental schemes for hair-thin and remarkably regular striations or hatchings which recall certain technical devices of contemporaneous goldsmithing. (B60 J185, 679, 742, and 807)

Jades

17 *Zoomorphic pendants*. The dragon, fish-bird and cormorant are late Shang or early Western Chou (13th to 11th century B.C.). The deer and hare are Western Chou (10th to 8th century B.C.). Jade, lengths respectively $4^1/_8$ in., $3^3/_4$ in., $1^3/_8$ in., $3^1/_{16}$ in., and $7/_8$ in.

Zoomorphic pendants or appliques generally carved out of small and thin slabs constitute one of the three major contributions of the Shang and Western Chou dynasties. Some of them, such as the arched brown dragon or the mottled tan bird with a fish tail, are composite or fantastic species similar to those which adorn contemporaneous bronze vessels and artifacts. Others, like the cormorant, the deer, and the hare, look refreshingly natural and seem to be less charged with symbolism. They may have been made exclusively to be worn as articles of personal adornment. (B60 J658, 698, 632, 849, and 573)

18 *Sculptures of animals*. Han dynasty (206 B.C.—220 A.D.). The bird is mottled black jade with brown markings, length 3 in.; the pig is mottled brown jade with black markings, length $3^5/_8$ in.; the female bear and the leonine unicorn are light gray-green jade with brown markings, lengths respectively $4^1/_8$ in. and $5^1/_4$ in.

Judging from the scant material on hand, the main contribution of the Han dynasty consists of figurines of small animals both real and fabulous. Carved in the round, frequently with caricatural overtones and full of mischievous liveliness, these animals contrast vividly with archaic zoomorphs. The bird, the finial of an auspicious staff for a very old person, has been known to jadeologists as early as 1889 when it was published for the first time in the form of a line drawing. The female bear is very similar to two bronze bears discovered in 1969 in the 2nd century B.C. tomb of the "Jade" Princess Tou Wan at Man-ch'eng in Hopei province.

(B60 J341, B69 J57, B65 J3, and B62 J10)

19 *Phoenix, camel and rhyton*. Mid medieval period (7th to 10th century A.D.). Jade, phoenix: grayish green with iron rust and brown markings, height $3^1/_4$ in.; camel: tan with brown veins, length $3^1/_4$ in.; rhyton: dark brown, height $3^1/_2$ in.

During the mid medieval period the naturalistic tendencies of the Han period were revived and reinforced. The phoenix, a graceful illustration of the new spirit, was a head ornament of the type that ladies of high rank would wear at court. An onyx rhyton, stylistically akin to our example, was found recently near Si-an fu in Shensi as part of a hoard dating from the T'ang dynasty (618—906 A.D.). Such libation cups were derived from Iranian silver wares of the Sassanian period (224—642 A.D.).

(B65 J15, B60 J869, and B60 J246)

20 *Vessels and sculpture*. The *tou*-shaped cup with lid is late Yüan or early Ming dynasty (14th to 16th century A.D.); gray green jade with brown and black markings, height $3^1/_2$ in. The jar surrounded by three playful boys is 16th century A.D.; mottled greenish gray jade with brown markings, height $3^1/_4$ in. The man grooming a horse was carved during the Ming dynasty (14th to 17th century A.D.); light green jade with brown markings, length 6 in.

Diverse as they are, these objects illustrate some of the new concepts that prevailed during the late Yüan and Ming dynasties. On the one hand, the antiquarian trend is considerably enriched by borrowings from all periods of the Chinese Bronze Age. On the other hand, the Chinese glyptic art enters its final sculptural phase with all kinds of subjects, including human beings and plants. All these statuettes are frequently larger and bulkier than before. Their robust, rounded volumes are enhanced by warm, waxy surfaces, and most quadrupeds now stand on their four legs instead of being mainly in reclining, crouching or squatting positions. (B60 J245, 164 and 388)

21 *Water receptacle in the shape of a citron.* Ming dynasty (15th to 17th century A.D.). Gray-green jade with brown markings, length 8 in.

One of the charms of many Ming jades rests in their hidden or not so hidden symbolism. This fruit is known in Chinese as "Buddha's hand" because its tendrils resemble the fingers of Buddha in certain typical hand gestures *(mudrā)*. It also symbolizes wealth as it suggests the gesture of grasping money. Unlike their predecessors, Ming lapidaries had a strong predilection for robust volumes and tactile surfaces; their creations were to be fondled as much as looked at. (B60 J9+)

22 *Incense burner in shape of a square ting.* Ch'ing dynasty, Ch'ien-lung period (18th century A.D.). "Mutton-fat" jade, height 6 in.

Emperor Ch'ien-lung's own aesthetic ideals were largely responsible for the third and main wave of archaism which prevailed during most of the 18th and 19th centuries. Unlike older carvers who worked for the most part from line drawings, those of the Ch'ien-lung period had access to the ancient bronze vessels of the imperial collection. They could produce pieces that were quite close to bronze models. At the same time, such objects were not servile imitations. Like this incense burner, they stand out as marvels of fully integrated anachronisms in which modern elements are carefully blended with those belonging to various stages of the ancient period.

(B60 J20)

23 *Incense burner in shape of a kuei.* Ch'ing dynasty, Ch'ien-lung period (18th century A.D.). Lapis lazuli, height 5³/₄ in.

During the 18th century court taste became very eclectic under the influence of Emperor Ch'ien-lung himself. Color began to be as important as shape and ornamentation. Lapidaries frequently resorted to a variety of stones with color effects never seen in jade. Lapis lazuli, a deep blue crystalline limestone, usually speckled with light brown or yellow, was imported from Tibet and Afghanistan. After the square *ting* of Pl. 22, this *kuei* is another successful example of stylistic juxtapositions blended into a highly original idiom, based on an entirely new calligraphic approach. (B62 J66)

24 *Miniature mountain.* Ch'ing dynasty, Ch'ien-lung period (18th century A.D.). Spinach green jade, height 8 in.

According to Chinese literature, miniature mountains were carved out of jade as early as Yüan dynasty, but so far no extant specimens can be dated earlier than the Ch'ing dynasty when they constituted one of the major ornaments of the writer's desk. The majority of such mountains served as grandiose settings for scenes of Taoist or Buddhist inspiration. This one, however, shows on both sides various moments in a hunt that takes place amidst luxuriant vegetation. The carving is unusually deep, sharp and precise, and it is likely that this mountain was produced in the same workshop as the brush holder of Pl. 25. (B60 J49)

25 *Brush holder.* Ch'ing dynasty, Ch'ien-lung period (18th century A.D.). Spinach green jade with black specks, height 7 in.

The eclectic mood which pervaded the 18th century also manifested itself in daring innovations with few or no ties with the past. Particular attention was paid to the making of a variety of objects for the writer's desk. Many such objects illustrate sacred or temporal scenes in full-fledged landscape settings. Thus, the entire surface of this thick-walled, five-footed cylinder is decorated with a continuous scene, which, in the manner of a handscroll, shows a procession of horsemen riding along a mountain path. Typically, this apparently innocent scene holds more than meets the uninitiated eye. Through a play upon words referring to the objects carried by the horsemen, it carries a hidden message which can be translated as follows: "May you promptly and according to your wishes attain peace and complete the three classes of officialdom". (B60 J29)

Ceramics

26 *Urn.* Late Neolithic, Yang-shao culture, Ma-ch'ang style (2000—1500 B.C.). Reddish buff pottery with designs painted in black and red, height 14¹/₄ in.

The Neolithic painted pottery of northern China is related in style to several groups found in central and western Asia. The main motif illustrated here is thought to be anthropomorphic, which would be very exceptional for the period. The mineral pigments are so resistant that they still retain most of their original brilliance. Ma-ch'ang in Kansu was both a cemetery and a dwelling site.

(B60 P1110)

27 *Covered jar.* Late Shang dynasty (ca. 1300—1028 B.C.), from An-yang, Honan. White pottery, height 8 in.

This is one of the finest and rarest vessels of Shang pottery. Found in fragmentary condition, it was reconstructed by the eminent Japanese archaeologist Sueji Umehara. Such vessels were too delicate for everyday use and must have been restricted to ceremonial or funerary functions. The design, including the vaguely anthropomorphic pattern, repeated five times on the main zone, is similar to those found on bronze vessels of the same period.

(B60 P538)

28 *Hu.* Late Warring States or Western Han dynasty (3rd to 1st century B.C.). Painted pottery, height 23 in.

Few are the pottery vessels of the period which escaped the impact of a now millennium-old metallic heritage, and this *hu* is no exception. At the same time, it is an outstanding illustration of a new decorative approach. Starting from the latter part of the Warring States period, potters began to embellish the surfaces of their products with intricate motifs usually inspired by designs found in goldsmithing or lacquer work. Here, intertwining cloud scrolls painted in red, white, and indigo faintly suggest abstracted animal shapes. (B60 P2391) *13*

29 *Dog*. Eastern Han dynasty (1st—2nd century A.D.). Hupei Province (?) Red pottery with brown glaze, height 14³/₄ in.

With the Han, the first fully established imperial dynasty, man and his immediate environment, namely animals—particularly domestic ones—buildings and bits of landscape took over the artistic scene, regardless of media and techniques. This humanization of all art forms reflects more gentle political ideals as well as more sophisticated religious practices. Ancestor worship, now revitalized by Confucianism, was, among other things, largely responsible for the manufacture of numerous mortuary figurines and models of houses or household furniture. This thematic development was accompanied by considerable technical progress, namely the possibility for potters to coat their products with thick lead glazes colored for the most part green, brown, or yellow. With its bulky head and neck, its exaggerated facial features, and its lumpy yet alert body, this dog is a good example of the slightly humorous and highly notional Han approach.

(B60 P83+)

30 *Bactrian camel*. Mid T'ang dynasty (680—750 A.D.). Pottery with three-colored glazes, height 35 in.

T'ang potters discovered the way of applying various coloring agents to the same feldspar glaze, thus creating those brilliant, variegated surfaces. This giant of a camel is an outstanding example of its kind.

T'ang funerary figurines illustrate primarily courtly, military, and exotic subjects. They reflect vividly the splendor of a cosmopolitan capital, the pleasures of the well-to-do, the might of the T'ang army, and the adventurous life of caravaneers along the desert avenues of the old silk road in Central Asia. Such figurines are also vivid expressions of the wave of realism that permeated the entire period. (B60 S95)

31, 32 *Incense burner and ewer*. Sung dynasty (respectively 10th to 13th century A.D., and 11th to 12th century A.D.). The ewer is porcelaneous stoneware of the Northern Celadon type, with olive green glaze, probably from Yao-chou, Shensi, height 9 in.; the incense burner is *Ch'ing-pai* porcelain with a light shadowy blue glaze, height 5¹/₄ in.

Some of the kilns which enjoyed the patronage of the Sung rulers reached an unsurpassable degree of sophistication and subtlety. True porcelain was produced at least as early as the beginning of the T'ang dynasty, but it is only with the Sung that it reached maturity. Such monochrome wares have remained models of perfection until the present day. The floral motifs or allusions that permeate shapes as well as ornamental schemes are typical of Sung court taste. (B60 P1233 and 1764)

33 *Pillow*. Sung dynasty (11th to 12th century A.D.). Ting ware (Hopei), white-glazed porcelain, height 6 in.

In the shape of a very young boy reclining on a rectangular couch and holding up a large, wide open fungus, this extraordinarily fine pillow is the product of one of the kilns that enjoyed imperial patronage during the Sung dynasty. (B60 P1351)

34 *Tiger-shaped pillow*. Late Northern Sung dynasty (1st quarter of 12th century A.D.). Tz'u-chou ware, glazed stoneware with black and white designs, height 4¹/₂ in.

In vivid contrast with the object of plate 33, this pillow exemplifies the creations of some of the kilns which were working at a popular level during the Sung dynasty. They were admittedly less sophisticated but also more independent and in some ways more daring both stylistically and technically than their court-sponsored counterparts. Free from official dictates, the potters employed at such kilns could give full vent to their imaginations. On at least two counts, underglaze painting and overglaze enamels, they set the pace of ceramic research for centuries to come. (B60 P423)

35 *Ceremonial Jar*. Late Northern Sung (ca. 11th century A.D.) Lung-ch'üan celadon, porcelaneous stoneware, height 9¹/₂ in.

Lung-ch'üan celadons are the culmination of a millennial tradition. They saw the light in the heart of the Yüeh region where jade-like glazes had been created and then perfected by generations of potters. Starting with the Southern Sung, these wares became the most sought-after of all celadons and were exported all over Asia where they were a source of inspiration for local potters, particularly in Korea and Thailand. (B62 P147)

36 *Mei p'ing vase*. Late Sung or Yüan dynasty (late 13th or 14th century A.D.). Chün ware, stoneware, lavender blue glaze with purple splashes, height 14 in.

A Sung creation, the *mei-p'ing* shape, literally "plum vase," was conceived primarily to hold flower arrangements. Sturdily potted and baked to stoneware hardness, Chün vessels are characterized by gray bodies, a brown slip on an unglazed base and bluish, thick opalescent glazes with high phosphatic content. The crimson splashes or suffusions which frequently enhance the lavender blue background result from the first attempt on the part of the Chinese potters to take advantage of copper fired under reduced conditions. (B60 P19+)

37 *Hexagonal vase*. Ming dynasty, Lung-ch'ing mark and period (1567—1572 A.D.). Porcelain with five-colored glazes and enamels of the *Wu-ts'ai* type, height 10¹/₂ in.

Early in the Ming dynasty blue-and-white ware was sometimes enhanced by green and red enamels. In the 16th century this increasingly popular type of decoration became very elaborate. During the reign of Lung-ch'ing new shapes and decorative motifs appeared, such as this rare hexagonal vase with an ornament of antithetical phoenixes. (B60 P2349)

38 *Platter*. Ming dynasty, Hsüan-te mark and period (1426—1435 A.D.). Porcelain with underglaze blue decoration, diameter 9 in.

At first, limited as they were, motifs painted under the glaze often displayed a great deal of individuality. In addition, the habit of painting in splashes with little or no outline was the source of lively and warm effects.

The main motif in the center of this platter consists of *14*

three bunches of grapes. The wave pattern of the rim first appeared in the Yüan dynasty. (B60 P2101)

39 *Vase.* Late Yüan or early Ming dynasty (14th to 15th century A.D.). Porcelain with underglaze red decoration, height 18 in.

Chinese ceramics officially enter their pictorial phase with such early white porcelains decorated in underglaze red or blue. The turning point must have taken place in the 14th century or slightly earlier.

This irreversible movement can be explained by two main factors: the increasing supremacy of painting over all other art forms, and, starting from the 14th century, the concentration of all court-sponsored kilns in one town, that of Ching-te chen in Kiangsi province which has rightly been dubbed the ceramic capital of the world. Rare as it is, this vase is characteristic of the beginning of this pictorial phase when ornamental schemes were practically restricted to dragons, plants, and flowers. (B60 P1235)

40 *Fish jar.* Ming dynasty, Chia-ching mark and period (1522—1566 A.D.). Porcelain with five-colored glazes and enamels of the *Wu-ts'ai* type, height 17 in.

Wu-ts'ai means literally "five colors." In a ceramic context, the term designates a type of porcelain decorated with multi-colored enamels derived from lead glass tinted with metallic oxides.

The Chia-ching period is noted for large potiches decorated with a variety of Taoist emblems which reflect the religious leanings of the reigning monarch. Here such emblems form a setting for large fish which are themselves symbols of wealth, as in Chinese the words for fish and abundance are homonyms. (B60 P78+)

41 *Vase.* Ch'ing dynasty, K'ang-hsi period (1662—1722 A.D.). Porcelain of the *Famille Verte* type, height 12¹/₄ in.

A technical triumph, the *Famille Verte* is an outgrowth of the *Wu-ts'ai* ware of the Ming period (see Pls. 37 and 40). During the Ch'ing dynasty, potters produced decorative pieces in increasing quantities, and it became a standard practice to make special stands in a variety of materials for such pieces. In this rare specimen, the stand is part of the vase itself. It is decorated with a wavy pattern that suggests veined wood, as well as the so-called "marbled ware" of the T'ang and Sung periods. (B60 P2+)

Miscellanea

42 *Lien.* Cosmetic box, dated 218 B.C. Lacquer with painted decor and metal fittings, height 7 in.

The use of lacquer was known in China since at least the Shang dynasty (ca. 1523—1028 B.C.). This box is the oldest dated piece of lacquer discovered so far. Its bronze fittings have silver inlays. Typically for the period, both lacquer and fittings are decorated with geometric designs dominated by spirals. As indicated by frequently detailed inscriptions, such objects were made in governmental factories according to an elaborate process that foreshadowed the assembly lines of modern times. (B60 M286)

43 *Mirrors* with dancing bear pattern, with animal belt and nipples pattern, and with dragon and clouds design. Respectively, Warring States (4th to 3rd century B.C.), Han (206 B.C.—221 A.D.) and T'ang (8th century A.D.). Bronze, diameters are 7¹/₂ in., 6³/₄ in., and 8⁷/₈ in.

Chinese bronze casters produced large quantities of fine mirrors from the 6th or 5th century B.C. to the 8th century A.D. Toward the end of the Warring States dynasty (3rd century B.C.), bronze mirrors became common articles of grave furniture. This is also the time when they began to bear dated or datable inscriptions, which explains why they are usually regarded as objects of great archaeological significance. All mirrors are equipped on the reverse, decorated side with at first loops and later knobs for the insertion of suspension cords.

(B60 B35+, 583, and 599)

44 *Peacock-shaped head ornament, gold cup and silver bowl.* T'ang dynasty (618—906 A.D.). Heights are respectively 10¹/₈ in., 2¹/₂ in., and 2¹/₂ in.

Disparate as they may look, these objects are the reflection of an age during which metal crafts underwent drastic changes. Influenced by Sassanian taste and techniques, Chinese gold and silversmiths created a wide variety of table ware and toilette articles to meet the exacting demands of a sophisticated court. The wings and tail of the strutting peacock are made of small gold cut outs assembled together by gold threads, a device which foreshadows the celebrated *cloisonné* technique of later periods. In addition, the cut outs are granulated and inlaid with small pieces of turquoise. The cup and bowl display examples of some of the most successful methods employed by the craftsmen of the time, such as raising, chasing, ring matting, etc. (B60 M312, B60 B819, and B60 M129)

45, 46 *Rhinoceros horn libation cups and bamboo brush holder.* The brush holder, signed by Chang Hsi-huang, is late Ming or Ch'ing (17th century A.D.); the larger cup is also late Ming, while the smaller one is mid Ch'ing (18th century A.D.). Heights are respectively 4¹/₈ in., 4⁵/₈ in., and 3 in.

Cups carved out of rhinoceros horn are mentioned in Chinese literature as early as the Han dynasty (200 B.C.—220 A.D.) and were once credited with the faculty of revealing poison by sweating. Bamboo carvings of various shapes were already popular objects for the scholar's desk during the Sung dynasty (960—1279 A.D.). However, rare are the examples of these highly perishable materials that can be dated earlier than the Ming dynasty. Chang Hsi-huang belongs to a small group of Ming bamboo carvers whose names are well established. The larger cup illustrates the famous poem, "The Red Cliff," by Su Tung-p'o of the Sung dynasty. The smaller one reflects an archaistic trend which flourished during the Ch'ien-lung period.

(B62 M87, B65 M23, and B65 M20)

47 *Kuan yü, Liu hai and his toad.* Ming dynasty (1368—1644 A.D.). Ivory, heights are respectively 11 in. and 10³/₄ in.

The earliest examples of ivory carving date from the Shang dynasty (16th—11th century B.C.), but free-sculpt-

ed statuettes remained extremely rare prior to the Ming dynasty when direct trade was established with Africa and its plenteous ivory supply. The early **Ming Kuan Yü**, a 2nd century hero who was deified at the end of the 17th century as the God of War, sits on a high chair in a posture typical of the classical Chinese opera. Liu Hai, with his monkey, three-legged toad, and string of cash symbolizes good fortune and wealth. (B60 S299 and 72)

48 *Cylindrical box, dish and box with rounded cover.* Ming dynasty (respectively, early 15th century A.D., late 15th century A.D. and mid 16th century A.D.). Lacquer, diameters are $4^3/_4$ in., 7 in., and 9 in.

The complex art of carving lacquer, which goes back at least to the Sung dynasty (960—1279 A.D.), reached its climax during the Ming period when ornamental schemes centered on flowers, plants, dragons, and figures in landscape settings. The unusual dish is deep red, the cylindrical box with overall floral decoration is bright red with a buff ground. It has a Yung-lo mark (1403—1424 A.D.) scratched on the base. With its multicolored decoration in which five-clawed, bushy-tailed writhing dragons play a conspicuous part, the large box is typical of the Chia-ching period (1522—1566 A.D.) and indeed bears a mark to that effect.

(B65 M16, B69 M1 [Gift of the Asian Art Foundation] and B60 M308)

49 *Vase.* Ming dynasty (16th century A.D.). *Cloisonné* enamel with gilt-bronze mounts, height $21^1/_8$ in.

The wealth of new materials and the unprecedented taste for brilliant colors which characterize the Ming dynasty are due not only to the peaceful prosperity that prevailed through most of the period, but also to an indomitable craze for novelties in all fields, including art. Starting from the Yüan dynasty, enameling on a bronze base, and, from the Ming, on a copper base as well, became popular as a result of techniques borrowed from western Asia and Europe. This large vase with robust contours is decorated with tight floral scrolls in red, yellow, and white against a turquoise ground. The dragon-shaped fittings were added at a later date, probably in the 18th century A.D. (B66 M6)

50 *Box.* Ming dynasty (early 17th century A.D.). Lacquer with basketry panels, length 19 in.

The earliest extant examples of painting on lacquer date from the Shang dynasty. Ming lacquers made extensive use of this technique to illustrate scenes with figures in landscape settings. Such scenes were usually inspired by contemporaneous paintings on silk or paper. The sides of this rare box are made of woven bamboo panels set in wooden frames. The interior and underside of the box are plain black. The colorful scene outlined in gold on a black ground represents an audience given by a high magistrate to a military official. (B60 M427)

51 *Nest of boxes,* Ch'ing dynasty, Ch'ien-lung period (18th century A.D.). Carved and inlaid lacquer, height $10^1/_4$ in.

Typical of a period which strove to combine intricate shapes and designs with technical perfection, this three-tiered nest of boxes is a tour de force in workmanship. Each of the tael-shaped boxes is decorated with floral motives in inlaid lacquer in red, yellow, green and black, while the elaborate cover and stand are of carved red lacquer against a buff ground. Impressive and varied as it is, the best Ch'ing lacquer does not display the warm fluidity and deep red tones of the previous period.

(B60 M128)

52 *Fish bowl.* Ch'ing dynasty, Ch'ien-lung period (1736—1795 A.D.). *Cloisonné* enamel, diameter $24^3/_4$ in.

This is an example of Ch'ing *cloisonné* at its best. The walls and base of the basin are of bronze but the wires attached to them and encasing the multicolored enamels are of copper, which gives greater flexibility to the ornamental scheme, copper being an eminently pliable metal. The inside is decorated with several species of aquatic animals such as fish, eels, frogs, and the like, while on the outside is a lively rendering of the well-known theme of the hundred deer, symbolizing longevity. The turquoise blue base is ornamented with disconnected plum blossoms.

(B60 M10+)

Sculpture

53, 54 *Tomb pillars.* Eastern Han dynasty (25—220 A.D.). Gray clay with traces of polychrome pigments, height $51^1/_2$ in. (left) and $52^1/_2$ in. (right).

Under the influence of ancestor worship, pre-Buddhist China attached particular importance to the rites connected with death and the afterlife. During the Han period, some of the most ambitious and sophisticated monuments and sculptures were made for the dead. These two pillars impressed with dragons and dotted lozenges and surmounted by squatting gnome-like creatures sculpted in the round were located at the entrance to inner chambers of tombs. They helped support door frames of the post-and-lintel type. (B60 S409 [left] and 410 [right])

55 *Section of a mortuary bed.* Six Dynasties (first part of the 6th century A.D.). Dark gray, fine-grained, oolitic limestone, width $80^1/_8$ in.

This rare and unusually fine piece of sculpture shows that even when Buddhism was at its height, funerary art remained under the influence of ancestor worship and was, as such, staunchly traditional. With the exception of the band of lotus petals which decorates the top of this lintel and is distinctly of Buddhist origin, all other motifs were inspired by ancient Chinese mythology. Standing in low relief and enhanced by finely incised details, these motifs represent dragons, birds, various monsters, a monster's mask and an incense burner of the *Po-shan-lu* type. They reveal that the Chinese sculptor of that period became so much of a calligrapher that he could transfer to his work almost all the subtlety and vivacity of the painting brush. (B60 S422)

56 *Winged unicorn.* Six Dynasties (265—589 A.D.) and probably dating from the middle of the sixth century. Light gray, fine-grained, highly indurated sandstone, length 42 in.

This impressive beast is a rare, if somewhat late, specimen of a fairly unified series of lions and chimeras that guarded the entrance of important sepulchres in southern and western China from the end of the Han through the Six Dynasties. Stylistically, this animal is closely related to those carved to serve as guardian monsters of the imperial tombs of the Liang dynasty (502—557 A.D.) at Nanking. (B60 S145+)

57 *Buddhist stele*. Northern Wei dynasty, dated 533 A.D. Light gray, medium-grained limestone, height 67 in.

Once accepted by the Chinese masses, Buddhism became a major source of artistic inspiration, particularly for architects, painters, and sculptors. For about six hundred years, the new religion monopolized China's best artistic talents. This monumental leaf-shaped stele of Buddha with attendants was carved at the same time as some of the most spectacular cliff temples at Lung-men in Honan province, and illustrates the most Chinese of all Buddhist styles. With its elongated figures and its calligraphic overtones, it reveals the basic aspirations of the indigenous sculptor. (B60 S44+)

58 *Buddhist votive stele*. Western Wei dynasty, dated 549 A.D., from Shansi province. Light gray, fine-grained limestone, height 67 in.

Starting from the first part of the sixth century, rectangular stelae were carved for temples where, together with their leaf-shaped counterparts (see preceding plate), they were placed as votive, propitiary, or commemorative monuments. They frequently include pre-Buddhistic features such as dragon-shaped tops and reflect the overwhelming current of sinicization that took place at that time. The deeply carved central niche of the stele represents Buddha flanked by two of his main disciples, Ānanda and Kāshyapa, in monk's attire, and by the Bodhisattvas Kuan-yin and Ta-shih-chih. On the bottom register are inscribed the names of the people who contributed to the making of the stele. (B60 S2+)

59 *Buddha seated in meditation*. Late Chao dynasty, dated 338 A.D. Gilt bronze, height 15^1/$_2$ in.

Almost a full millennium elapsed between the death of Buddha in India and the popularization of Buddhism in China. Even though the way had been paved by Confucianism and Taoism, it took a long time for this foreign religion to get a firm foothold in staunchly conservative China.

This statuette is the oldest piece of dated Chinese Buddhist sculpture in existence. While already distinctly Chinese by its physical features, it retains many characteristics harking back to Northwest Indian prototypes. (B60 B1034)

60, 61, 62 *Buddhist altarpieces*. Northern Wei dynasty. The Bodhisattva standing on a lotus pedestal dates from the second part of the fifth century A.D. The shrine with two seated Buddhas is dated 472 A.D. and the Avalokiteshvara Padmapāni ("Lotus Holder") is dated 484 A.D. Gilt bronze, heights respectively 5^3/$_4$ in., 6^3/$_8$ in., and 6^1/$_2$ in.

Many such statuettes were cast during the Wei dynasty to serve as family shrines. Early examples such as these were usually supported by table-like daises with splayed legs and revealed a good deal of Central Asian influence. The two seated Buddhas are Prabhūtaratna and Shākyamuni, illustrating one of the best-known themes of the *Lotus Sūtra*. (B60 B638, 1035, and 637)

63 *Pratyeka Buddha*. Northern Ch'i dynasty (550—577 A.D.), probably from Hsiang-t'ang shan, Hopei province. Medium gray, fine-grained oolitic limestone, height 42 in.

Pratyeka Buddhas, who can be easily distinguished from other Buddhas by their conical, turban-like *ushnīsha*, have attained Buddhahood for themselves. They are consequently ranked below the Buddhas and Bodhisattvas who have done and are doing so much for the salvation of mankind. The blending of austerity, smoothness and, in parts, mannerism in this statue is typical of the metropolitan style of the Northern Ch'i period when Chinese Buddhist sculpture, now entering the third phase of its Golden Age, was beginning to feel the influence of Gupta India.
(B60 S153+)

64, 65 *Altar group and standing Kuan-yin*. T'ang dynasty (late 7th century A.D.). Gilt bronze, heights 12^3/$_4$ and 11^5/$_8$ in.

These statuettes and the following piece exemplify the fourth and last phase of the Golden Age of Chinese Buddhist sculpture. This was the time when T'ang rule held sway over a China that covered more ground and was more unified than ever before. Maitreya, the central deity in the altar group, is seated on a high throne in Western fashion and is surrounded by a retinue of diminutive personages including two Bodhisattvas, two monks, and two guardians. With his well-balanced body, his dynamic torso, and his graceful feminine head, the Kuan-yin reflects the T'ang sculptor's interest in realistic human forms. (B60 B8+ and 661)

66 *Buddhist votive stele*. Early Sui dynasty, dated 595 A.D., from Pao-ting, Hopei province. Pale buff, coarse-grained marble with traces of pigments and gilt, height 33 in.

In the central and eastern provinces of northern China the bulk of Buddhist sculptures carved by Sui workshops is subdued and fairly homogeneous. The theme illustrated here is that of the two Buddhas seen in an earlier gilt bronze example (see Pl. 61). In this case, Prabhūtaratna and Shākyamuni are flanked by two monks and surmounted by a third Buddha and a "flying" *stūpa* with garlands held in mid-air by dragons and *apsaras*. The decor of the lower part of the stele consists of an incense burner supported by two gnomes and flanked by seated lions and *dvārapālas*. (B62 S1+)

67 *Head of Buddha*. T'ang dynasty (early 8th century A.D.) from the Lei-ku-t'ai caves at Lung-men, Honan province. Medium to dark gray, fine-grained limestone, height 26 in.

This head once belonged to a gigantic statue whose body still occupies the central place in one of the Lei-ku-t'ai caves in the eastern sector of Lung-men. Early in the 8th century, the Buddhist church enjoyed unreserved

support from the court. Buddhas are depicted as regal and Bodhisattvas as princely. The mystic smile and ascetic features of former ages are now replaced by full, well-fed faces and a benign countenance which at times verges on the condescending. (B60 S38+)

68 *Seated Kuan-yin.* Sung dynasty (ca. 12th century A.D.). Wood with traces of pigments, height 52 in.

The main contribution of the Sung period to Buddhist sculpture consists of a group of large Bodhisattvas of which this Kuan-yin is an outstanding example. The entire group is the expression of a northern tradition which may have originated during the Chin and was still alive in the 14th century. It is characterized by portly, bare-chested, full-faced figures with elaborate headdresses and a profusion of jewels and scarfs. With his right leg raised and supporting his right arm and his left leg bent inward, this monumental Kuan-yin is seated in the "royal ease" position. (B60 S24+)

69 *Seated Bodhisattva.* Liao dynasty (907—1124 A.D.). Gilt lacquer over wood, height 50 in.

This rare sculpture illustrates the most original trend in Liao sculpture. The large rectangular head rests on an elongated torso which contrasts with short, tubular legs. The garments are remarkably plain despite a few mannered convolutions in the area of the legs. Such statues seem to be patterned after abstract geometrical schemes that are completely divorced from T'ang ideals. They may be the result of an audacious reinterpretation of the "columnar style" of the second half of the 6th century A.D. (see Pls. 63 and 66). (B60 B500)

Painting and Calligraphy

70 *Two birds on a blossoming branch.* Southern Sung dynasty (12th to 13th century A.D.). Hanging scroll, ink and colors on silk, height 9³/₄ in.

Following an exuberant T'ang dynasty, the ephemeral Five Dynasties and the fragile but vibrant Sung dynasty corresponded to an age of quiet introspection with strong poetical and philosophical overtones. This change of mood and interest was due not only to the sharp decline of Buddhism and to the considerable weakening of the country as a result of lack of leadership. There were also some positive factors, such as the attainment of full maturity on the part of several art forms, particularly painting, great technical improvements in many fields, and ultimately the encouragement of several emperors and their immediate entourage in an unprecedented refining to taste. (B69 D3)

71 *Tribute Bearers.* By Jen Po-wen of the Yüan dynasty (14th century A.D.). Detail of a handscroll, ink and colors on silk, length 86³/₄ in. Colophon by Wen Cheng-ming (1470 —1559 A.D.).

From at least as early as the T'ang dynasty, some of the best court painters were commissioned to record the passage of foreign envoys coming to the Chinese capital to pay tribute to the emperor. This is a detail of a scroll that illustrates the arrival of such a procession of envoys. The gifts include the statue of a lion, a sword, an incense burner, and three magnificent Bactrian horses with blankets made of richly decorated brocade. Jen Po-wen was the grandson of Jen Jen-fa (1254—1327 A.D.) and there is some speculation that Po-wen copied here a work by his celebrated grandfather, who in turn would have been inspired by a much older painting. (B60 D100)

72 *Portrait of Duke Feng-kuo.* Yüan dynasty (1279—1368 A.D.). Hanging scroll, ink, gold, and colors on paper, height 71¹/₁₆ in.

This is one of the few early Chinese portraits in existence. As was customary in those days, it was painted after the subject had died and had been deified, which would account for its hieratic features. The only part of the painting that escapes a seemingly fixed Confucian iconography is the very sensitive face. Duke Feng-kuo, who was known during his life time (1085—1147 A.D.) under the name of Chao Ting, passed into history as an implacable defender of the integrity of Chinese territory and as one of the main proponents of Neo-Confucianism. The colophon inscribed in the upper left corner of the painting seems to indicate that the posthumous portrait was made for one of two temples dedicated in 1331 A.D. to Chao Ting in his home town in Shansi province. (B70 D3; Gift of the Asian Art Foundation)

73 *Wintry Landscape.* Anonymous. Late Sung or early Yüan dynasty (13th century A.D.). Hanging scroll, ink and light colors on silk, height 78¹/₄ in.

Slightly tardy as it may be, this monumental landscape stays within the best tradition of the grand manner of the Northern Sung dynasty. With all their fine details, their interest in human activities, and their realistic approach, these grandiose compositions were by no means conceived to suggest pretty, cosy little corners of nature. They tried to encompass the whole of the universe in its various moods and multiple rhythms. They are as much works of the soul as they are of the eye and hand, a hand which frequently attains dizzy heights of virtuosity owing to life-long calligraphic training. (B69 D13; Gift of the Asian Art Foundation)

74 *Song of the fisherman.* Calligraphic poem by Ch'en Hsien-chang (1428—1500 A.D.). Hanging scroll, ink on paper, height 49³/₄ in.

For two thousand years or so, the Chinese have regarded calligraphy as the supreme art form. This is hardly surprising in a country whose system of writing has been replete with aesthetic potentialities. While learning to write, most creative artists spent their formative years training their minds, eyes, and hands to transcribe all things and concepts in the universe in terms of images made of lines and arranged in rhythmical compositions. It stands to reason that they would ultimately become indifferent to any reality that could not be expressed in a linear idiom. This also explains why calligraphy played

such an important part in other art media, such as painting and sculpture. Ch'en Hsien-chang, the leading Neo-Confucian philosopher of the early Ming dynasty, was noted for his cursive calligraphy, which he wrote with a home-made weed brush.

(B68 D6; Gift of the Asian Art Foundation)

75 *Landscape after Wang Wei's "Wang Ch'uan-T'u"*. By Sung Hsü (1523—1605 A.D.), dated 1574 A.D. Detail of handscroll, ink and colors on silk, length 29¹/₂ in.

While calligraphy had already been the backbone of painting for many centuries, it was during the Yüan and early Ming dynasties that it emerged to the point where it became futile to try to disassociate strictly painterly elements from calligraphic ones. At first, this type of painting, known as *Wen-jen hua* or "literary man's" style, was a revolutionary movement, but toward the end of the 16th century it became the norm accepted by most painters. With such artists, calligraphy no longer served nature: it was nature which served calligraphy. Typically, this largely abstract landscape is not really conceived in terms of rocks, mountains, trees, water, and clouds, even less in terms of light and dark, but in terms of contour and texture strokes. The "Wang Ch'uan" was Wang Wei's (699—759 A.D.) country estate, and Wang Wei's depiction of it is usually regarded as the first true Chinese landscape.

(B67 D2; Gift of the Asian Art Foundation)

76 *Brown Landscape*. By Tung Ch'i-ch'ang (1555—1636 A.D.). Hanging scroll, ink and light colors on silk, height 56¹/₄ in.

This is another example of the kind of abstract landscape favored by the *Wen-jen* movement toward the end of the Ming dynasty. Here, a modular unit, spindle-shaped, is repeated throughout the composition. Tung Ch'i-ch'ang, one of the greatest names in painting, connoisseurship, and art criticism, is responsible for the codification of a theory whereby all Chinese painters can be divided into two categories: those who relish the outward aspects of nature, and those who place all emphasis on the inner realities of human nature as well as nature in general. Of course Tung's preference went to the latter. The validity of this intellectual approach may be challenged, but it must be recognized that Tung's theories and predilections played a major role in the evolution of Chinese painting, and even more so in the literature devoted to it until the present day. (B67 D1)

77 *After the Rain*. Landscape by Hsiang Sheng-mo (1597—1658 A.D.). Hanging scroll, ink on paper, height 35³/₁₆ in.

Influenced as he was by the Wu school of painting in general, and by Tung Ch'i-ch'ang in particular (see preceding plate), Hsiang Sheng-mo was very much of an eclectic, capable of highly individual statements. This is one of them. Here, through what remains essentially post-Yüan calligraphy, the painter recaptures quite convincingly some of the realistic mood of the Northern Sung grand manner, thus combining elements which Tung and his more faithful followers would have rejected as incompatible. (B72 D37)

78 *Pine Lodge amidst Tall Mountains*. Landscape by Wu Pin (ca. 1568—1626 A.D.). Hanging scroll, ink and light colors on paper, height 10 feet ⁵/₈ in.

The 17th century is replete with such fantastic sceneries which hold together exclusively through the magical power of the brush. They show that once the already tenuous link between visual appearance and calligraphic license was severed, everything became possible. Here, Wu Pin, a court painter, influenced by the individualistic Wu school of painting, treats a Northern Sung composition in a very personal manner. With him, mountains and rocks are distorted to suit almost cubist visions.

(B69 D17; Gift of the M.H. de Young Memorial Museum Trust Funds and the Avery Brundage Collection Symposium Funds)

79 *Landscape in the manner of Huang Kung-wang*. By Wang Yüan-ch'i (1642—1715 A.D.), dated 1708 A.D. Detail of handscroll, ink and colors on paper, length 108³/₄ in.

Wang Yüan-ch'i, the youngest of the celebrated Four Wang Masters, contributed toward establishing the Ch'ing Orthodox school as one of the most cohesive and highly respected movements of the late 17th and early 18th centuries. The main contribution of the Orthodox school, and maybe also its main shortcoming, has been the codification of the *Wen-jen hua* calligraphic approach. Wang Yüan-ch'i developed a highly original style, based not only on a particularly pulsatile brushwork, but also on warm, contrasted colors that are used architectonically as well as lyrically.

(B69 D6; Gift of the Asian Art Foundation)

80 *The River Bend*. Landscape by K'un-ts'an (active 1650—1675 A.D.), dated 1661 A.D. Hanging scroll, ink on paper, height 39¹/₂ in.

K'un-ts'an, a Buddhist monk, ranks among the three most famous individualist painters of the 17th and early 18th centuries. He is known for his precise, firm, and rythmical brushwork and for dense, almost somber compositions where craggy peaks and bristly trees are somewhat softened by expanses of cotton-like clouds. The poem which is inscribed in the upper right corner of the painting tells of K'un-ts'an's satisfaction in being able to live a secluded life in close communion with nature.

(B65 D53)

81 *Lotus*. By Yün Shou-p'ing (1633—1690 A.D.), dated 1688 A.D. Hanging scroll, colors on silk, height 66¹/₂ in.

Yün Shou-p'ing, one of the Six Masters of the Ch'ing dynasty, is often regarded as the last great Chinese painter of flowers and as such was followed by a host of imitators. Like other outstanding artists, he was very versatile. One of his favored techniques, exemplified here, consisted of painting realistic flowers without bounding outlines in a manner which Chinese connoisseurs called the "boneless" style. It may well be, however, that Yün Shou-p'ing's enduring fame was due principally to the subtle refinement of his color schemes.

(B69 D5; Gift of the Asian Art Foundation) *19*

82 *Epidendrums, bamboo and fungi growing from rocks*. By Cheng Hsieh (1693—1765 A.D.), dated 1761 A.D. Hanging scroll, ink on paper, height 74³/₈ in.

It is perhaps with such slightly esoteric works that one understands best the very special relationship which in China links painting to calligraphy, poetry, and indirectly, to philosophy. Cheng Hsieh, one of the Eight Eccentrics of Yangchow, specialized in the painting of plants, particularly bamboo and orchids. His eccentricity was not just stylistic. In complete contradiction to the ethics prevailing among most scholar-artists, he openly sold his paintings and even advertised his work in a manner not too different from that of modern publicity.

(B67 D6; Gift of the Asian Art Foundation)

83 *Hall of Green Wilderness*. Landscape by Yüan Yao (court painter in the 18th century during Yung-cheng and Ch'ien-lung periods), dated 1770 A.D. Hanging scroll, ink and colors on silk, height 5 feet 3 in., width 7 feet 6 in.

Early in the 18th century some court painters, among the most talented, set themselves to reviving the naturalistic approach and precise brushwork of the great masters of the Northern Sung period, combined with the romantic mood of the Southern Sung, thus deliberately divorcing themselves from the "literary man's" movement. Yüan Yao, the nephew of Yüan Chiang, the originator of this revival, modeled his style after that of his celebrated uncle. The Yüans are noted for the ambitious scope of their compositions, their neat, precise brushwork, and the contrast, at first puzzling, between contorted mountains and trim, almost finicky, buildings. (B70 D1)

Korea

84 *Ceremonial crown*. Old Silla (ca. 6th century A.D.). Gilt bronze, height 10¹/₂ in.

This object is one in a small group of gilt bronze crowns that have been discovered fairly recently. Their provenance has not been fully established, but they closely resemble in size, form, and manufacture the famous gold crowns unearthed in the royal cemeteries at Kyungju in 1921 and dating from the Old Silla dynasty. This particular example consists of an outer band surmounted by three tree-shaped and two antler-shaped uprights, which seem to reflect shamanistic beliefs or traditions, and of an inner cap made of two bow-shaped bands crossing at right angles. Two openwork horn-like projections are attached to the cap. This frail object was once embellished by numerous little circles of cut gold alternating with jade *magatama*. Some of the gold spangles are still in place, but the *magatama* have all disappeared, as have two long pendants that were hanging from the outer band. (B66 B24)

85 *Covered jar*. End of Old Silla or beginning of United Silla dynasty (7th century A.D.). Ash-glazed gray stoneware, height 10¹/₂ in.

From the 5th century A.D. to about the middle of the 7th century A.D., the potters of the kingdom of Silla in southeastern Korea produced large quantities of distinctive stoneware vessels, some of which were ultimately placed in large rounded tumuli to serve as grave furniture. The most typical vessels are characterized by tall openwork feet and incised geometrical patterns. This transitional piece has none of the usual features. Besides the horizontal grooves that cover the vessel practically from top to bottom, the decoration consists of applied straps and rivets and of danglers. All these embellishments are suggestive of metallic prototypes. (B64 P59)

86 *Standing Buddha*. United Silla (8th century A.D.). Gilt bronze, height 19 in.

The first waves of Buddhist influence reached Korea from China in the 4th century A.D., but the new religion was not firmly implanted in the peninsula before the beginning of the 6th century. Derived from Chinese models of the T'ang period (Pl. 64), this statuette ranks among the largest and earliest Korean Buddhist effigies outside of Korea. With its oversized head, its expressive but stern expression, its squat body proportions and its elaborate pedestal, this sculpture is an excellent illustration of the truly national style which in religious sculpture was the main contribution of the United Silla dynasty.

(B65 B64)

87 *Wine pot*. Koryŏ dynasty (early 12th century A.D.). Porcelain with celadon glaze, height 9⁵/₈ in.

In the West as well as in Asia, Korean pottery is perhaps best known for this type of ware. Celadons, equal if not superior to those of China, were produced in great quantities during most of the Koryŏ dynasty (918—1392 A.D.). Early specimens such as this celebrated wine pot betray a strong Chinese influence. The shape of this particular vessel is derived from a metallic model, probably made of silver. With its subtle bluish green tint, the thin glaze is an outstanding example of the so-called "kingfisher" color, a term used by 12th century Korean potters to designate their own wares. (B60 P123+)

88 *Jar and cover*. Koryŏ dynasty (13th century A.D.). Inlaid celadon, height 8¹/₂ in.

Toward the middle of the 12th century Korean potters devised an exclusively indigenous technique whereby they could decorate their celadons with inlaid designs. This technique, which may have been an offshoot of the underglaze painting decoration of Chinese origin, consisted of incising the desired patterns into the clay and then filling the incisions with white and reddish brown slips. After glazing and firing, the white slip remained unchanged, while the reddish brown slip usually turned black. The main decoration of this elegant jar is thus made of black and white floral sprays. (B64 P55)

89 *Buddha and eight Bodhisattvas*. Koryŏ dynasty (ca. 14th century A.D.). Hanging scroll, ink, gold, and colors on silk, height 59¹/₂ in.

Very few Buddhist paintings of the Koryŏ period have survived. Practically all extant examples were, until quite recently, attributed to the Sung or Yüan dynasties. There

is no doubt that a close stylistic relationship exists between the Chinese prototypes and the Korean variants. However, this small group of Korean paintings displays a number of indigenous traits that are nowhere to be found in their Chinese counterparts. Such are the oversized heads, the linearity of the facial features, the paunchy, squat bodies, the pronounced geometrical rendering of the garments, the studied asymmetry of the composition, and the very elaborate decoration of the pedestal that looks like a platform. (B72 D38)

90 *Wine bottle*. Early Yi dynasty (15th to 16th century A.D.). Punch'ŏng type stoneware, height 12 in.

Punch'ŏng is a technical term which refers to a wide variety of ceramic wares made essentially for the people in general throughout the Yi dynasty (1392—1910 A.D.). Just as early Koryŏ celadons owed a great deal to their Chinese counterparts, early Yi Punch'ŏng vessels were inspired by Tz'u-chou pottery (see Pl. 34). Painted Punch'ŏng wares such as the one illustrated here are the most representative of the whole production. Made in large numbers in the Keryongsan kilns in central Korea, these were covered by a white slip of uneven thickness and painted in iron brown with animal and plant motifs of remarkable simplicity and boldness. (B65 P63)

Japan

Ceramics

91 *Jar*. Jōmon culture (3rd millennium B.C.), probably from Kantō. Earthenware, height 17 in.

Unlike Korea, Japan was not exposed to Chinese culture in any meaningful way until the first waves of Buddhist influence in the 5th century A.D. To understand the substance of Japanese art, even modern Japanese art, it is indispensable to study carefully the artistic production of the archipelago when it was more or less left to itself. This type of low-fired, thick-walled pottery was made throughout the Japanese Neolithic culture for over 4,000 years. Even though there is no direct line of descent between such pieces and later productions, these early specimens explain at least indirectly the innate sense of the Japanese potter for sculptural effects. (B60 P932)

92 *Ring-shaped bottle*. Late Tomb period (5th to 6th century A.D.). Sue type from Hiroshima, grayish black stoneware, height 12 inches.

The production of Sue wares in Japan starting from the 5th century reflects new advanced techniques imported from Korea and more particularly from the kingdom of Silla (see Pl. 85). Fired in sloping kilns at temperatures reaching 1,200 or 1,300 degrees centigrade, this ware was eminently suited to household use, even though most of the extant examples were found as part of the grave furniture of the tomb mounds after which the period in question was named by historians. Most shapes were strictly utilitarian: bowls, dishes, jars, etc. Quite a few vessels, however, assumed highly imaginative silhouettes. (B64 P33)

93 *Platter*. Early Edo period (early 17th century A.D.). Ko Kutani ware, enameled porcelain, diameter 16 in.

This type of ware is among the most prized of all Japanese porcelains. Many questions regarding the origin and early development of this production have not been given conclusive answers as yet, but specialists generally agree that Ko (or Old) Kutani kilns were in operation for about forty years during the 17th century. The principal contribution of those kilns rests with chromatic effects of unprecedented boldness. These are due to the application of multicolored enamels over the glaze. The main decor of this unusually large platter consists of three auspicious plants: a bamboo, a pine tree, and a plum tree which, as a group, is known in Chinese as "The Three Friends" (see Pls. 130, 131). (B66 P36)

94 *Tray with handle*. Momoyama period (1573—1615 A.D.). Ao-Oribe type from the Mino kilns, stoneware with polychrome glazes and painted designs, width 8⅞ in.

Owing to the emergence of new cultural forces, the widening of the art market with a marked plebeian trend, and the sensitivity of practically all art forms to the influence of Zen aesthetics (particularly the tea ceremony), the short Momoyama period stands out as an age of inexhaustible creativity as well as subtle innovation. It is with Oribe ware that the use of copper-green glaze was introduced in Japan. The decoration of this molded tray combines this new technique with brown iron oxide patterns painted under a clear glaze. (B64 P34)

95 *Dish*. Momoyama period (1573—1615 A.D.). E-Shino type from the Mino kilns, stoneware with painted design, diameter 14¾ in.

Together with Oribe ware (see preceding plate), Shino ware ranks among the most imaginative ceramics of the Momoyama period. Practically all the vessels belonging to this category were made specifically for the tea ceremony and reflect the subtle, sculptural approach of the great tea masters who were in this domain undisputed arbiters of taste throughout the period in question. With its typically irregular contours and its decoration of calligraphic plant motifs in iron oxide painted under a thick milky glaze, this dish is a remarkable example of a subgroup known as E-Shino, or Painted Shino. (B66 P37)

96 *Jar with lid*. Early Edo period (17th century A.D.). Kakiemon ware, enameled porcelain, height 10 in.

Early in the Edo period northwestern Kyūshū became a major center of ceramic production, specializing in the making of a variety of porcelains. Among these the Kakiemon enameled wares of rather obscure origin were destined for a career of international magnitude. They formed the bulk of some of the most famous collections in Europe and were imitated by leading manufacturers, such as those of Meissen in Germany and Chantilly in France. Kakiemon porcelains are best known for their fine lustrous glazes and their clear multicolored enamels, which frequently include a special kind of persimmon red. In fact, the entire production was named after the potter or group

21

of potters who achieved this particular type of red since in Japanese "kaki" means "persimmon." (B60 P1206)

97 *Plates.* Mid Edo period (18th century A.D.). Nabeshima ware, enameled porcelain, diameters are $7^7/_8$ in. for the largest plate and $5^7/_8$ in. for the other two.

The large plate is decorated with circular strings of camellias, one of the small plates with three bamboo baskets filled with cherry blossoms, the other one with a spray of Chinese agrimony. All motifs are painted in underglaze blue as well as in polychrome enamels with a predominance of red and yellow. The Nabeshima kilns were officially established in northwestern Kyūshū early in the 18th century. The powerful Nabeshima clan, whose sophisticated taste and high standards of quality are well exemplified here, never sold this ware commercially during the Edo period. (B60 P46+, B62 P23, and B64 P15)

98, 99 *Young couple.* Mid Edo period (18th century A.D.). Old Imari ware, porcelain decorated in underglaze blue, gold, and polychrome enamels, heights of statuettes are respectively $18^1/_4$ and 18 in.

The term "Old Imari" designates a variety of porcelains made in northwestern Kyūshū during the late 17th and 18th centuries and escaping more specific classification such as Kakiemon (see Pl.96) or Nabeshima (see Pl.97). This production reflects a plebeian taste for brilliant colors and for themes inspired by daily life scenes. The bulk of it consists of receptacles of all kinds. Such figurines belong to a smaller group, the subjects of which are frequently quite similar to those illustrated by the better known *ukiyo-e* prints. (B64 P20 and 21)

100 *Basket-shaped bowl.* Attributed to Ogata Kenzan (1664—1743 A.D.). Stoneware decorated in overglaze enamels, diameter 7 in.

Kenzan, an accomplished and versatile artist, was one of the "Three Great Masters" of the so-called Kyōto school which emerged as a major ceramic force in the second half of the 17th century. The school was the first to apply overglaze enamels to pottery, and its most celebrated members were the first Japanese potters to sign their creations. Kenzan, who had two great creative periods separated by a commercial eclipse of twenty-two years, lived to be almost eighty and was extremely prolific. He became a legendary figure and had many followers who did not hesitate to use his signature. As a result, only an infinitesimal portion of his admittedly considerable production has met with the unanimous approbation of contemporary critics and art historians.

(B69 P32; Gift of The Ney Wolfskill Fund)

101 *Stem bowl.* By Okuda Eisen (1753—1811 A.D.). Porcelain with red and green overglaze enamels, height $5^3/_4$ in.

Eisen stands out as the leading potter of the second generation of the Kyōto school (see preceding plate). He was the first member of the school to apply polychrome enamels to porcelain bodies. In addition, his background, interest, and taste were vastly different from those of his illustrious predecessors. Born into a family of Chinese origin, he was well versed in the Chinese classics and developed a strong predilection for Chinese subjects. Thus, for all its originality, this bowl was inspired by a celebrated group of late Ming export porcelains usually known in the West as Swatow ware. (B60 P1234)

Sculpture

102 *Haniwa warrior.* Late Old Tomb period (ca. 6th century A.D.), from Fujioka, Gumma prefecture. Reddish earthenware, height $47^1/_2$ in.

From the 3rd to the 6th century, large tumuli were built over wide areas in Honshū, the main island of the Japanese archipelago. Plain cylinders of low-fired clay, as well as various kinds of statues and models made from the same material, were placed on top or in the vicinity of these monumental tombs. Known as *haniwa*, these objects reflect the introduction of new burial practices which were probably imported from the continent. This warrior is typical of the series of sculptured *haniwa* in which the potter-sculptor achieved lively effects with remarkably economical means. The eyes and mouth are simply gouged out, and only essential details like the riveting of the helmet, the shoulder trappings, and the gauntlets are rendered realistically. (B60 S204)

103, 104 *Bonten and Taishaku-ten.* Tempyō period (8th century A.D.). Dry lacquer, heights respectively $55^1/_8$ and $55^3/_4$ in.

This pair of Buddhist figures, which derive ultimately from the Indian deities Brahmā, the creator of all things, and Indra, the Sun God, rank among the oldest Japanese dry lacquer sculptures in the Western world. They date from a period when Buddhist statuary in Japan was almost entirely dependent on Chinese models of the T'ang dynasty. Such statues are hollow and weigh so little that a small child can carry them. Stylistically, they are akin to the celebrated pair in the Hokkedō of the Tōdai-ji in Nara. The hands, shoes, and octagonal pedestals are later replacements. (B65 S12 and 13)

105 *Guardian.* Heian period (9th century A.D.). Wood with traces of polychrome pigments, height 37 in.

The first century of the Heian period (794—1185 A.D.) corresponds to the last phase in the assimilation of Chinese Buddhism. It was marked by the introduction of Esoteric Buddhism and its complex, awe-inspiring pantheon. This is the fierce effigy of one of the minor deities whose main responsibility was to protect Buddha, his Law, his temples, and his faithful. Carved from a single piece of light wood, the guardian was originally crushing under his feet a grimacing gnome-like figure symbolizing evil in general and, in particular, the enemies of Buddhism. (B67 S1)

106, 107 *Jikoku-ten and Zōjō-ten.* Late Heian period (12th century A.D.). Wood. Heights are respectively 68 in. and $66^1/_2$ in.

These additional examples of the statuary of Esoteric Buddhism during the Fujiwara period belonged originally to a group of Four Guardian deities known in Japanese as 22

Shitennō. Derived from Indian mythological gods, these fierce deities, of which Pl. 105 illustrates an early specimen, acted as guardians of the Buddhist universe. They were usually placed at the four corners of the main platform in a temple. The platform was regarded as a microcosm of the universe, and each of the four guardians, who can generally be distinguished from one another by their attributes, were assigned one of the cardinal points. Thus Jikoku-ten (right) is the Guardian of the East and Zōjō-ten (left) that of the South. (B63 S17+ and 18+)

108 *Nyoirin Kannon.* Early Fujiwara period (first half of the 10th century A.D.). Wood with traces of gesso, gilt, and polychrome pigments. Height of figure 23³/₄ in., height of pedestal 18 in.

While much of early esoteric sculpture is stern or even fierce (see Pls. 105, 106, 107 and 109), mature examples often reflect refreshingly humanizing tendencies. With his stately yet graceful posture, his round, full face and his streamlined torso, the Bodhisattva of Compassion is a remarkable specimen of the latter group. His attributes, now lost, consisted of a jewel, a string of prayer beads, a lotus flower, and the sacred Wheel of the Law.

(B71 S3; Gift of Mr. and Mrs. George F. Jewett, Jr., the Asian Art Foundation, and the de Young Museum Society Auxiliary)

109 *Fudō Myō-ō.* Late Heian period (12th century A.D.). Wood, height 40¹/₄ in.

This outwardly forbidding statue is a three-dimensional rendering of the same deity appearing in Pl. 117. Fudō, the protector of the followers of the esoteric Shingon sect of Buddhism, is usually armed with a rope to catch the wicked and a sword to punish them. In conformity with the then-prevailing iconography, he is shown seated on what was probably a rock-like pedestal. The corners of his bulging eyes are squared off, and his monstrous mouth is equipped with a pair of fangs. (B60 S146+)

110 *Amida Nyorai.* Late Heian period (12th century A.D.). Gilt and lacquer on wood with traces of pigments. Height of figure 36 in., height of pedestal 26¹/₂ in.

In spite of its immense popularity, Esoteric Buddhism, as exemplified by the foregoing two plates, did not entirely supplant earlier trends. In fact, by the end of the 10th century A.D. numerous ateliers working in the restful tradition of the Pure Land sects were already actively concocting what was to become the classical formula in sculpture as well as in painting. With his rounded, stately elegance and his introspective serenity reflecting the aristocratic taste of the period, this Amida is a striking illustration of the formula in its full maturity. (B60 S10+)

111 *Shō-Kannon.* Late Heian period (12th century A.D.). Gilt and lacquer on wood. Height of figure 66 in., height of pedestal 14¹/₂ in.

Shō-Kannon is the basic or immutable form of Kannon, the Bodhisattva of Compassion (see Pl. 108 for another form) who, as one of the principal attendants of Amida (see Pls. 110 and 116), occupied a major place in the liturgy of the Pure Land sects from the 11th century on. In spite of its royal bearing and coiffure, this effigy, whose style closely resembles that of the Amida of the preceding plate, suggests unreserved commiseration as one would expect from the most benevolent and perhaps the most solicited of all the Bodhisattvas. The lotus bud which Kannon holds in his right hand, while a later replacement, is a symbol of redemption. (B60 S420)

112, 113 *Thunder and Wind Gods.* Early Edo period (17th century A.D.). Architectural carvings, wood, heights 39 in.

Apparently this type of interbeam support, with outside frames that vaguely suggest outstretched frogs' legs (*kaerumata* in Japanese), first came to light during the Kamakura period (1185—1334 A.D.). Easily recognizable by their drum and windbag, the Thunder and Wind Gods were usually depicted in the form of husky gnome-like figures. In a manner which is quite typical of much of the sculpture of Japan during the Edo period, they resulted from an approach in which the bizarre, or even the monstrous, was tempered with a good deal of humor. Such carvings were at times placed at the ends of buildings as protection against damage from the natural elements.

(B60 S2+ and 3+)

114 *Bishamon-ten.* Late Momoyama—early Edo period (16th to 17th century A.D.). Wood with gilt and polychrome pigments, height 55 in.

The pictorial tendencies that were smoldering in much of late Heian and Kamakura sculpture came to the fore in all subsequent periods and were occasionally responsible for spectacular and convincing achievements. Bishamon-ten, the Guardian of the North, is one of the Four Guardians whose iconography was discussed in an earlier historical context (see Pls. 105, 106 and 107). This popular deity ultimately derives from Kuvera, the Indian God of Wealth, and was also worshiped as such in Japan. His main attributes are a *stūpa* and a spear. (B60 S170+)

115 *Fugen Bosatsu.* Kamakura period (13th century A.D.). Hanging scroll, colors and cut gold *(kirikane)* on silk, height 25 in.

For all its complex and at times awe-inspiring iconography, Esoteric Buddhism took the first decisive step toward the popularization of the Law because the fundamental principle of its revolutionary doctrine was that everyone could attain Buddhahood during his own lifetime. This Fugen, the Bodhisattva of Benevolence, riding his six-tusked white elephant in a cloudy paradise, is a vivid illustration of such humanizing tendencies. (B66 D2)

116 *Kangyō-mandala* (14th to 15th century A.D.). Hanging scroll, ink, gold, and colors on silk, height 67 in.

In Japan as in India and Indianized countries *mandalas* were used originally as visual aids to private meditation. Later on, however, under the influence of the Pure Land sects, they played an important part in rituals such as baptism or ordination. The *Kangyō-mandala*, commonly known as the *Taima-mandala*, belongs to the latter group. It depicts Amida Buddha in all his glory. Surrounded by

his favorite Bodhisattvas and lesser deities, the Buddha is seated in the center of his Western Paradise where he welcomes the souls of the faithful. On the left of the main scene and below it are sixteen smaller paintings illustrating the so-called "Sixteen Visions of Amida," while the right border tells the story of Prince Ajatasatru, whose treachery caused his mother to call for Amida's help and to be rewarded by the visions depicted here. (B61 D11+)

Painting

117 *Fudō Myō-ō.* Kamakura period (13th century A.D.). Hanging scroll, ink and colors on silk, height 68 in.

Esoteric Buddhism played a major role in the religious life of Japan from the 8th to the 10th centuries, and remained highly influential as a source of artistic inspiration until the first part of the Kamakura period. Esoteric iconography is characterized by an eclectic, populous pantheon with multi-headed, multi-eyed, multi-armed, fanged, and blazing-haired deities originally conceived in 8th century India. Fudō (literally the Immovable) is the most prominent in a group of Five Fierce Bodhisattvas regarded as manifestations of the Five Wisdom Buddhas' wrath against evil. He personifies steadfast resistance to temptation. (B70 D2; Gift of the Asian Art Foundation)

118, 119 *Birds, flowers, reeds, and trees on the river.* By Sesshū (1420—1506 A.D.) and dated the 78th year of Sesshū (i.e. 1497 A.D.). Pair of six-fold screens, ink and light colors on paper, each screen is 70 in. high.

This is one in a very small group of pairs of "birds-and-flowers" screens that can be safely attributed to Sesshū, the foremost master of the Muromachi period, and indeed one of the greatest painters of all times. Sesshū, a Zen priest, was brought up in the tradition of the Southern Sung Academy of Painting. A twelve-year-long trip to China reinforced his predilection for this particular school. However, these examples of his mature style stand out as typically Japanese masterpieces. As far as subject matter and composition are concerned, they owe very little to any Chinese prototypes. (B60 D11 and 12)

120 *Li T'ai-po looking at the waterfall.* By Sōami (?—1525 A.D.). Hanging scroll, ink on paper, height 24¾ in.

Unlike Sesshū (see preceding plate), Sōami was not a Zen monk. He belonged to a family of great artists and connoisseurs who were employed by the *Shōguns* as art advisers. Yet this unusually talented family also worked for Zen monasteries, and it may be that this painting is the result of such parallel activities. In Zen aesthetics the theme of "viewing the waterfall" represents the moment when a priest, all absorbed in the fascinating sound and movement of falling water, suddenly attains enlightenment. With its verticality, its relative shallowness, its bold contrasts in ink tonalities and its powerfully agitated brushwork, this painting is characteristic of a time when *Suiboku* masters had adapted what were originally Chinese styles to Japanese scenery and sensibility. (B62 D11)

121, 122 *Landscapes of the four seasons.* By Shikibu Ryūkyō (first half of the 16th century A.D.). Pair of six-fold screens; ink, gold, and light colors on paper. Each screen is 67½ in. by 127 in.

This magnificent work by a relatively little-known artist is one of the best in a small group of late 15th- and early 16th-century screens describing seasonal changes in almost continuous landscapes. While the painting is treated as a single entity, the successive passages from spring (on the right of the first screen) to winter (on the left of the second screen) are subtly and convincingly rendered, here by budding trees, there by luxuriant vegetation and outdoor activities, farther down by fall colors, and finally by white roofs, snow-capped peaks, and bare trees. Such paintings were inspired by Chinese prototypes and were meant to look Chinese, yet the brushwork and coloring of this particular pair are unmistakably Japanese. (B60 D48+ and 49+)

123, 124 *Tartars hunting and playing polo (Hokuteki).* Attributed to Kanō Sōshū (1551—1601 A.D.). Pair of six-fold screens; ink, gold, and colors on paper. Each screen is 65 in. by 137½ in.

The shortlived but exuberant Momoyama period (1573—1615 A.D.) is perhaps best known in the West for the variety and brilliance of the murals and screens which were commissioned by wealthy townsmen and farmers, as well as by feudal lords. A good part of these large-scale and opulent paintings came from the remarkably talented brushes of Kanō school artists who specialized in the decoration of castles, temples, and villas. The theme of the "Northern Barbarians" illustrated here is a rare one, regardless of school, but the carefully balanced compositions, the bold yet precise brushwork, the attention paid to minute details, and the lavish use of gold are all characteristic of the Kanō school. Sōshū was the younger brother and heir apparent of the celebrated Kanō Eitoku. (B69 D18A and 18B; Gift of the Asian Art Foundation)

125, 126 *Southern Barbarians (Namban).* Kanō school. Late Momoyama or early Edo (late 16th to early 17th century A.D.). Pair of six-fold screens, ink and colors on gold paper. Each screen is 68¼ in. by 131 in.

In a way, this other Kanō school work forms a pendant to the "Northern Barbarians" of the preceding plate. Yet it should be noted that the screens which depict the arrival of Jesuit priests and Portugese traders in Nagasaki and Sakai during the second half of the 16th century are much less hard to come by than those dealing with the Northerners. The Westerners (or "Southern Barbarians" as the Japanese used to call them after the Chinese manner) with their strange ships, their curious attire, their unexpected physical characteristics, and their exotic goods became very popular subjects that were frequently rendered with caricatural but not unfriendly humor. (B60 D77+ and 78+)

127 *Horses tethered in stables (Umaya-zu).* Kanō school, late Momoyama or early Edo (early 17th century A.D.). Sixfold screen, ink, gold, and colors on paper, 47⅝ in. by 118 in.

Chargers were bound to become a favorite subject with the horse-loving warriors of Japan. This particular theme of splendid stallions tethered in their stables was first depicted toward the end of the Muromachi period (1392—1573 A.D.). This present group is an example of the mature phase of this type of painting. The horses are represented standing or prancing in open stalls. Bamboo or other plants and trees among clouds furnish the usual background of such compositions. In spite of a certain calligraphic and chromatic unity where Kanō and Tosa elements are adroitly blended, this screen was obviously made up of sections of two or three separate ones probably produced by the same workshop. (B69 D8)

128, 129 *Playing the lute under a pine tree* by Uragami Gyokudō (1745—1820 A.D.) and *Landscape in the manner of Tung Yüan* (dated 1835 A.D.) by Nakabayashi Chikutō (1778—1853 A.D.). Respectively ink and light colors on paper, height 11¹/₄ in.; and ink on paper, height 22³/₄ in.

In spite of obvious differences in size and style, these landscapes are expressions of the same artistic and highly intellectual movement which flourished in Japan during the 18th and early 19th centuries. Known as *Nanga* ("Southern Painting") or *Bunjinga* ("Literary Man's Painting"), this movement was composed of a number of individualists rather loosely linked together by their profound respect and admiration for the *Wen-jen* tradition of the Yüan, Ming, and Ch'ing dynasties (see Pls. 75, 76, 77, 80, and 81). (B69 D49 [Gift of the Ney Wolfskill Fund] and B67 D16 [Gift of the Asian Art Foundation])

130, 131 *The three friends (Shō-chiku-bai)*. By Maruyama Ōkyo (1733—1795 A.D.). Pair of six-fold screens, ink and gold wash on paper. Each screen is 66¹/₄ in. by 146 in.

Ōkyo, the founder of a school known as Maruyama-Shijō, created a striking and refreshingly new style by combining Chinese themes with Kanō brushwork and occasionally Western perspective. This unprecedented formula resulted in a new kind of realism which paved the way for the downright Western movements of the late 19th and early 20th centuries. It will be remembered that in China, pines, bamboo, and plum trees, when grouped together, were traditionally known as the Three Friends (see Pl. 93). Emblems of longevity, they also symbolized the virtues of the perfect gentleman and personified the three great religions: Buddhism, Confucianism, and Taoism. (B60 D55+ and 56+)

India

Sculpture

132 *Yakshī*. Kushān period (2nd century A.D.), Mathurā. Red sikri sandstone, height 27 in.

In India, for over two thousand years, artists and craftsmen alike relied primarily on iconographies developed by three great religions: Hinduism, Buddhism, and Jainism. Nowhere else in the world has religion been a more important factor in artistic creativity, and nowhere else have

sculpture and architecture been more lithic and inseparable. That stone should have remained the ideal medium of artistic expression was to be expected from a people imbued with immutable values and working for eternity. This magnificent female figure is in fact a decorative motif for a pillar which once belonged to a railing placed around a Buddhist or Jain monument. *Yakshīs* were worshipped as nature spirits and symbols of fertility from time immemorial. They rank among the most ancient deities that were incorporated in the Hindu, Jain, and Buddhist pantheons. (B69 S13; Gift of the Asian Art Foundation)

133 *Bust of Buddha*. Kushān period (ca. 2nd century A.D.), Mathurā. Red sikri sandstone, height 20¹/₄ in.

In Northern India and in the Gandhāra region, corresponding to today's Pakistan and Afghanistan, two distinct versions of the Buddha image developed gradually and simultaneously during the Kushān period, i.e. during the first three centuries of our era. Workshops in Mathurā in Northern India, one of the earliest and most prolific centers of Buddhist art, created their version of the Buddha image on the foundation of types and techniques established by the early Indian tradition (see Pl. 132). The Mathurā Buddha is consequently the most Indian-looking Buddha. As can be seen here, he is usually shown with large, oval eyes and softly smiling lips. His face radiates a friendly, human warmth which is also present in the swelling roundness of the torso. (B65 S10)

134 *Bodhisattva*. Kushān period (2nd to 3rd century A.D.), Gandhāra. Schist, height 41 in.

In contrast with the school of Mathurā (see preceding plate), that of Gandhāra relied heavily on Greco-Roman stylistic concepts which had found their way into the provincial workshops of the Roman empire. This is perhaps best seen in the facial features of free-standing Buddhas and Bodhisattvas, which are frequently adapted from such classical models as the Apollo of Belvedere. As usual, this impressive Bodhisattva is portrayed as a princely figure with the garments, coiffure, and jewels that are the signs of his rank. He holds in his left hand a sacred water vessel. (B60 S597)

135, 136 *"Māyā's dream"* and *"The inheritance"*. Kushān period (ca. 3rd century A.D.), Gandhāra. Schist; widths are respectively 11³/₈ in. and 16¹/₂ in.

One of the most appealing aspects of Gandhāran art consists of reliefs carved out of the gray schist which is typical of the region. A great many of these reliefs illustrate various scenes in the life of the Buddha. Here, for instance, the upper relief depicts Queen Māyā's dream of the miraculous conception of the Buddha, who, in the shape of a baby elephant, enters his mother's side while she rests on a couch. (B64 S5)

After his enlightenment the Buddha returned to his home where he met again Yashodharā, his wife, and Rāhula, his young son. Prompted by his mother, Rāhula asked his father for his inheritance. Two episodes of this famous scene are represented on the lower relief. (B60 S283)

137 *Vishnu and attendants*. Kushān period (ca. 4th century A.D.), Mathurā. Red sikri sandstone, height 31¹/₄ in.

Hinduism and Hindu art find their roots in the prehistoric cultures of the Indus Valley. They were never completely superceded by Buddhism or Buddhist art. Hinduism corresponds to a fairly successful attempt to codify ancient cults honoring innumerable cosmic deities. In time, this codification emphasized the importance of three main deities: Brahmā the Creator, Vishnu the Preserver and Shiva the Destroyer. This early representation of Vishnu shows the hefty, four-armed god wearing a high crown and holding his usual attributes, the lotus bud, the conch, the club, and the discus. The diminutive figures on either side of Vishnu can be regarded as personifications of the lower attributes, i.e. the club and the discus. (B73 S17)

138 *Ekamukha-linga*. Gupta period (5th to 6th century A.D.). Central India. Fine-grained sandstone with partial glaze on forehead and lunar motif, height 58 in.

Shiva, one of the members of the so-called Hindu Trinity (see preceding plate), assumes many different forms, including the *lingam*, which is the phallic symbol of the god. The *lingam* itself could take on a variety of shapes (see Pl. 150). This rare example is decorated with a powerful, almost free-sculpted head of Shiva, who is easily recognizable by his third eye, his ascetic knot, and the crescent that adorns it. With its noble, classical features, this head is typical of the Gupta period which many regard as the climax of Indian sculptural art.

(B69 S15; Gift of the Asian Art Foundation)

139 *Harihara*. Gupta period (6th century A.D.), probably Central India. Sandstone, height 42¹/₂ in.

Half Shiva and half Vishnu, this statue is an outstanding illustration of the syncretic tendencies that brought about a rapprochement between Saivism and Vaishnavism during the Gupta period. The right side of the statue represents Shiva with some of his customary iconographic features, such as the crown made of matted locks, half a third eye incised on the forehead, the trident, and the cobra. The left side, the one reserved for Vishnu, is marked by the presence among other things of the *kirīta* crown. Despite this complex iconography, the statue displays the kind of stylistic unity and uncompromising quality that are hallmarks of the best Gupta sculpture.

(B70 S1; Gift of the Asian Art Foundation)

140 *Dvārapāla*. Chola period (10th century A.D.), South India. Granite, height 69¹/₂ in.

Dvārapālas are guardian deities assigned to the protection of doorways, primarily in religious buildings. Although this imposing statue was carved in the round, its back was left unfinished, which indicates that it was originally placed against a wall. Though the crowned head is strictly frontal, the powerful body gradually twists to one side so that the legs are shown almost completely in profile. The left leg is raised and rests on a mace encircled by a cobra. The ferocious guardian displays all the facial features characteristic of his type including bulging eyes,

fangs, pointed ears, and flaming hair. Dvārapālas necessarily come in pairs. The mate to this one is now in the Rietberg Museum in Zurich. (B60 S425)

141 *Brahmānī*. Chola period (9th century A.D.), probably from Kānchīpuram, South India. Granite, height 29 in.

Brahmānī is the female consort of Brahmā, the central figure in the Hindu Trinity (see Pl. 137). She is also the first in a group of seven deities known as the Seven Mothers. The sensuous facial features, the heavy breasts, the slender waist, and smooth articulations of this three-headed (but a fourth head is understood), four-armed deity are typical of the medieval period of Dravidian art. Brahmānī is seated cross-legged on a low semicircular base where the swan *(hamsa)*, Brahmā's vehicle and symbol, is carved in low relief. (B60 S47+)

142 *Varāha* (10th century A.D.), Western India. Gray schist, height 32¹¹/₁₆ in.

The main deities of Hinduism assume many different forms, which correspond to the various functions they perform according to Hindu mythology. In this *avatār* of Vishnu, the god is shown as a human being with the head of a boar. This is the Cosmic Boar, who rescued the earth goddess held in captivity in the bottom of the ocean by the serpent demon Hiraṇyāksha. Carved in almost full profile, Varāha holds in three of his four hands attributes characteristic of Vishnu, namely the conch, the discus, and the mace. Bhūmidevī, the Earth Goddess, rests seated on Varāha's upper left elbow. (B62 S15+)

143 *Door jamb*. (10th to 11th century A.D.), Madhya Pradesh. Gray-green, fine-grained granite, height 48¹/₂ in.

Hindu temples are swarming with free-standing sculptures, carvings, and bas-reliefs of all kinds, so that one is tempted to describe them as "sculptural buildings." This powerful door jamb, in which practically all the available space has become the prey of the sculptor, is a good case in point. Here fabulous and real animals mingle with lithe female figures in some sort of fantastic dance. The whole scene exudes considerable joie de vivre and a great deal of humor. The griffin, a mythological variant of the lion, spills forth a string of pearls.

(B70 S7; Gift of the Asian Art Foundation)

144 *Chaurī-bearer and drummer*. Medieval period (11th to 13th century A.D.), probably from the region of Mount Ābū, Rājasthān. White marble, heights are respectively 29³/₄ in. and 28¹/₂ in.

Jainism, like Buddhism, originated in the 6th century B.C. in reaction against the cumbersome liturgy and the system of castes of Brāhmanism. This religion started as a philosophical and social movement but soon developed into an elaborate theological system with a complex pantheon and a powerful church. The Jain temples of Mount Ābū, all carved in pure white marble, rank among the most celebrated religious buildings in India. The domes of such temples are covered with sculptures similar to these delightful figures. The *chaurī* (fly-whisk bearer) also holds a water vessel in her right hand. (B61 S45+ and 46+)

145 *Crowned Buddha.* Pāla period (10th to 11th century A.D.), Bihār. Black chlorite, height 41 in.

After the irreversible decline of Buddhism following the downfall of the Gupta dynasty early in the 7th century, northeastern India, particularly in the provinces of Bihār and Bengal, was the only region to remain under the influence of the Buddhist faith. In art, this influence manifested itself in a major way until about the 12th century. The main theme illustrated by this stele is that of the Devāvatāra, a manifestation of the Buddha Shākyamuni as he descends from the heaven of the thirty-three gods where he has spent three months teaching the True Law to his mother. The general style, including the posture and the clinging garments, is ultimately derived from Gupta prototypes, but the jeweled crown, the earrings, and the heavy necklace are concessions made to the taste prevailing in contemporary Hindu statuary, as well perhaps as reflections of the increasing importance of Vajrayāna (or Tantric) Buddhism. (B65 S11)

146 *Vishnu and attendants.* (11th to 12th century A.D.), Central India. Reddish sandstone, height 51$\frac{1}{2}$ in.

This stele was carved approximately one thousand years later than the statue illustrated in Pl. 137. Even a cursory comparison of the two pieces will enable the reader to appreciate iconographical analogies as well as conceptual and stylistic differences. The present version no longer looks like a deified yet approachable human being. In his rigid frontality and immaculate perfection, Vishnu looks here like the epitome of godhead. Such steles were made partly to assert the supremacy of Vishnu over all other Hindu deities, and this is the very theme of the top register where the god appears at the apex and is flanked by effigies of Brahmā and Shiva, who are seated at a lower level. (B63 S9+)

147 *Shiva Tripurāntaka.* (11th century A.D.), Central India. Red sandstone, height 24$\frac{1}{2}$ in.

Griffins, or *shārdūlas*, and elephants, comparable to those of the preceding plate, are part of the decoration of this relief, which illustrates one of the most famous deeds of valor accomplished by Shiva. The ten-armed Destroyer is in the process of annihilating with one single arrow the demon dwellers of the Three Castles. This is the last episode of a legend in which the Three Castles were reputed unconquerable until such time when, after a thousand years, they would unite and be destroyed by a single arrow. Besides a bow, Shiva brandishes a shield, a spear, a skull-club, a cobra, a trident, and two swords. His gluttonous elephant-shaped son, Ganesha, is hiding behind his right leg (see also Pl. 149). Typically, the whole scene is permeated by a powerful rhythm suggestive of some sort of epic dance. (B63 S6+)

148 *Shiva Dakshināmūrti.* Chola period (11th to 12th century A.D.), probably from the Tanjore district, South India. Granite, height 41$\frac{1}{2}$ in.

This aspect of Shiva (see also Pls. 138, 148, 150, 152, and 192) became more or less the specialty of South Indian workshops during the medieval period. The versatile god is shown here in a particularly noble scene and appealing form as the great teacher of wisdom, yoga, music, and science in general. Immediately recognizable by his third eye and the crescent in his hair, the Sage is seated on a high throne, one leg resting on a gnome-like demon who personifies ignorance. The usual attributes of the deity are the snake, the fire, and the book. However, three out of the four arms of this statue have become damaged and only the book is left. It is not, therefore, possible to state that this sculpture is a Jñāna rather than a Vyākhyāna-Dakshināmūrti, despite its close resemblance with the Jñāna-Dakshināmūrti of the Shiva Temple at Avūr in the Tanjore district. (B63 S50+)

149 *Seated Ganesha.* Hoyshala period (ca. 12th to 13th century A.D.), from Mysore, South India. Chloritic schist, height 35$\frac{1}{2}$ in.

Short-lived as it was, the Hoyshala dynasty is to be credited with a very distinctive type of sculpture. The raw material used by Hoyshala workshops, chloritic schist, has the peculiarity of being soft when quarried. It consequently lends itself to unusually delicate carving, and the final Hoyshala products often look like lithic lacework. Ganesha, the elephant-headed son of Shiva and his *shakti* Pārvatī, was and still is one of the most-worshipped deities in India and neighboring countries. This is no doubt largely due to the versatility of his talents, since he is at once the patron god of gourmets, scholars, and thieves. The four-armed deity holds an axe, a broken tusk, a lotus (no longer visible), and a bowl of sweetmeats.

(B68 S4; Gift of The de Young Museum Society)

150 *Shiva Lingodbhavamūrti.* Chola period (ca. 13th century A.D.), South India. Granite, height 49$\frac{1}{2}$ in.

Since this aspect of Shiva was conceived primarily to assert the god's supremacy over all other members of the Hindu pantheon, it constitutes a retort to the kind of Vaishnavite statements we analyzed briefly in connection with the stele of Pl. 146. Here, however, the message is considerably more direct and clear. It is the illustration of a famous legend where Brahmā and Vishnu were both claiming to be the Creator of the Universe. In the midst of their dispute they were confronted by a *lingam*, in the shape of a flaming pillar, that suddenly appeared before their eyes. The *lingam* rose to such heights and plunged into such depths that Brahmā, shown here as a swan (see Pl. 141), could not reach its top; nor could Vishnu, in the form of a boar (see Pl. 142), fathom its base. At this point the *lingam* burst open to reveal Shiva, in his Candrashekhara form, thus affirming his own claim to the title of Creator. (B65 S3)

151, 152 *Balakrishna and Somāskanda.* Late Chola or early Vijayanagar period (13th to 14th century A.D.), South India. Bronze, 24$\frac{1}{2}$ in. high and 29 in. wide.

Since the medieval period, southern workshops have produced a number of remarkable bronze sculptures for Vaishnavite and Saivite temples. It seems that many of

these bronzes were cast specifically to be carried in processions. Krishna is probably the most popular *avatār* of Vishnu (see also Pls. 142 and 150). Here the playful god is shown as a child who has just stolen butter from the family reserve and runs away with his prize. The Somāskanda is a family group. It shows Shiva, his *shakti* Umā and their bandy-legged baby son Skanda. This piece bears an inscription which gives the names of the donor and his ancestors. (B60 S157+)

153 *Yakshī or Sālabhajikā.* Eastern Gaṅgā dynasty, reign of Narasiṁha Deva (ca. 1238—1264 A.D.), from the Sūrya Temple, Konārak, Orissā. Ferruginous sandstone, height 48 in.

The Sūrya temple in Konārak, also known as the Black Pagoda, is noted not only for the magnificence of its ruins, but also because it displays erotic sculptures of great audacity and imagination. This relatively chaste figure harks back to very ancient prototypes such as the one we illustrate in Pl. 132. At the same time, with its fully developed and somewhat conventionalized volumes, it reflects the influence of Gupta aesthetics, which in northeastern and eastern India lingered well into the medieval period.

(B68 S2; Gift of the Asian Art Foundation)

154 *Saivite saint.* Vijayanagar period (14th to 15th century A.D.), probably from the Tanjore district, South India. Bronze, height 36 in.

In addition to principal deities such as Shiva, Umā (Pārvatī), and Vishnu, South Indian workshops produced a large quantity of Saivite saints that are in effect personified manifestations of a total devotion to Shiva. This almond-eyed, sharp-nosed, broad-shouldered, slender-waisted, star-naveled, slightly swaying youth is a prime example of the kind. The Vijayanagar school has been noted for a certain finickiness resulting from an excessive concern for conventionalism. This exceptionally fine figure, however, succeeds in blending stylized features with downright realistic elements, and this is no doubt the secret of its spellbinding charm. (B69 S14)

155 *Nandi.* Vijayanagar period (late 15th century A.D.), South India. Granite, height 55 in.

This monumental piece of sculpture was once an important feature of a temple dedicated to Shiva. Nandi is the vehicle or mount of Shiva, and such sculptures were placed low on the ground or in a separate little shrine, where they faced the image of Shiva or the *lingam* located in the inner shrine of the main temple (see Pl. 138). Nandi was and still is worshiped in his own right as a symbol of fertility. The powerful animal is bedecked from horns to hooves with finely carved ornaments, including a blanket, the decoration of which reveals a certain amount of Persian influence.

(B68 S3; Gift of The Atholl McBean Foundation)

Southeast Asia

Sculpture and Ceramics

156 *Head of Buddha.* Early Dvāravatī period (ca. 7th century A.D.), Thailand. Sandstone with traces of gilding, height 11 in.

The Indianized kingdom of Dvāravatī ruled over a large area of present-day Thailand, particularly the southern part of the Menam Basin, from the 6th to the 11th centuries A.D. Without being exactly the first to be recorded in the history of Thailand, the Dvāravatī period is the first to have handed down to us a fairly large body of sculptures that can be organized into a coherent whole. Despite their obvious allegiance to canons established by the Gupta school, Dvāravatī workshops, which served primarily Hīnayāna temples, succeeded very early in developing a style of their own, exemplified by this serenely austere yet youthful head. The rather low, flat forehead, high cheekbones, short, high-bridged nose, and protruding lips reflect the ethnic characteristics of the Dvāravatī people, who were of Mòn origin.

(B68 S8; Gift of the Asian Art Foundation)

157, 158 *Avalokiteshvaras.* The smaller dates from the 7th century A.D.; the larger from the 9th century. Both come from Pra Kon Chai in northeastern Thailand. Bronze; heights are respectively 27$\frac{1}{2}$ in. and 37 in.

These statues represent the initial and terminal phases in the evolution of a style which, despite certain Mòn-Dvāravatī and Chenla influences, is distinctive from all other early styles in Southeast Asia. They belong to a group of Mahāyāna bronze sculptures that were found in 1964 and constitute one of the main archaeological discoveries of modern times. They have been ascribed tentatively to the Canāsha kingdom, whose religious convictions were different from those of its neighbors. Avalokiteshvara or Lokeshvara, "The Lord of All the Worlds," is the same deity who is worshiped in China and Japan under the names of Kuan-yin and Kannon (see Pls. 58, 65, 68, 108, and 111). To our knowledge, the athletic pectoral muscles of the smaller statue have no parallel in Khmer or Indian art. (B65 B57 and B66 B14)

159 *Female deity.* Khmer (10th century A.D.). Sandstone, height 52 in.

The origins of the Khmer empire are obscure or, at best, legendary, yet at the height of their power the Khmer (ancestors of today's Cambodians) ruled not only over Cambodia, but also over large areas in Thailand, Laos, and Cochin China. This almost life-size statue may well be the most complete and significant in a small group which marks the transition between the Bakheng and Koh Ker styles toward the beginning of the second quarter of the 10th century. Typically for the period, the noble facial features reflect canons of masculine beauty and are consequently rather stern despite a half-smiling expression. Among other salient iconographic elements, sinuous beauty

creases below the breasts and elaborate belt pendants are particularly noticeable.

(B68 S19; Gift of the Asian Art Foundation)

160 *Vishnu*. Khmer, Pre Rup style (mid 10th century A.D.). Gray sandstone, highly polished, height 56 in.

Partly divine and partly royal, this statue is a vivid illustration of a typically Khmer concept whereby a king was assimilated to a god. It seems that at first this identification applied only to deceased monarchs but early in the 9th century Jayavarman II instituted the cult of the God-King *(Devarāja)*, which flourished until the end of the Khmer empire. According to this cult the king had to be worshipped in his lifetime as the incarnation of a god. Stylistically, this sculpture is quite close to the Female Deity of the preceding plate, yet it displays a number of distinctive characteristics such as the high and arched forehead, the sharp ridge formed by rich linear eyebrows, and the distant, although still benign, expression. The most spectacular feature may well be the headdress. It consists of an octagonal tiara and a high diadem tied up in the back by a kind of havelock which covers the nape.

(B65 S7)

161 *Shiva and Devi (?)*. Khmer, Baphuon style (late 11th century A.D.). Veined sandstone, heights are respectively 44 in. and 41 in.

This half-divine, half-royal couple constitutes another remarkable illustration of the *Devarāja* cult (see preceding plate). Here, however, the deity implied is Shiva, and not Vishnu, as clearly indicated by the presence of a third eye in the middle of the king's forehead. The Baphuon style corresponds to a period when Khmer sculptors yielded to an ideal of feminine beauty regardless of sex, which of course was in complete contradiction with former trends (see for instance Pl. 159). The soft, streamlined contours of these unusually delicate figures, their restrained facial features, their relatively discreet headdresses and adornments, and their tightly fitting garments all contribute to emphasize the charm of their youthful and, in the case of Shiva, slightly effeminate bodies. (B66 S2 and 3)

162 *Lintel*. Khmer (late 11th century A.D.). Reddish sandstone, width 64$\frac{1}{2}$ in.

Lintels are among the most common and also the most ornate elements of Khmer architecture. The earliest examples used essentially motifs borrowed from the vegetable kingdom, while the latest specimens frequently illustrated narrative scenes with a profusion of human and animal figures (see Pl. 164). Typically, what was originally a horizontal branch of foliage has, in this intermediate piece, been broken up into four scrolls of approximately equal size. The monstrous head, which forms the focal point of this exuberant lintel, is that of Kāla, one of the aspects of Shiva as time god in Indian mythology. The Khmer borrowed this particular motif from Javanese iconography at least as early as the 9th century and endowed it with great protective power. Thus, in this context Kāla is regarded as protector of the doorway. (B68 S13)

163 *Lintel*. Khmer (late 11th century A.D.). Reddish sandstone, width 79$\frac{1}{2}$ in.

Contemporaneous as it is with the lintel of the preceding plate, this one reflects a vastly different taste which seems to have prevailed in Northeastern Thailand, particularly in the region of Phimai. The main register depicts a prince or a king being entertained by musicians and dancers. All the faces of the actors in this lively scene display pronounced ethnic characteristics. The lower register is decorated with stylized celestial geese shown in profile, with the exception of the central bird which is in frontal position. Celestial geese symbolize the propagation of the Buddhist faith throughout the world. (B72 S3)

164 *Lintel*. Khmer, Angkor Wat or early Bayon period (12th century A.D.). Reddish sandstone, width 74 in.

Three-dimensional Khmer statuary is essentially solemn, static, and hieratic (see Pls. 159, 160, and 161). Conversely, Khmer reliefs are usually bursting with life. This is particularly true of the lintels of the Angkor Wat period, which frequently mirror the lushness and overwhelming exuberance of the surrounding jungle. In all likelihood this monumental lintel is a lithic version of an episode of the *Rāmāyaṇa*, an ancient Indian epic which narrates in great detail the adventures of Rāma, one of the numerous incarnations of Vishnu (see for instance, Pls. 137, 142, and 151). Certain details in the execution point to workshops that flourished north of the Dangrek mountains when the Khmer empire was at its apex. (B66 S7)

165 *Horse in full trappings*. Khmer, late Angkor Wat or early Bayon period (12th century A.D.). Reddish sandstone, length 29 in.

Very few Khmer horses in the round have survived and none of the half-dozen known pieces resembles this one. The youthful charm of this little animal results partly from the vivid contrast between its lively, sensitive head and its stocky, barrel-shaped body supported by tubular legs, and partly from the careful blending of realistic and abstract features. The elaborate collar, the leg clasps and the richly decorated blanket all denote that this was no ordinary horse, but rather one that took part in processions or parades. This is further corroborated by the presence of three squarish perforations on the back. These must have served for the insertion of supports for a rider, a dais, or both. (B68 S10;

Gift of the de Young Museum Society Auxiliary)

166 *Buddha on Mucilinda*. Khmer, Bayon style (late 12th to early 13th century A.D.). Gray sandstone, height 29 in.

The conversion of Jayavarman VII and of his kingdom to Theravāda (or Hīnayāna) Buddhism in the late 12th century resulted in a radical change in the iconography of Khmer three-dimensional carving. Images inspired by Hinduism disappeared almost entirely, to be replaced by effigies of Buddha and of his attendant Bodhisattvas. This statuette illustrates a favorite theme. As the Buddha was lost in meditation just before attaining enlightenment, he was assailed by torrential rains, at which

point the Serpent King Mucilinda came to his rescue by offering its coils for a seat and its seven heads for a canopy. This episode in Buddha's life was particularly popular with Khmer sculptors, owing to the predominant role played by snake deities in Khmer mythology. (B69 S8)

167 *Buddha seated in meditation.* U-Thong style (13th to 15th century A.D.), Central Thailand. Bronze, height 16⅜ in.

During the 11th and 12th centuries, the Mòn kingdom of Dvāravatī (see Pl. 156) was occupied by the Khmer who in turn were displaced by the Thai in the 13th century. The Thai, who originally came from southwestern China, did not unify the country until the 14th century. At first they established a number of rival principalities or small kingdoms. Although they were all fervent followers of the Theravāda school of Buddhism, these kingdoms developed their own styles with, at times, pronounced local characteristics. The U-Thong style is best known for such bronze statuettes that still bear the mark of a lingering Khmer influence, especially in the treatment of facial features. (B71 S4)

168 *Torso of standing Buddha.* Early Ayuthiā style (15th to 16th century A.D.), Thailand. Bronze with traces of gilt, height 23 in.

The Ayuthiā period corresponds to the first truly national style in Thailand. Most authors recognize that the bulk of Ayuthiā sculpture is unimaginative, mechanical, and frigid. Yet, there are a few superb exceptions, to wit, this very sensitive torso, which, despite obvious mutilations and a certain stylization of the rather stern facial features, retains a good deal of the warm human appeal that is usually associated with earlier periods. Such rare transitional pieces rank among the best sculptures ever produced on Thai soil. (B67 S7; Gift of the Asian Art Foundation)

169, 170, 171 *Jar, Platter and Ewer.* (Ca. 15th century A.D.), Annam. Blue-and-white porcelain, diameter and heights are respectively 15⅛ in., 8 in., and 6 in.

Since at least the Han period (206 B.C.—220 A.D.), North Vietnamese potters have stayed well within the sphere of influence of their Chinese counterparts. Nevertheless time and again they were able to produce strikingly original wares. While "technically" Chinese, these objects reflect an indigenous taste which combines what is to the Chinese eye an erratic use of available space, with a rather choppy disposition of secondary motifs and a predilection for superbly shaped footrims with a satin-like finish. In addition, the base of the platter is coated with a chocolate-brown slip of a kind unknown in China. Such pieces were made for export, as well as for local markets. Large quantities of them have been found in the Phillipines, Indonesia, and Japan. (B65 P69, B68 P16, and B70 P5)

Lamaist Sculpture and Painting

172, 173 *Avalokiteshvara* (sPyan-ras-gzigs) and *Āryāvalokiteshvara* (Hp'ags-pa-sPyan-ras-gzigs). (Ca. 1300 A.D. and 14th century A.D.), Western Tibet or Ladakh. Bronze with pigments and gold paint, with inlays of silver for the first and silver and copper for the second; heights are respectively 12 in. and 13½ in.

Tantric or Esoteric Buddhism (see also section on Japanese Painting and Sculpture), which originated in India as a form of Mahāyānist Buddhism cross-fertilized by Saivism, was introduced into Tibet during the 7th and 8th centuries. By combining this already very complex doctrine with some of their autochthonous beliefs, the Tibetans soon developed their own form of Tantric Buddhism, also known in the West as Lamaism. These relatively early statuettes represent two different aspects of one of the most popular Bodhisattvas in the pantheon of the so-called "benign" or "serene" deities. It is here of special interest to note that each Dalai Lama is regarded as an incarnation of Avalokiteshvara. (B60 S230 and 231)

174 *Samvara* (bDe mc'og). (17th century A.D.), Tibet. Gilt bronze, height 12 in.

Samvara (or "Best Happiness") is one of the most potent in a group of tutelary deities *(Yi-dam)* which Lamaism incorporated into the already populous pantheon of Esoteric Buddhism. The four-headed, twelve-armed, wrathful deity is shown here holding his *prajñā* (consort) in *yab-yum* (sexual embrace). This union symbolizes the realization of the absolute, the male figure representing the Buddha principle and the female figure knowledge and the absolute. The divinity tramples two diminutive beings, one of them four-armed, and brandishes a number of attributes including an axe, a cup made of a skull, a *vajra*, a bell, and fragments of elephant hide. (B60 B179)

175 *Dīpankara Buddha.* (17th century A.D.), Nepal. Gilt copper repoussé, height 27½ in.

Hinduism and Buddhism flourished and intermingled in Nepal for centuries until such time when, profoundly modified by the constant encroachments of Hinduism, and paralleling a similar evolution in India, Buddhism became increasingly esoteric. While Lamaism penetrated Nepal, it never became the official religion that it was in Tibet, Bhūtan, Sikkim, and Mongolia (see preceding plates). Dīpankara, a Buddha of the Past, is shown here with an elaborate, seven-pointed crown and richly decorated garments. The small-featured, sensitive face is typically Nepalese. Such statues are taken from private homes or temples every five or twenty years to be displayed in processions. (B71 S6)

176 *White Tārā.* (18th century A.D.), Nepal. Gilt copper repoussé, height 22½ in.

This masterpiece could only come from the hands of an accomplished artist, and, indeed, the reputation and influence of Nepal's workshops spread as far as China. Tārās, the *prajñās* (consorts) of various Buddhas, are late creations of Indian Buddhism. In Nepal, the White Tārā is the *prajñā* of Buddha Vairocana. Her main attributes are eyes on her forehead, palms, and soles. Together with Buddhas and Bodhisattvas, Tārās belong to the benign pantheon of Tantric Buddhism (see Pls. 172, 173). Their popularity increased significantly as time went on, and they assumed many different forms. (B60 S22+)

177 *Yamāntaka-mandala* (gšin-rje-gšed). (Late 17th to early 18th century A.D.), Tibet. *Tanka*, gouache on cotton, height 16¹/₂ in.

Mandalas form a special group of *tankas* made specifically as visual aids for meditation and as supports for the very essence of the divinity. They are schematic renderings of a cosmos whose center is occupied by the main deity with whom the practitioner seeks to identify in order to attain liberation. A ferocious manifestation of Mañjushrī (the Bodhisattva of Wisdom), Yamāntaka, one of the great Dharmapālas (the Defenders of Faith) is the exterminator of Yama (the Hindu God of Death). In this form, he is known as Vajrabhairava, and displays an unusually complex iconography with thirty-four arms, sixteen legs, and nine heads, the center one being that of a bull. He is black and naked. The style of this *mandala* closely follows the Nepalese tradition. (B63 D5+)

178 *Amitāyus* (Ts'e dpag med). (18th century A.D.), Tibet. *Tanka*, gouache on cotton, height 63 in.

Tankas (literally "something that is rolled up") are Lamaist paintings which serve as visual aids in various spiritual and ritual exercises. Each was made by at least two artists, one who traced the outlines and another who applied the paint. The painters had to conform scrupulously to the iconographic dictates of the sacred texts which described each deity with painstaking minuteness. Being the God of Boundless Life, Amitāyus, a form of Amitābha, enjoys immense popularity in the Lamaist world. Painted red, wearing an ornate crown, the nimbate deity is seated in adamantine position on a lotus throne. His hands, resting on his lap, hold a *kalasha* (a vase for holding ambrosia). The landscape settings that surround the throne show considerable Chinese influence. (B60 D24)

179 *Mahākāla Brāhmanarūpa* (mGonpo Bramzei). (18th century A.D.), Tibet. *Tanka*, gouache on cotton, height 22 in.

This is the tutelary deity of the Saskya-pa, a powerful sect which established its hegemony over the whole of Tibet during the second part of the 13th and the first part of the 14th century. The deity, wearing a human skin and sitting on a prostrate figure, is surrounded by his female acolytes who are engaged in particularly gory activities. At the top of the *tanka* three serene figures form a striking contrast with the main subject. They are, at the center, Vajradhara, the Primordial Buddha, and on either side Saskya-pa Pandita and Phags-pa, the chief abbot of the sect, who was given the title of "Imperial Religious Tutor" by Khublai Khan, the founder of the Yüan dynasty in China.

(B63 D4+)

Iran

Ceramics and Bronzes

180 *Goblet.* (Mid 4th millennium, B.C.) from Tepe Sialk III. Buff pottery painted in brownish black, height 9¹/₂ in.

Early in the prehistoric period, Iranian potters devised strikingly original ornamental schemes combining more or less abstracted human and animal shapes with geometrical motifs. At Sialk, during the period dating approximately from 4200 to 3400 B.C., the animal kingdom is represented mainly by snakes, birds, dogs, lions, panthers, camels, or, as exemplified here, capridae. Generally shown in full profile and intense, lively postures, these animals frequently display an exaggerated feature which varies with each species. For instance, caprids' horns, camels' necks, or lions' paws are disproportionately long or prominent. The decorator was thus able to utilize the most characteristic elements in each animal to create unusually convincing decorative effects. (B60 P459)

181, 182 *Pitchers.* (10th century B.C.), from Tepe Sialk VI. Pinkish buff pottery painted in red, heights 6¹/₂ in. (upper) and 7¹/₂ in. (lower).

A quantity of similar vessels have been found in one of the necropolises of Sialk (Necropolis B). Their distinctive shape may have been inspired by metallic models which are known to have been made at the same time. Ornamental schemes still blend animal and human shapes with geometric motifs, but are considerably bolder and more refined than those of Sialk III (see preceding plate). The pointed halos that encircle the front part of both these pitchers are very common and are thought to be symbols of the sun. (B60 P2004 and 2131)

183 *Female figure and theriomorphs.* (10th to 8th century B.C.), from the region of Amlash. The female figure is of black baked clay, the stag and "horned bird" are of brick-colored baked clay. Heights are respectively 11 in., 11³/₈ in., and 5¹/₂ in.

These are among the most characteristic shapes in a group of objects which were discovered during this generation and are particularly attractive to the modern eye. We know little about the so-called Amlash culture, but its sculptural achievements are widely appreciated as ranking among the best of any period. One of the secrets of the Amlash potter was to combine simple rounded volumes with highly abstracted and, at times, atrophied features. While this is purely coincidental, Amlash art, just as modern art, seems to be based on a conscious geometrization of human and animal forms with a complete disregard for natural proportions.

(B68 P2; Gift of the Asian Art Foundation,
B62 P9+, and B62 P80)

184 *Cheek-piece, standard tops, and pin.* (Late 2nd to early 1st millennium B.C.), from Luristān. Bronze; heights are respectively 7 in., 7³/₄ in., 4³/₄ in., and 10⁵/₈ in.

The northern part of the mountainous province of Luristān has during the past fifty years or so yielded a number of bronze artifacts that are loosely called "Luristān Bronzes," and form a distinctive branch of the Steppe Art. The bulk of this material consists of weapons, harness fittings, and votive and ritual objects, as well as purely ornamental pieces. Many such items feature real or fantastic animals, frequently in positions of confrontation, and sometimes in association with human figures that have

31

variously been interpreted as legendary heroes of Mesopotamian origin or as the Great God and Goddess. Practically all Luristān bronzes come from uncontrolled excavations and as such cannot be dated with precision.

(B60 B17+, B62 B95B, B62 B82, and B62 B54)

185 *Jar and bowls.* (12th to 13th century A.D.). The jar is from Rayy, the bowls are from Rayy or Kashan. Pottery with luster decoration (jar) and overglaze enamels *(minai)* (bowls). Height of jar 5¹/₂ in., diameters of bowls respectively 8¹/₃ in. and 6¹/₂ in.

In Islamic Iran of the late 12th and 13th centuries such ceramic centers as Rayy, Kashan, or Saveh developed or exploited a variety of new techniques which reflect an unprecedented taste for brilliant or even dazzling ornamental schemes. Some of the motifs, as in the Rayy jar, remain stylistically quite traditional. Others, on the contrary, were inspired by contemporaneous miniature painting. The bowl showing a prince seated between two attendants amidst foliage patterns and bird designs is a good case in point. (B60 P2000, 1863, and 1869)

JAPANESE COLORED WOODBLOCK PRINTS IN THE ACHENBACH FOUNDATION FOR GRAPHIC ARTS

The Achenbach Foundation for Graphic Arts is housed in the California Palace of the Legion of Honor, overlooking the Pacific Ocean in San Francisco. Moore S. Achenbach, an advertising agency executive in San Francisco, became interested in the print world in 1898 while he was a student at the Pennsylvania Academy of Fine Arts. Starting in a small way, and continuing over fifty years, Moore and his wife Hazel collected nearly 80,000 prints and drawings. In 1948 they created the Achenbach Foundation for Graphic Arts and presented their entire collection of prints to the city of San Francisco. Today the Achenbach Foundation is one of the most important and historically comprehensive graphic collections in the country, and is the largest in the Western United States. It houses not only about 100,000 Western prints from the 15th century to the present, but also nearly 2,000 drawings, and illustrated books. In addition, there is an ex-cellent reference library of more than 3,000 volumes. Though smaller in number, about 2,000 in all, a significant collection of Japanese and other Oriental prints and drawings has been formed around the two collections of Catherine Ball and Carlotta Mabury; these two collections had originally been donated to the M. H. de Young Memorial Museum, another municipal museum in San Francisco, and then transfered to the Foundation in 1967. The same year recorded important purchases of five rare and choice color woodblock prints by Harunobu, Shunshō, Kiyonaga, Utamaro, and Sharaku. The precious wild-eyed actor print by Sharaku was the first work of this enigmatic artist to enter the collection (Pl. 189). The bulk of the collection consists of prints made during the Edo period (1615—1868 A.D.), but also includes works from the late 19th century and examples of avant-garde movements of the 20th century.

DESCRIPTION OF ILLUSTRATIONS

186 *A man and a courtesan watching a young man write*. By Okumura Masanobu (1686—1764 A.D.). Hand-colored woodblock print, height 10⁵/₈ in.

Okumura Masanobu, the founder of one of the early *Ukiyo-e* schools, remained active as a designer and an innovator of techniques for several decades, from the late 17th to the mid-18th century. This scene shows an intimate threesome in one of Yoshiwara's tea houses. A man and a courtesan are looking at a *wakashū* (a young male entertainer) as he begins writing. They are all reclining on the floor, thus creating a continuous mass of curves. The flowing lines of their costumes are set against the straight lines of doors, a screen, a divider, and other small items for room settings. The basic composition is printed in ink and shows such fine details as the landscape painting on the sliding door in the rear, various patterns on fabrics, the decoration on a lacquer tobacco set, and food on a tray placed behind the figures. The print is carefully hand colored, as was customary until the mid-18th century, when color printing, a technique originated by Masanobu, became popular.

187 *"Righteousness"*: Couple Looking at an Illustrated Book. By Suzuki Harunobu, (1725—1770 A.D.). Full-color woodblock print, height 9¹/₆ in.

This scene entitled "Righteousness" is one of a set of five prints illustrating the Five Virtues. Suzuki Harunobu was one of the foremost masters in capturing the most fragile essence of idealized feminine beauty. A young, somewhat effeminate man holding an illustrated book for young girls sits on his knees and turns to a woman who is seated on a bay window fingering her fan. The illustration in the book probably accompanies a Chinese apologue on

righteousness. However, what seems to captivate the woman is the young man rather than the book. Harunobu frequently made use of diagonal lines for his interiors, thus emphasizing verticality. Here this is particularly obvious in connection with the heavy frame of the sliding door. This print is done in *nishikie* or "brocade print" technique, in which colors are applied by means of several blocks, each cut to print a separate color on black ink outlines. The poem in the cartouche explains what righteousness is about.

188 *Courtesan of Kōya Tamagawa*, from the Series of "The Six Tama Rivers." By Kitagawa Utamaro (1753—1806 A.D.). Full-color woodblock print, height 14¹⁵/₁₆ in.

This print is one of a set of "Mu Tamagawa" based on ancient poems composed on six rivers named Tama in various parts of Japan. Many sets by different artists have survived. In this set by Kitagawa Utamaro, each print portrays a different type of courtesan. This one, from Kōya, appears to be somewhat low-class but quite spirited, smoking a long tobacco pipe. While Harunobu's interest seems to have been focused on graceful female figures and interesting circumstantial settings (see preceding plate), Utamaro established an entirely new trend. This type of composition is called *ōkubie* or "large head print" and is usually set against a plain background. A pompous coiffure with a multitude of hair ornaments creates an interesting contrast with the rather static facial expression. The composition is further embellished by layers of colored garments with various patterns and by well-placed details such as the hand of the courtesan. In this particular print, the face and hand are outlined with vermillion rather than with the usual black ink, a device which suggests effectively the softness and warmth of flesh. The fan-shaped cartouche represents a scene of Kōya, while the rectangular one contains a satirical poem detailing the poisonous but inviting charm of the courtesan.

189 *The actor Sakata Hangorō as the villain Fujikawa Mizuemon in the play Hanayama Bunroku Soga.* By Tōshūsai Sharaku (active 1793—1794 A.D.). Full-color woodblock print with a mica background, height 13¹/₂ in.

The almost total lack of biographical information on Tōshūsai Sharaku and the resulting controversies which surround whatever little is known of him do not seem to hinder an appreciation of his works: if anything, they add the charm of mystery. To date only about one hundred

and sixty of his prints have been identified. However, it should be noted that this seemingly small number of works was created within a period of ten months during the sixth and seventh years of the Kansei era (1793—1794). Of his works, almost all of which are Kabuki actors, the best are in *ōkubie* format, quite often against a mica background creating a silvery effect. In this monochromatic impression of the actor Hangorō, the facial expression and pose are at the same time remarkably stylized and individualized.

190 *Great waves off the coast of Kanagawa*, from "The Thirty-Six Views of Mt. Fuji". By Katsushika Hokusai (1760—1849 A.D.). Edo period. Full-color woodblock print, height 9¹³/₁₆ in.

Ocean waves are perhaps the most dynamic subject matter for a printmaker. Here, in a scene from Katsushika Hokusai's "Thirty-Six Views of Mt. Fuji," the main motif, the mountain itself, is completely dwarfed by extremely exaggerated waves. These high, raging waves burst into crashing white caps arranged decoratively as if they were cascading white blossoms. Tiny figures in three buffeted boats are reduced and stylized, puppet-like in size. Hokusai also made a vast number of still life prints of fish and other sea creatures, as well as of birds and flowers. His paintings on silk portray beautiful women, picnics, and clam-gathering scenes. In spite of this eclecticism, his name will always be most strongly associated with his landscapes and seascapes.

191 *The night rain at Karasaki*, from "The Eight Views of Ōmi." By Andō Hiroshige (1797—1858 A.D.). Full-color woodblock print, height 8¹⁵/₁₆ in.

Rain in Japanese prints had been used as a device to create interesting groupings of figures under an umbrella until Andō Hiroshige adopted it as a main theme. The result was a series of several excellent rain scenes, including this one. Usually in such scenes, Hiroshige used diagonal lines to suggest stormy rain, while in this composition, nearly monochromatic, the rain falls down vertically and quietly muffles even the slightest sound on the land. Unlike most of his other landscapes, this one is devoid of human figures. The famous pine tree stands alone and still, the boughs laden with rain. Along with this series of views of Ōmi, the famous "Fifty-three Stations on the Tōkaidō" established Hiroshige as a landscapist equal to Hokusai.

THE UNIVERSITY ART MUSEUM, BERKELEY

The University Art Museum, located on the Berkeley campus of the University of California, is a young institution, established in 1965. After five years of exhibitions in a renovated campus powerhouse, the new museum building opened in November 1970. Designed by two young architects, Richard Jorasch and Ronald Wagner, working with the well-known San Francisco architect Mario Ciampi, the building is the largest university art museum in the world. It has come to be recognized as one of the most original and exciting museum designs of recent times, and provides expansive, dynamic spaces for exhibiting the works of art.

Although the museum building is new, its collection incorporates some older gifts to the University of California as well as recent acquisitions. Among the older holdings in Asian art is the Armes Collection of approximately one thousand Japanese prints. Especially strongly represented are *surimono*, actor prints of the Katsukawa school, and landscape prints by Hokusai, Hiroshige, and others.

Purchases and gifts over the past nine years have provided a small but steadily growing group of Far Eastern paintings. Most are relatively late in date—Chinese paintings of the Ming and Ch'ing dynasties, Japanese works of the Edo period—but a few represent earlier centuries. Indian paintings and drawings make up another small group that is added to as opportunities allow. Several private collections on extended loan augment the museum's own holdings and are used for exhibition and study. The exhibitions are closely coordinated with University courses, and are often organized through seminars or with the participation of graduate students.

Asian art in media other than painting and prints is not well represented, but the ethnological collections of nearby Lowie Museum of Anthropology, which include, for instance, a collection of Japanese folk ceramics, are occasionally drawn on for objects of artistic quality.

DESCRIPTION OF ILLUSTRATIONS

192 *Head of the Buddha*. Kushān Period (late 3rd century A.D.), from Swat, Pakistan. Schist, height 14½ in.

The hair is rendered in snail-shell curls, with the *ushnīsha*, or cranial protuberance, set off by a narrow ribbon. The *ūrṇā*, or tuft of hair, appears in the center of the forehead. Half-closed eyes convey an air of detached contemplation. The sensitive modeling of the lower half of the face contrasts with the more formalized and abstract character of the upper portion.

(UAM 1968. 73; Gift of Alice Boney)

193 *Seated Buddha (Shakyamuni or Maitreya)*. T'ang dynasty (late 7th to early 9th century A.D.). White marble of Ting-chou type, China, height 11¾ in.

The figure is headless and the right arm is missing.

The left hand is in the *bhūmisparsha mudrā*, resting on the left knee, and the legs are in the *dhyānāsana* or meditative posture of crossed legs with both soles turned upward. Some indication of the original three neck-folds remains above the chest, which is exposed down to the midriff undergarment. The *sanghāti* fully covers one shoulder; a lappet partially covers the other and then falls to cover the legs and the upper portion of the dais. The human form is apparent beneath the garment, which also provides a series of naturalistic and rhythmic drapery folds, ranging from the loose, tubular folds of the stomach, to the bunched, overlapping plates on the arms, to the incised pattern on the base. (UAM 1969. 53)

194 *Portrait of Weng Te-hung*. By Tseng Ch'ing (1568—1650

A.D.), dated 1639 A.D. Late Ming dynasty, China. Hanging scroll, ink and colors on paper, height 46³/₄ in.

The artist's inscription on the right margin reads: "(In the) *chi-mao* (year, 1639), Autumn, the 7th month, Tseng Ch'ing painted (this) at the Peaceful Retreat." The influence of Western styles is to be seen in his use of facial shading for an effect of three-dimensionality. As a specialist in portraiture, Tseng often worked in collaboration with other artists; here an inscription in the upper left notes that the "True and Simple Taoist, Ts'ao Hsi-chih, painted the scenery." The longer inscription at the top, written in 1641 by Chin Hsing-hua, a friend of the late Ming calligrapher Weng Te-hung, begins: "Most people, in painting portraits, depict the appearance; only Mr. Tseng searches for the spirit ... In depicting Mr. Weng Hsing-lo, Mr. Tseng has understood him and caught his soul." This type of portrait, known as an "Engaging in Pleasure" picture and usually drawn from life, aims at depicting the appearance and character of the mature man and functions later as a rather specific and intimate remembrance of him engaged in some favored pursuit— all in contrast to the more formal and generalized qualities of the ancestral portrait. (UAM 1967. 22)

195 *A scholar instructing girl pupils in the arts.* By Ch'en Hung-shou (1599—1652 A.D.). Ch'ing dynasty, China. Hanging scroll, ink and light colors on silk, height 35³/₄ in.

Inscription by the artist: "Old and Late, Hung-shou painted (this) at the Willow Bridge." The painting can be dated after 1646, the year in which the artist adopted the name "Old and Late," and is a fine example of his mature style. Ch'en delights in the design and textural values of such details within the painting as the brocade cover of the scholar's lute, the lotus painting on the fan, or the patterned sashes worn by the students. The linear quality of his figure drawing has antecedents in the Six Dynasties period; Ch'en comments on that earlier style and on his own world by slight distortions that yield distinctive and highly expressive combinations of humor with poignancy, realism with idealism.

(UAM 1967. 12; Gift of Elizabeth Hey Bechtel)

196, 197 *Reminiscences of Nanking.* By Tao-chi (1644 — before 1720 A.D.). Ch'ing dynasty, China. Two leaves of a ten-leaf album dated 1704. Ink and colors on paper, height of each leaf, 6 in.

Tao-chi, the greatest individualist painter of the early Ch'ing period, was descended from the imperial line of the Ming dynasty that had fallen to the Manchus in 1644. His early and middle years were spent in a wandering life that corresponds in general to the flowering of several schools of early Ch'ing painting. His later years were spent in Yang-chou, where he wrote his *Hua-yü Lu*

("Notes on Painting") around 1704, the years of the present album; both reveal his mature thought on the art of painting and mark a complete break from the ideas and style of the prevailing orthodox school of painters. These scenes illustrate Tao-chi's new uses of wash and color, as well as his avoidance of conventional brush modes and compositions. The presentation is refreshingly simple, direct, and intimate.

The artist's inscription on one of the leaves reads:

Six Dynasty lightning charred the trees,
 steeled and tempered until today.
Two rise up, framing lonely hollows,
 branching sides like broken-pegged lutes.
Pointing toward heaven, strength preserved by spirit,
 reaching for the sun, lapels moistened by dew.
If one leans toward their empty hearts,
 summit music is faintly heard.

I regularly searched for plum-blossoms at Ch'in-huai. Wandering to the Green Dragon Mountain, before an old temple I saw those two trees, which are ginkoes. I had retained a poem, five words to a line, and now, waving my wine, suddenly remembered this, and wrote it out to give my old friend Chüeh-weng a laugh.

The contemplative scholar, seated on the ginko tree while listening to the wind whistling down the hollow trunk, is surely Tao-chi himself; we may also feel that the trees reveal something of the character of the artist as he stood firm in the face of dynastic overthrow, sickness, and old age. (UAM 1973. 40. 1—10)

198 *Branch of blossoming plum.* By Li Fang-ying (1695—after 1754 A.D.), dated 1754 A.D. Ch'ing Dynasty, China. Hanging scroll, ink on paper, height 63¹/₂ in.

The artist's inscription reads in part:

Faint mist and pale ink,
 the essence of jade;
Pomp and vanity washed away,
 untouched by the dusty world.
Could such a blossom yield to vulgar show?
 In essays and colors,
value the pure and true.

Li was himself one who had "left the vanities of the dusty world" by resigning his post as District Magistrate in Anhui province and retiring to live by his painting skill in Yangchou and Nanking. Li specialized in painting such subjects as branches of blossoming plum and other simple flower and plant motifs. Variegated colors and glossy brushwork are eschewed in favor of rich tonalities of ink, rough brushwork that features abrupt changes of direction and movements that double back on themselves, and a largely abstract division of the format to create shapes interesting in themselves.

(UAM 1967. 14; Gift of Elizabeth Hay Bechtel)

THE STANFORD UNIVERSITY MUSEUM

The University art collections are housed in the Leland Stanford, Jr. Museum, built in memory of their son by Senator and Mrs. Leland Stanford. The Stanford Museum was the first major museum built west of the Mississippi River. It was a quadrangular building of four wings measuring 665 by 332 feet. Its 300,000 square feet of floor space was just about double that of New York's Metropolitan Museum at the time. It was also America's first steel-reinforced concrete structure.

Leland Stanford, Jr. had collected souvenirs of the family trips abroad and had hoped one day to establish a public museum. After his death from typhoid fever in 1884, his parents carried out his idea as a memorial to him. During the planning of the museum, they decided to build a great university. Having lost their only child before his sixteenth birthday, the Stanfords made all the children of California their children; they wished to offer an education to those who could not attend the schools of Europe or the East. The Leland Stanford, Jr. University opened in 1891, and the Leland Stanford, Jr. Museum opened in time for the fall term in 1892.

The earthquake which devastated San Francisco in 1906 severely damaged the University thirty miles away. The north and south wings of the museum collapsed and large sections of the collections were damaged or destroyed. By 1909 the west wing had been abandoned and the collections consolidated in the east wing, which has remained in use. The Stanfords lived to see their dream accomplished, but not to see the subsequent destruction.

The Asian collection began with the purchase of the Baron S. Ikeda collection of Chinese and Japanese art in 1903. Having visited and admired the collection in Japan, Mrs. Stanford persuaded the Baron's son to permit her to obtain it for the university after his father's death. It is especially strong in ceramics and lacquers, but also contains some fine Japanese paintings.

In 1941 Mr. Mortimer C. Leventritt, an alumnus, presented his collection of European and Asian art. The Thomas Welton Stanford Art Gallery, built in 1917 with funds given by the brother of Senator Stanford, was remodeled in part to receive this collection. In 1963 it was moved to the museum. The Leventritt Collection includes Chinese and Japanese funerary, religious, and household items covering a wide range of time from prehistory through the eighteenth century; there are, as well, a few Thai sculptures and paintings of the Ayuthiā and Bangkok periods.

Mr. Frank G. Marcus gave his well-known collection of fifty-five Chinese mirrors in 1954 and subsequently bequeathed his collection of Chinese miniature bronze objects, dating from the Shang through the T'ang Dynasties.

The Frank E. Buck Collection of Chinese jade was presented in his memory by Mrs. Alice Meyer Buck in 1962. This collection contains superb examples of Ming and Ch'ing jade vessels and ceremonial objects.

The Stewart and Ellen M. Marshall bequest in 1970 brought many fine pieces into the collection, including Chinese bronze vessels and ceramics, as well as paintings and sculptures of the later Indian dynasties.

Many individual gifts have been made as well, permitting several gaps, particularly in South Asian areas, to be filled with excellent representatives of these cultural styles.

DESCRIPTION OF ILLUSTRATIONS

China

199 *Pair of horses with riders.* Eastern Han dynasty (25—220 A.D.), China. Pottery with traces of pigments, height 12³/₄ in.

Such pieces were buried as substitutes for real people and animals in the expectation that they would come to life in the spirit world along with their dead masters. These were mass-produced in molds, but their elegance of form and simplification of detail are so spirited that they achieve a high degree of artistic excellence.

(41. 65; Leventritt Collection)

200 *Eleven-headed Kuan-yin.* T'ang dynasty (618—906 A.D.), China. Gilt bronze, height 9¹/₂ in.

This late 7th-century Buddhist figure is the Bodhisattva of Mercy, who hears the cries of the distressed and aids them. The multiple heads are indicative of the amalgamation of Hindu and Buddhist concepts in the late development of the Mahāyāna School known as Vajrayāna, an esoteric form of Buddhism which represented the powers of divinities in physical forms and attributes.

(41. 54; Leventritt Collection)

201 *Eight-lobed mirror.* T'ang dynasty (618—906 A.D.), China. Bronze, diameter 5³/₈ in.

The front is a slightly convex polished reflecting surface. The back is decorated with bird and landscape elements in relief. In the center a crouching lion forms a boss through which a silk suspension cord could be passed. The motifs were both cosmological and auspicious. The ducks with tied bow and phoenixes with long curving tails symbolized connubial fidelity and eternal happiness, making such mirrors popular wedding gifts.

(54. 259; Marcus Collection)

202 *Wen-shu, Bodhisattva of Wisdom.* Yüan dynasty (1279—1368 A.D.), China. Wood with traces of color, height 51 in.

Wen-shu is the Chinese name for the Indian Bodhisattva Mañjushrī. This sculpture was probably produced in the first few decades of the Yüan dynasty, when the style prevailed in the workshops set up in the capital by Khublai Khan for the foreign sculptor, A-ni-ke (of Mongolian or Nepalese descent). The hands are replacements.

(41. 137; Leventritt Collection)

203 *Reclining water buffalo.* Ming dynasty (1368—1644 A.D.), China. Green-gray nephrite, length 11¹/₂ in.

The alert vitality displayed in this example sets it apart from other jade carvings of the same subject. The water buffalo was an ancient sacrificial animal offered at certain times of the year as well as at the time of the burial of a noble person. It is symbolically associated with the earth and may have had a prominent role in the sacrifices made to the spirit of the earth to ensure its fruitfulness and abundance. It has also been the most useful draft animal throughout Asia and as such the closest ally of the farmer. It is no wonder then that this powerful animal has been

gratefully remembered in jade, perhaps as an offering to a temple.

(68. 38; Buck Collection)

204 *Landscape in the manner of Chü-jan.* By Wang Kai (active ca. 1679—1705 A.D.). Ch'ing Dynasty (1644—1912 A.D.), China. Hanging scroll, ink and light color on paper, height 78 in.

Although the painting is said to be in the manner of Chü-jan, a 10th-century painter from Nanking, it shows an equal debt to Wang's immediate master, Kung Hsien (ca. 1660—1700 A.D.), also of Nanking. Wang Kai is perhaps best known for his supervision of the famous *Painting Manual of the Mustard Seed Garden*, printed with colored woodblocks in 1679. His paintings were usually small, the present painting being one of the few large ones known. Formerly in the Victoria Contag Collection (Nü-wa-chai).

(67. 66; Gift of the Committee For Art at Stanford)

Japan

205 *Rakan (Buddhist disciple).* Kamakura period (1185—1334 A.D.), Japan. Hanging scroll, ink and colors on silk, height 66 in.

The holy man, perhaps Panthaka, one of the Sixteen Disciples, gazes at a dragon which he has apparently conjured from the bottle in his left hand. The small attendant tries to hide under his master's robe. Paintings of disciples, sages, and famous masters formed an important category of Sung Dynasty painting in China and continued to flourish in Japan. (9268; Ikeda Collection)

206 *Hōnen Shōnin Gyōjō Ezu (Biography of Saint Hōnen).* Kamakura period (1185—1334 A.D.), Japan. Section of a handscroll, ink and colors on paper, height 12⁹/₁₆ in., length 20¹/₄ in.

The episode represented is the arrival of the Imperial Magistrate at the home of Hōnen for the purpose of arresting him prior to his being sent into exile. Hōnen had aroused the wrath of some of the influential leaders of Buddhist sects who saw in his simplified ritual and simple faith in the mercy of Amida Buddha a challenge to their own sects. His popularity was enormous and the Pure Land faith he promulgated is still the most popular form of Buddhism in Japan. The scroll from which this section comes is the oldest extant picture scroll of the life of Hōnen. (64. 6; Gift of Mrs. Philip N. Lilienthal in memory of her husband)

207 *Incense box.* Kamakura period (1185—1334 A.D.), Japan. Wood covered with black and gold lacquer, length 3³/₈ in.

The edges of the box were bound with pewter. The design of chrysanthemum flowers was executed by sprinkling coarse or fine powdered gold onto layers of wet lacquer; coarse for the background and fine for the flowers, in the manner of sowing grain by sprinkling it over the ground. This "flat sown picture" *(hiramakie)* was a Japanese innovation, invented in the Nara period.

(9341; Ikeda Collection)

208 *Ewer*. Edo period (1615—1868 A.D.), Japan. Satsuma ware, designs in red, blue, and gold overglaze enamels, height 14 in.

The pair of dragons on this side are balanced by a pair of phoenixes on the opposite side: symbols representing the Emperor and Empress, respectively. The Satsuma kilns were first established on the island of Kyushu by Korean potters in the 17th century, but, by the 1870's, when this piece was made, the earlier plain dark ware had been transformed into a type of low-fired buff pottery which flowered into the 19th century multicolor style which soon became synonymous with garish overstatement. The present example, however, is a classic balance of form and design marking the conjunction of the Korean simplicity and the Chinese overglaze enamel technique as it was practiced in the Arita area of Kyushu to the northeast of Satsuma. (9300; Ikeda Collection)

209 *Woodcutter gazing at a waterfall*. By Katsushika Hokusai (1760—1849 A.D.). Edo period, Japan. Sketch, ink and colors on paper, height 11³/₄ in.

The painter is perhaps best known for his designs for colored woodblock prints. The usual scene of common people going about their daily tasks with animated vigor is replaced here by a contemplative subject rare for Hokusai. The woodcutter is shown resting after his hard day's work, enraptured by the power and beauty of the waterfall. (9263; Ikeda Collection)

India

210 *Head of a Buddha*. Kushān dynasty (ca. 50—320 A.D.), from Hadda, Afghanistan. Stucco with traces of pigment, height 8¹/₄ in.

The Gandhāra Region of the upper Indus saw the rise of a style based upon Classical precedents. Images of the Buddha were made in the stereotype of Apollo. At first the meeting of Roman techniques with Indian concepts produced some awkward results, but by the third or fourth century the Indian preference for geometric volumes and simplified surfaces had transformed the Roman illusionism into a highly stylized abstraction. The *ūrnā* is between the eyes and the lips are painted red. The eyes and eyebrows are black. This head was formerly in the André Malraux Collection.

(56. 14; Gift of Mrs. Alice Meyer Buck)

211 *Head of a Buddha*. Gupta dynasty (320—600 A.D.), Mathurā, India. Red sandstone, height 7¹/₄ in.

This late 4th or early 5th-century head indicates the high level of accomplishment of the Gupta sculptors in the area of Mathurā, Northcentral India, where the preceding Kushān Dynasty had established its winter capital. The exquisitely defined surface of the gently swelling forms remains intact although the nose is damaged. The treatment of the hair is derived from the ancient Achaemenid style practiced at Persepolis and introduced into India via trade and diplomatic contacts with Iran.

(62. 107; Gift of Mrs. Philip N. Lilienthal in memory of her husband)

Thailand

212 *Head of a Buddha*. Ayuthiā style (16th century A.D.), Thailand. Bronze, height 12 in.

While the Mahāyāna form of Buddhism practiced in North Asia developed myriad divinities, that of South Asia revered the historical Buddha and paid homage to him through depictions of scenes from his life, his previous lives or through single images. The serenity of this head admirably expresses the inner contemplation and compassionate peace which are the aim of Buddhism in all its forms. (41. 226; Leventritt Collection)

ASIAN ART MUSEUM OF SAN FRANCISCO:
THE AVERY BRUNDAGE COLLECTION

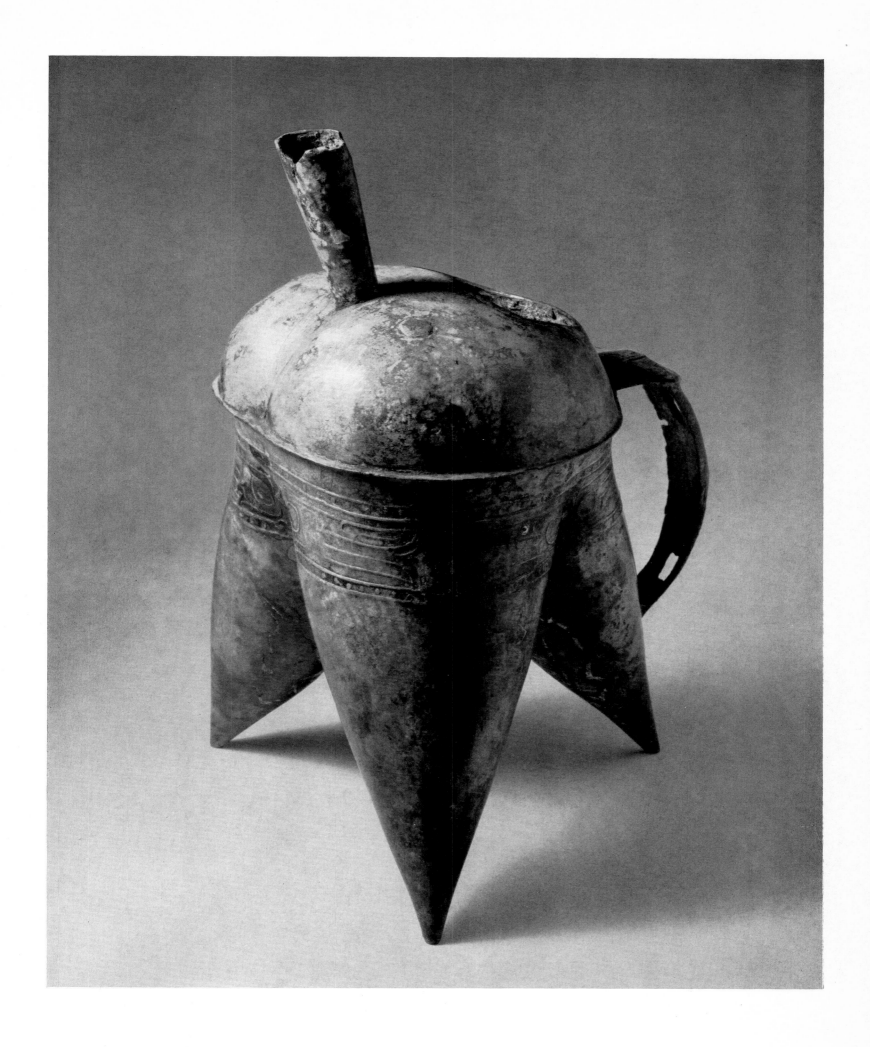

1 Li-ho, middle Shang dynasty (16th to 14th century B.C.)

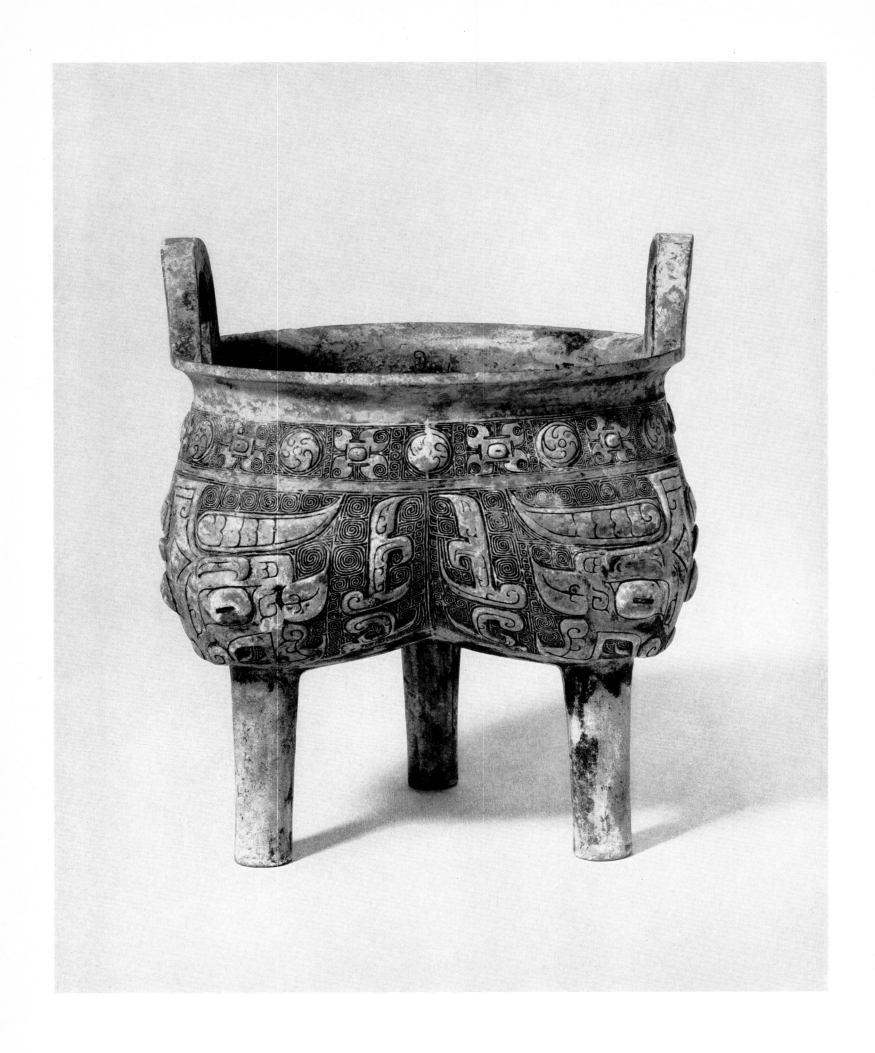

2 *Li-ting, late Shang dynasty, An-yang style (ca. 1300—1028* B.C.*)*

3 *Chia, late Shang dynasty (13th to 11th century* B.C.*)*

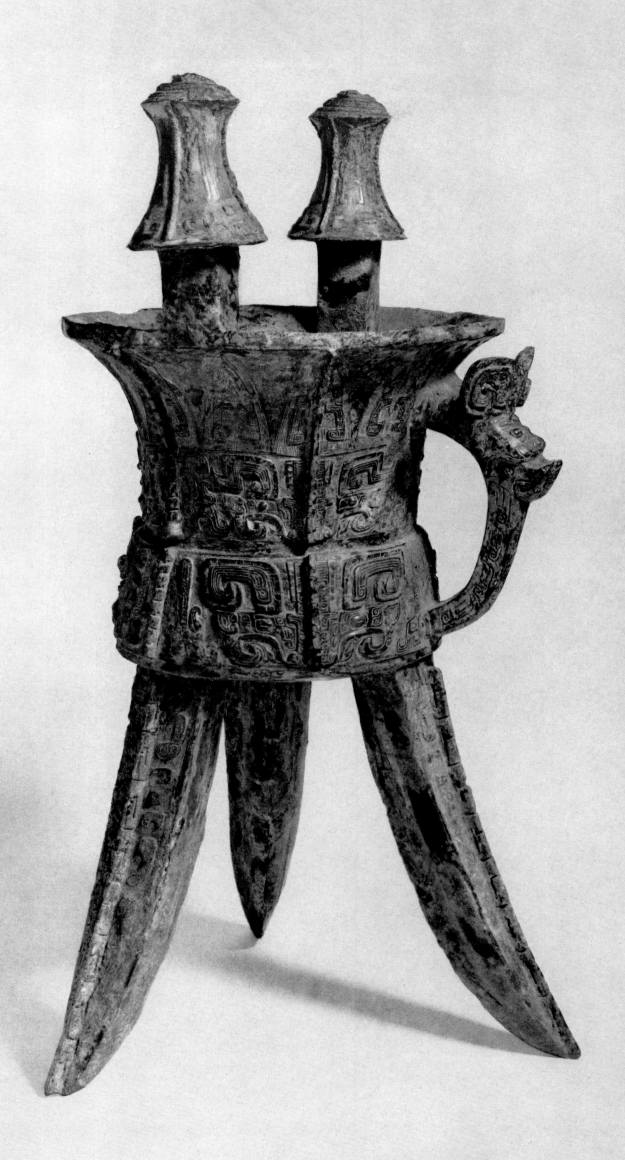

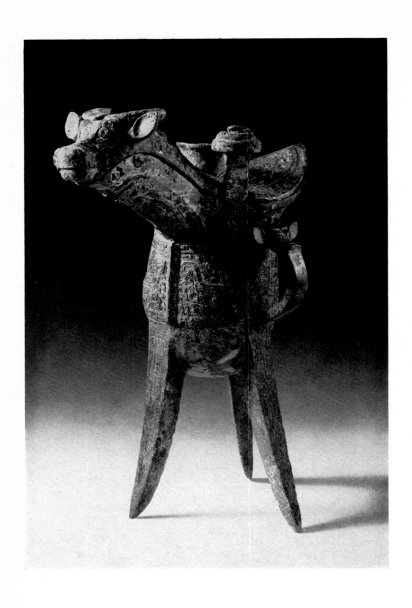

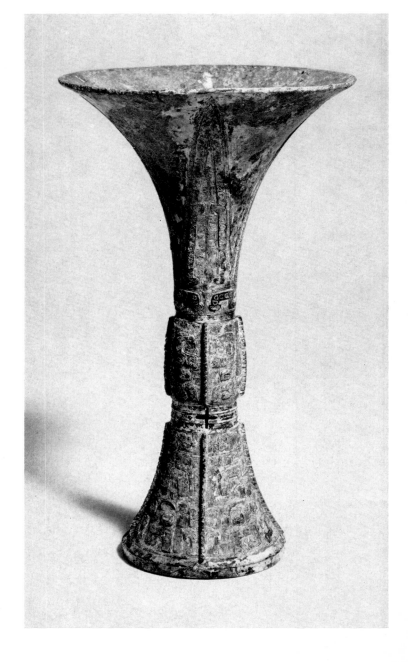

4 Chüeh, latter part of late Shang dynasty (12th to 11th century B.C.)

5 Ku, late Shang dynasty, An-yang style (ca. 1300—1028 B.C.)

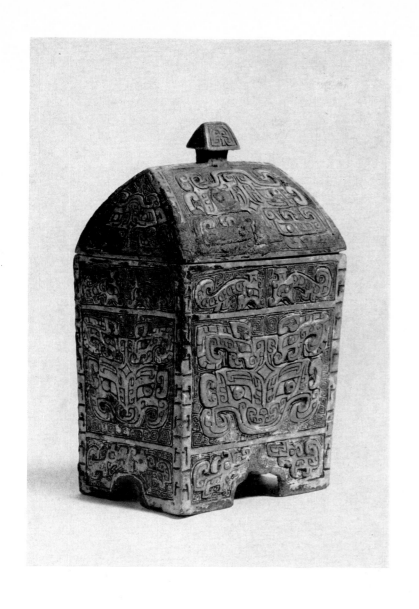

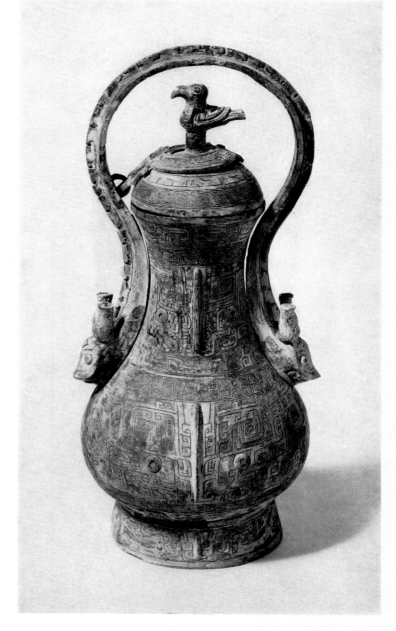

6 Fang I, late Shang dynasty (13th to 11th century B.C.)

7 Yu, late Shang dynasty, An-yang style (ca. 1300—1028 B.C.)

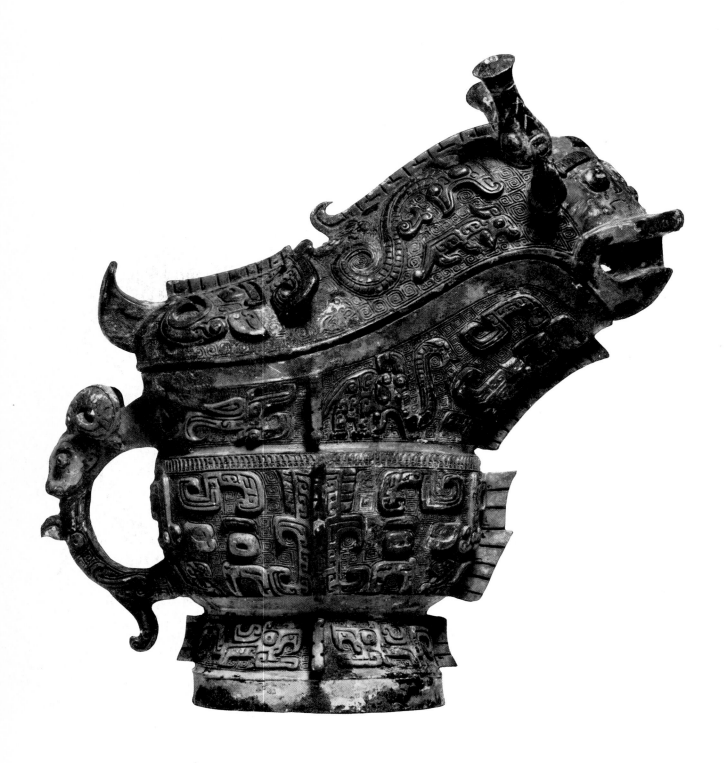

8 *Kuang, latter part of late Shang dynasty (12th to 11th century* B.C.*)*

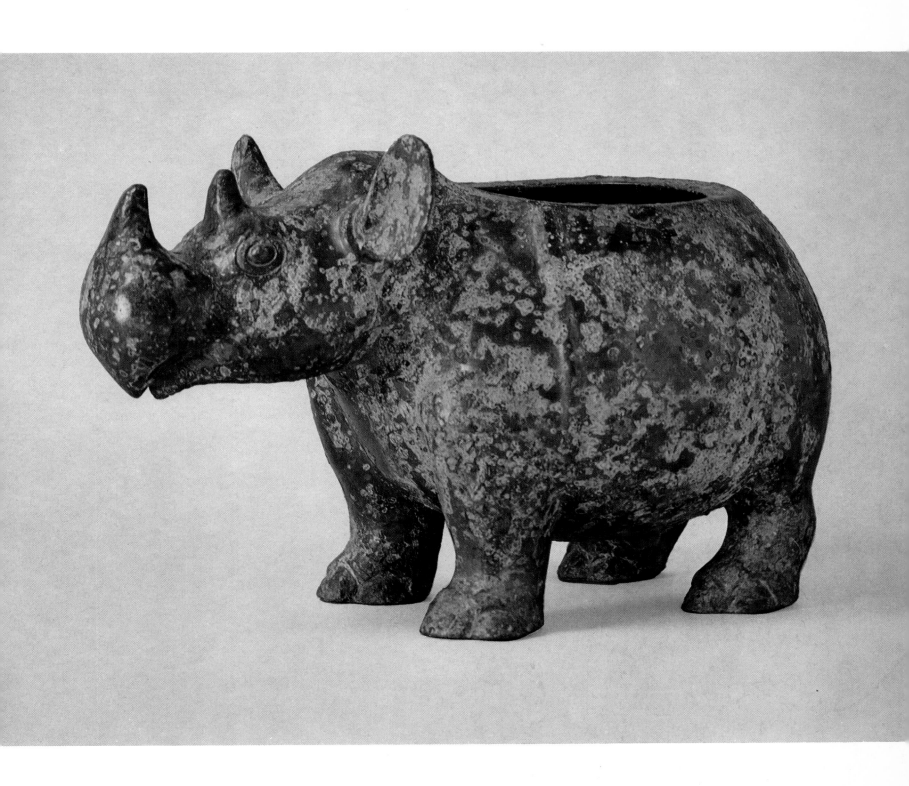

9 Rhinoceros, latter part of late Shang dynasty (ca. 11th century B.C.*)*

10 *Fang Ting, early Western Chou dynasty (ca. 1024—1005* B.C.*)*

11 *Hu, late Western Chou dynasty (9th to 8th century* B.C.*)*

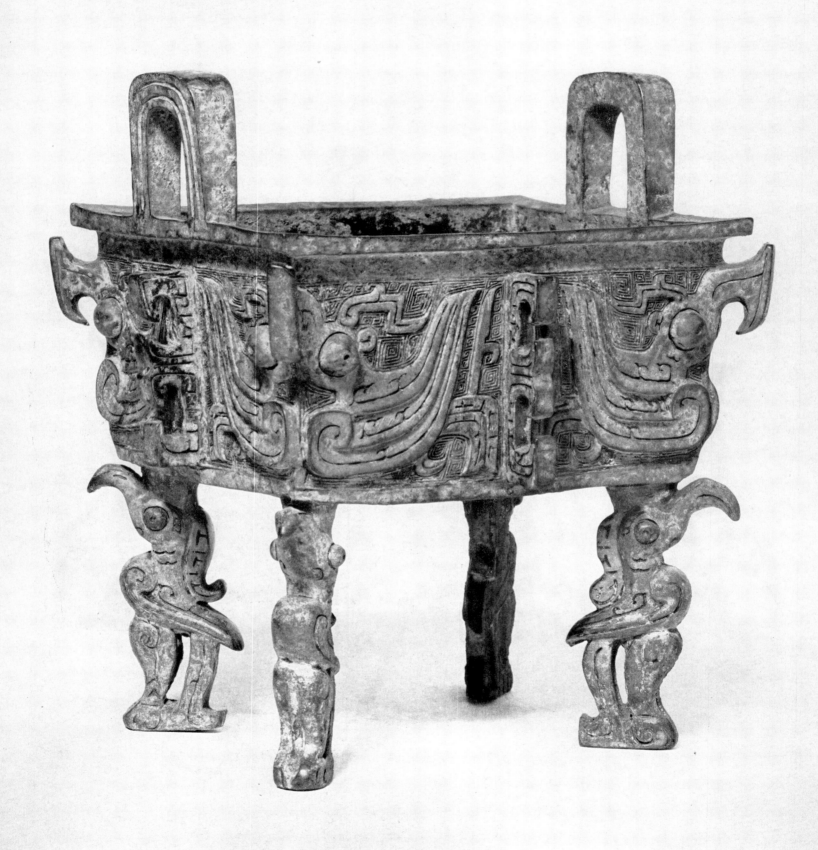

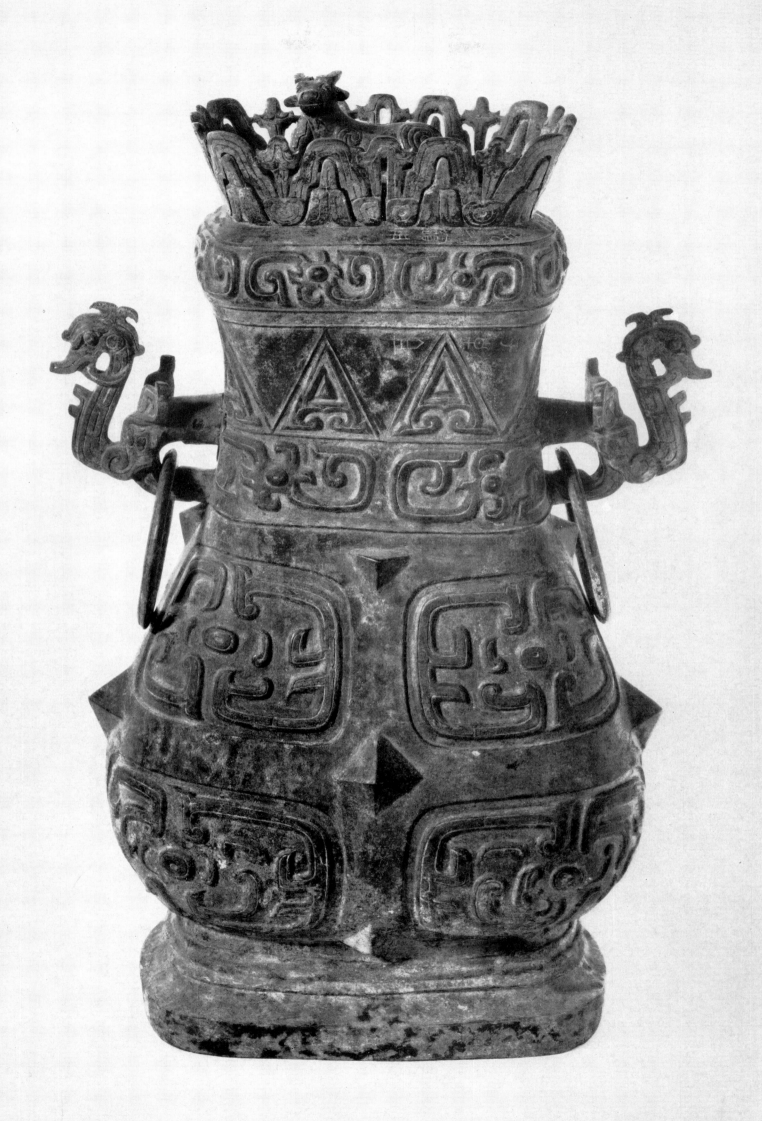

12 *Chien, Ch'un-ch'iu period (late 6th to early 5th century* B.C.)

13 *Hu, mid Warring States period (5th to 4th century* B.C.)

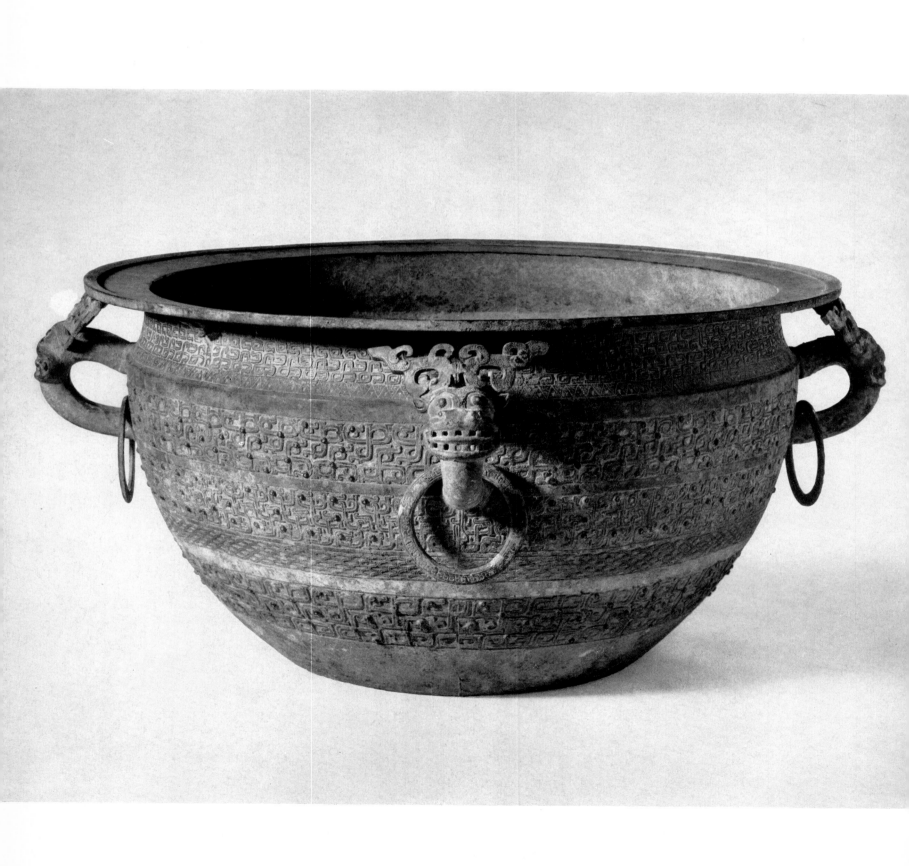

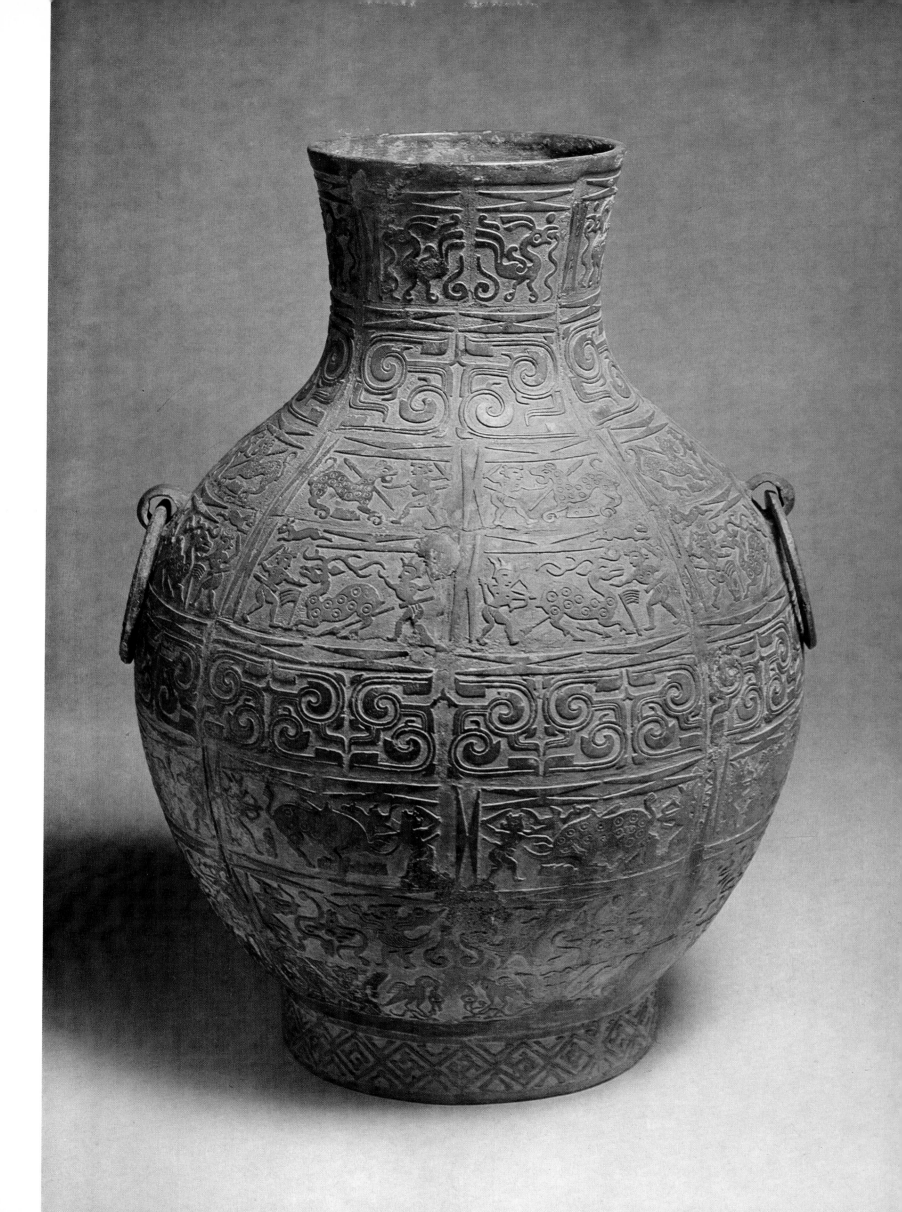

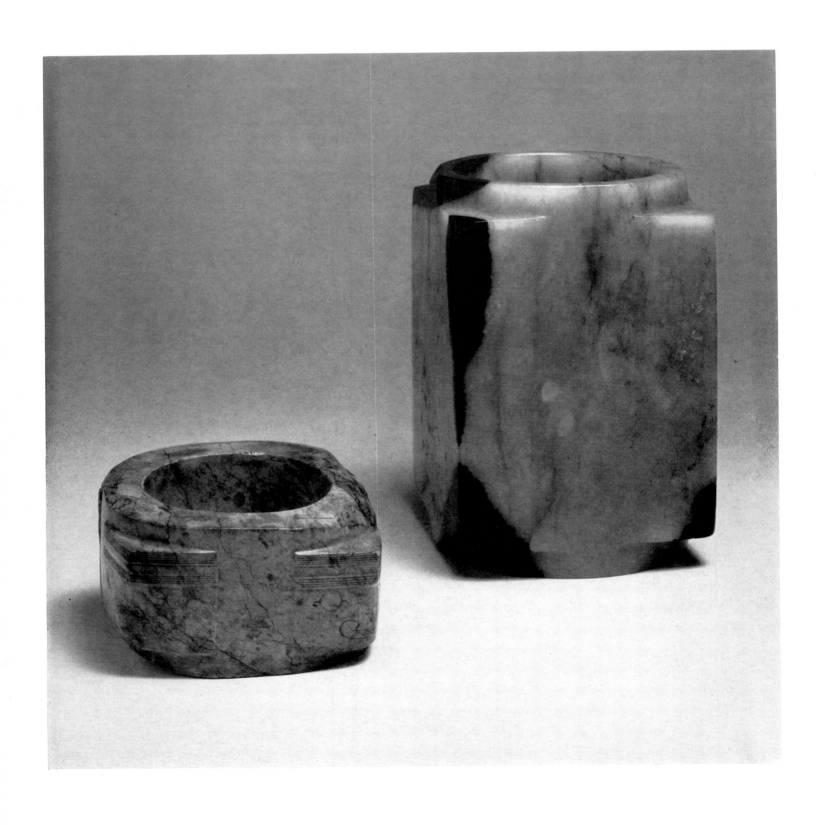

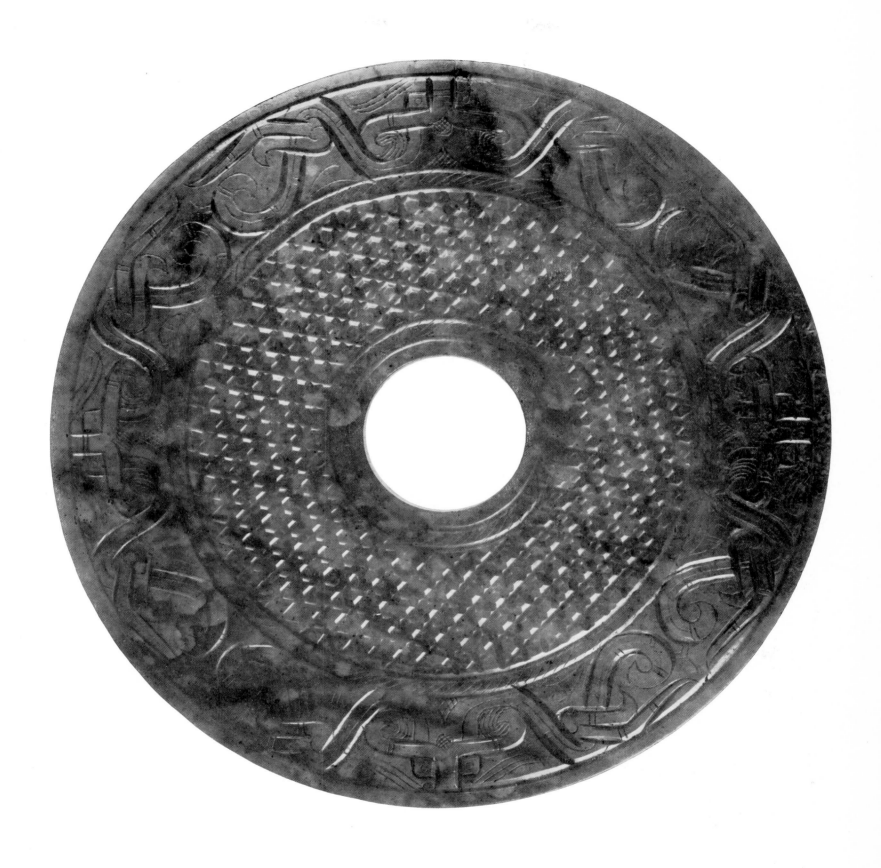

15 Pi, Warring States period (5th to 3rd century B.C.*)*

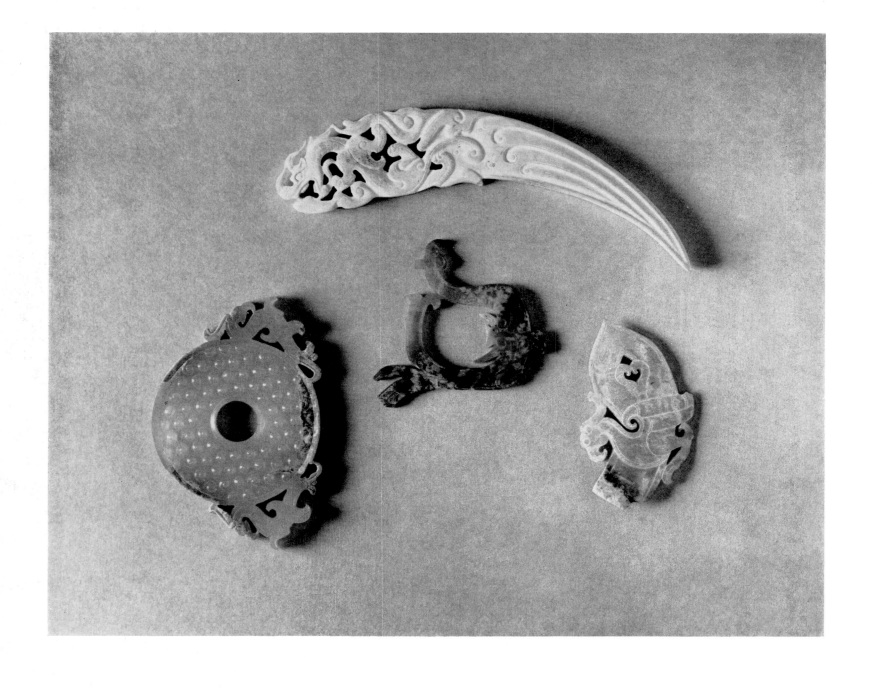

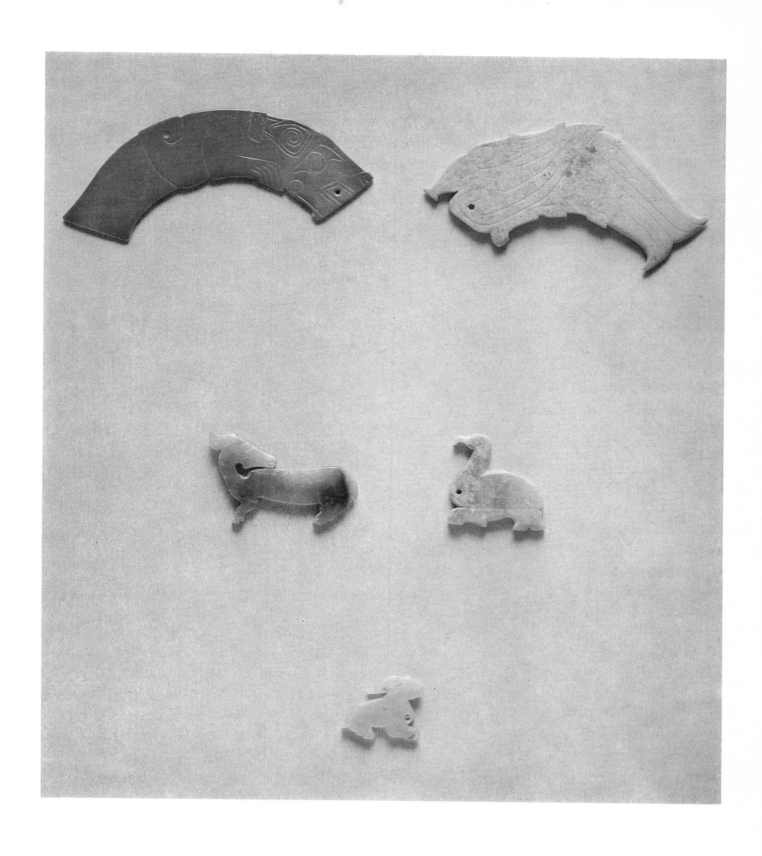

17 Zoomorphic pendants, late Shang or early Western Chou (13th to 11th century B.C.*)*

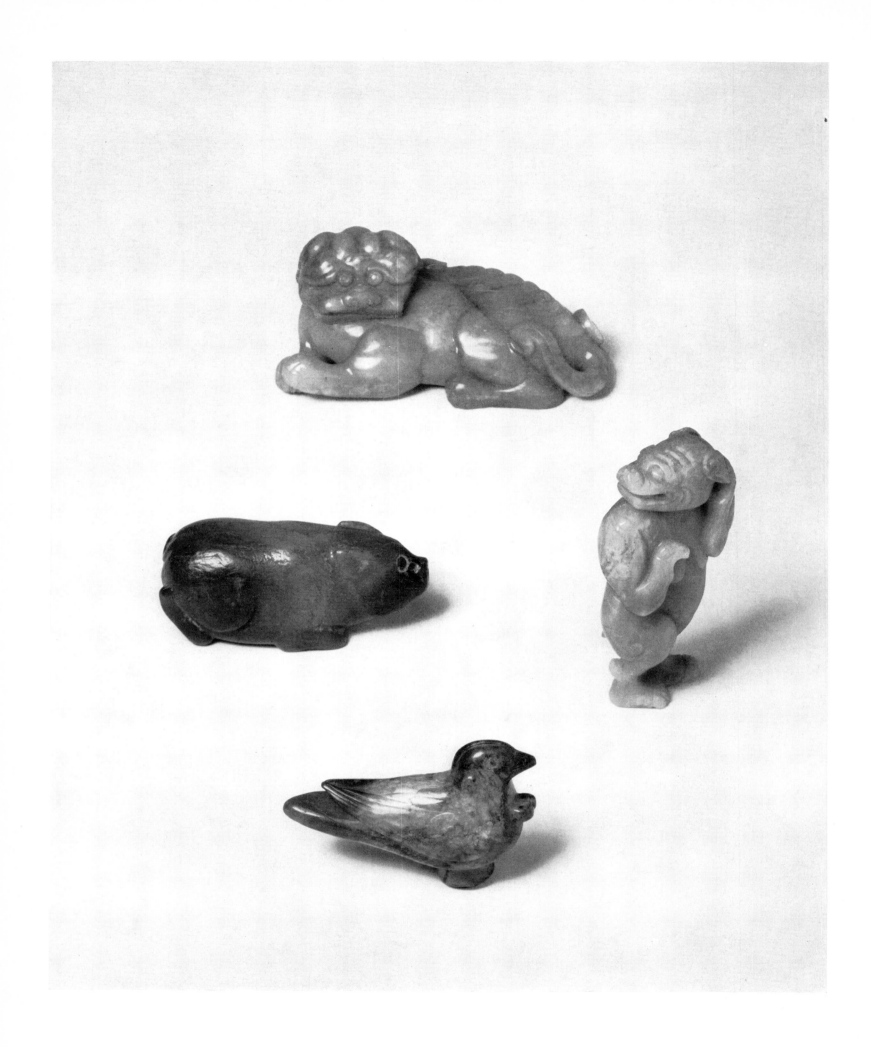

18 Zoomorphs, Han dynasty (206 B.C.—*220* A.D.*)*

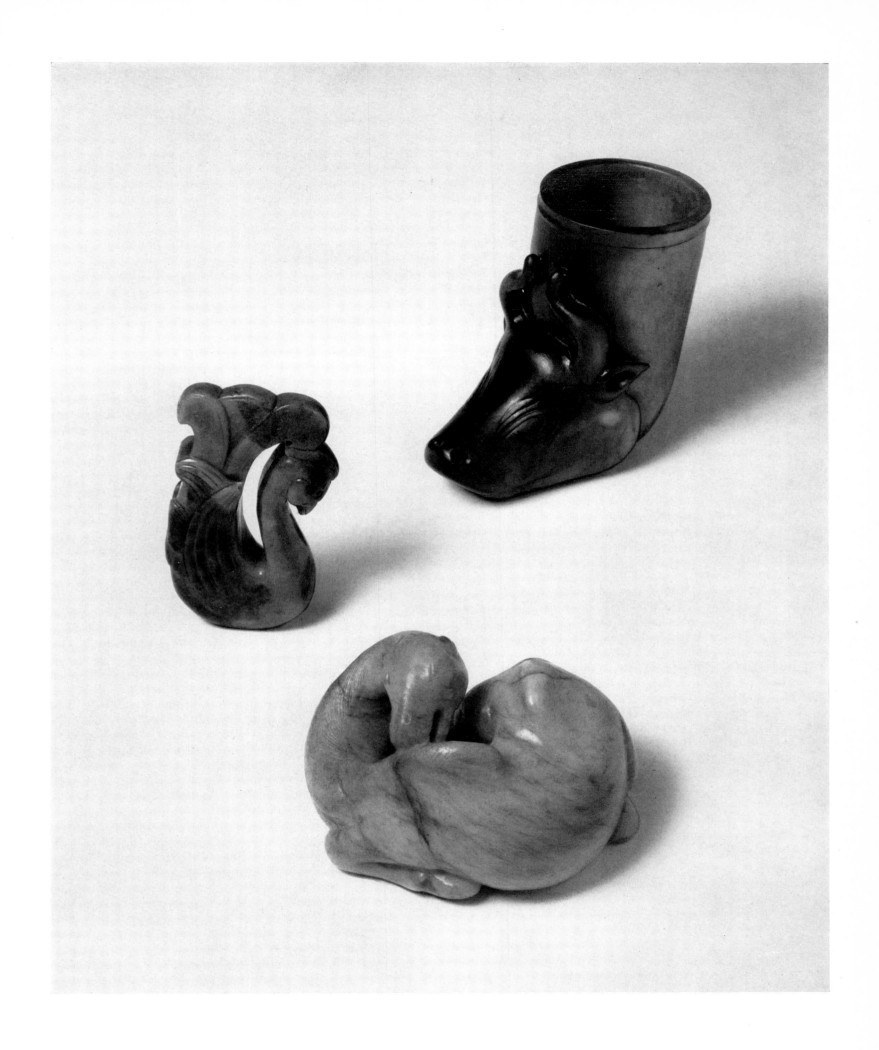

19 Phoenix, camel, and rhyton, mid medieval period (7th to 10th century A.D.*)*

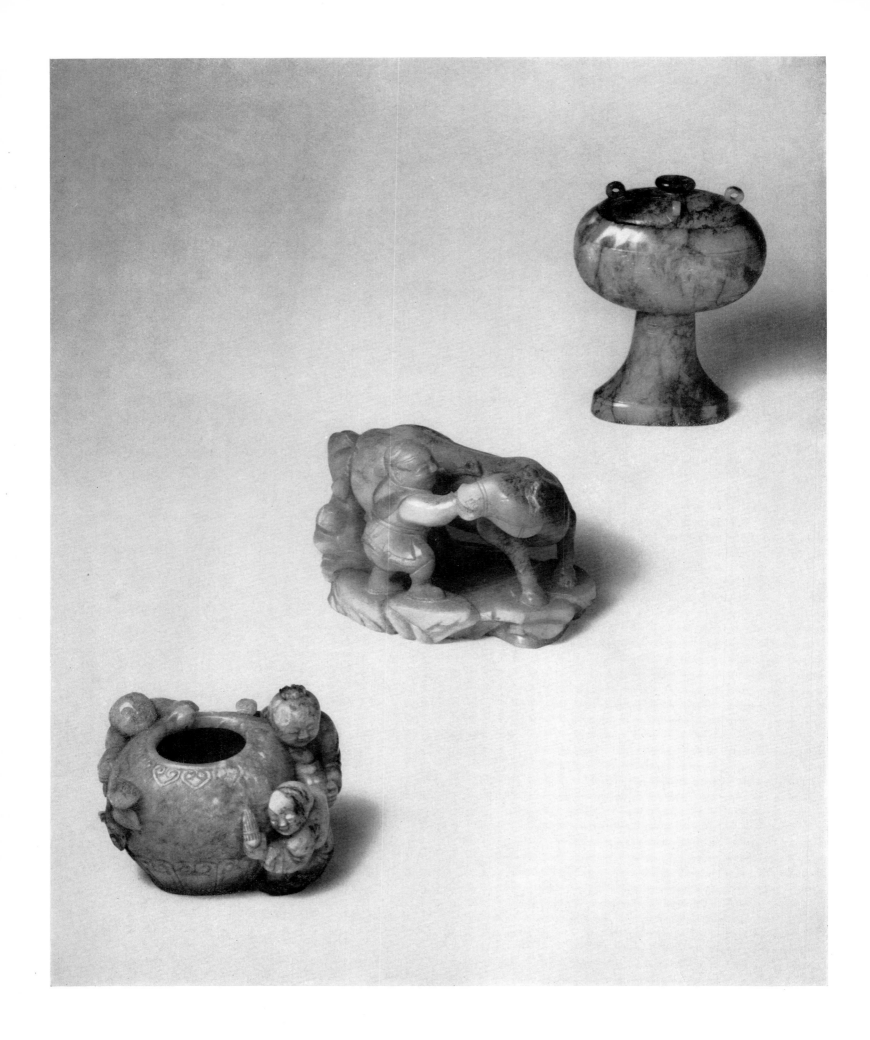

20 Vessels and sculpture, late Yüan or early Ming dynasty (14th to 16th century A.D.)

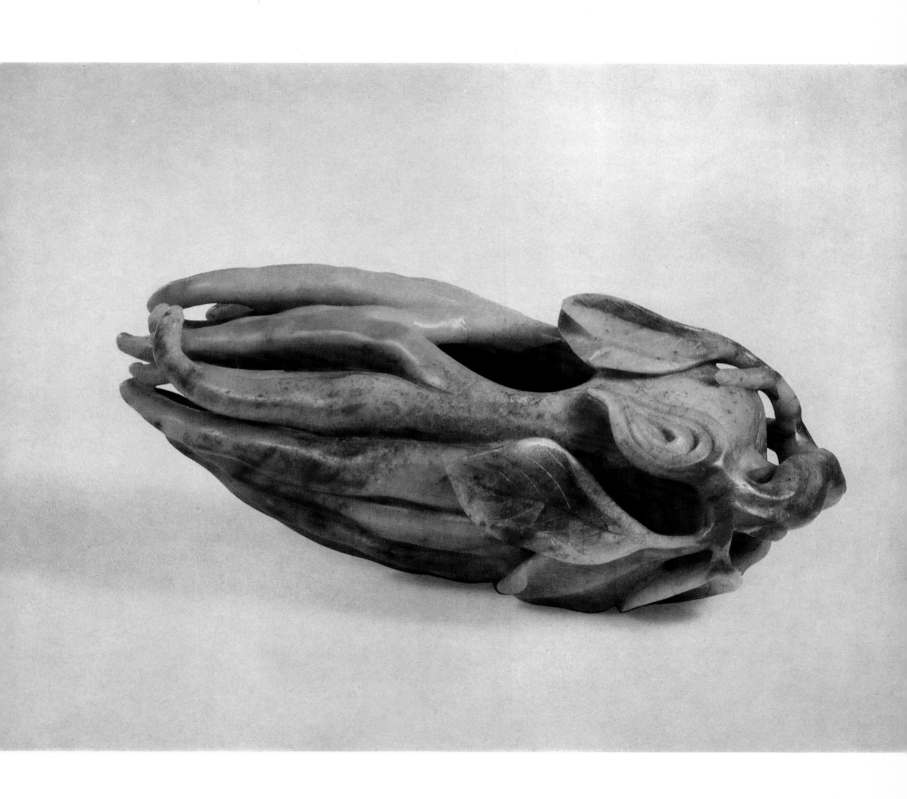

21 Water receptacle, Ming dynasty (15th to 17th century A.D.)

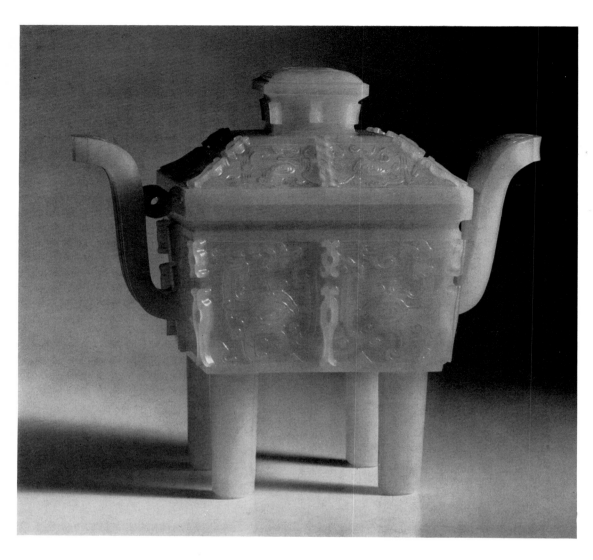

22 *Incense burner, Ch'ing dynasty*
 (18th century A.D.*)*

23 *Incense burner, Ch'ing dynasty*
 (18th century A.D.*)*

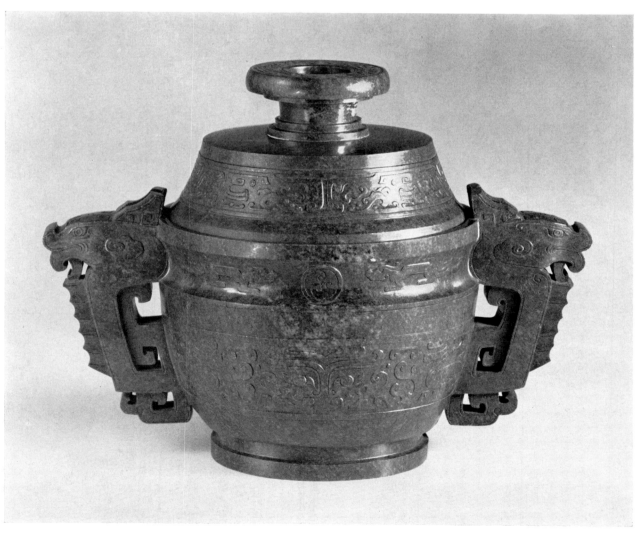

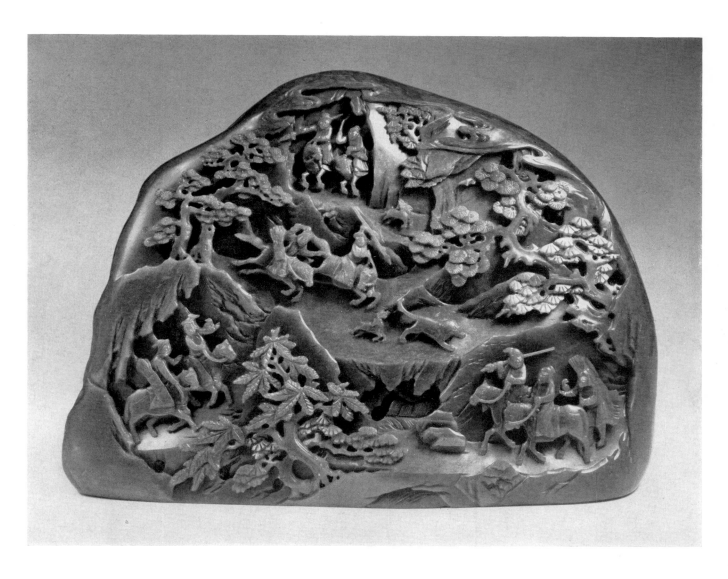

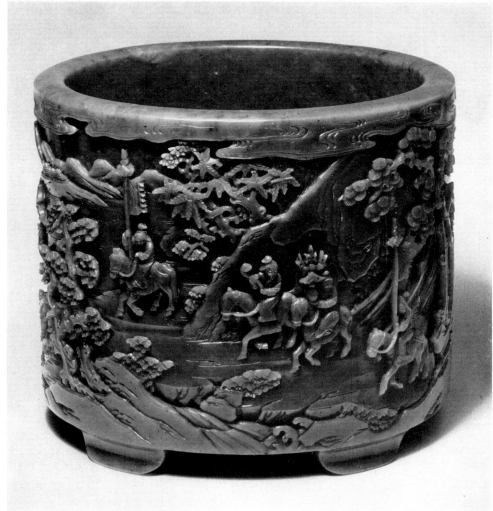

24 *Miniature mountain,*
 Ch'ing dynasty (18th century A.D.*)*

25 *Brush holder, Ch'ing dynasty*
 (18th century A.D.*)*

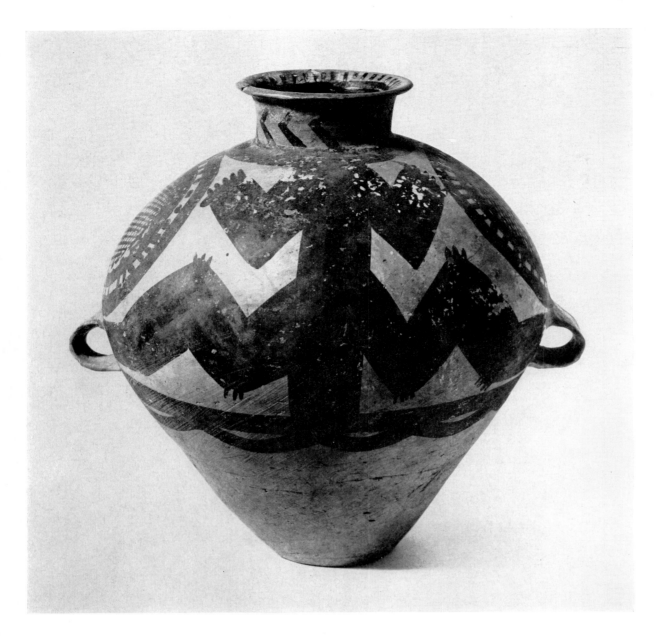

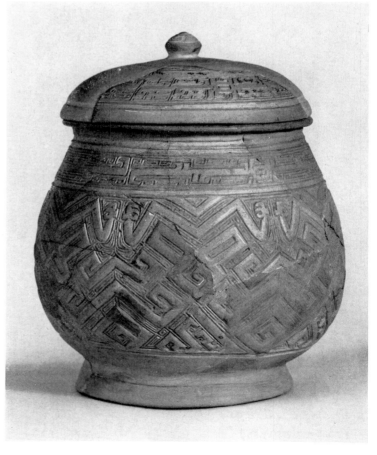

26 *Urn, late Neolithic, Yang-shao culture*
 (2000—1500 B.C.)

27 *White pottery jar, late Shang dynasty*
 (ca. 1300—1028 B.C.)

28 *Hu, late Warring States or Western Han*
 (3rd to 1st century B.C.)

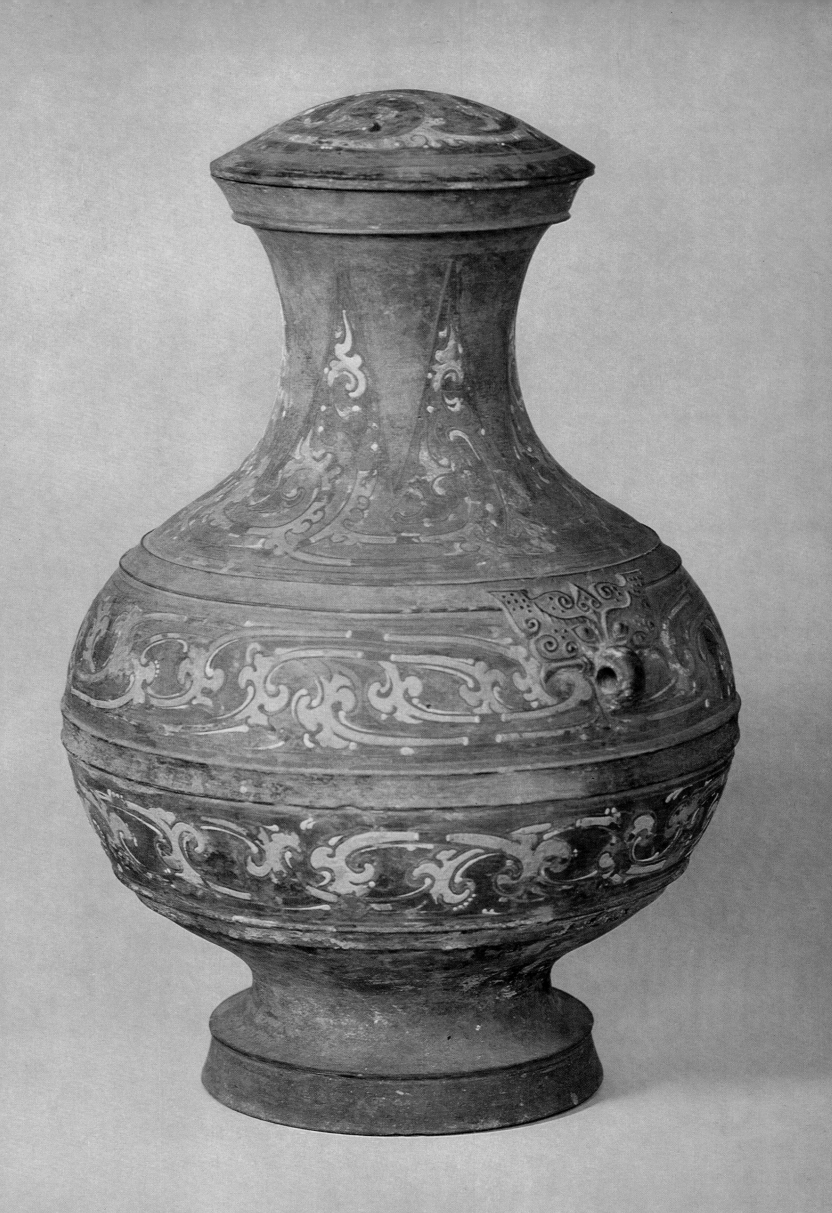

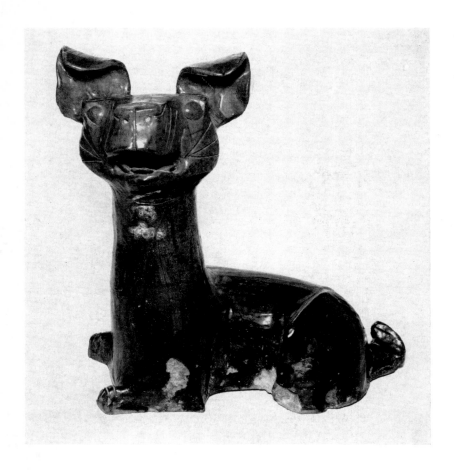

29 *Dog, Han dynasty (206* B.C.—*220* A.D.*)*

30 *Bactrian camel, mid T'ang dynasty (680—750* A.D.*)*

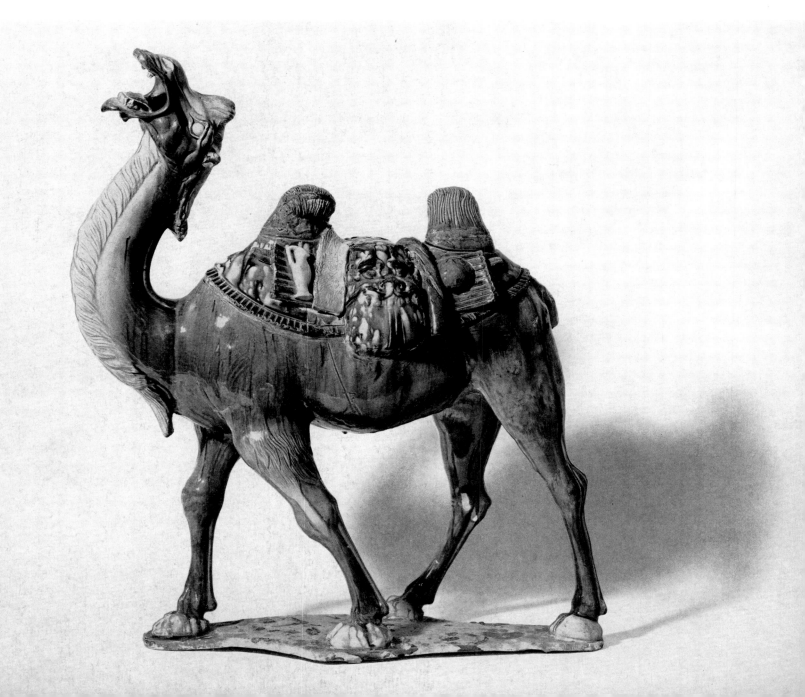

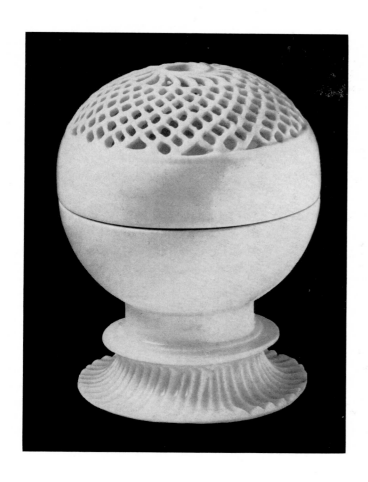

31 *Incense burner, Sung dynasty*
 (10th to 13th century A.D.*)*

32 *Ewer, Sung dynasty (11th to 12th century* A.D.*)*

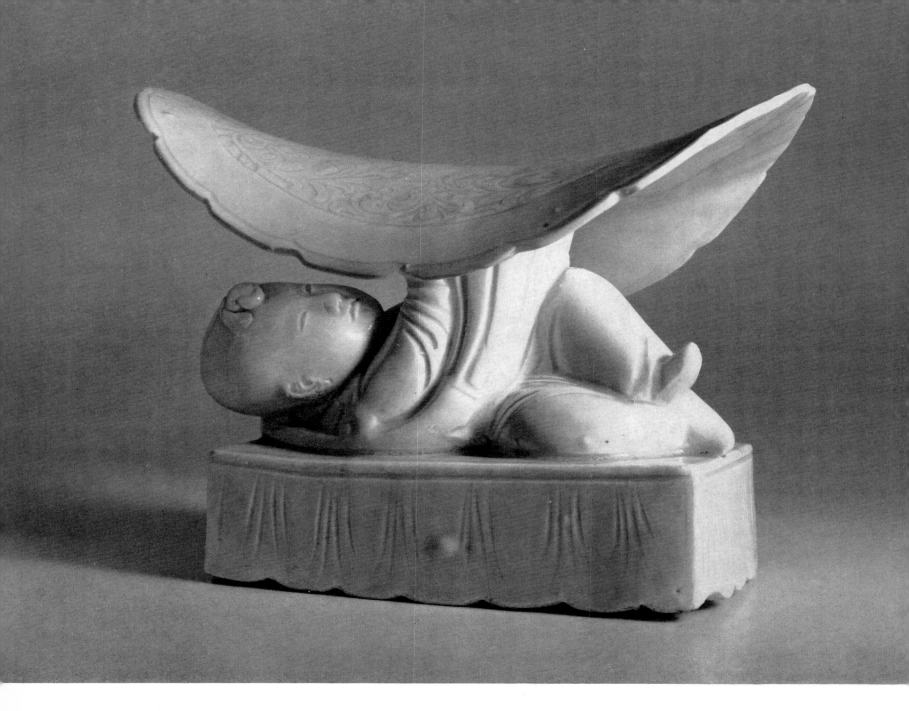

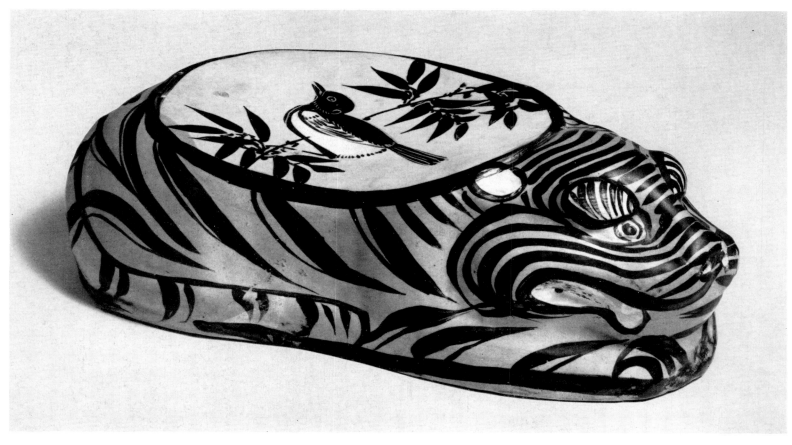

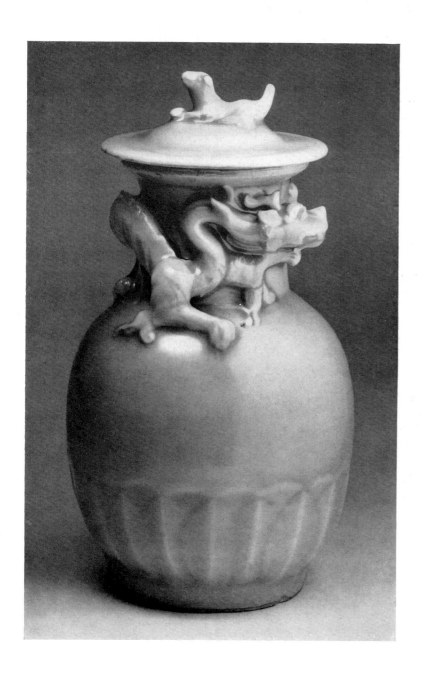

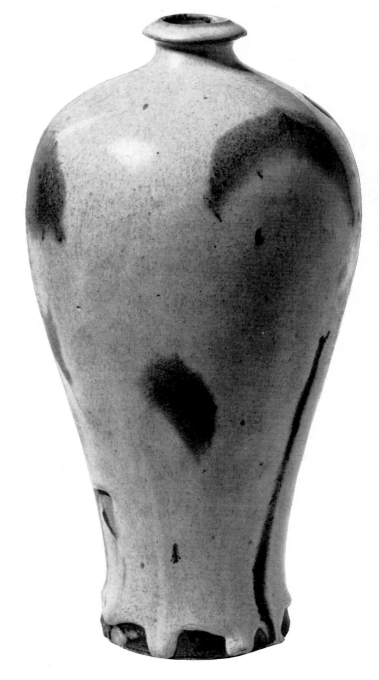

33 *Ting pillow, Sung dynasty (11th to 12th century* A.D.*)*

34 *Tz'u-chou pillow, late Northern Sung dynasty (early 12th century* A.D.*)*

35 *Lung-ch'üan jar, late Northern Sung dynasty (ca. 11th century* A.D.*)*

36 *Chün mei-p'ing vase, late Sung or Yüan (late 13th or 14th century* A.D.*)*

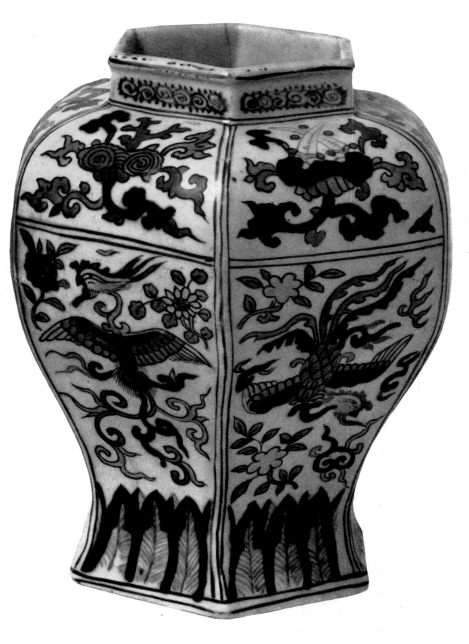

37 *"Five-color" vase, Ming dynasty, Lung-ch'ing period
(1567—1572 A.D.)*

38 *Blue-and-white platter, Ming dynasty, Hsüan-te period
(1426—1435 A.D.)*

39 *Underglaze red porcelain vase, late Yüan or early Ming
(14th to 15th century A.D.)*

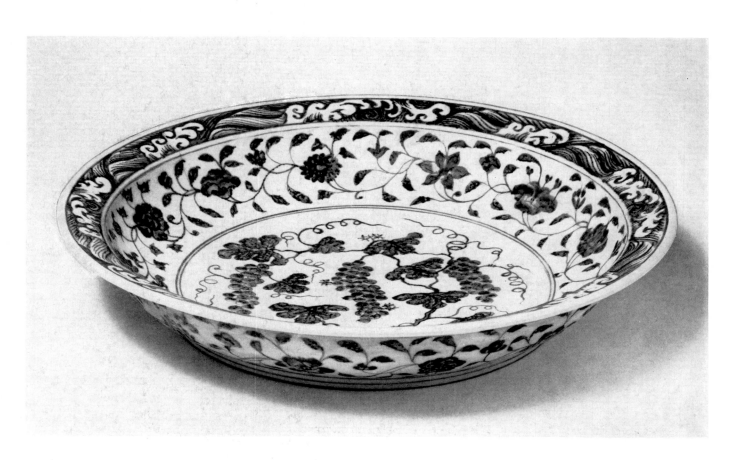

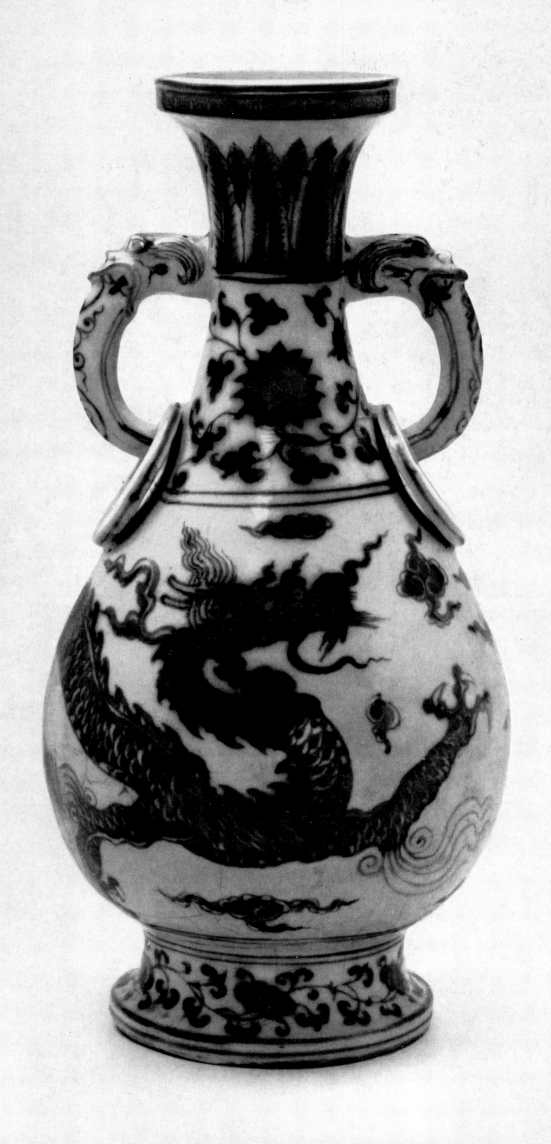

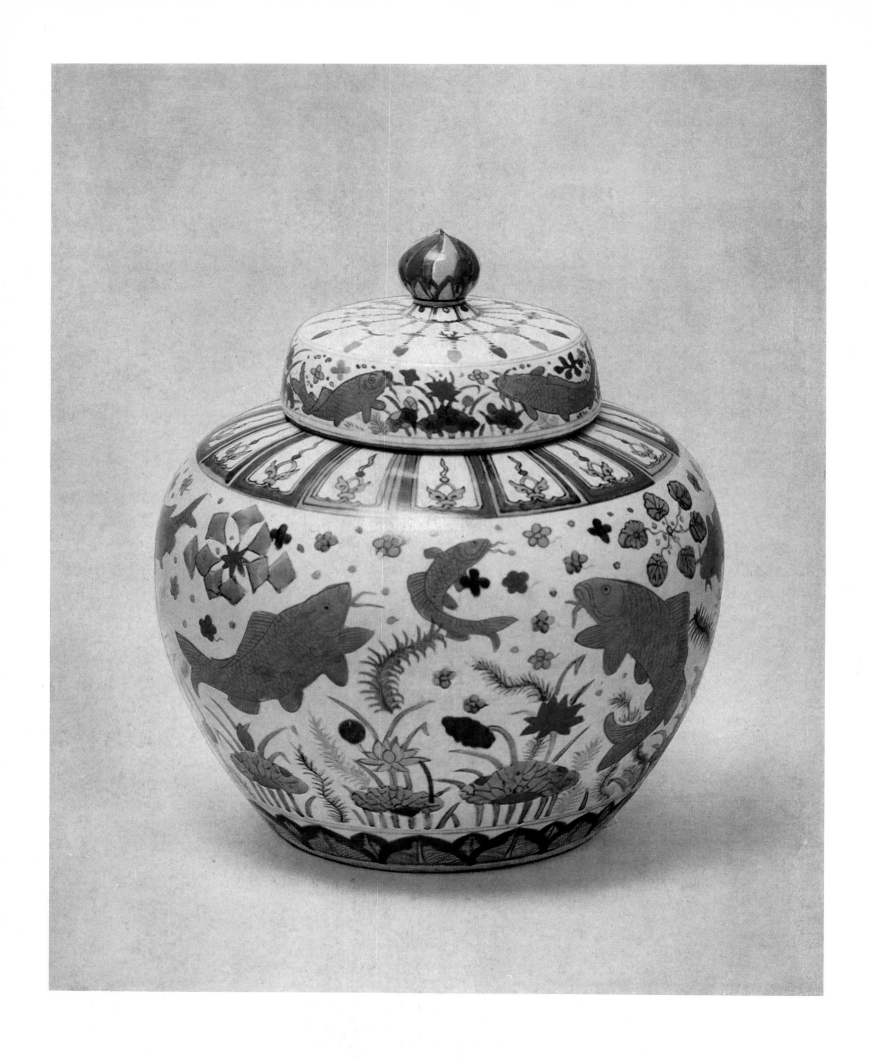

40 Fish jar, Ming dynasty, Chia-ching period (15 2—1566 A.D.)

41 Famille Verte vase, Ch'ing dynasty, K'ang-hsi period (1662—1722 A.D.)

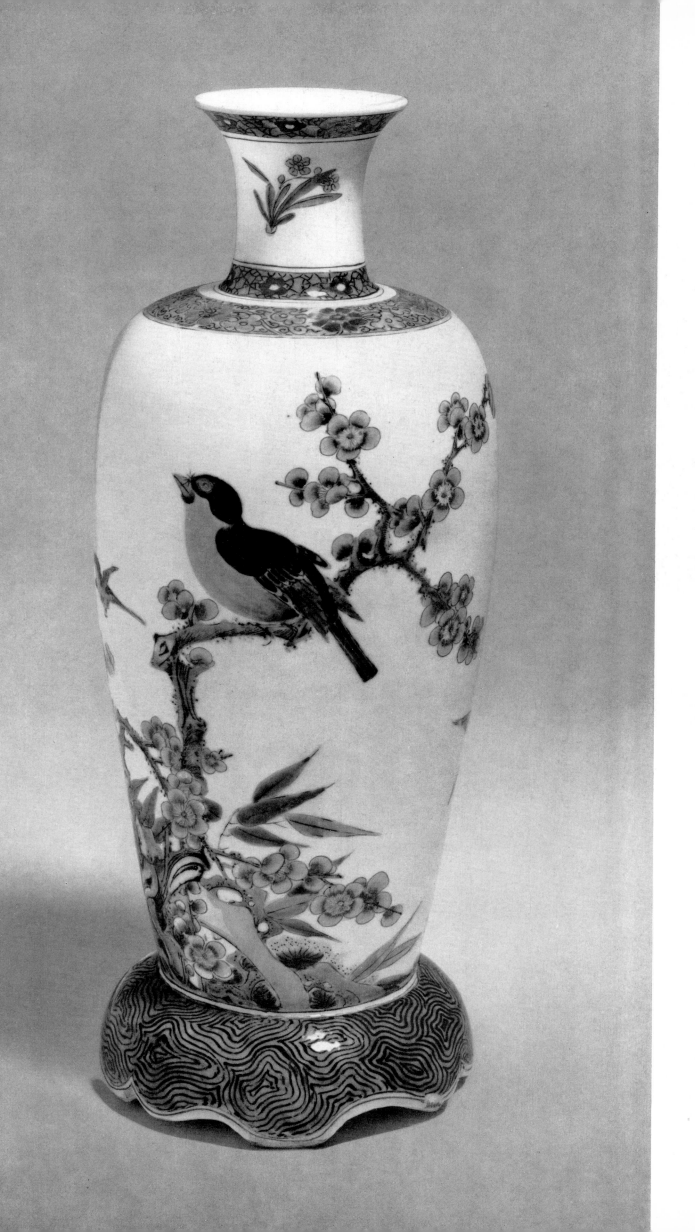

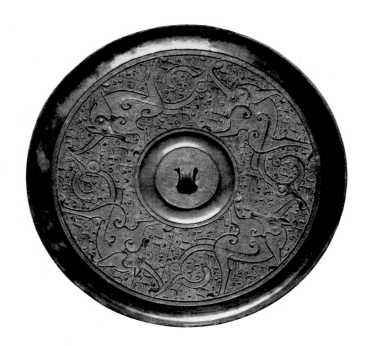

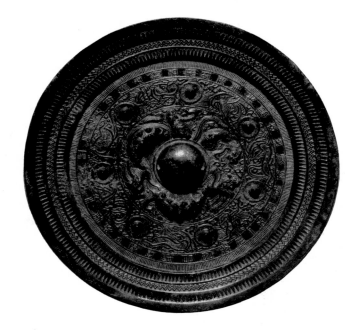

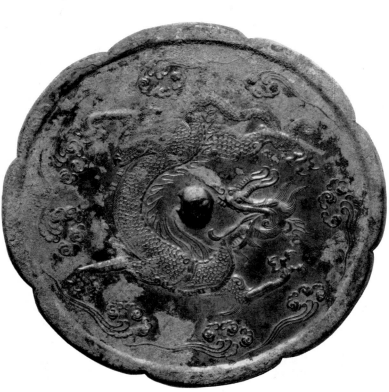

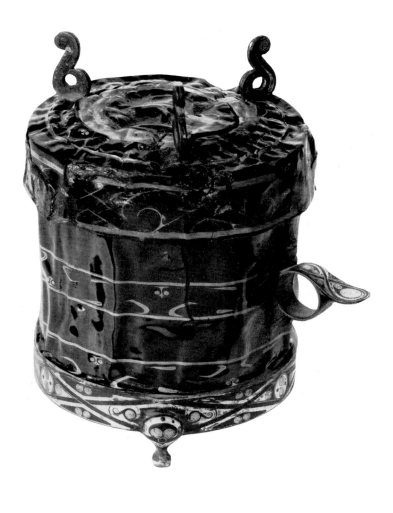

42 *Lacquer box, Ch'in dynasty, dated 218* B.C.

43 *Bronze mirrors, Warring States to T'ang dynasty
(4th century* B.C. *to 8th century* A.D.*)*

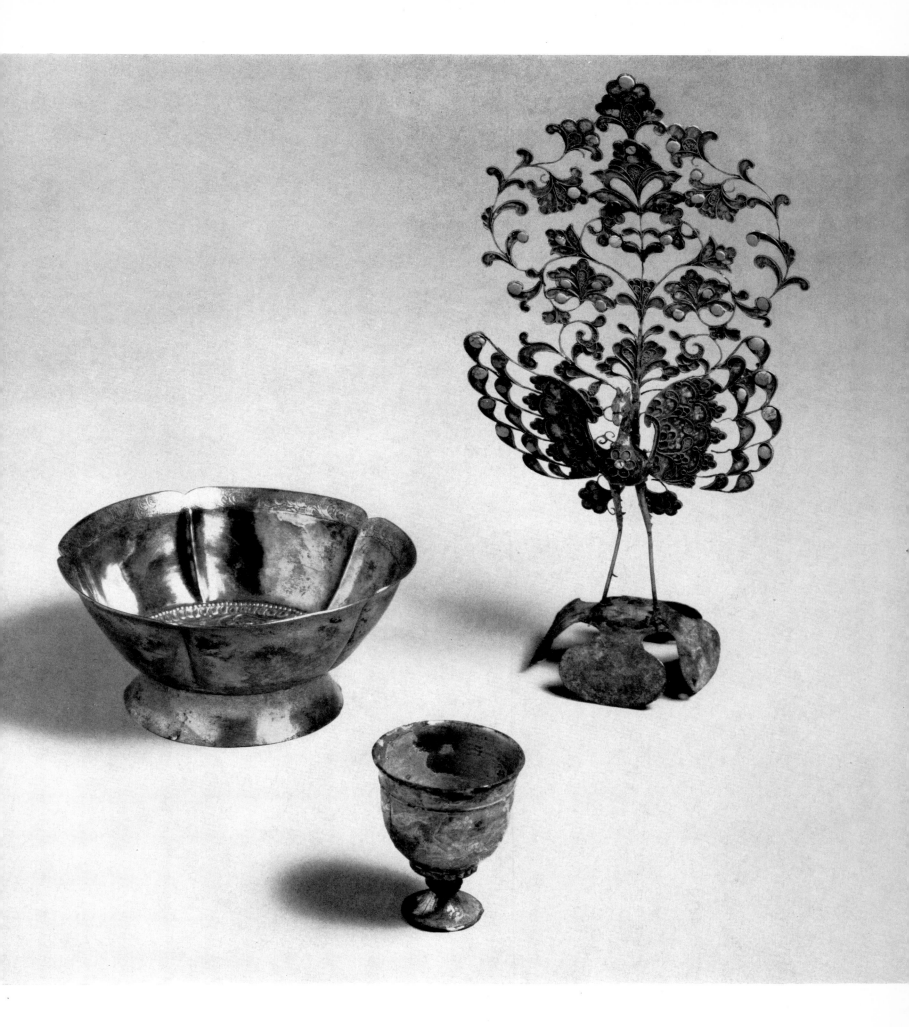

44 Head ornament, cup and bowl, T'ang dynasty (618—906 A.D.)

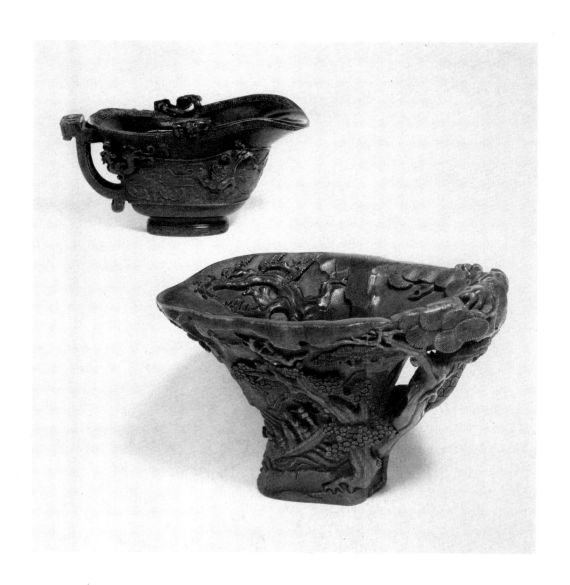

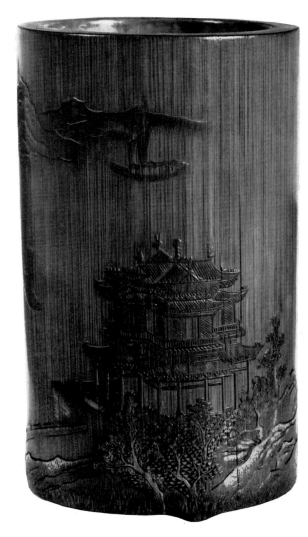

45, 46 Rhinoceros horn cups and bamboo brush holder (17th to 18th century A.D.)

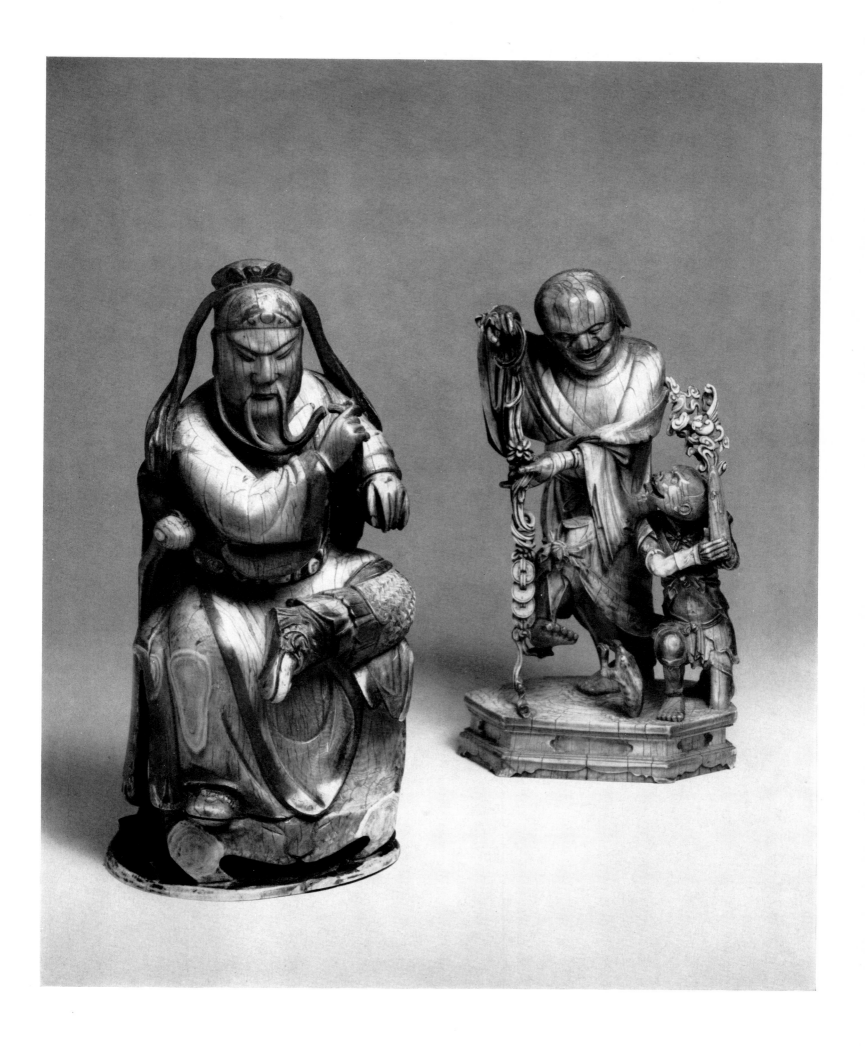

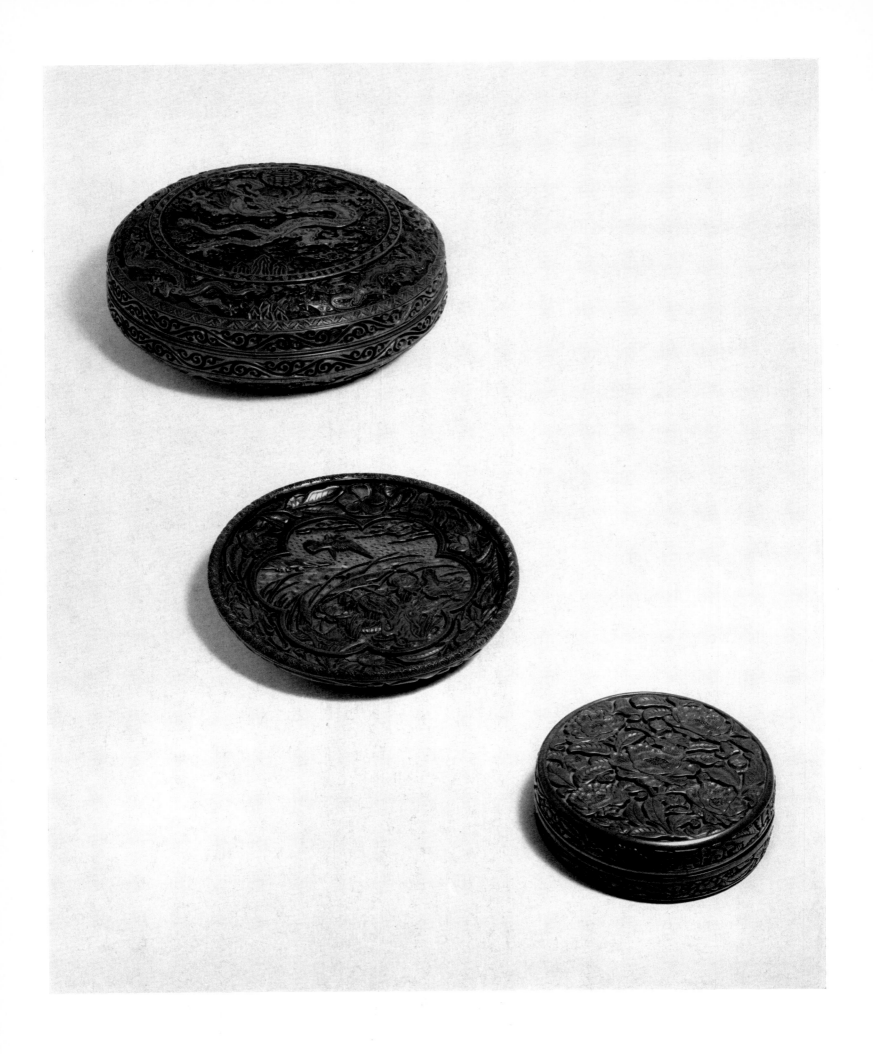

48 Lacquer boxes and dish, Ming dynasty (15th to 16th century A.D.)

49 Cloisonné vase, Ming dynasty (16th century A.D.)

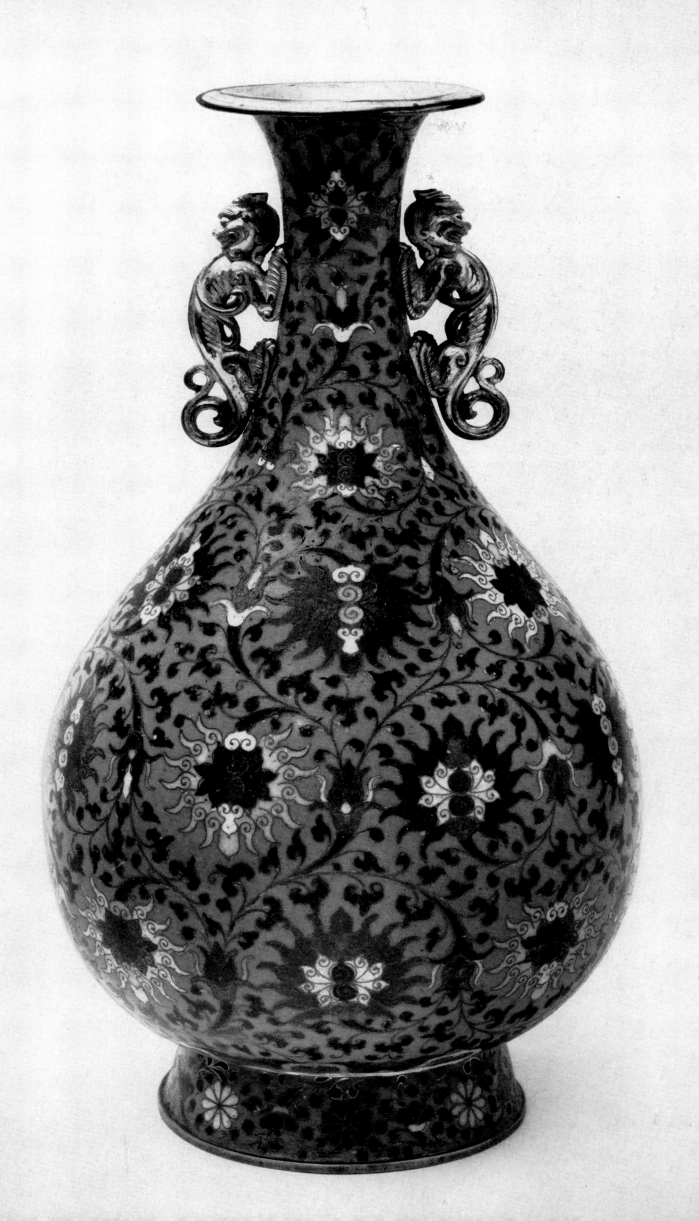

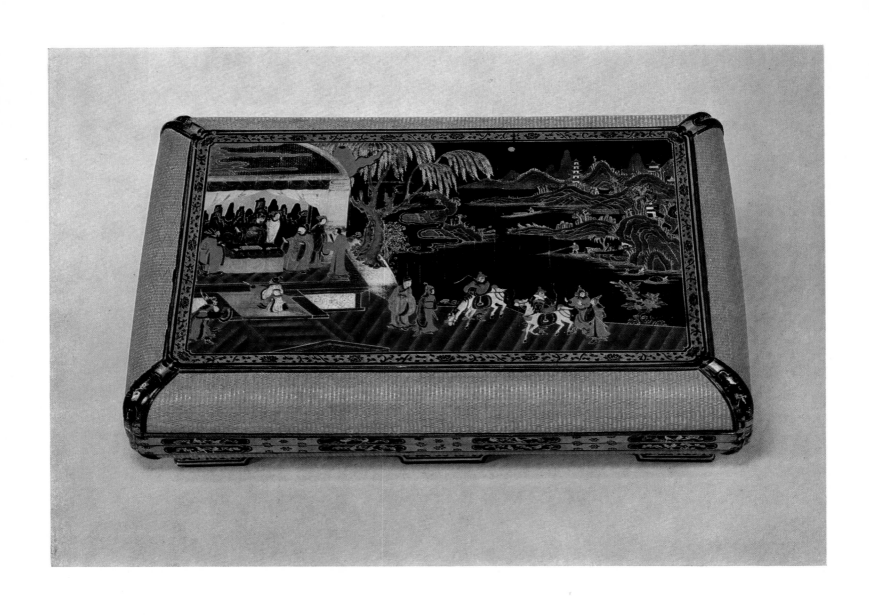

50 Lacquer box, Ming dynasty (early 17th century A.D.)

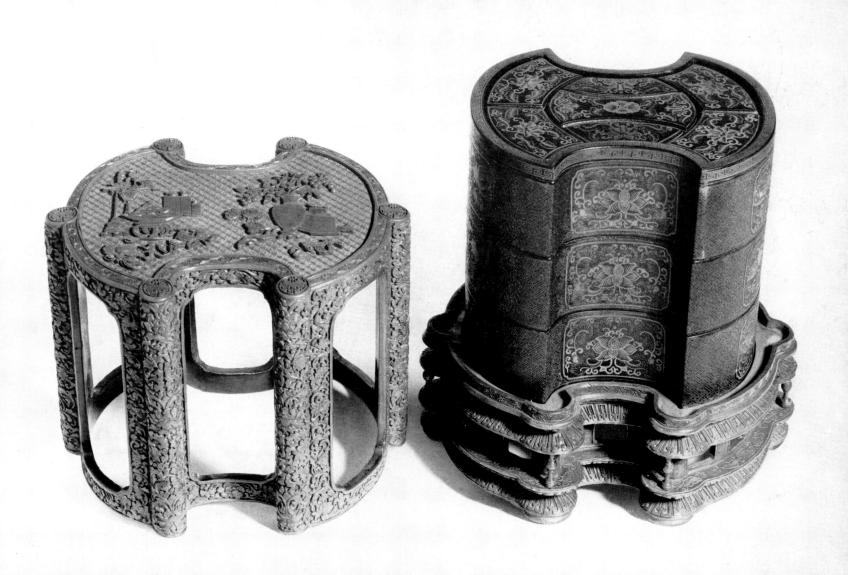

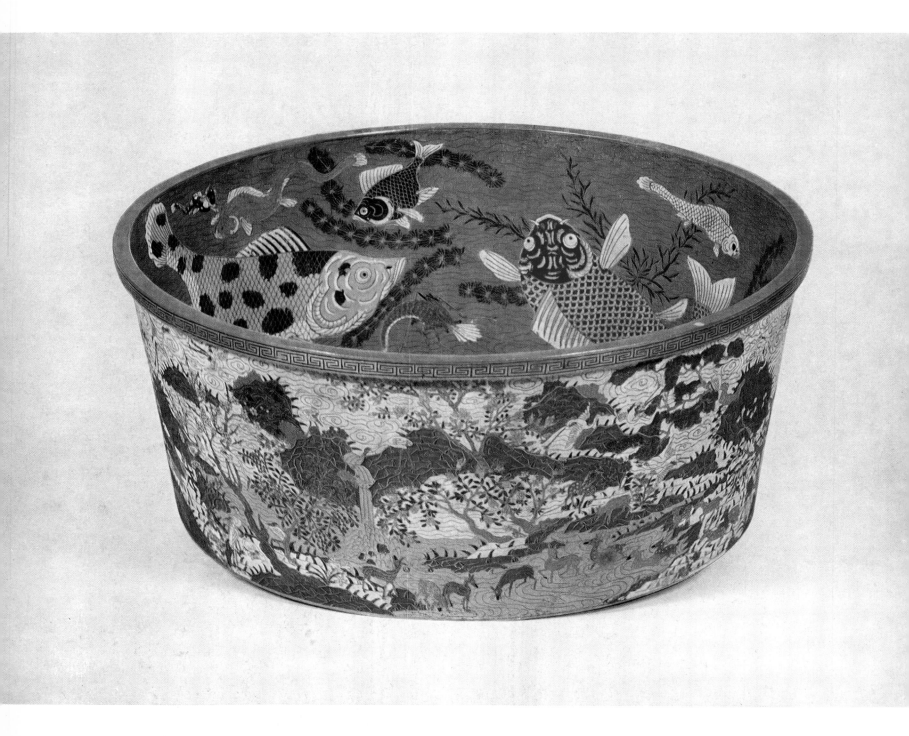

52 Cloisonné fish bowl, Ch'ing dynasty, Ch'ien-lung period (18th century A.D.)

53, 54 Tomb pillars, clay, Eastern Han dynasty (25—220 A.D.)

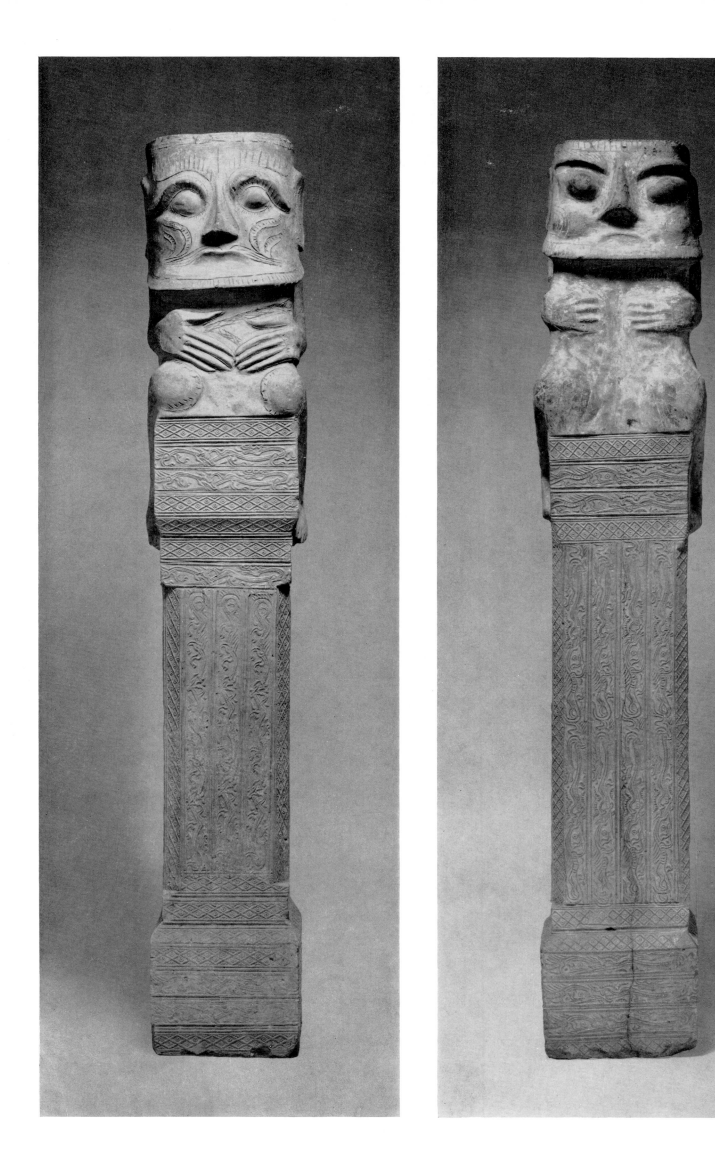

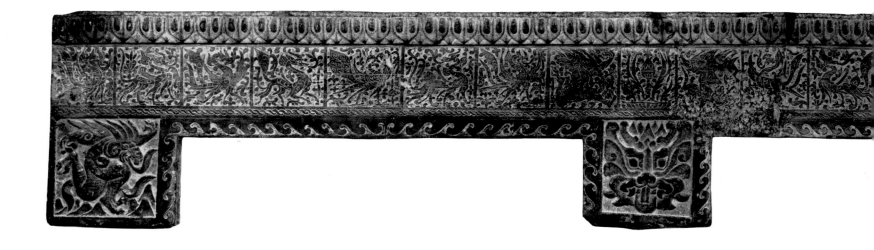

55 *Mortuary bed (section), limestone, Six Dynasties (early 6th century* A.D.*)*

56 *Unicorn, sandstone, Six Dynasties (mid 6th century* A.D.*)*

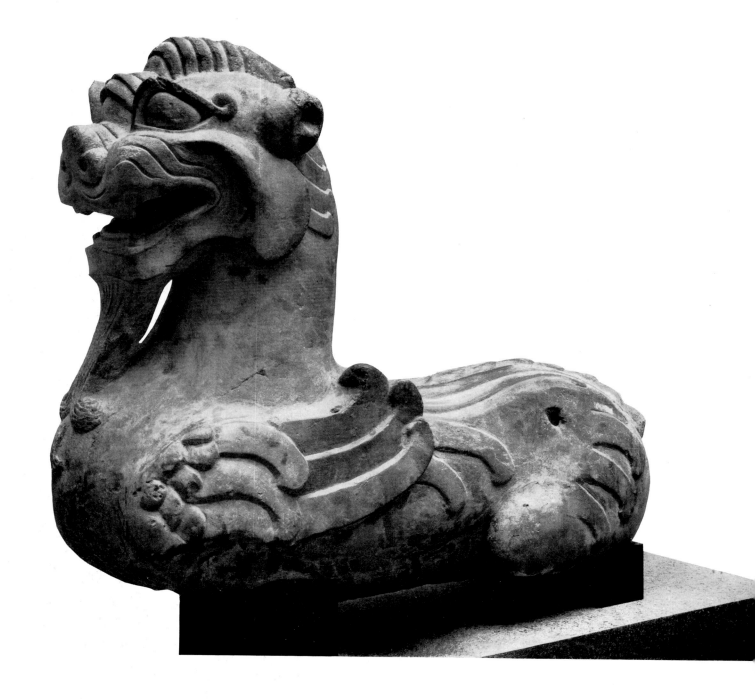

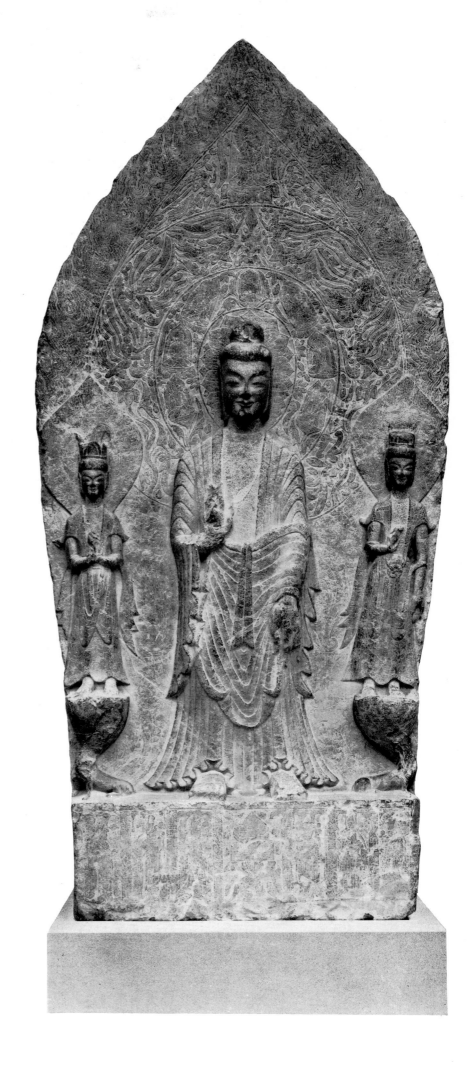

57 Buddhist stele, limestone, Northern Wei dynasty,
 dated 533 A.D.

 Following pages:

58 Buddhist stele, limestone, Western Wei dynasty,
 dated 549 A.D.

59 Gilt bronze Buddha, later Chao dynasty,
 dated 338 A.D.

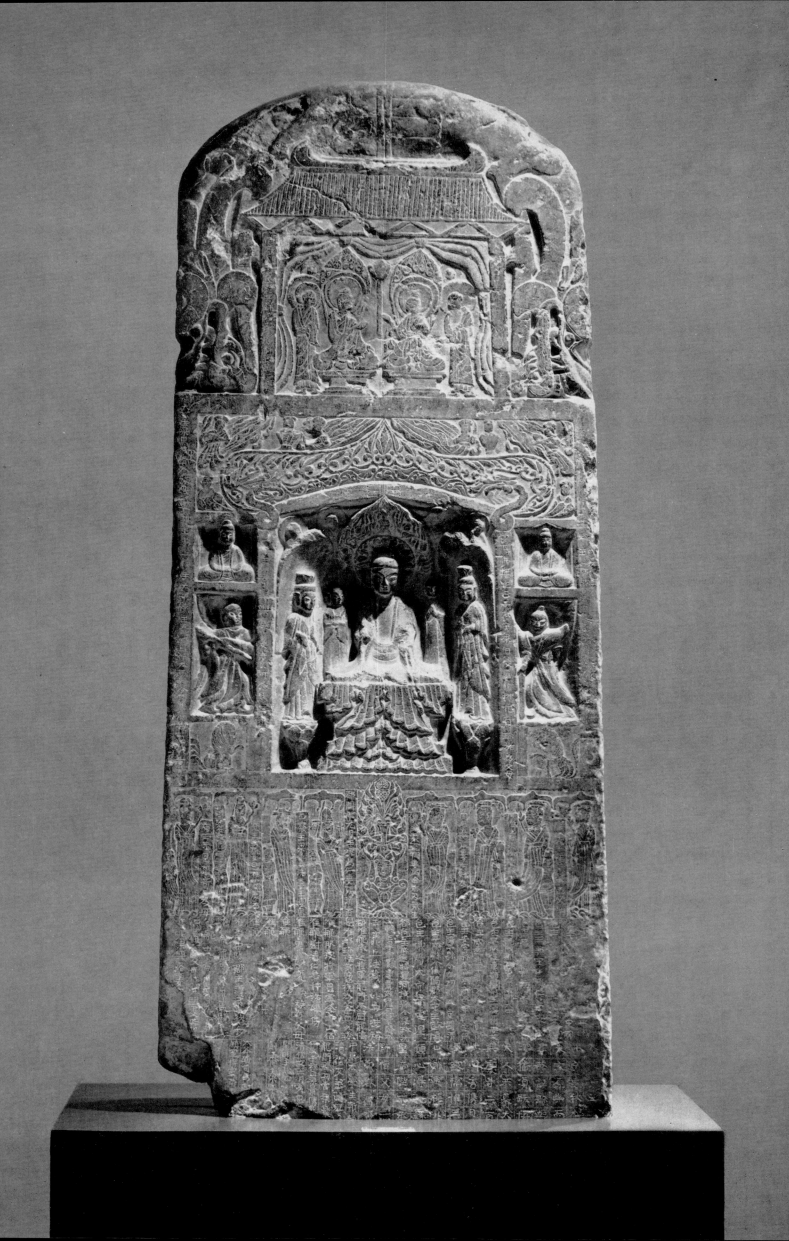

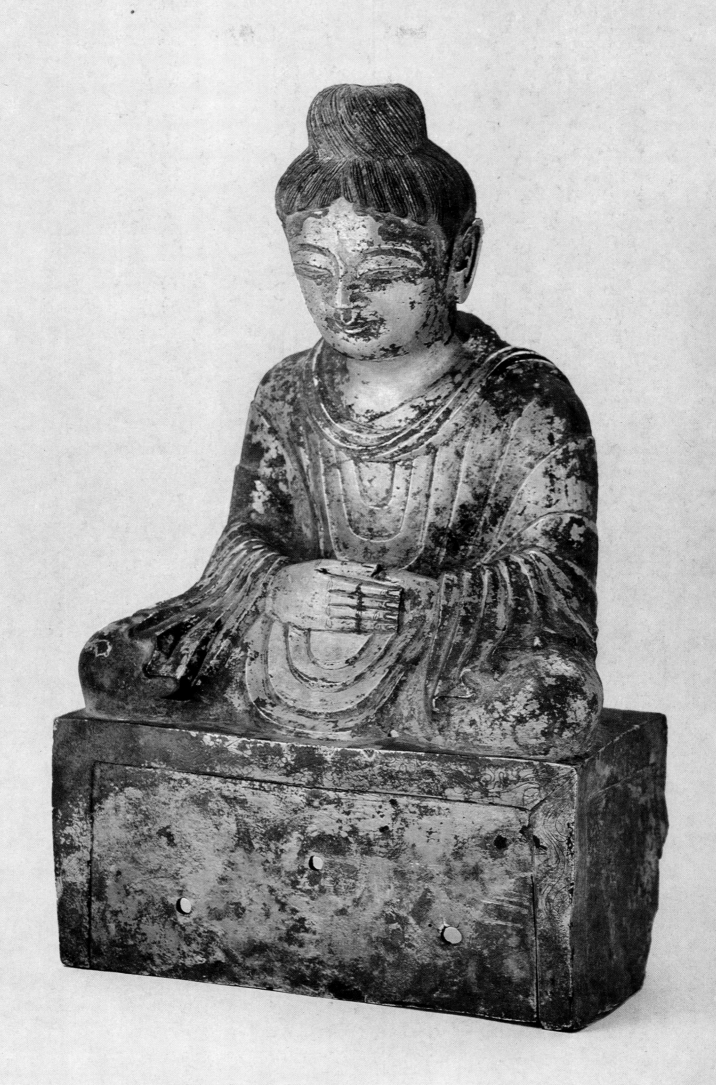

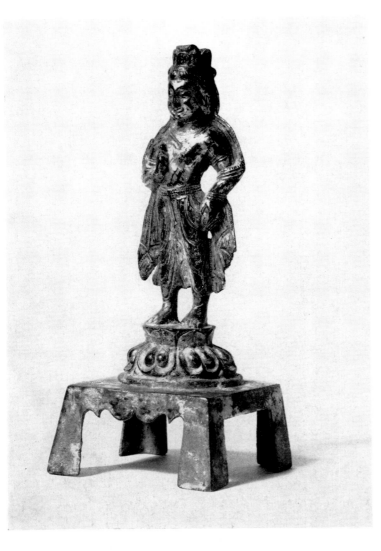

60, 61, 62 *Gilt bronze Buddhist altarpieces,*
 Northern Wei dynasty (5th century A.D.*)*

63 *Pratyeka Buddha, limestone, Northern Ch'i dynasty*
 (550—577 A.D.*)*

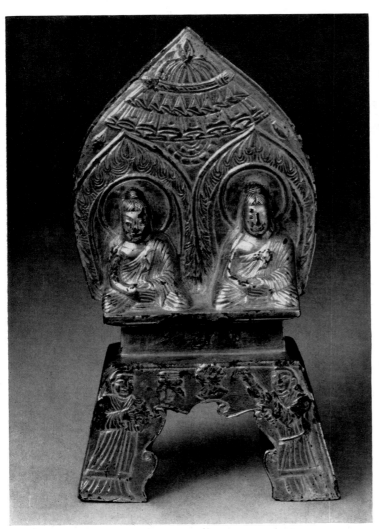

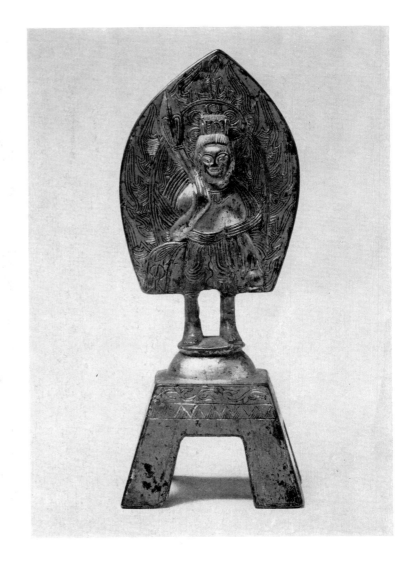

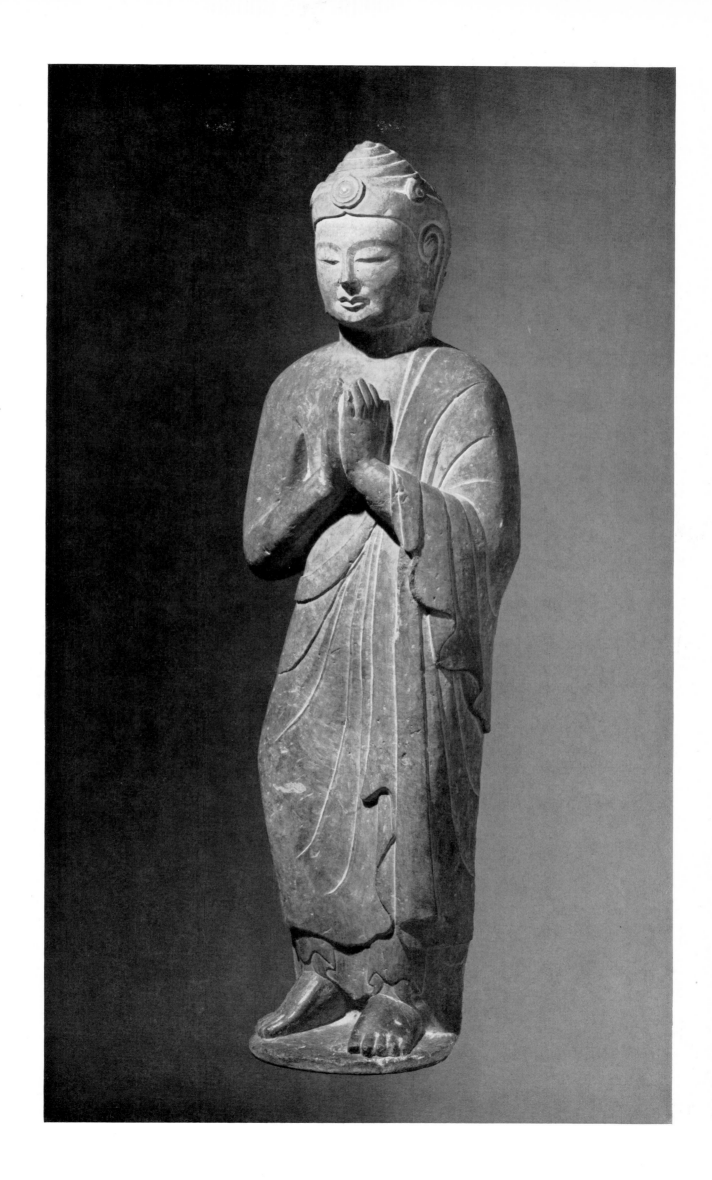

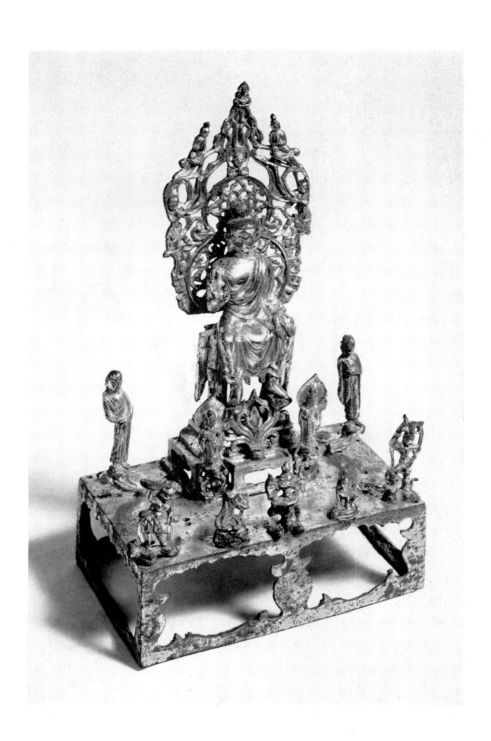

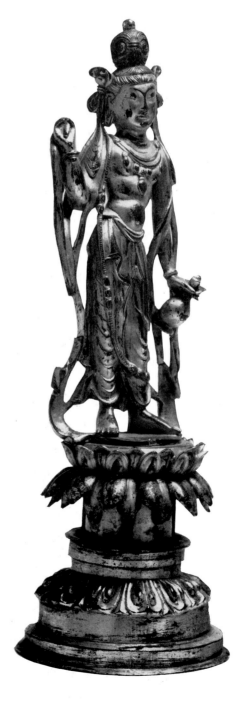

64, 65 Gilt bronze altarpiece and Kuan-yin, T'ang dynasty (late 7th century A.D.)

66 Buddhist stele, marble, early Sui dynasty, dated 595 A.D.

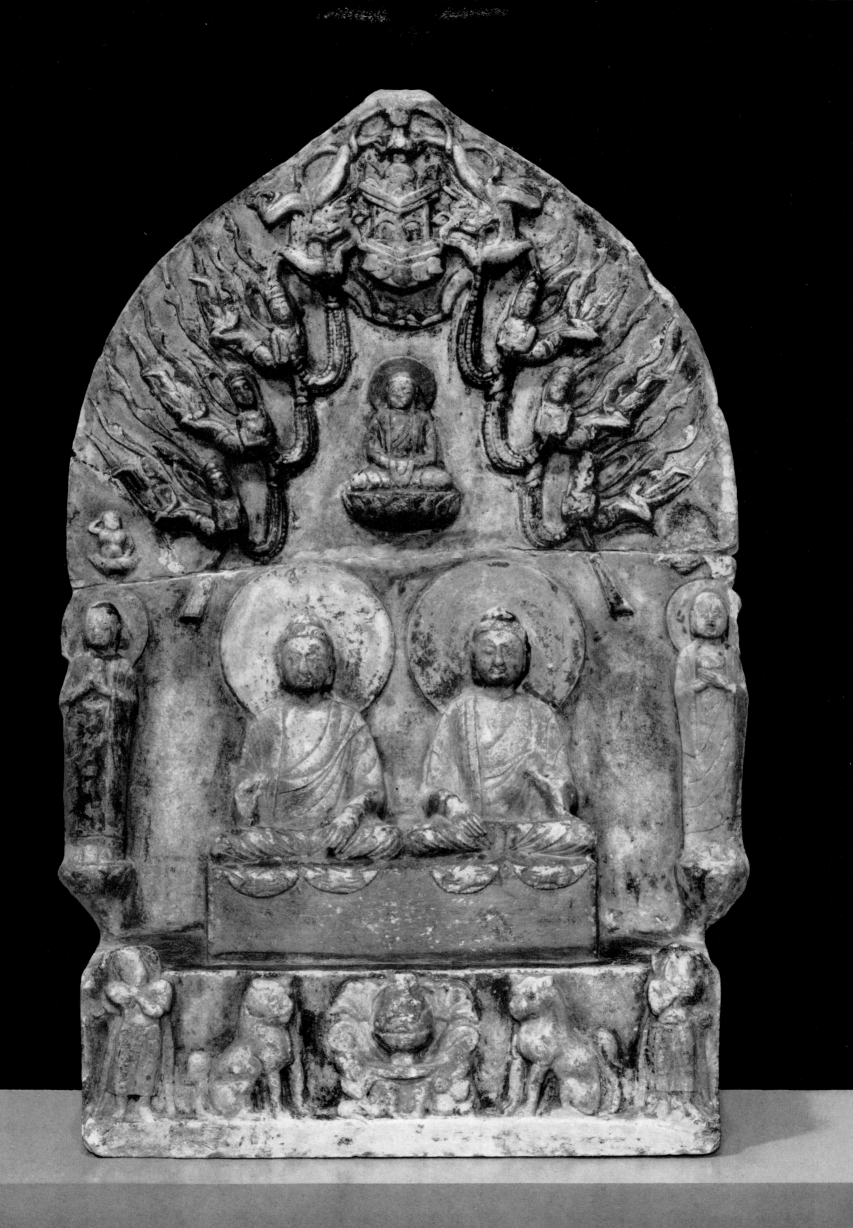

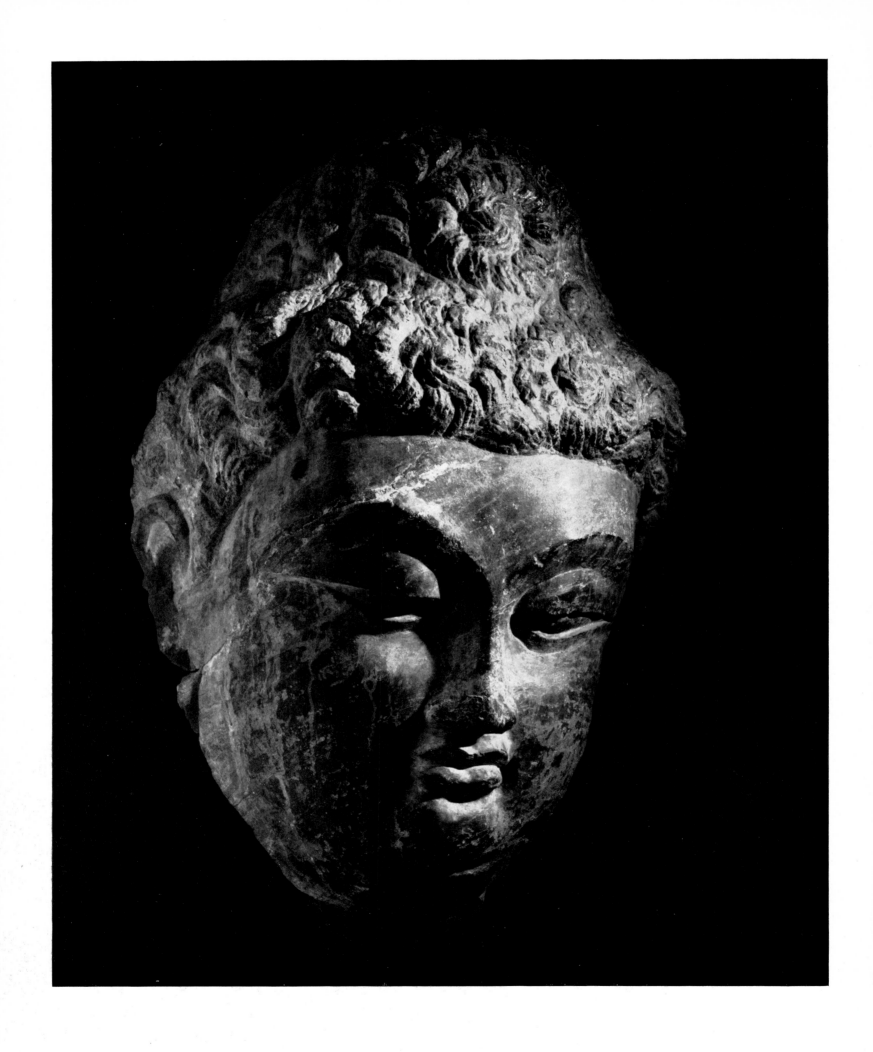

67 Head of Buddha, limestone, T'ang dynasty (early 8th century A.D.)

68 Kuan-yin, painted wood, Sung dynasty (ca. 12th century A.D.)

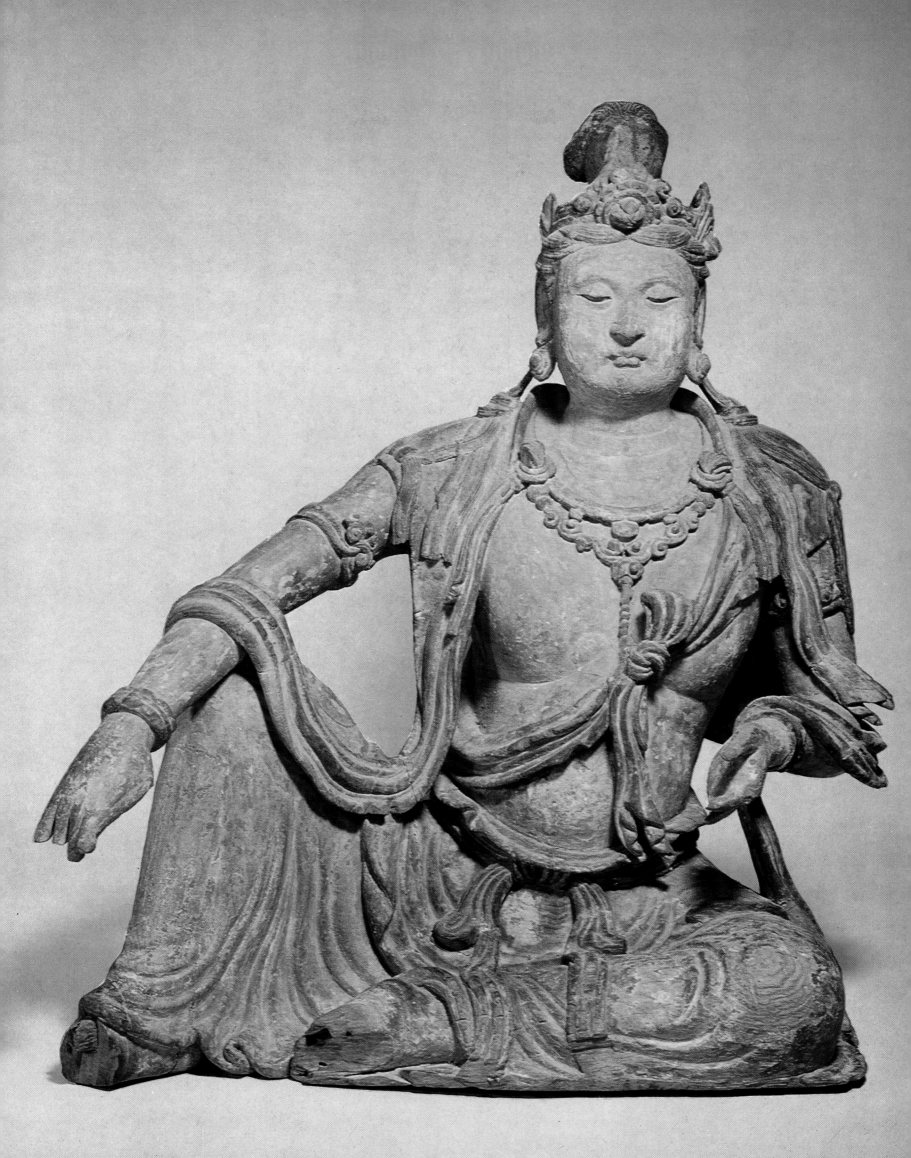

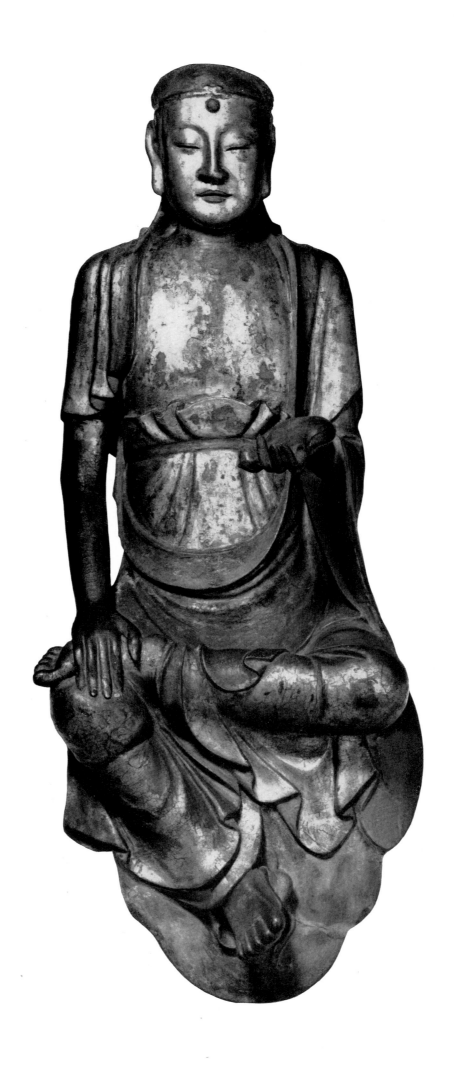

69 Bodhisattva, wood and gilt lacquer, Liao dynasty (907—1124 A.D.)

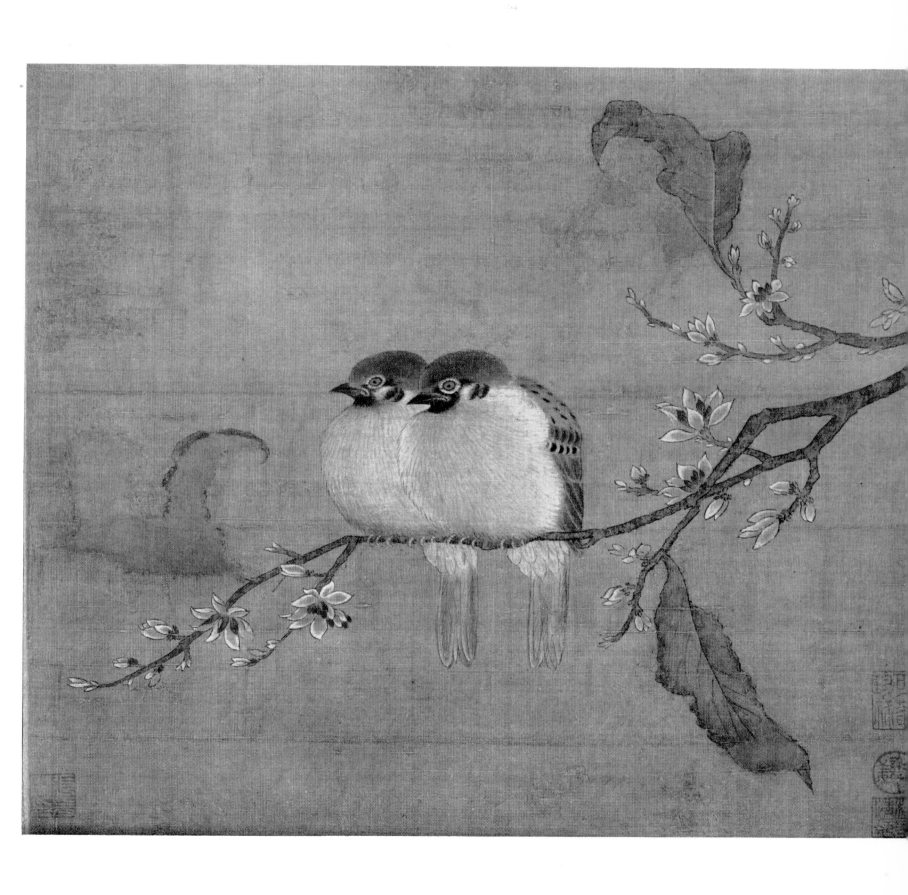

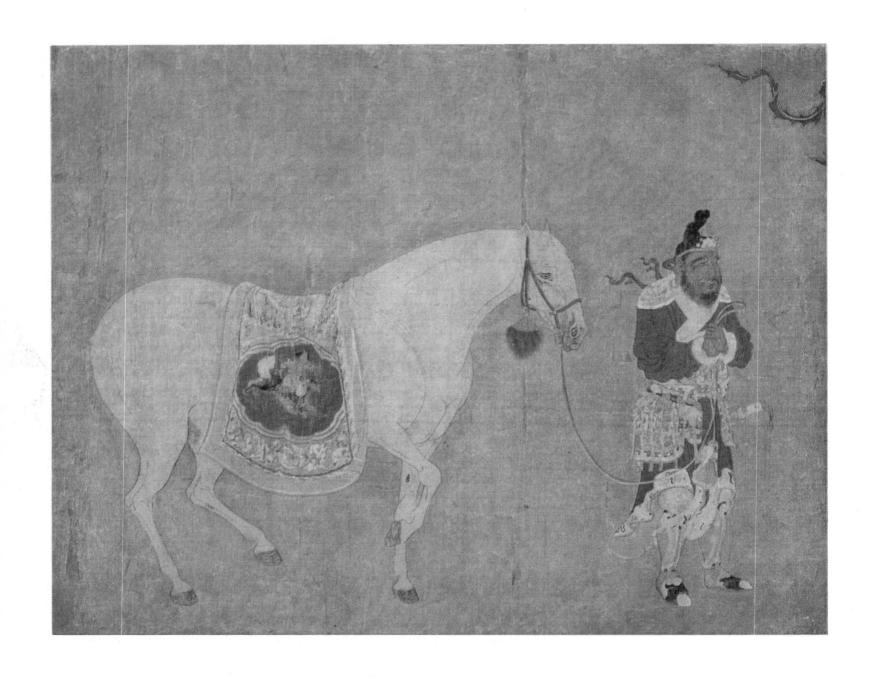

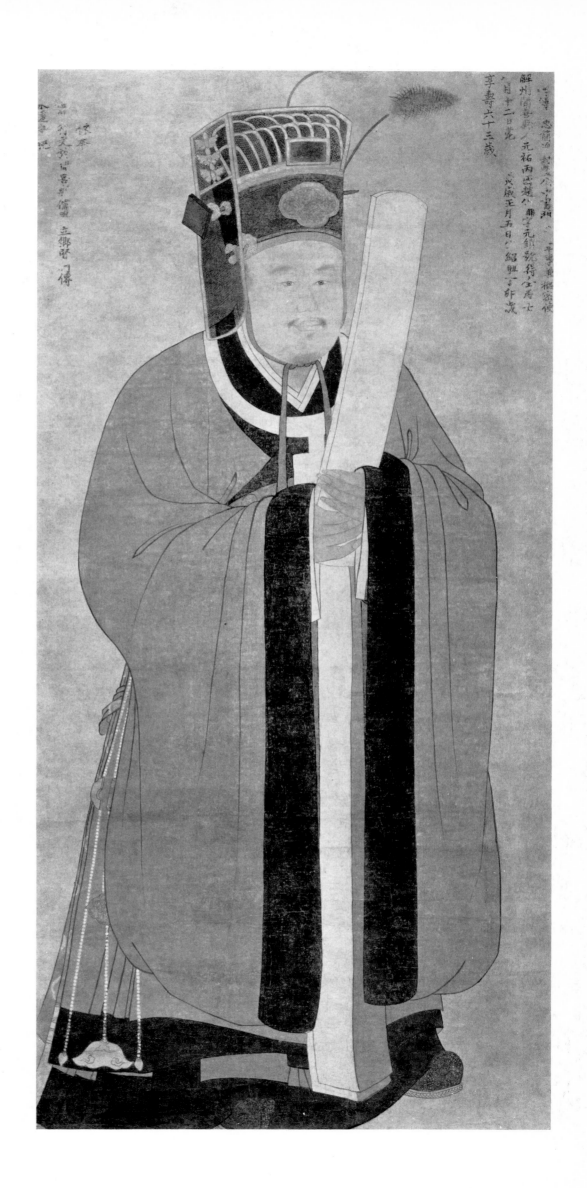

72 *Duke Feng-kuo, Yüan dynasty*
 (*1279—1368* A.D.)

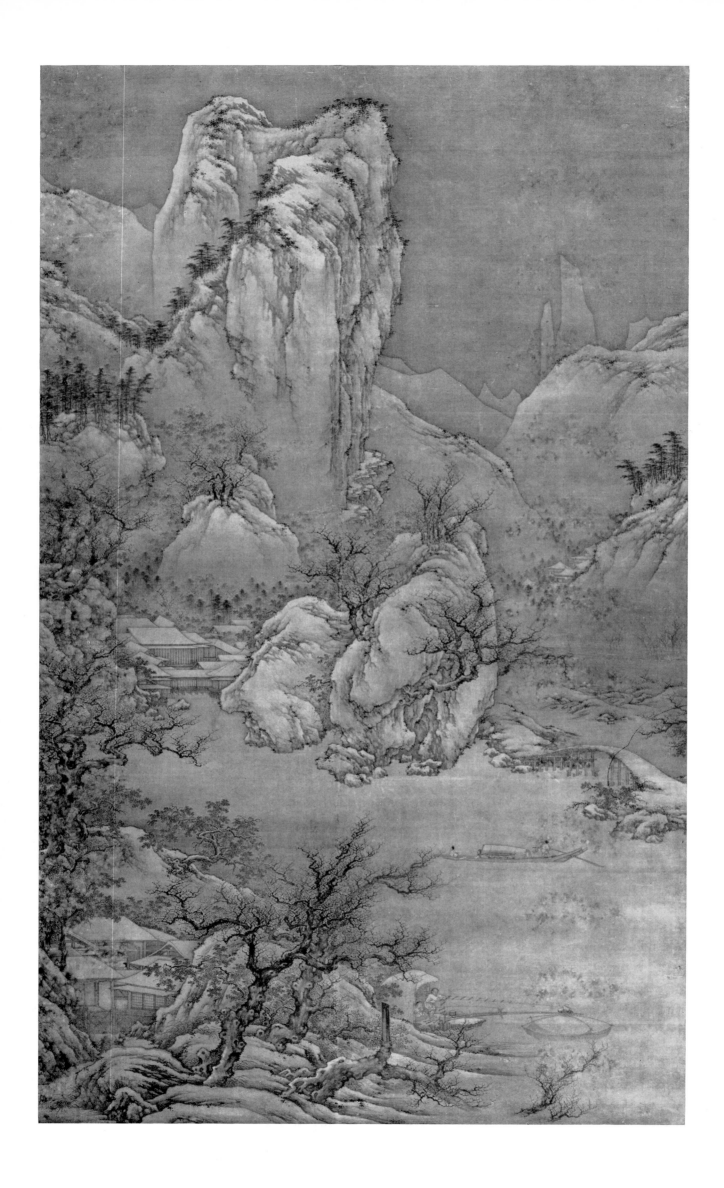

73 *Wintry Landscape, late Sung or early Yüan dynasty (13th century* A.D.*)*

74 *Calligraphy, by Ch'en Hsien-chang (1428—1500* A.D.*)*

75 *Landscape, by Sung Hsü, dated 1574* A.D.

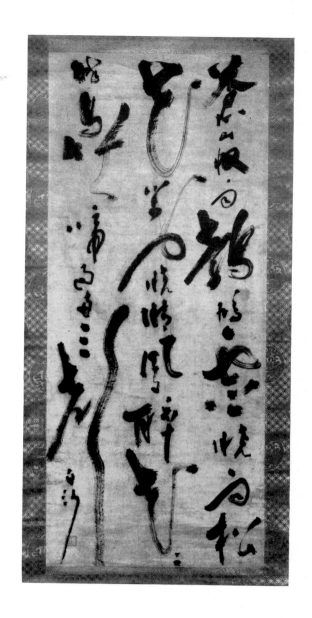

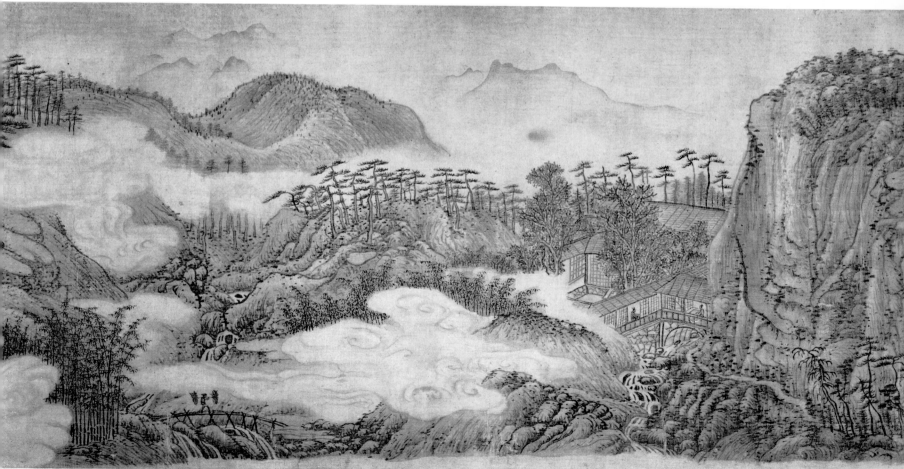

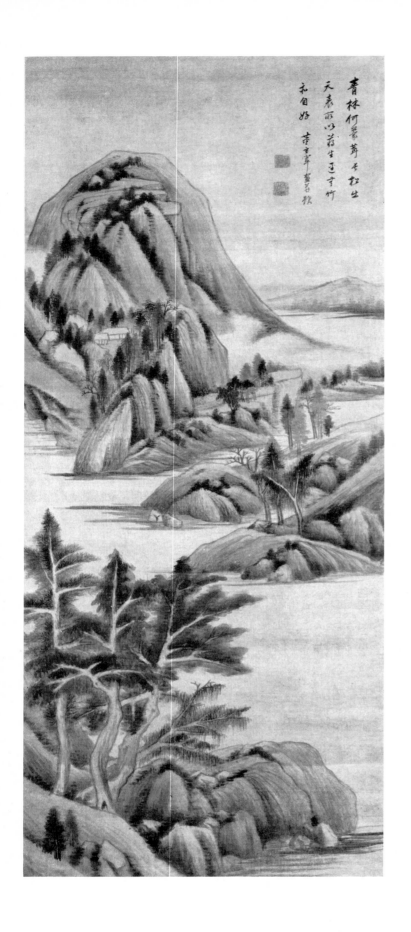

青林何景草木枯生
天春兩以莊生曳尾竹
元自好 董玄宰畫并題

雨過林香浸溪幽絮時後
嚴伊人在壑
項聖謨寫并題

76 *Brown Landscape, by Tung Ch'i-ch'ang (1555—1636 A.D.)*

77 *After the Rain, by Hsiang Sheng-mo (1597—1658 A.D.)*

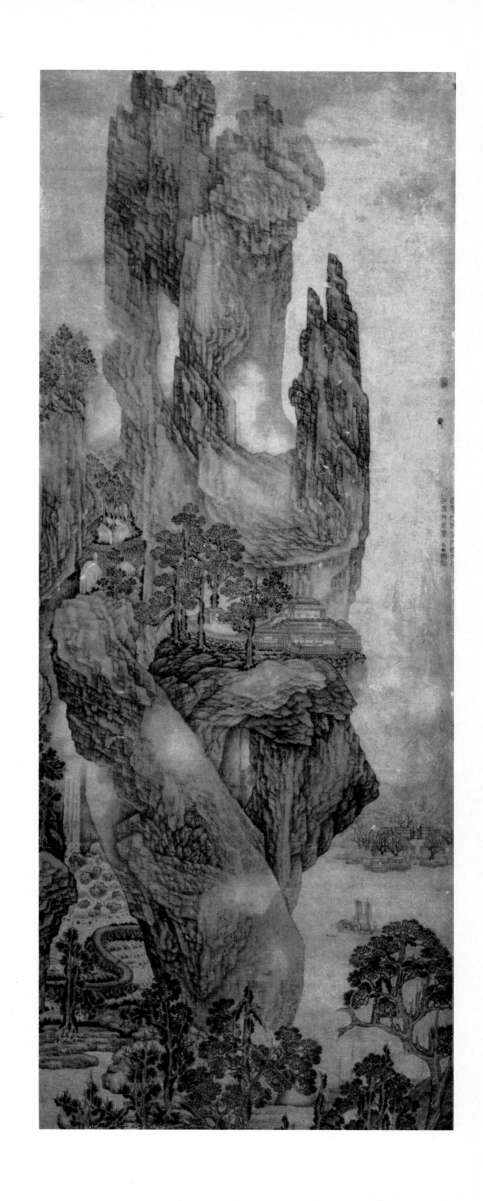

78 Pine Lodge Amidst Tall Mountains,
by Wu Pin (ca. 1568—1626 A.D.)

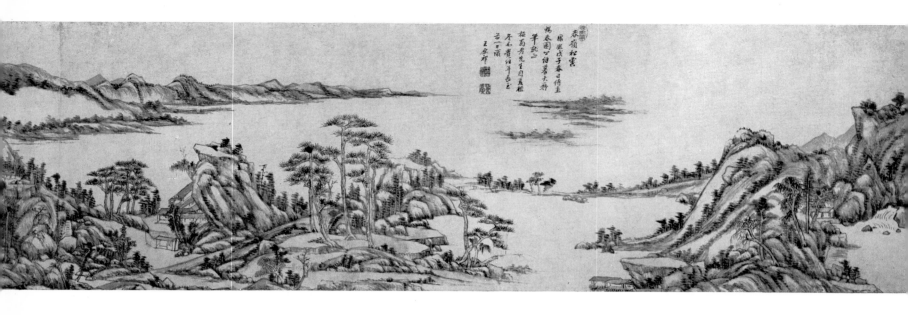

79 *Landscape, by Wang Yüan-ch'i, dated 1708* A.D.

80 *The River Bend, by K'un-ts'an, dated 1661* A.D.

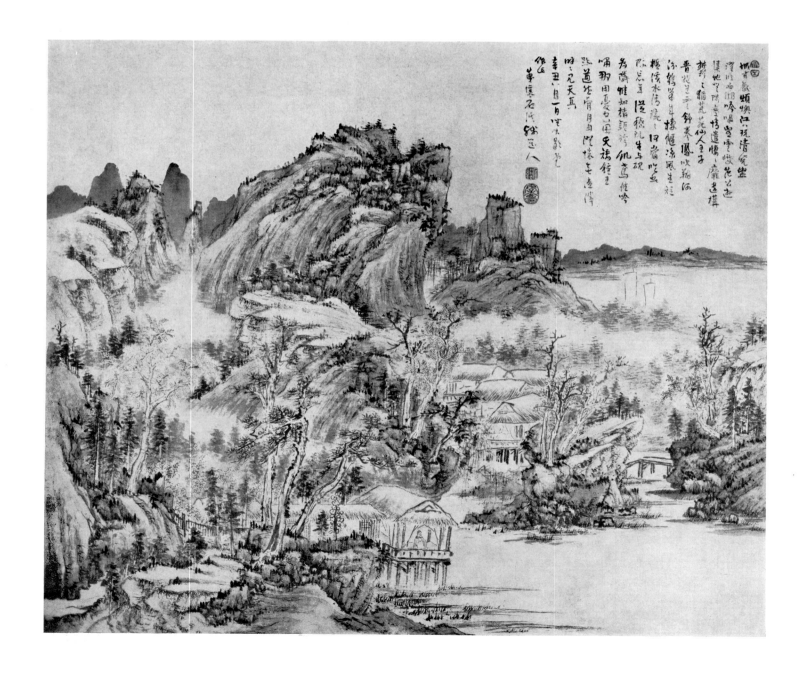

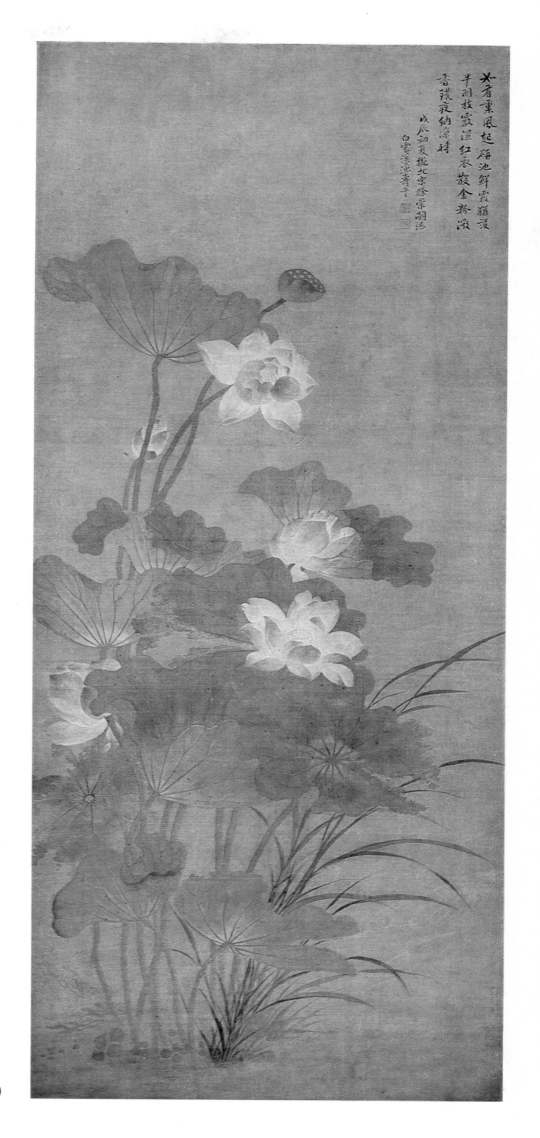

81 Lotus, by Yün Shou-p'ing (1633—1690 A.D.)

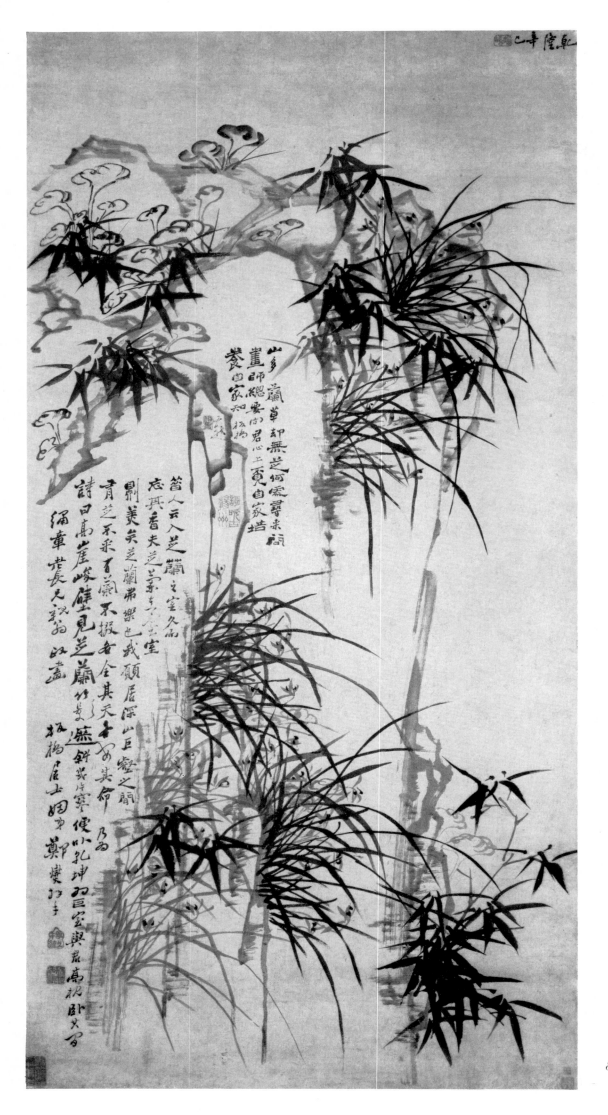

82 *Plants and Rocks, by Cheng Hsieh,
dated 1761* A.D.

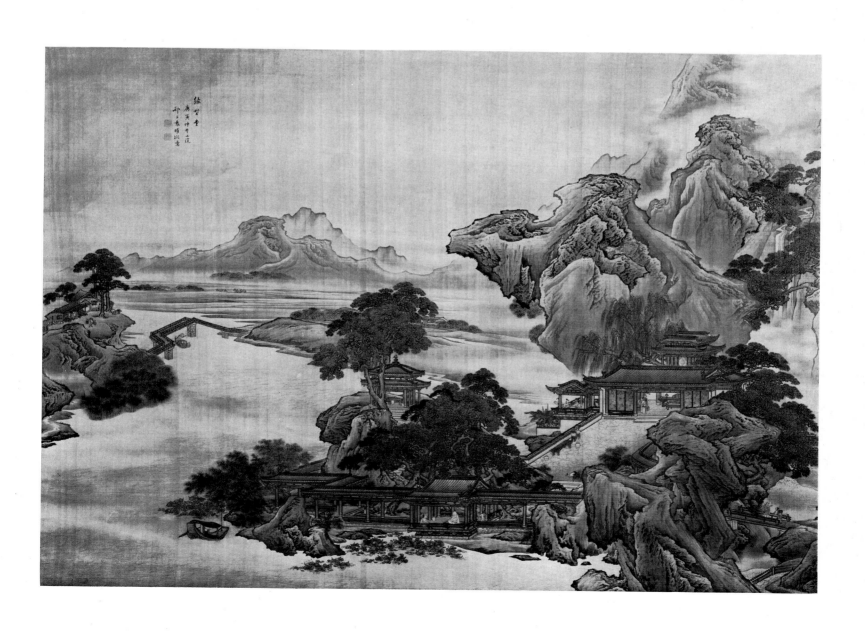

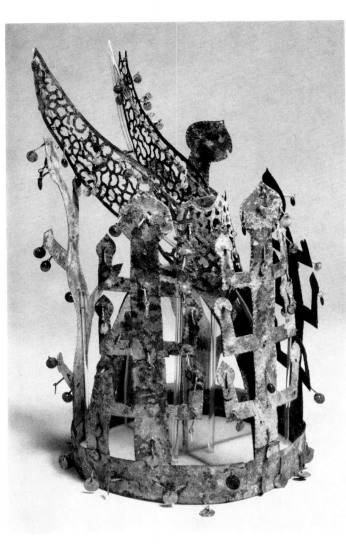

84 *Ceremonial crown, gilt bronze, Old Silla dynasty (ca. 6th century* A.D.*)*

85 *Covered jar, stoneware, late Old Silla or early United Silla dynasty
(7th century* A.D.*)*

86 *Buddha, gilt bronze, United Silla dynasty (8th century* A.D.*)*

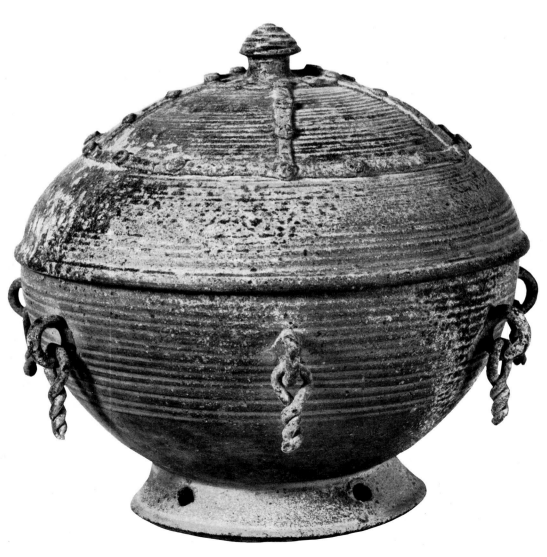

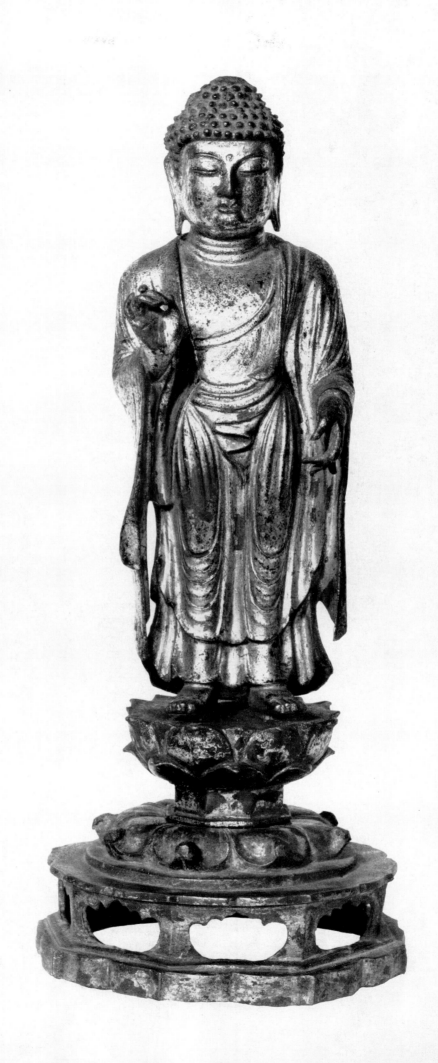

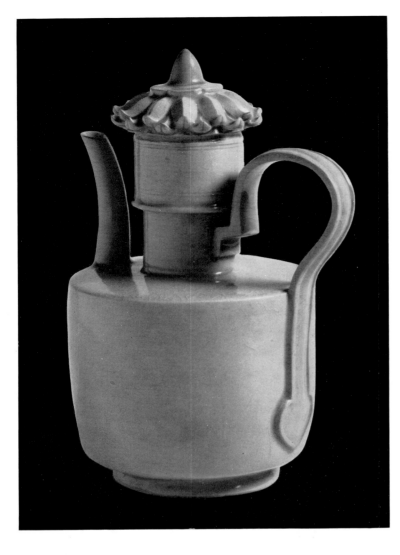

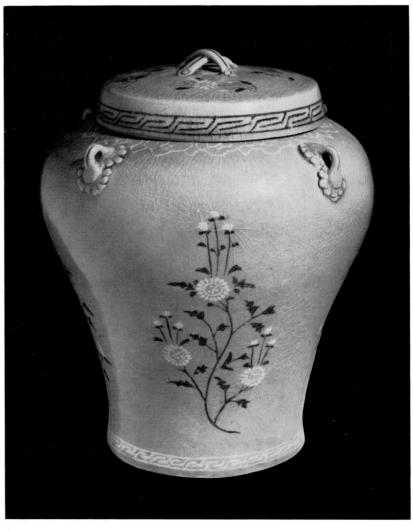

*87 Wine pot, celadon, Koryǒ dynasty
(early 12th century A.D.)*

*88 Covered jar, inlaid celadon, Koryǒ dynasty
(13th century A.D.)*

*89 Buddhist painting, Koryǒ dynasty
(ca. 14th century A.D.)*

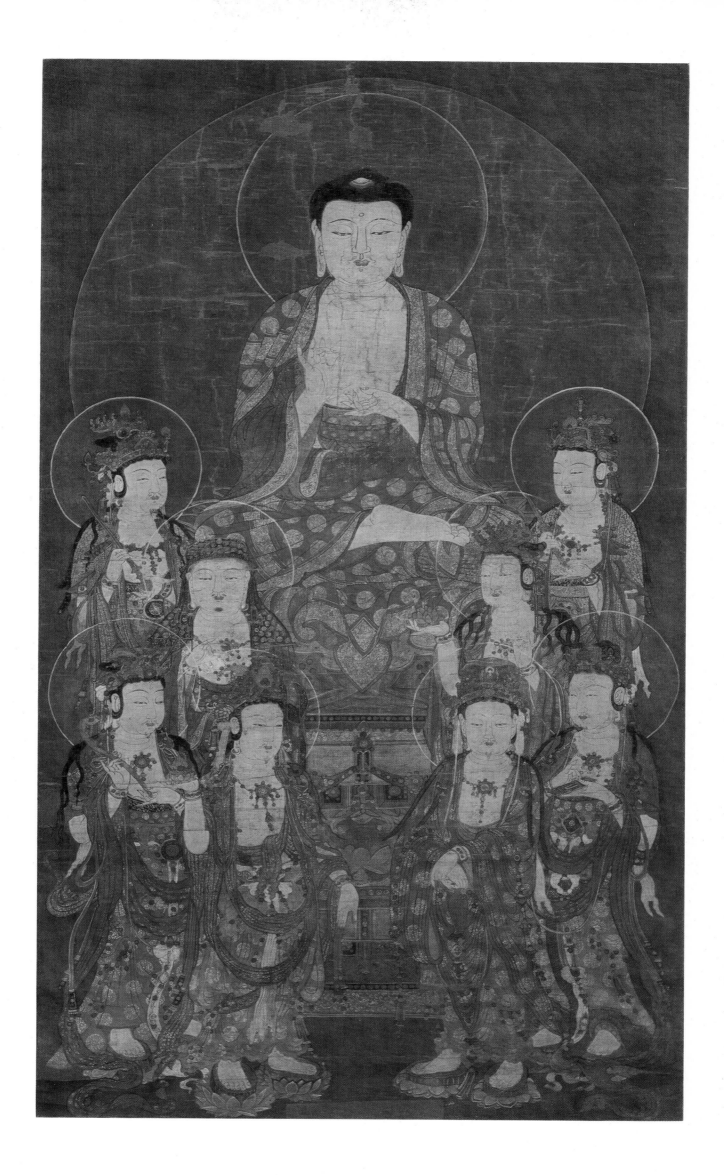

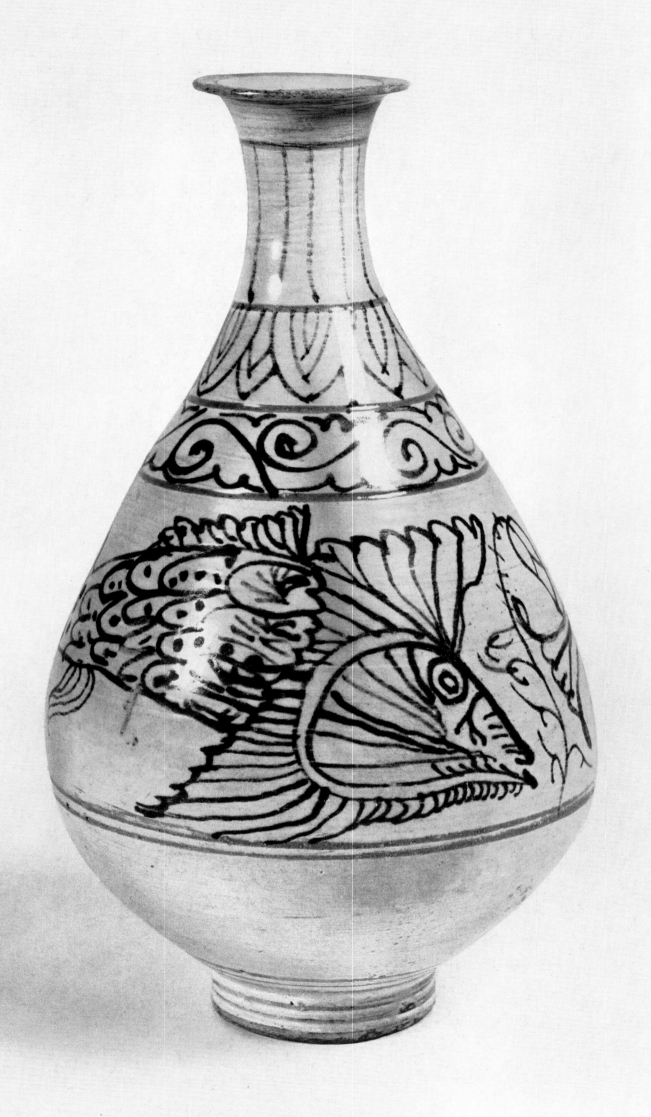

90 *Wine bottle, stoneware, early Yi dynasty*
 (15th to 16th century A.D.*)*

91 *Jar, Jōmon culture (3rd millennium* B.C.*)*

92 *Bottle, Sueki, Kofunjidai (5th to 6th century* A.D.*)*

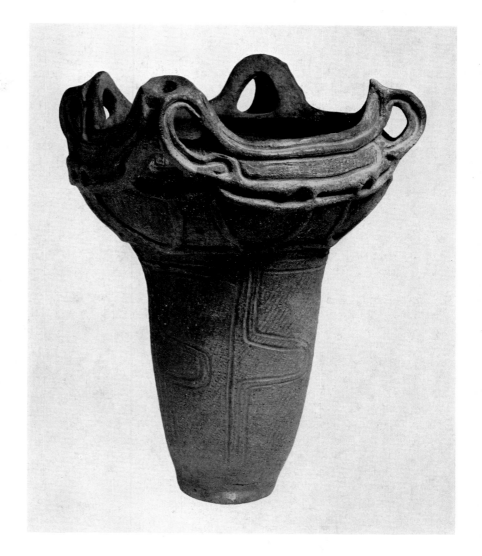

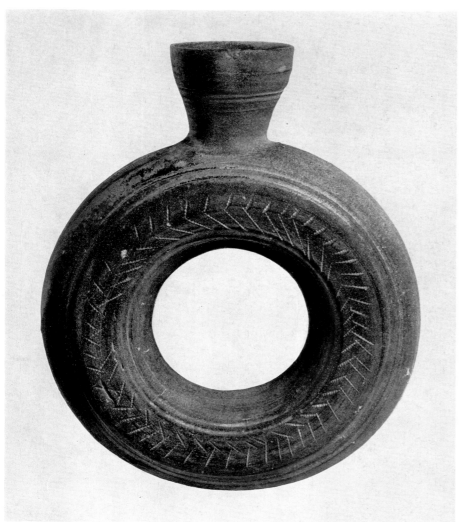

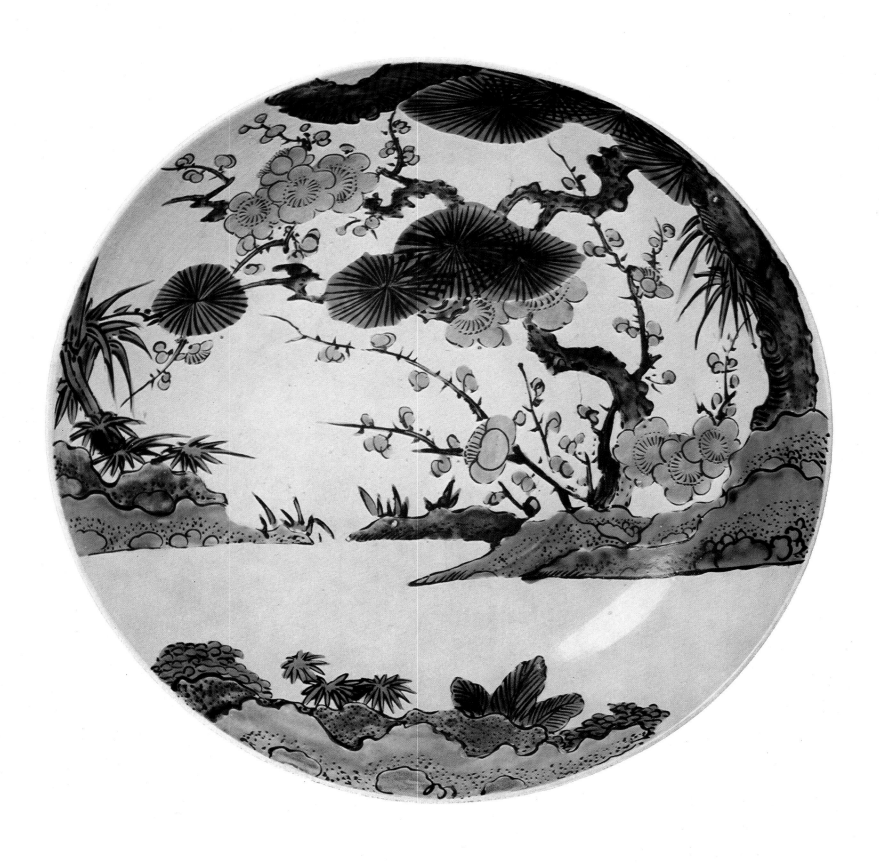

93 Platter, Ko Kutani, early Edo period (early 17th century A.D.)

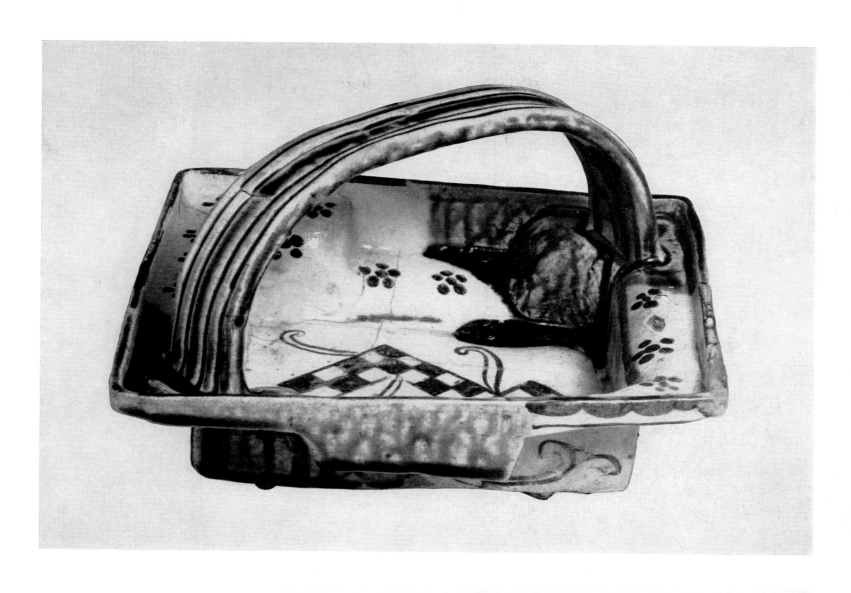

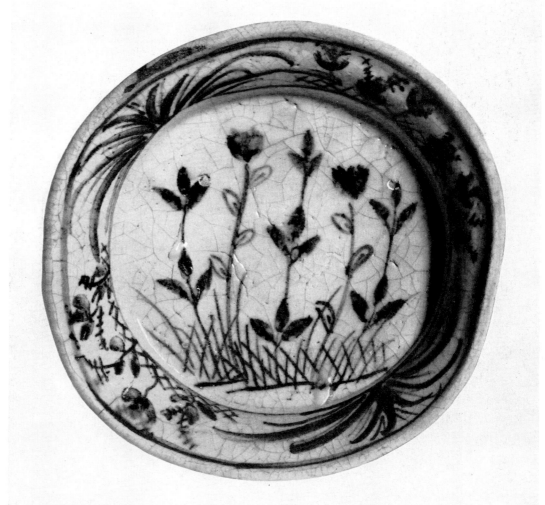

94 *Tray, Ao-Oribe, Momoyama period*
 (1573—1615 A.D.*)*

95 *Dish, E-Shino, Momoyama period*
 (1573—1615 A.D.*)*

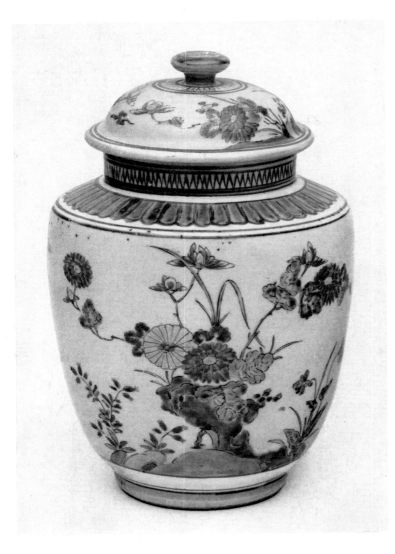

96 *Covered jar, Kakiemon, early Edo period (17th century* A.D.*)*

97 *Plates, Nabeshima, mid Edo period (18th century* A.D.*)*

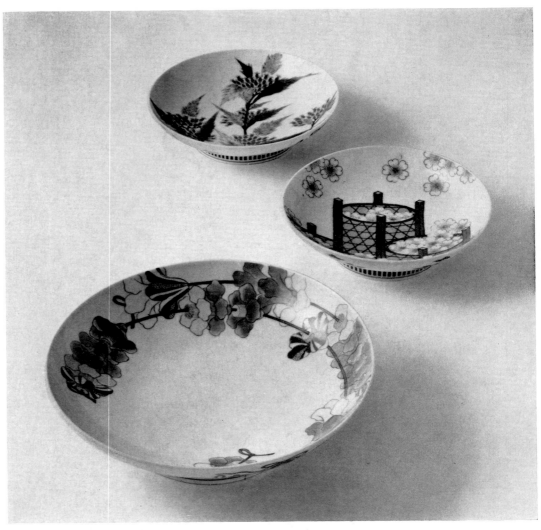

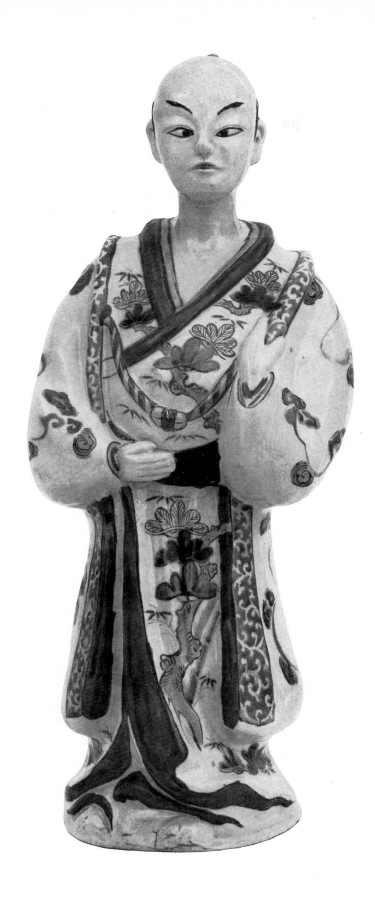
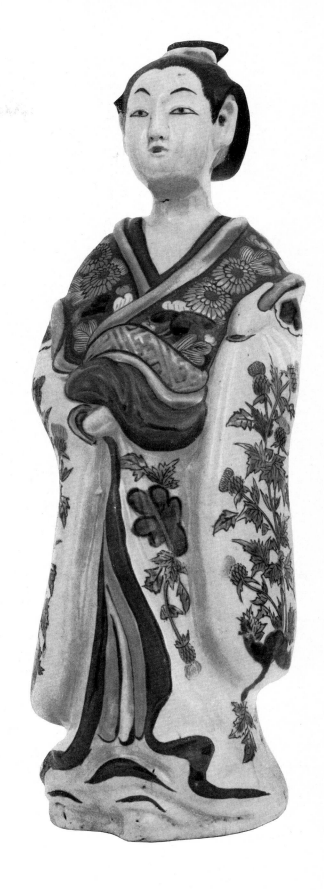

98, 99 Couple, Old Imari, mid Edo period (18th century A.D.*)*

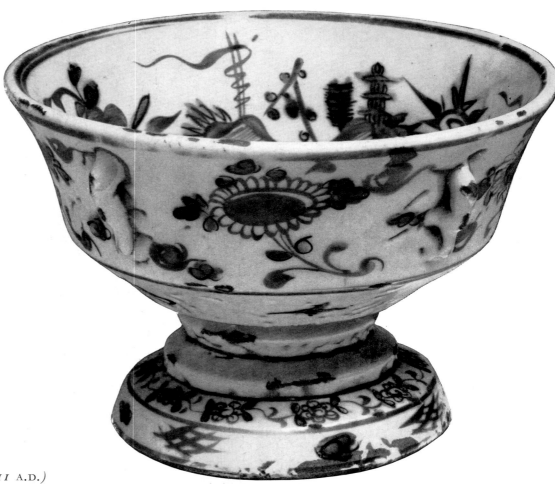

100 *Bowl, attributed to Ogata Kenzan*
 (1664—1743 A.D.)

101 *Bowl, by Okuda Eisen (1753—1811 A.D.)*

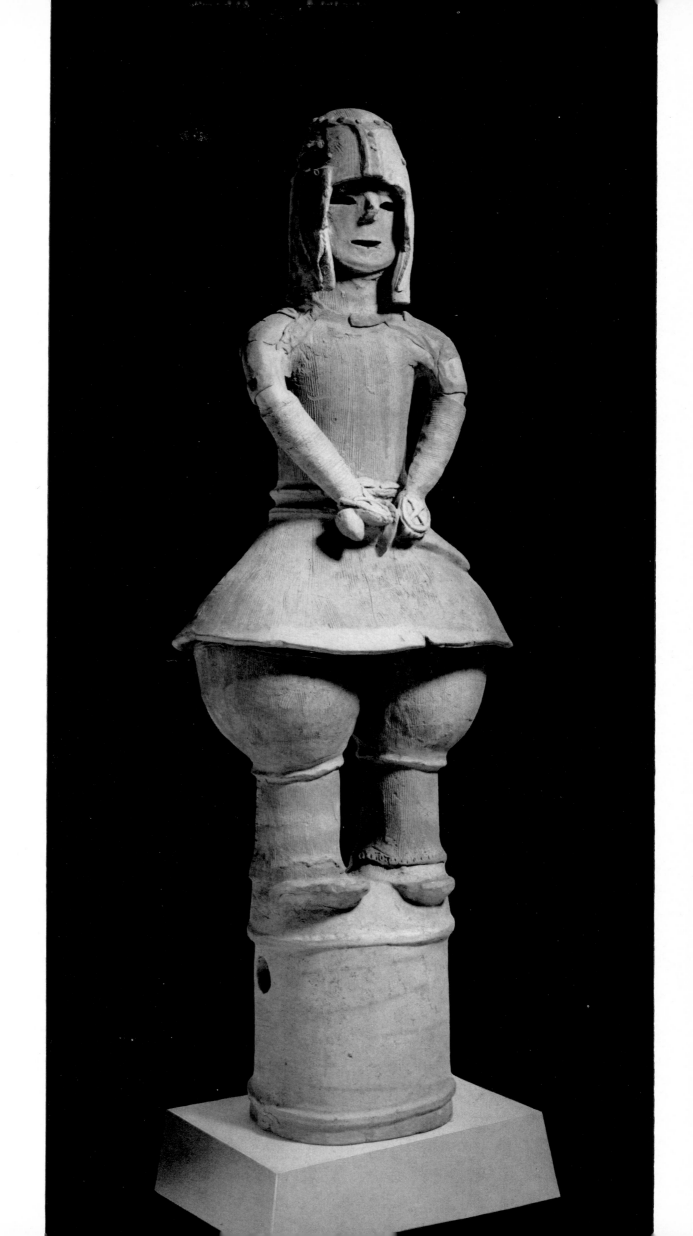

102 Haniwa warrior,
earthenware, Kofunjidai
(ca. 6th century A.D.)

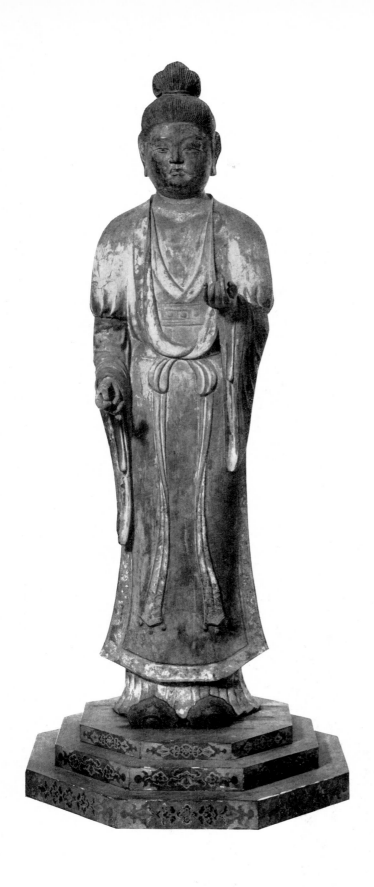

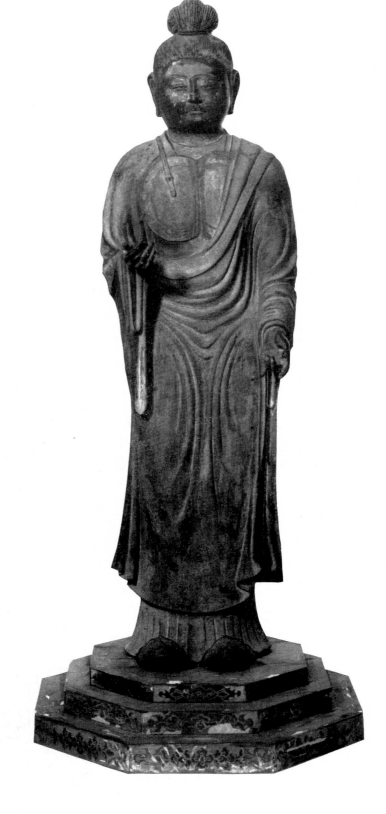

103, 104 Buddhist statues, dry lacquer, Tempyō period
 (8th century A.D.)

105 Guardian, wood, Heian period (9th century A.D.)

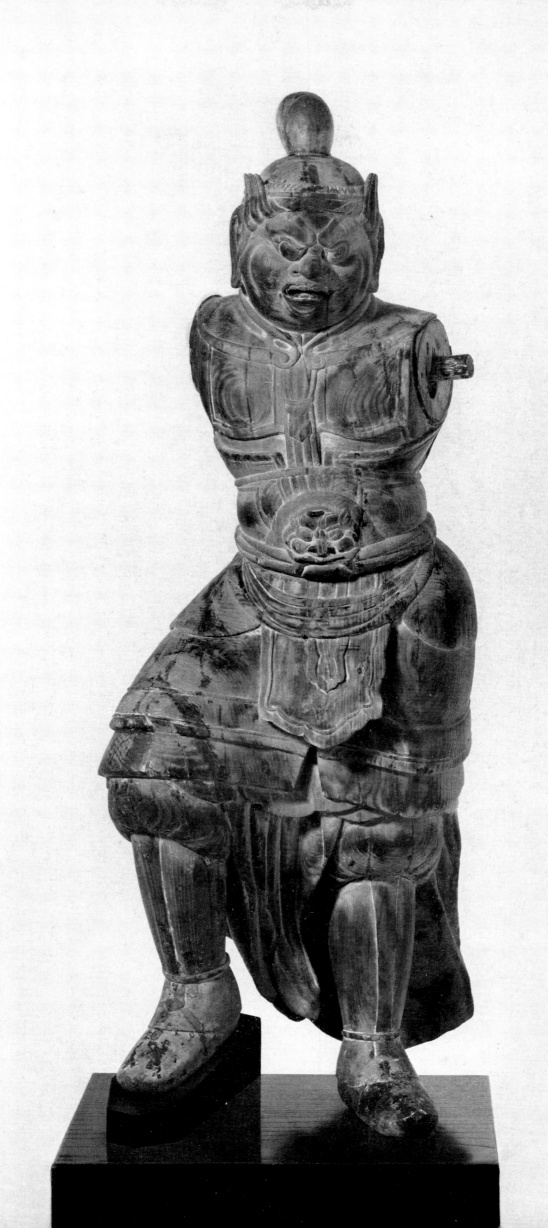

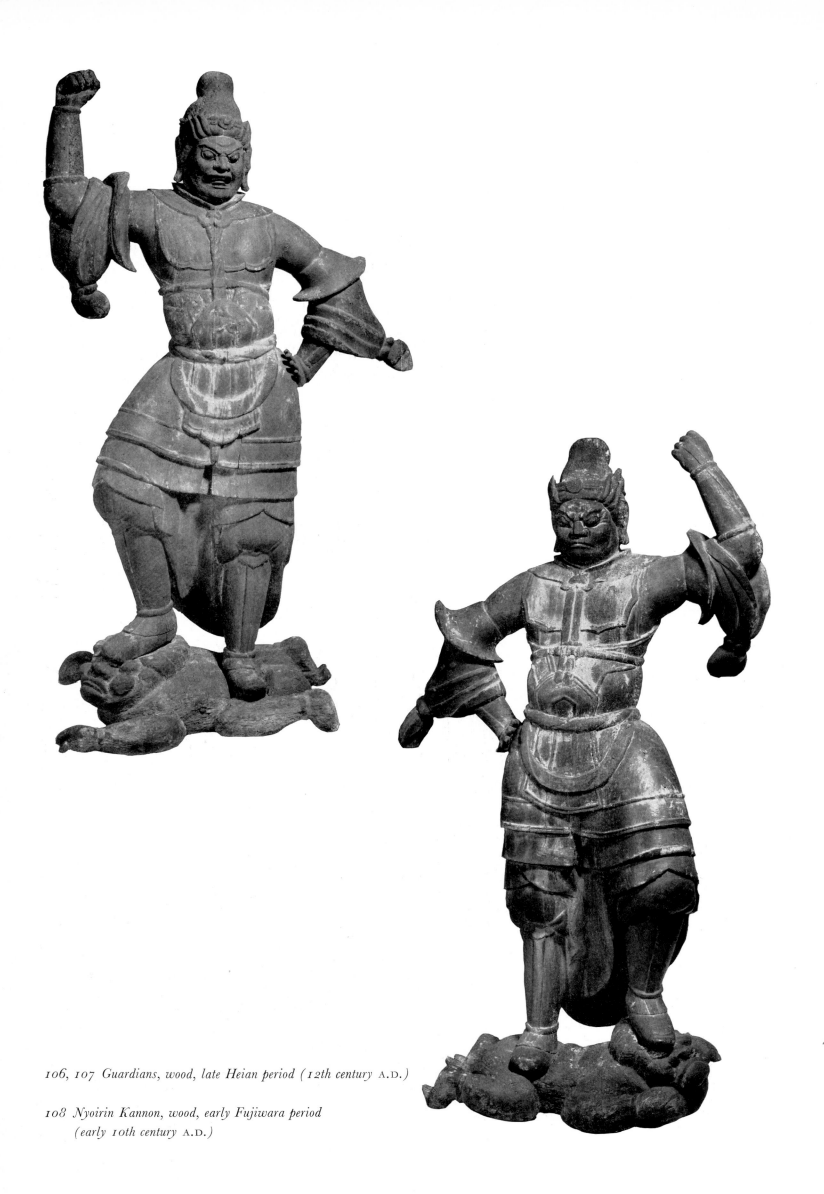

106, 107 Guardians, wood, late Heian period (12th century A.D.*)*

108 Nyoirin Kannon, wood, early Fujiwara period
 (early 10th century A.D.*)*

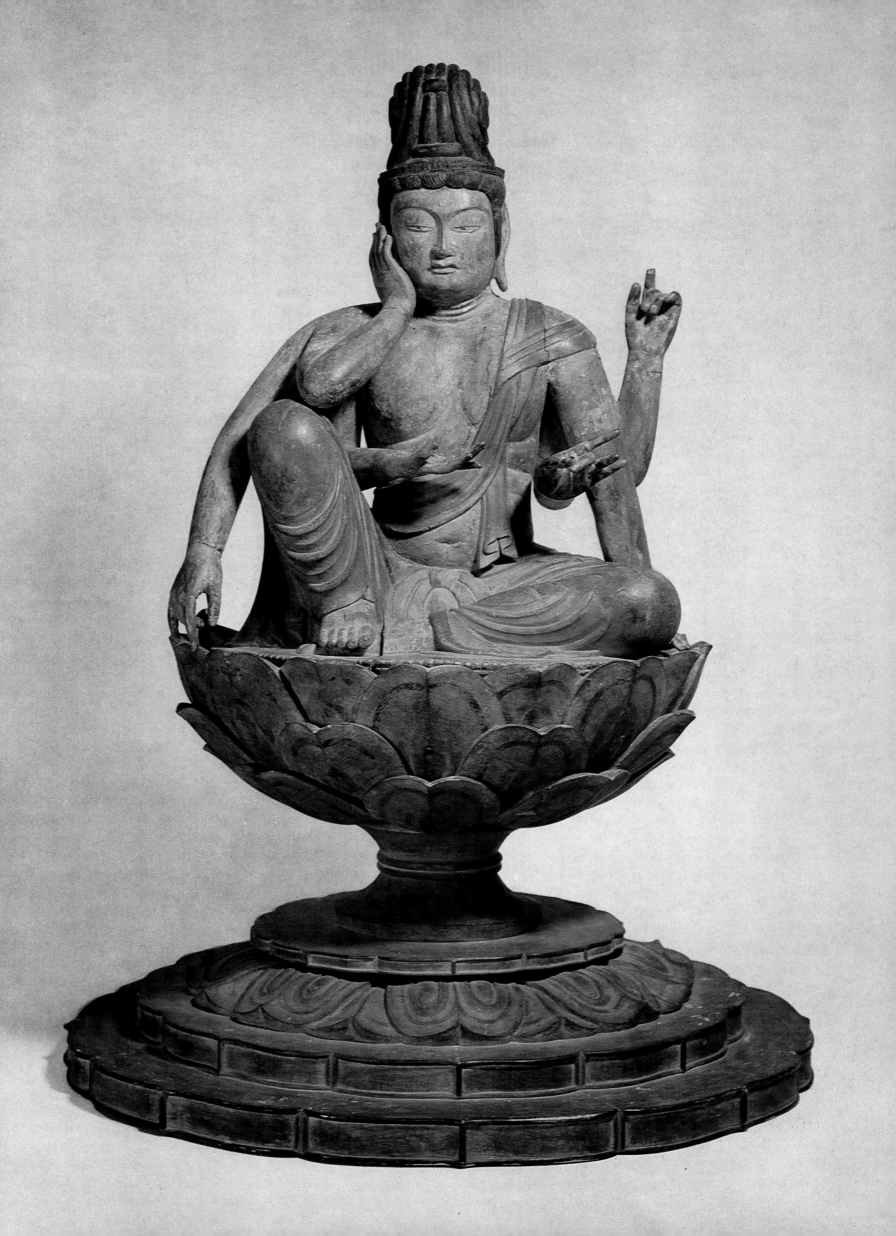

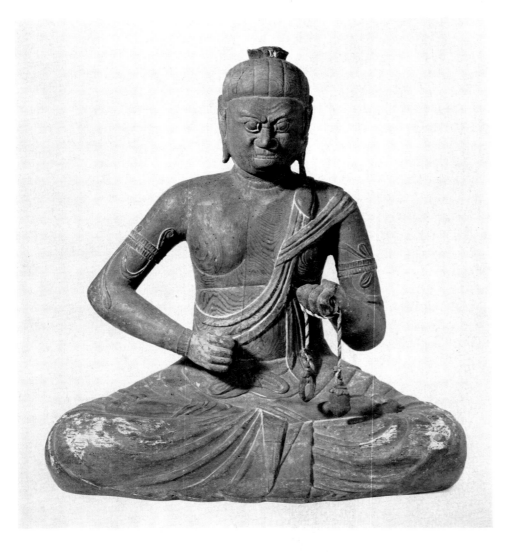

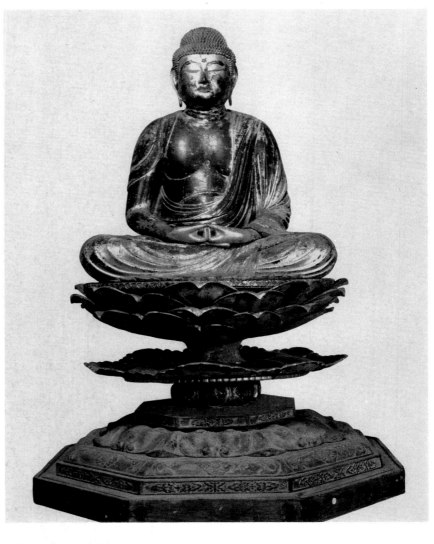

109 *Fudō Myō-ō, wood, late Heian period*
 (12th century A.D.*)*

110 *Amida Nyorai, wood, late Heian period*
 (12th century A.D.*)*

111 *Shō-Kannon, wood, late Heian period*
 (12th century A.D.*)*

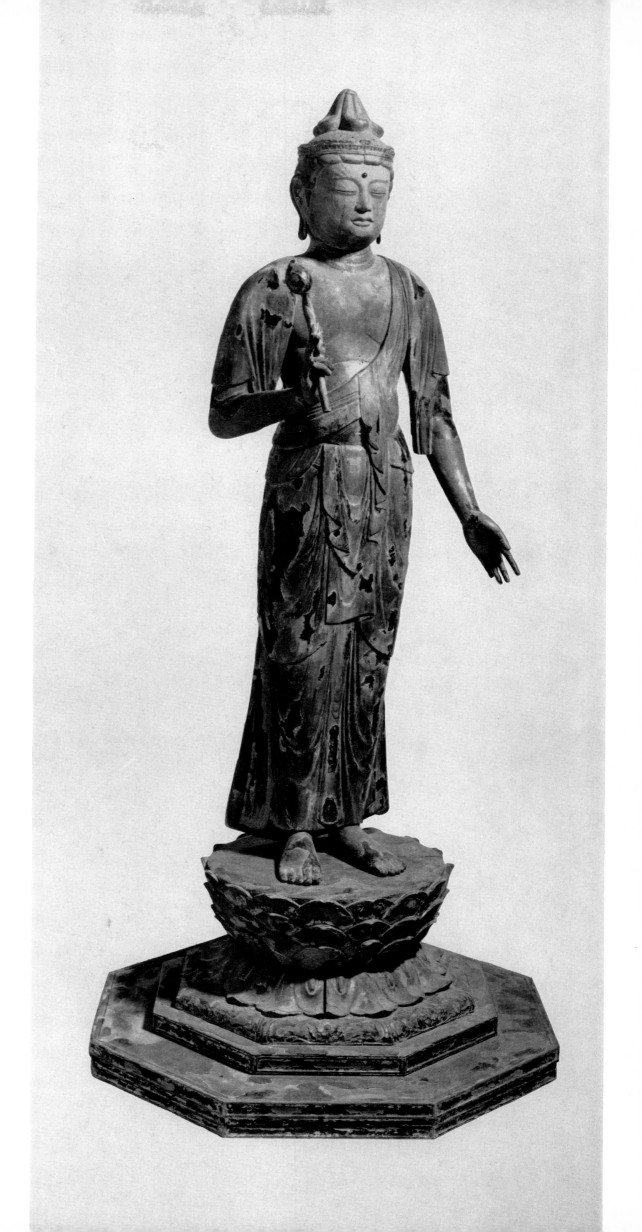

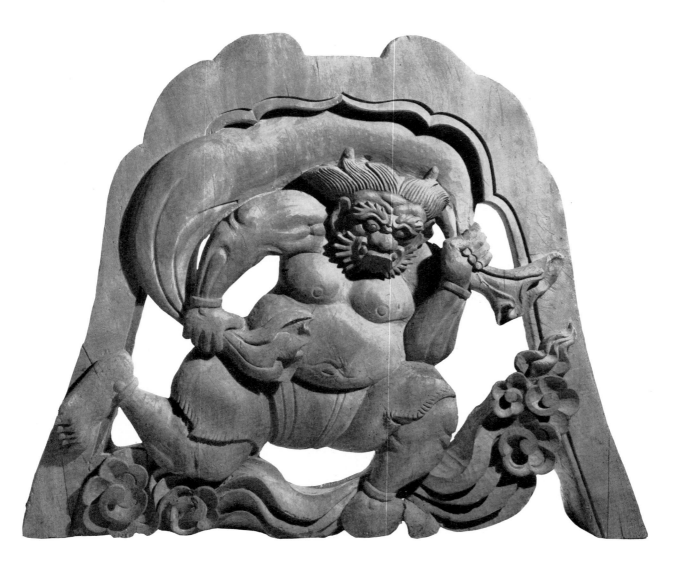

112, 113 Thunder and Wind Gods, wood,
early Edo (17th century A.D.)

114 Guardian, wood, late Momoyama—early
Edo period (16th to 17th century A.D.)

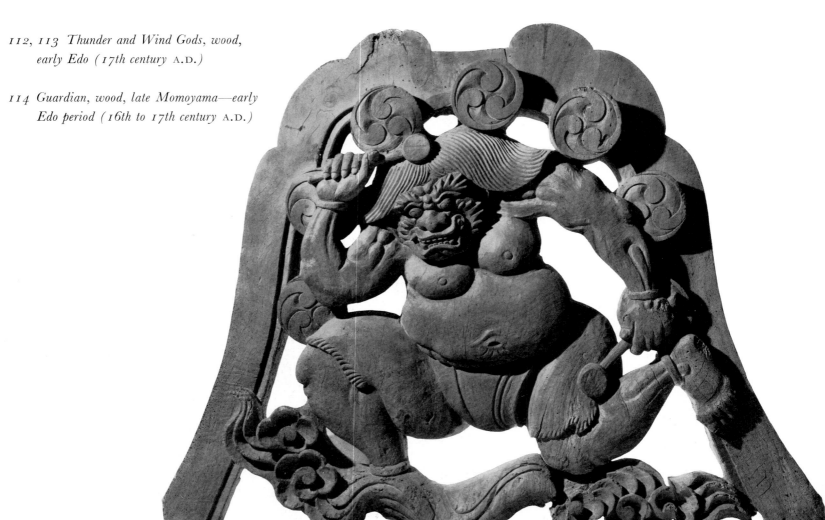

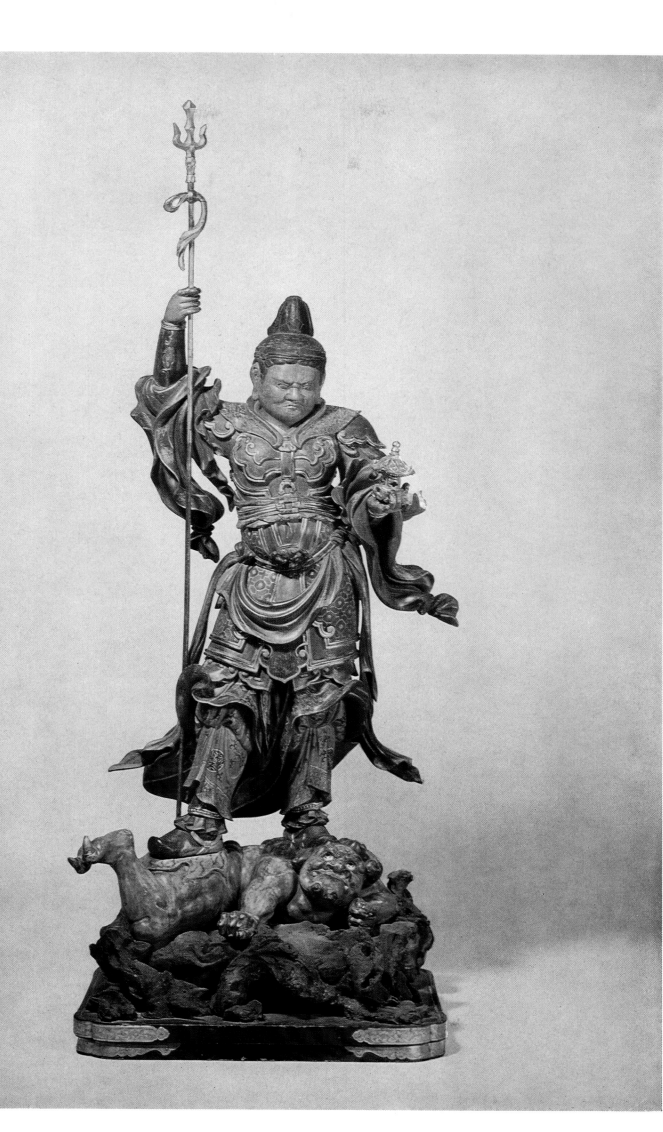

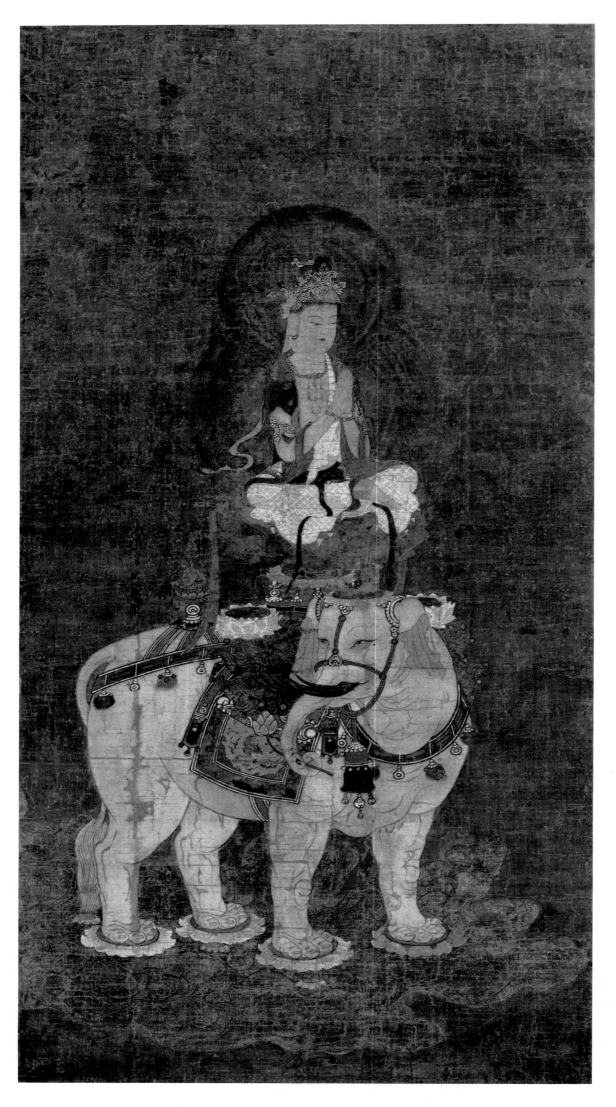

*115 Fugen Bosatsu,
Kamakura period
(13th century* A.D.*)*

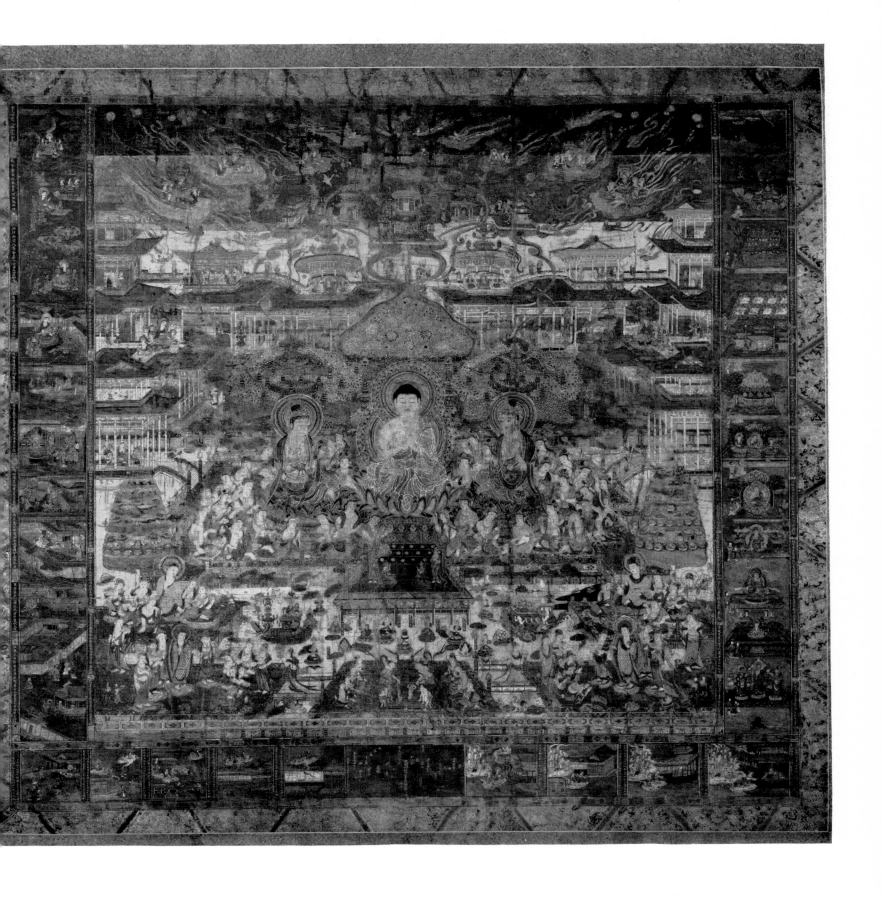

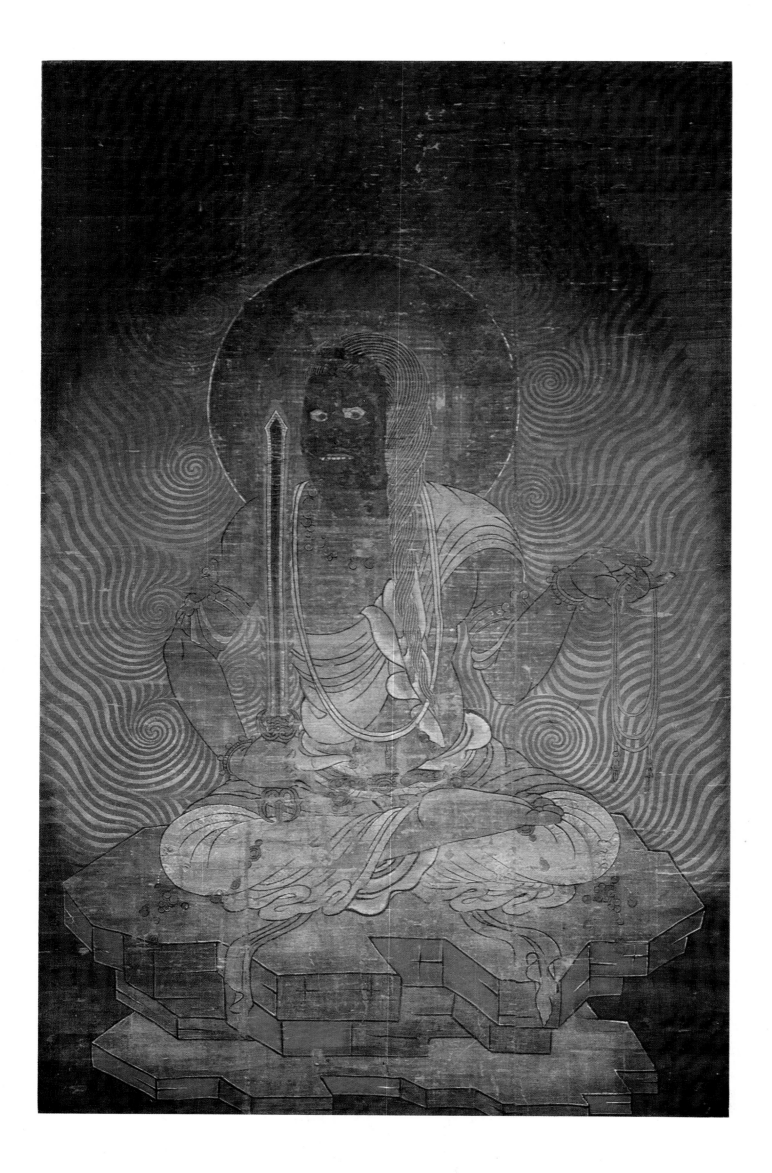

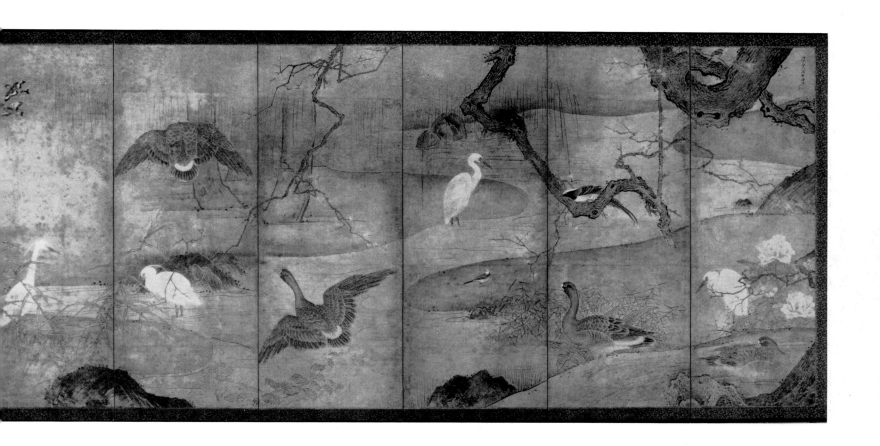

117 *Fudō Myō-ō, Kamakura period (13th century* A.D.*)*

118, 119 *Screens, by Sesshū, dated* 1497 A.D.

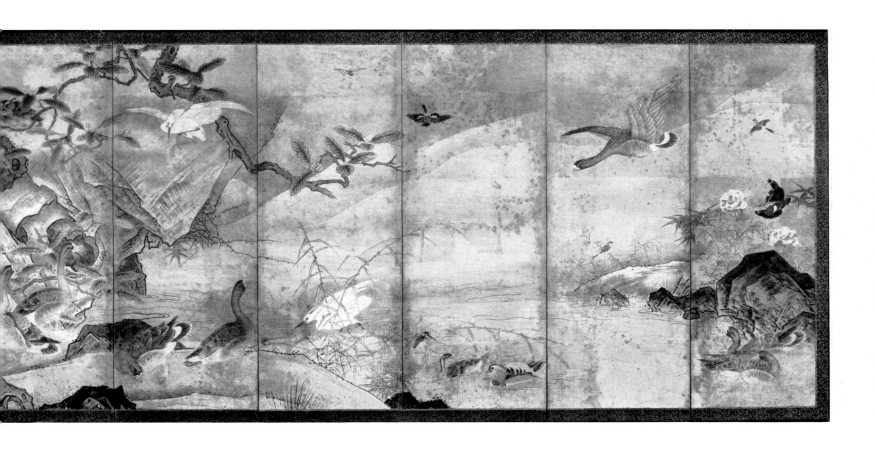

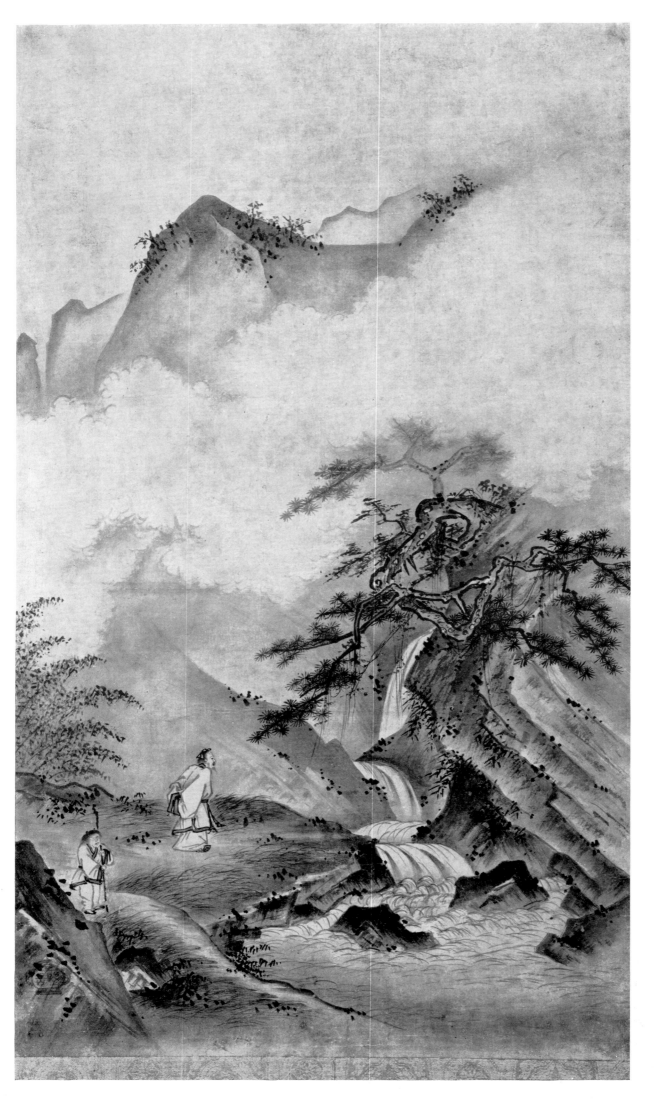

120 *Landscape, by Sōami*
(?—1525 A.D.)

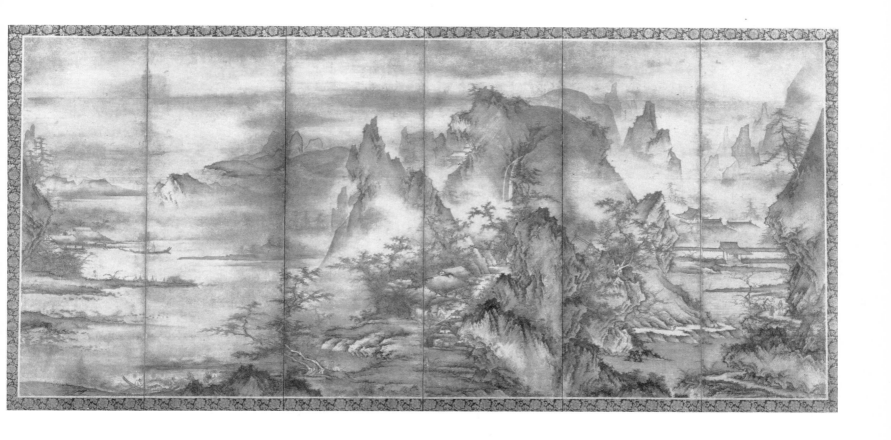

121, 122 *Screens, by Shikibu Ryūkyō (early 16th century* A.D.)

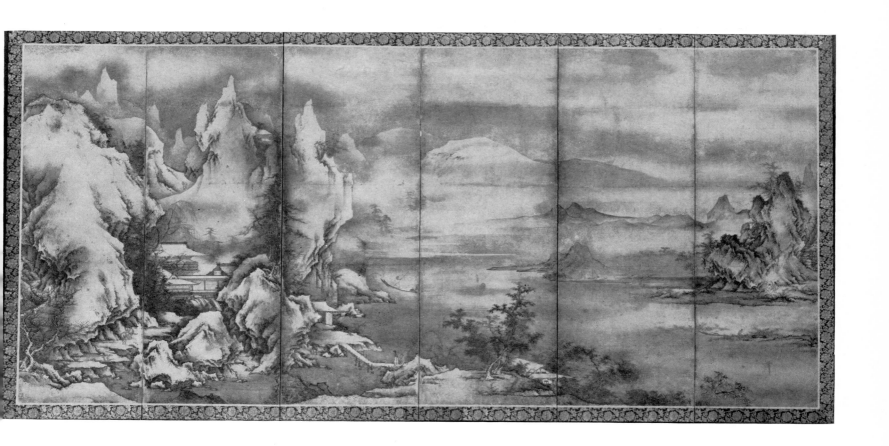

123, 124 Screens, attributed to Kanō Sōshū (1551—1601 A.D.)

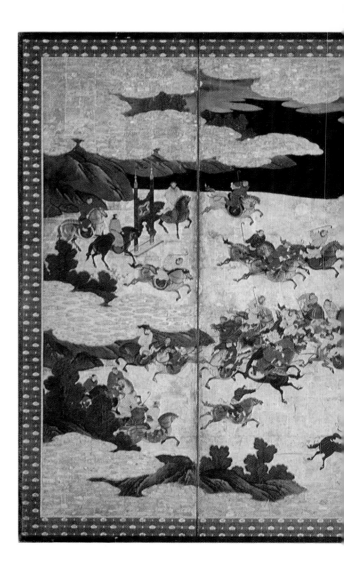

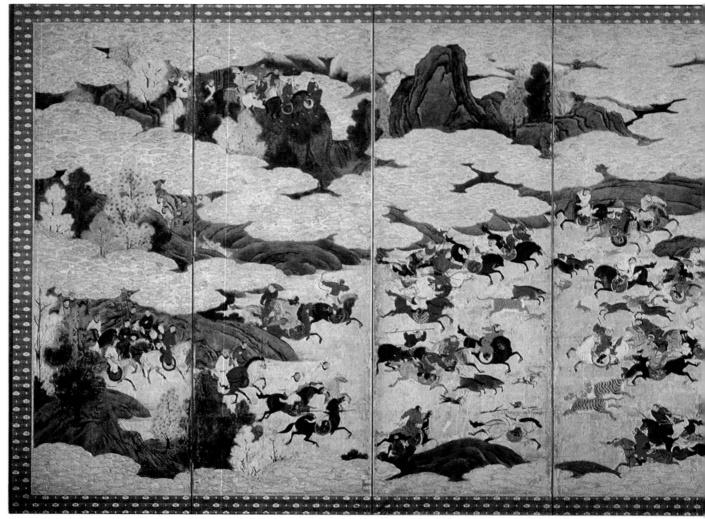

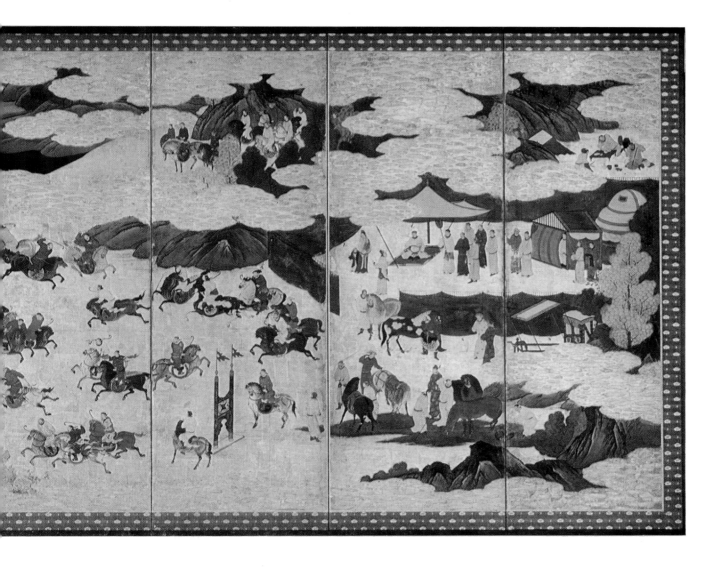
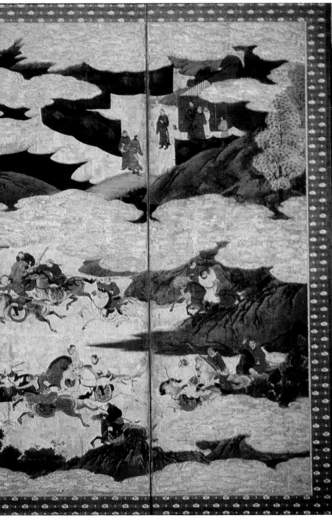

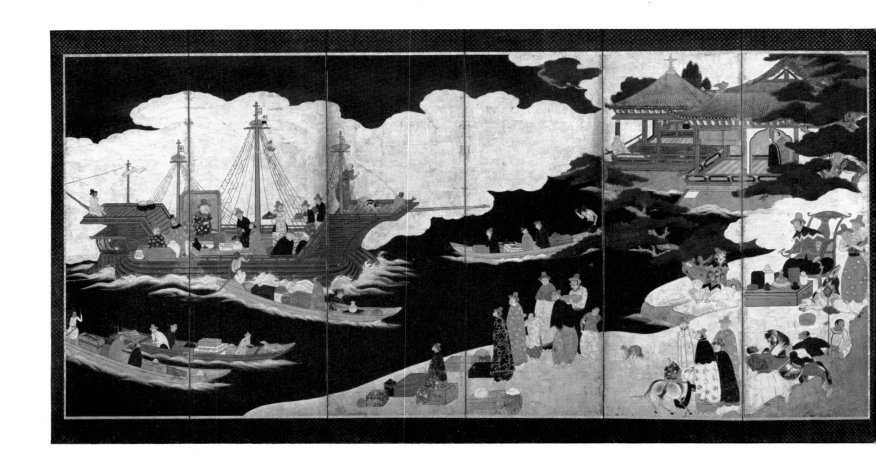

125, 126 Screens, Kanō school (late 16th to early 17th century A.D.)

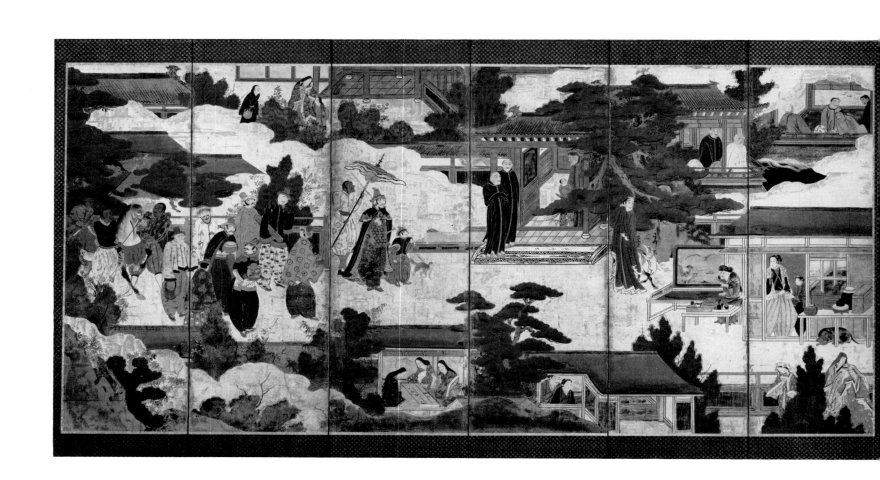

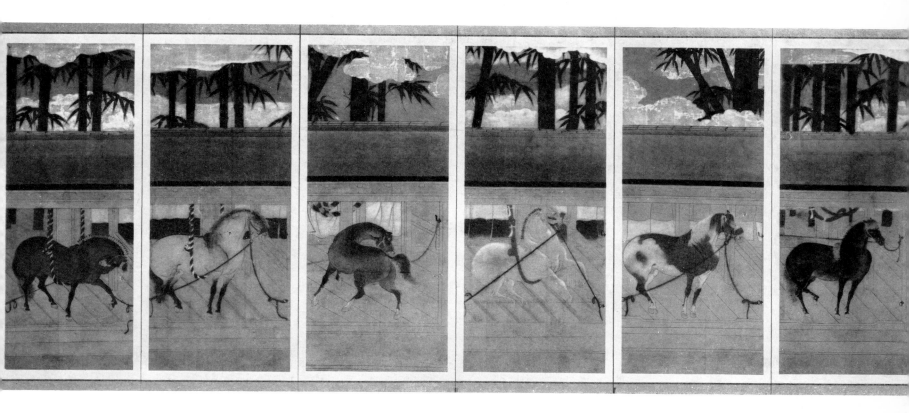

127 Screen, Kanō school (early 17th century A.D.*)*

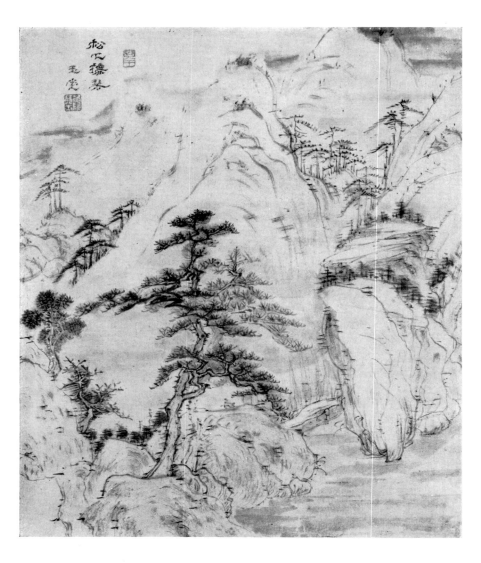

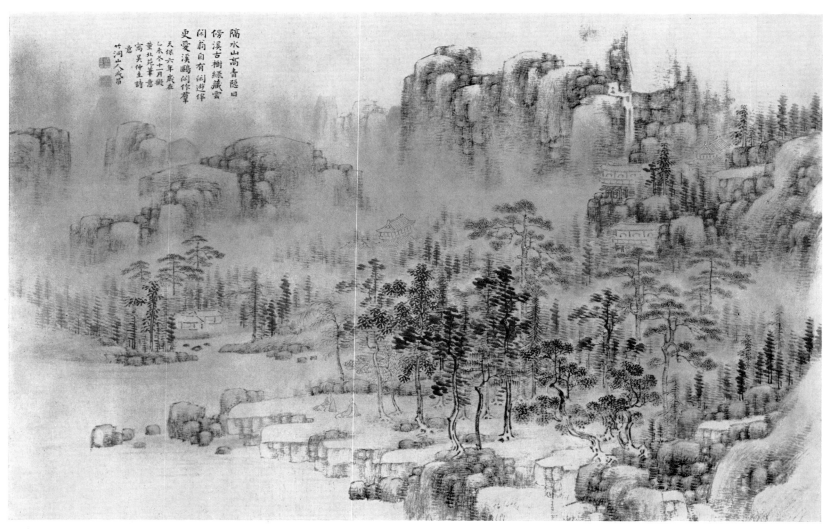

128 Landscape, by Uragami Gyokudō
(1745—1820 A.D.)

129 Landscape, by Nakabayashi Chikutō,
dated 1835 A.D.

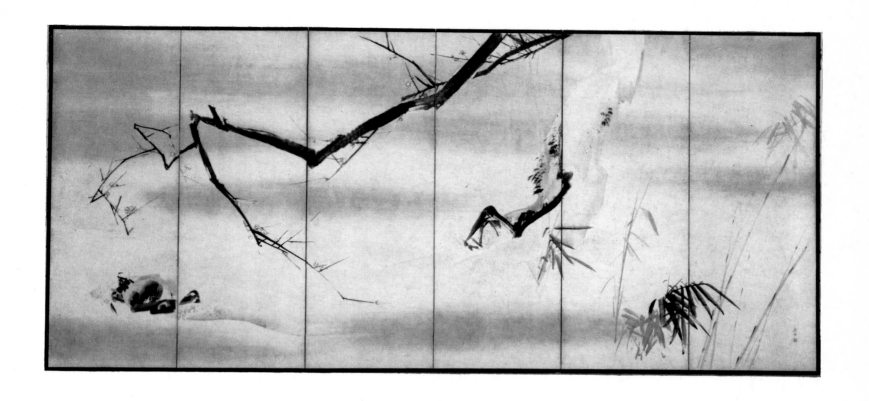

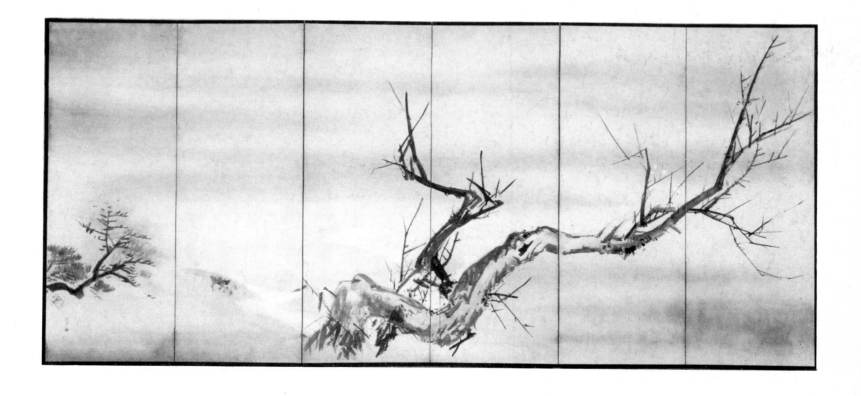

130, 131 Screens, by Maruyama Ōkyo (1733—1795 A.D.)

132 *Yakshī, sandstone, Kushān period (2nd century* A.D.*)*

133 *Buddha, sandstone, Kushān period (ca. 2nd century* A.D.*)*

134 *Bodhisattva, schist, Kushān period (2nd to 3rd century* A.D.*)*

135, 136 *Reliefs, schist, Kushān period (ca. 3rd century* A.D.*)*

137 *Vishnu, sandstone, Kushān period (ca. 4th century* A.D.*)*

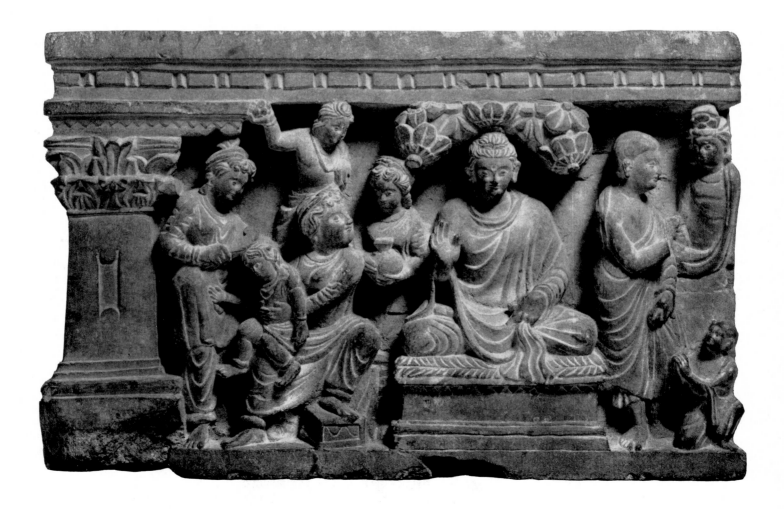

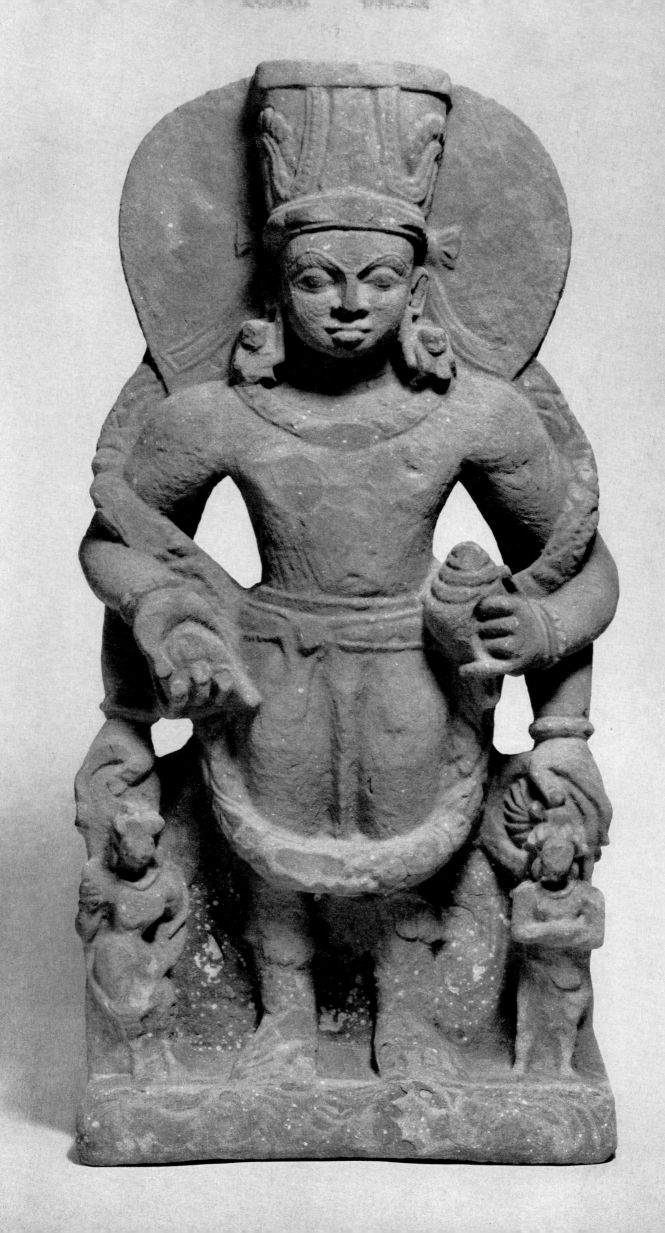

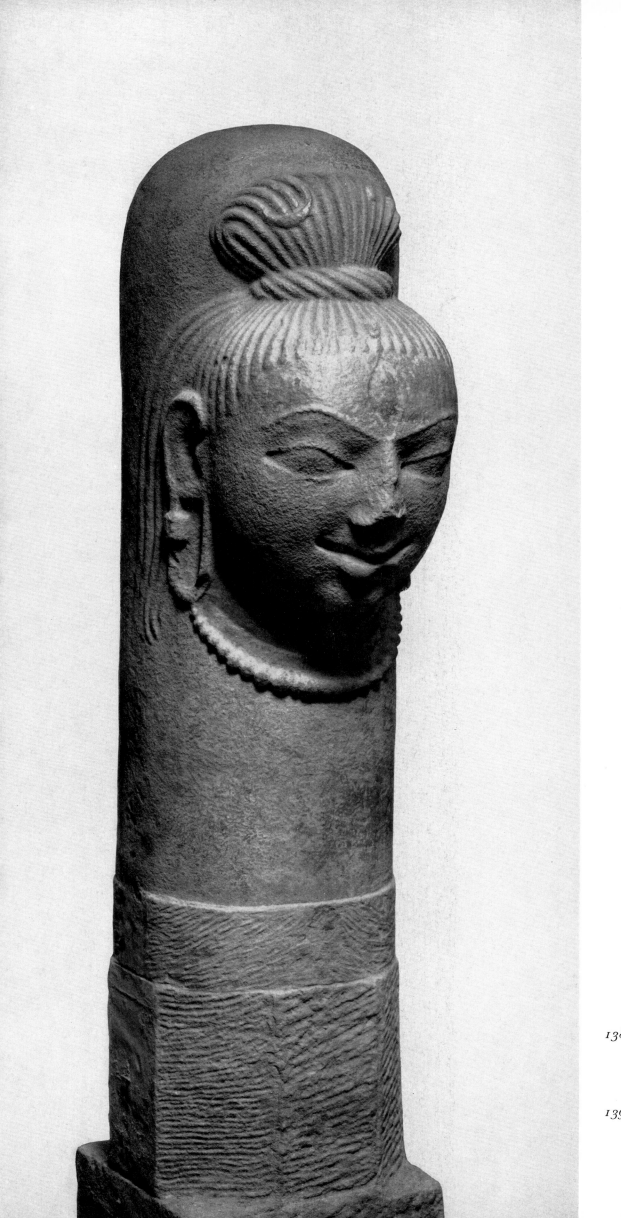

138 *Ekamukha-liṅga,*
sandstone, Gupta period
(5th to 6th century A.D.*)*

139 *Harihara, sandstone,*
Gupta period (6th century A.D.*)*

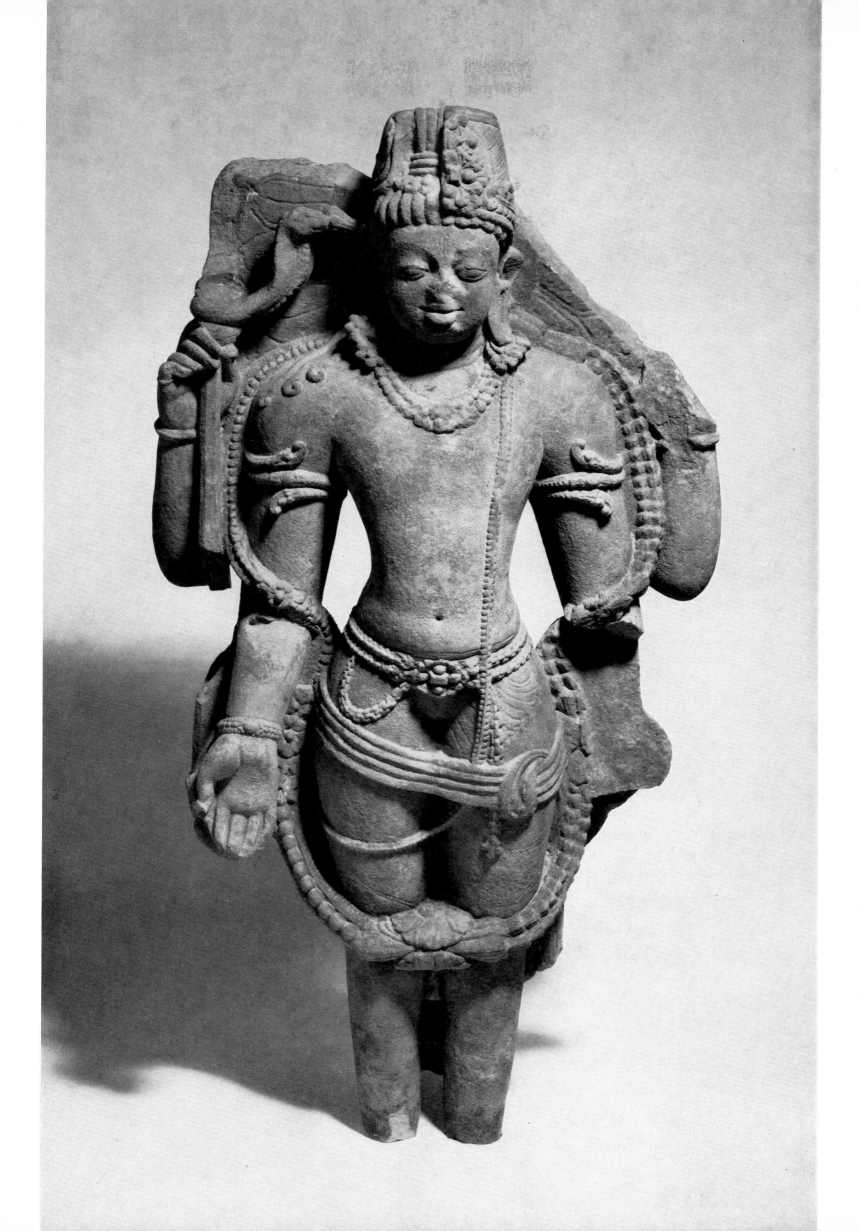

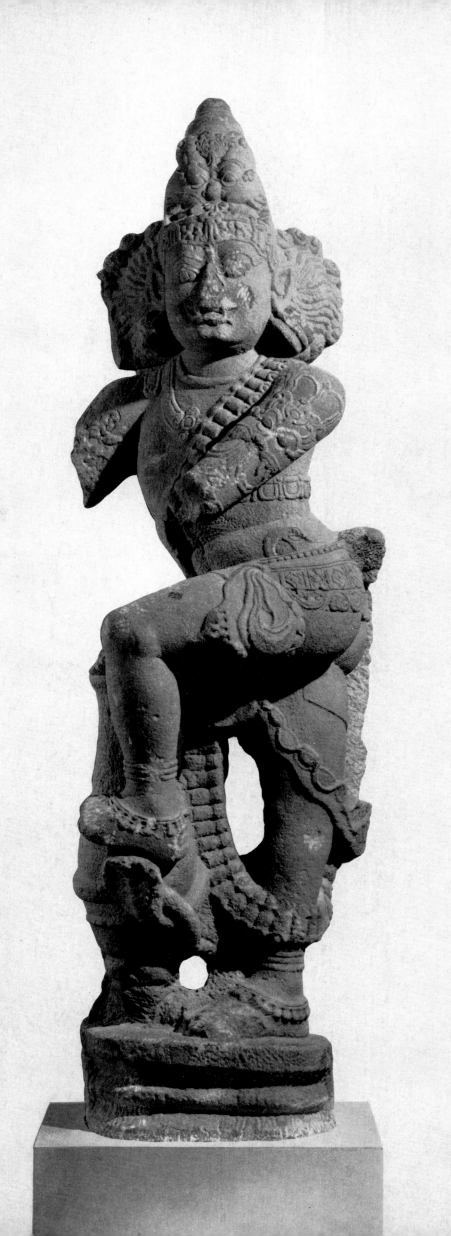

140 *Dvārapāla, granite,*
 Chola period (10th century A.D.*)*

141 *Brahmānī, granite,*
 Chola period (9th century A.D.*)*

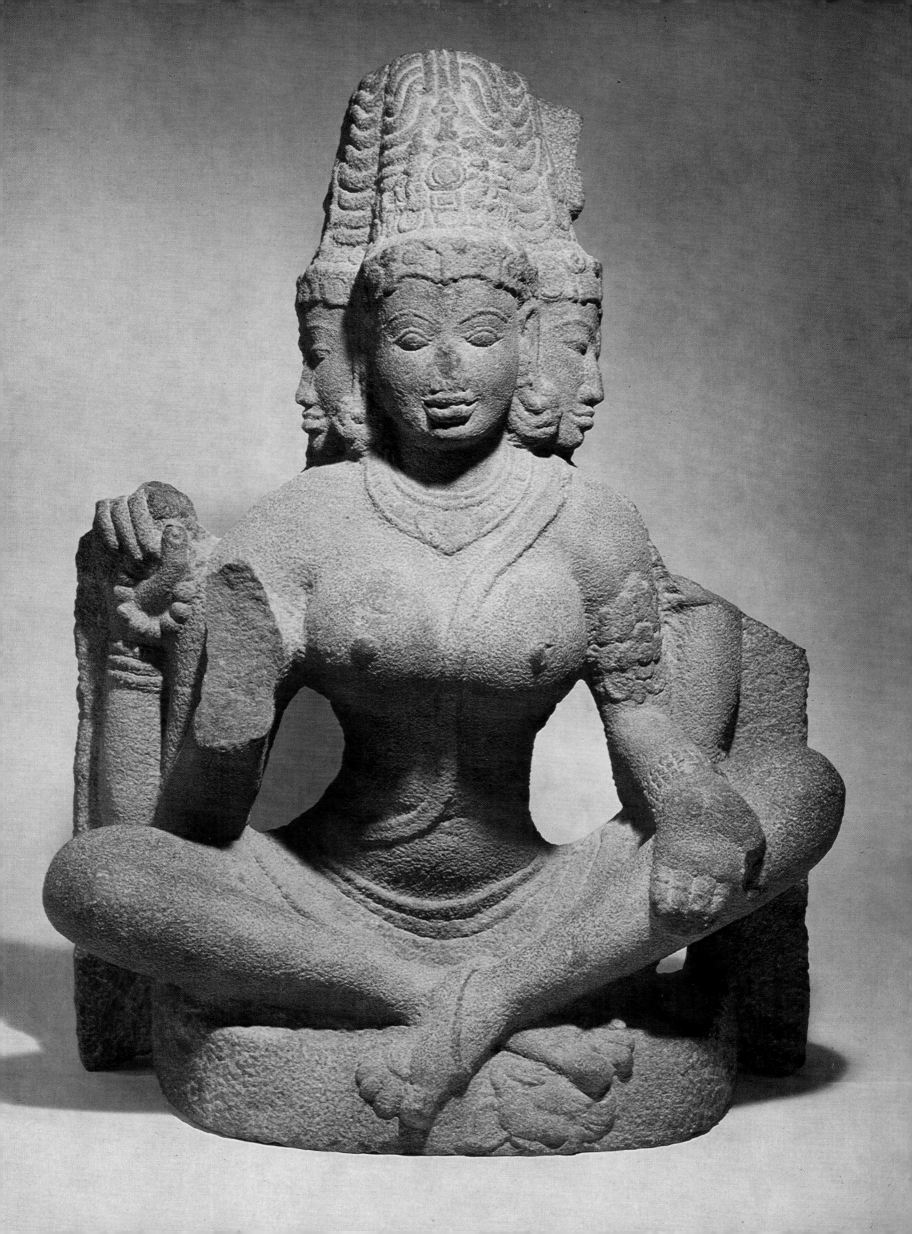

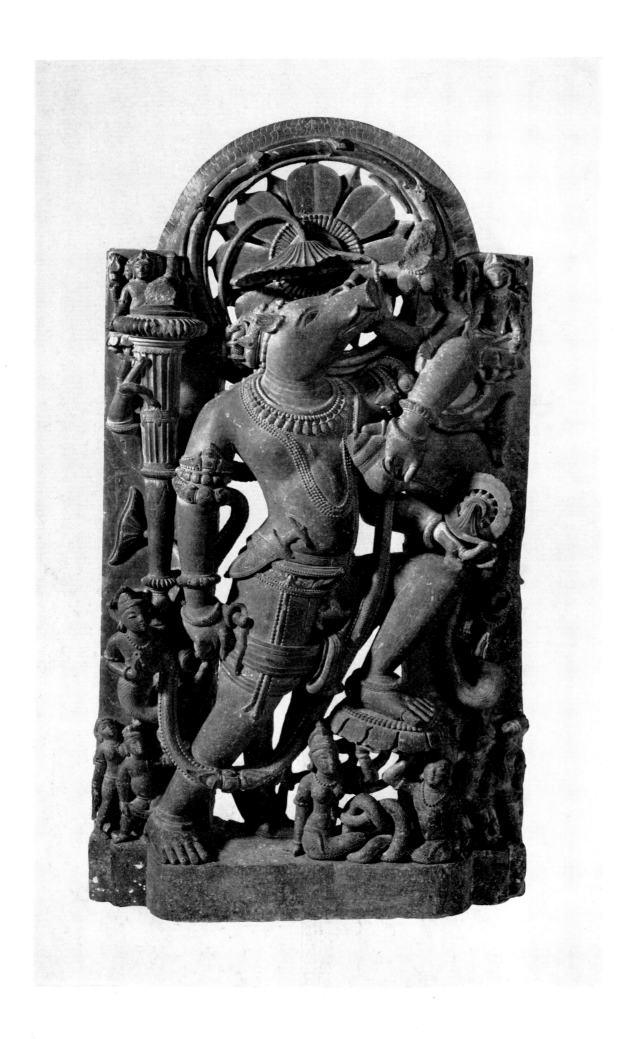

142 *Varāha, schist, Western India (10th century* A.D.*)*

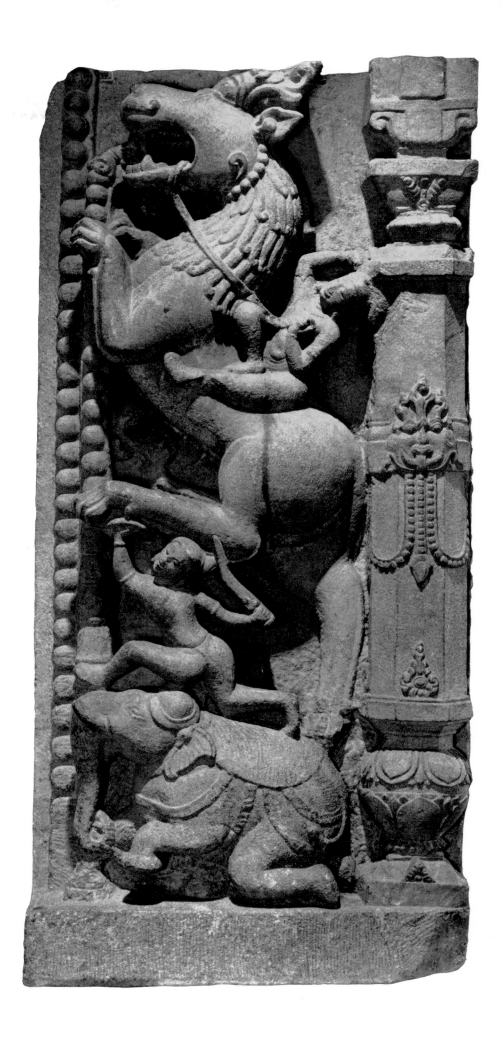

143 *Door jamb, granite, Madhya Pradesh (10th to 11th century* A.D.*)*

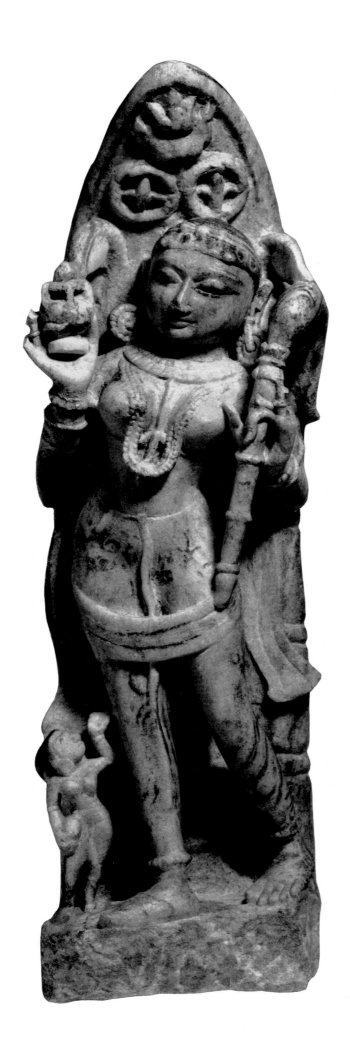

144 *Female figures, marble, medieval period*
(11th to 13th century A.D.*)*

145 *Buddha, chlorite, Pāla period (10th to 11th century* A.D.*)*

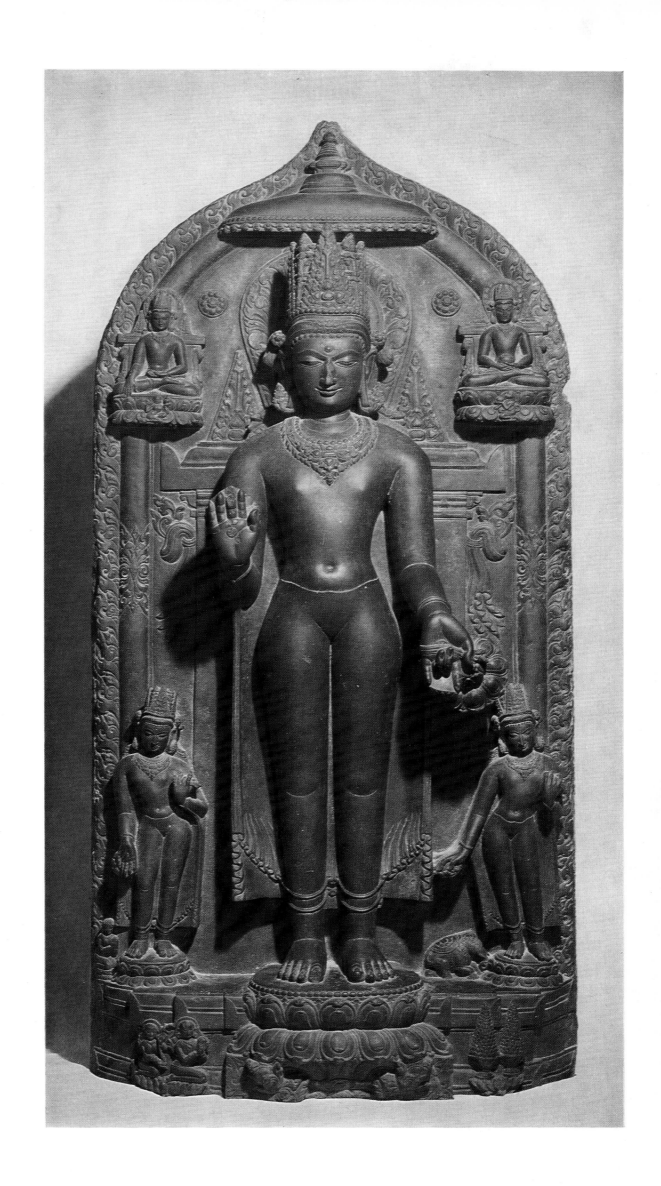

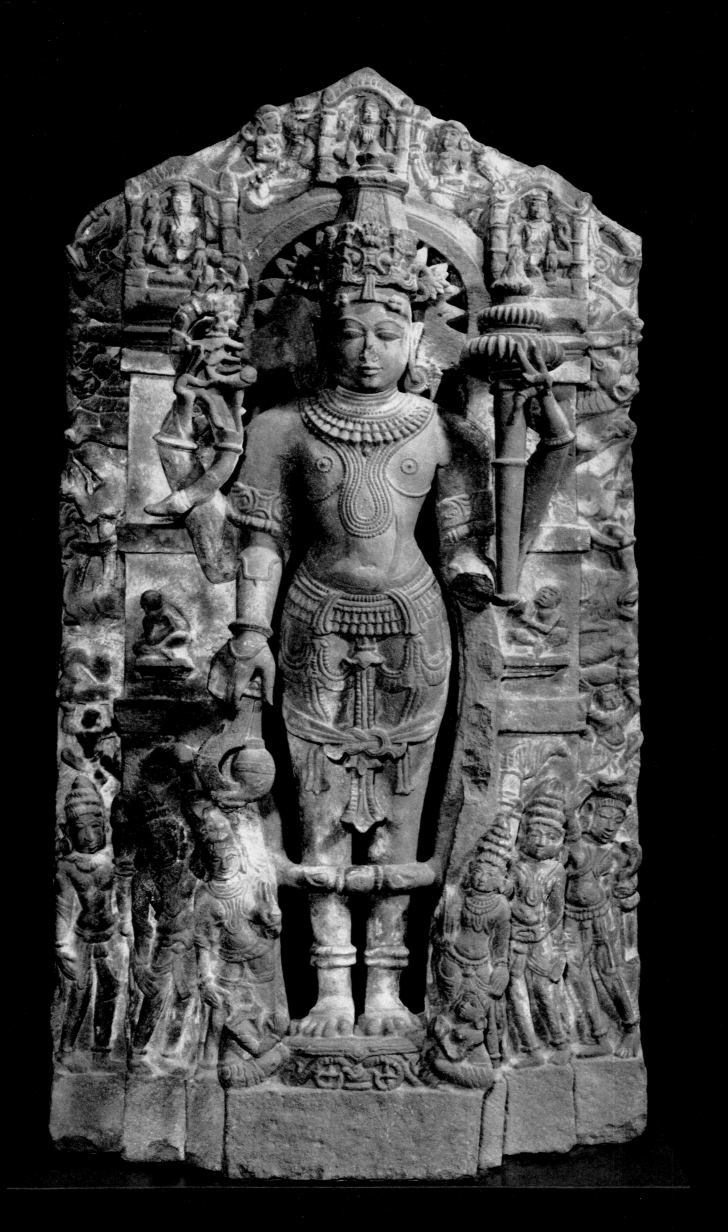

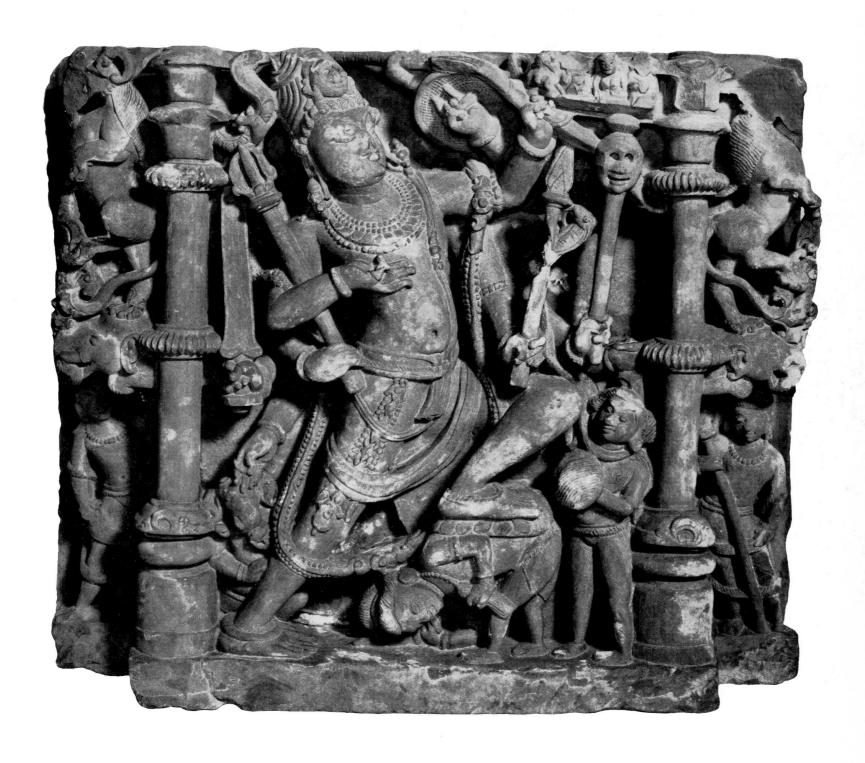

146 Vishnu, sandstone, Central India (11th to 12th century A.D.)

147 Shiva Tripurāntaka, sandstone, Central India (11th century A.D.)

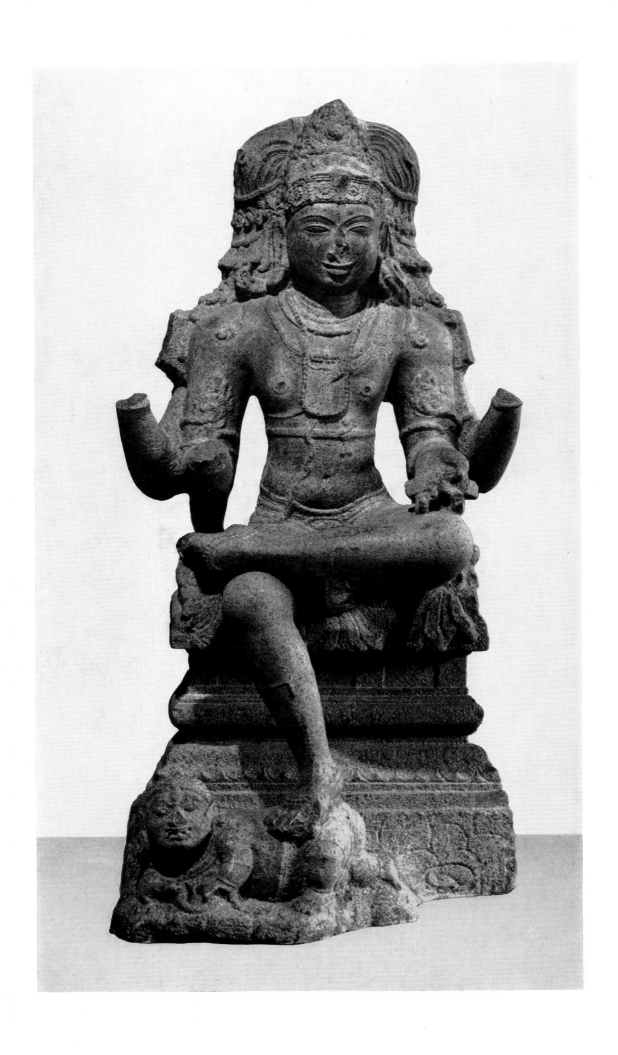

148 Shiva Dakshināmūrti, granite, Chola period (11th to 12th century A.D.*)*

149 Ganesha, schist, Hoyshala period (ca. 12th to 13th century A.D.*)*

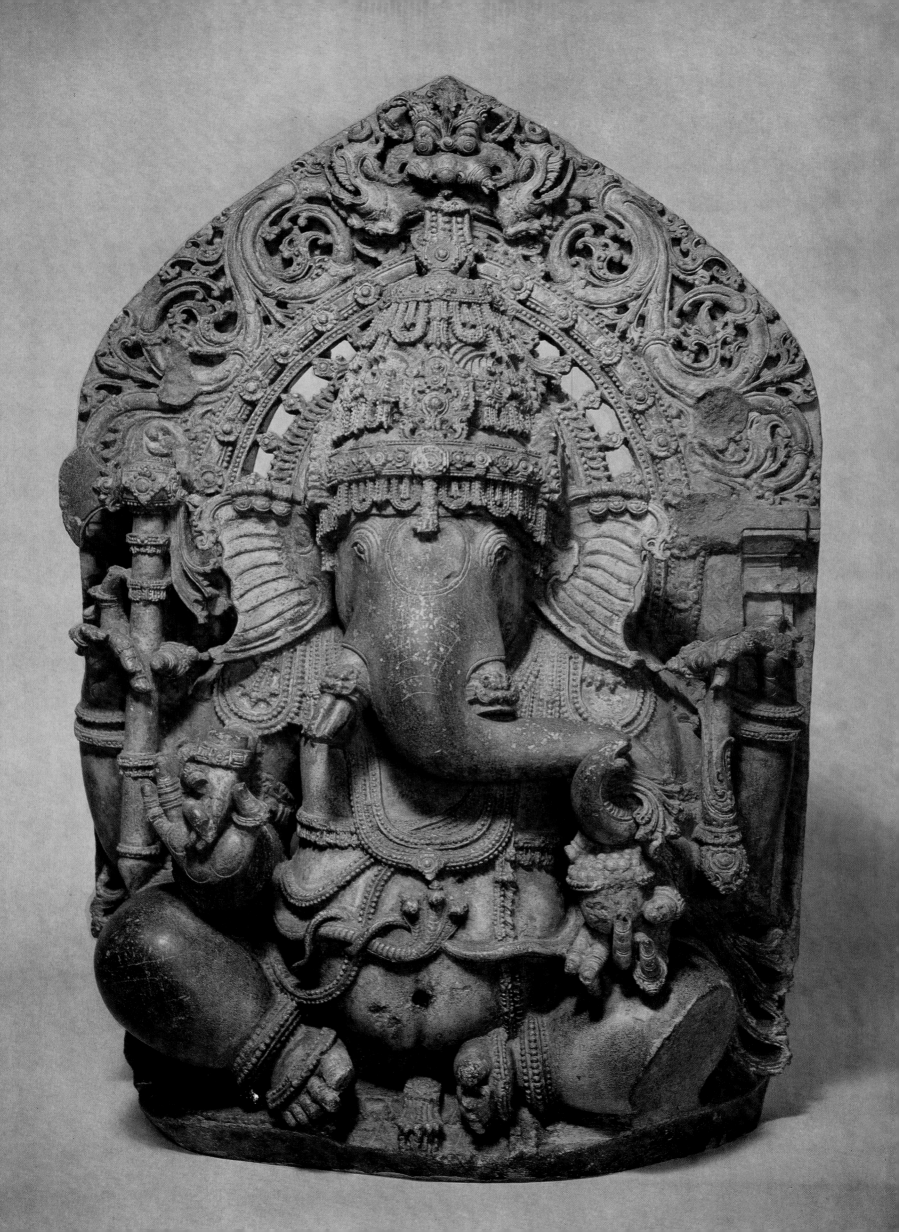

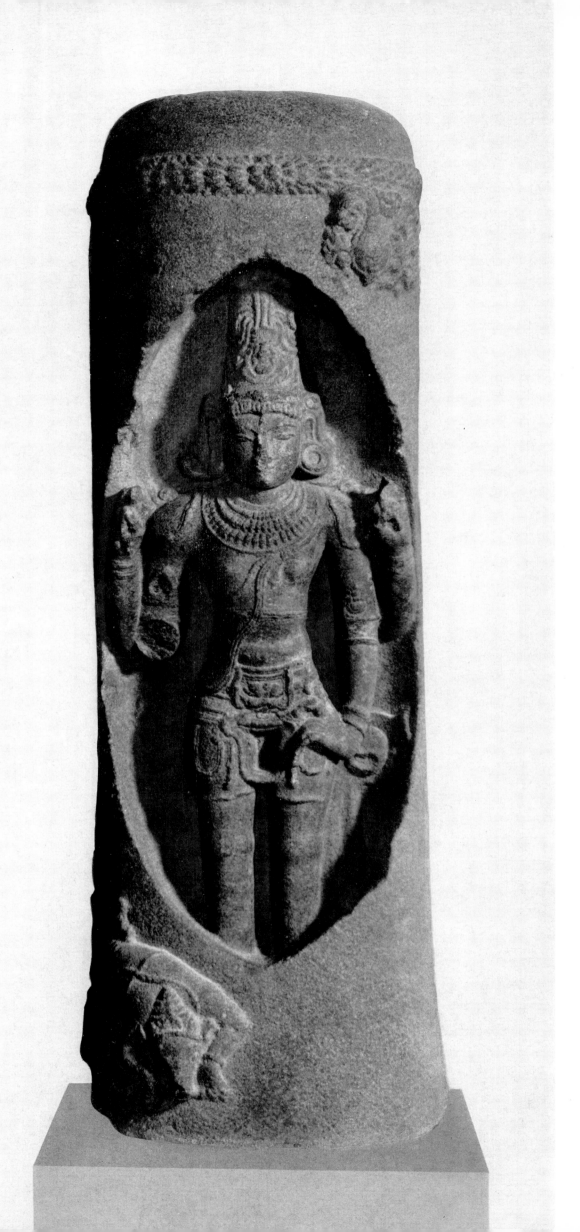

150 Shiva Lingodbhavamūrti,
granite, Chola period
(ca. 13th century A.D.*)*

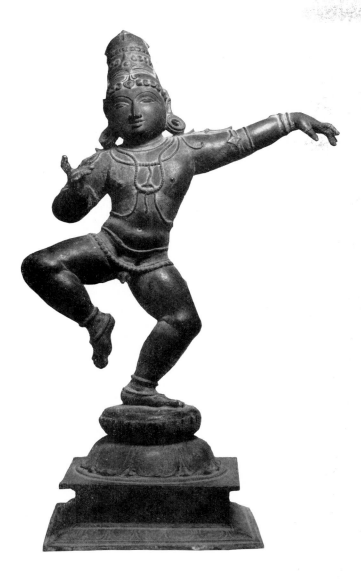

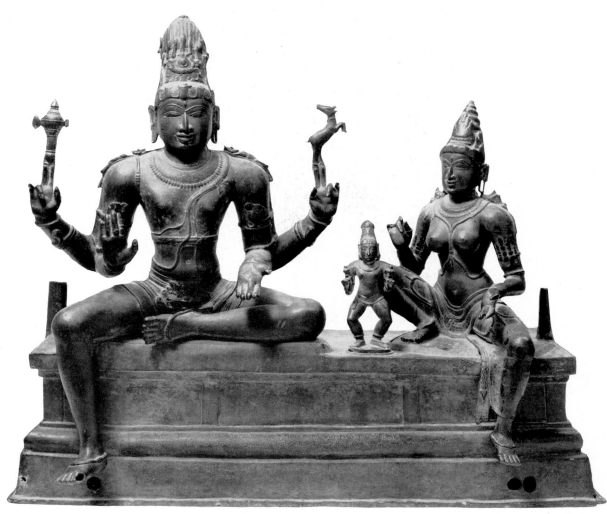

151, 152 Balakrishna and Somāskanda, bronze, late Chola or early Vijayanagar period (13th to 14th century A.D.)

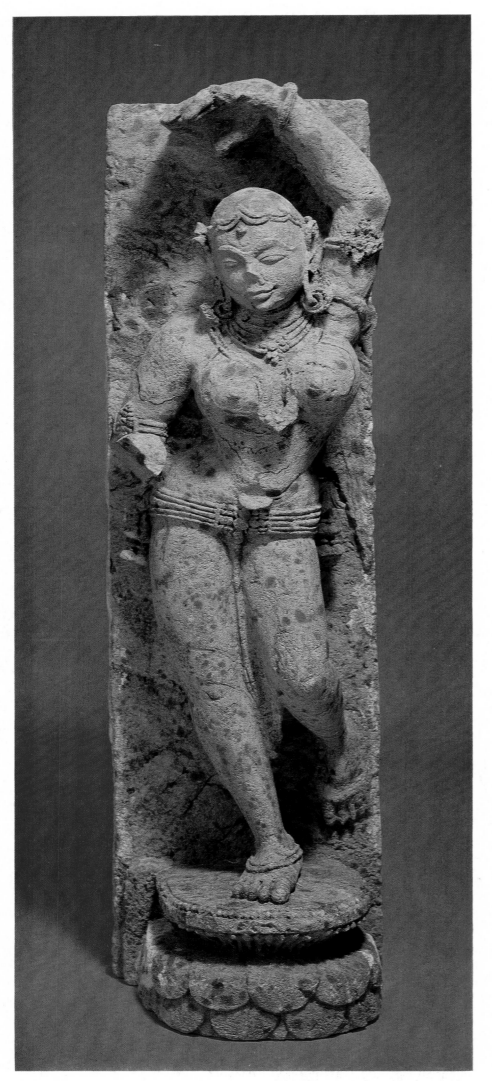

153 *Yakshī or Sālabhajikā, sandstone,*
 Eastern Ganga dynasty (ca. 1238—1264 A.D.)

154 *Saivite saint, bronze, Vijayanagar period*
 (14th to 15th century A.D.)

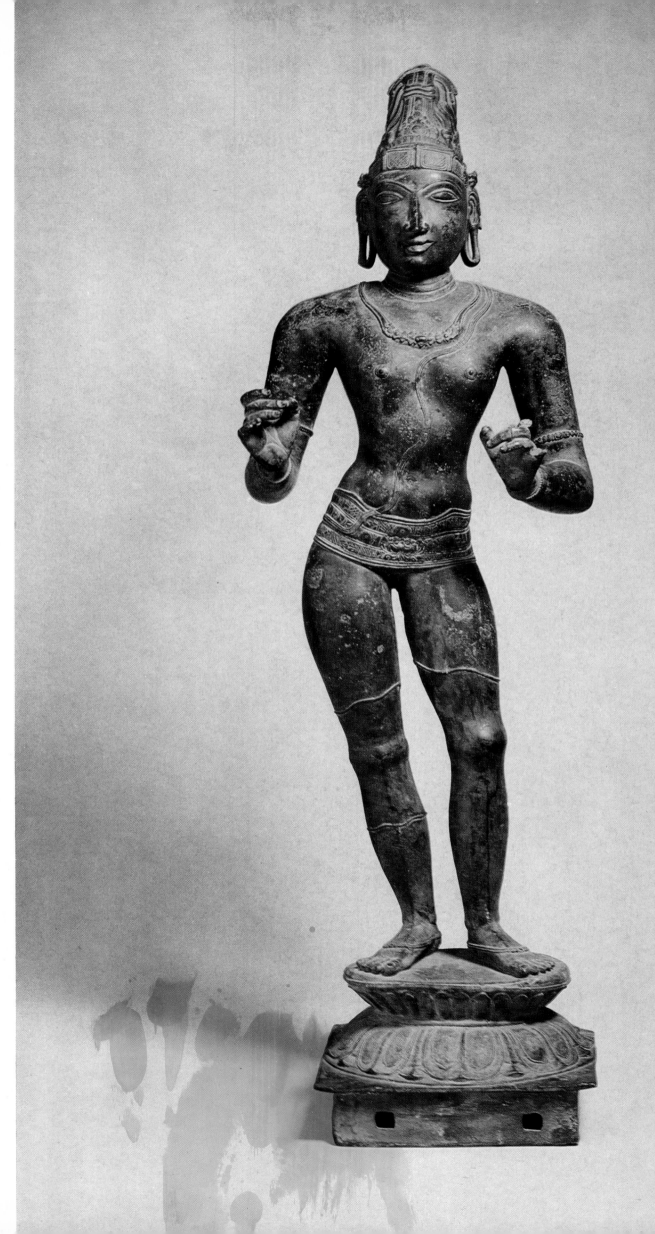

155 *Nandi, granite, Vijayanagar period (late 15th century* A.D.)

156 *Head of Buddha, sandstone, early Dvāravatī (ca. 7th century* A.D.)

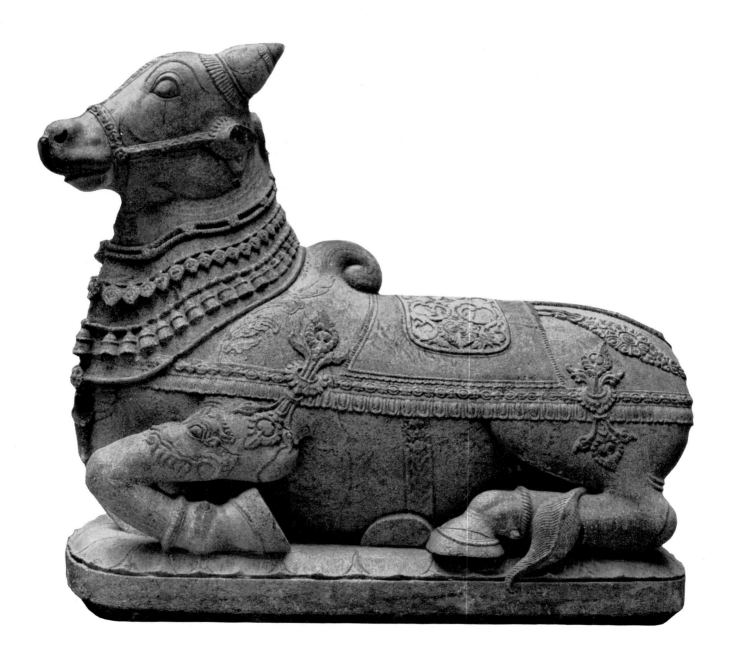

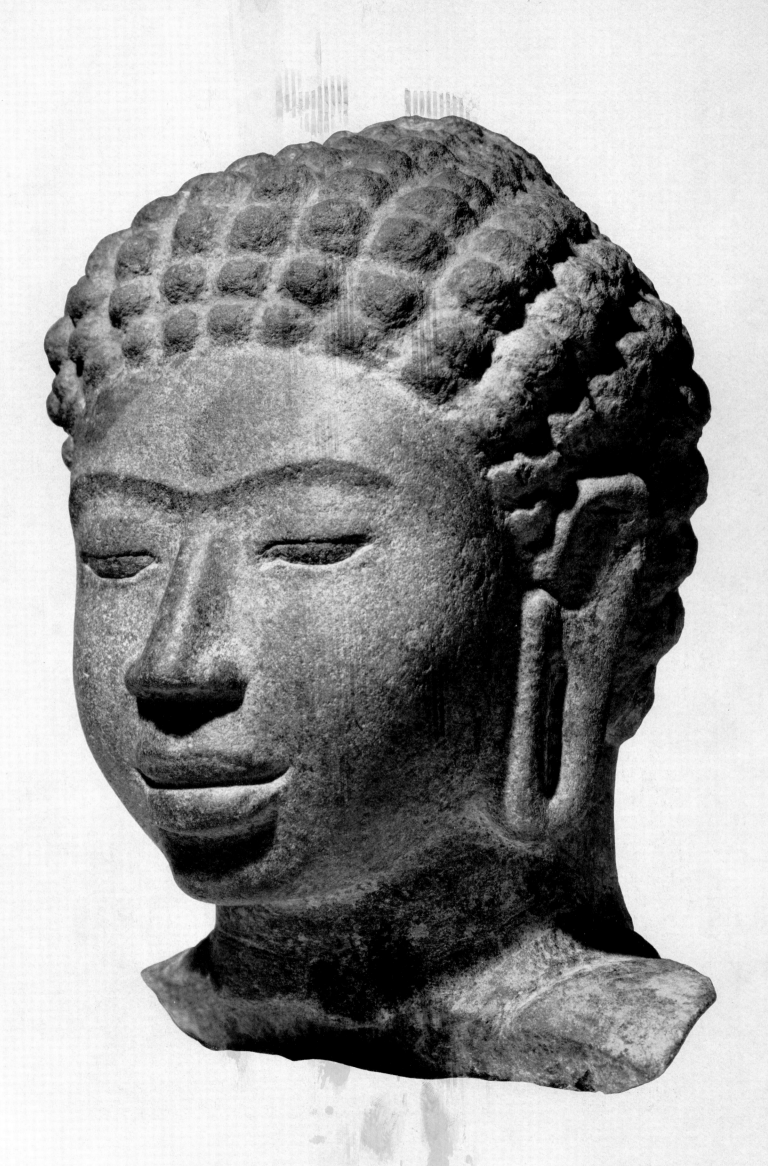

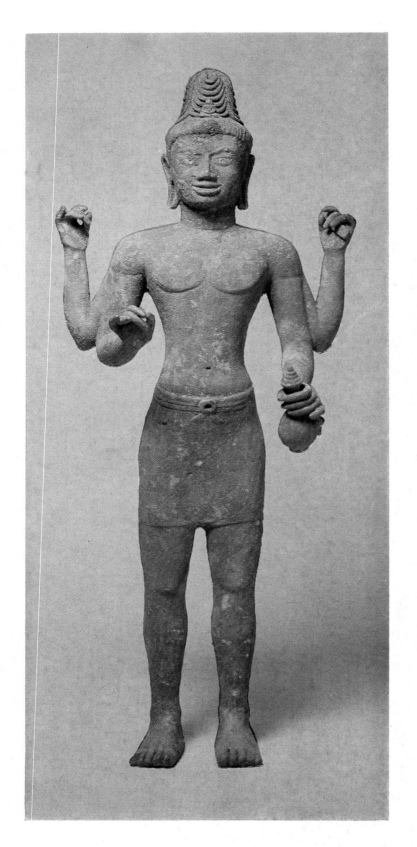

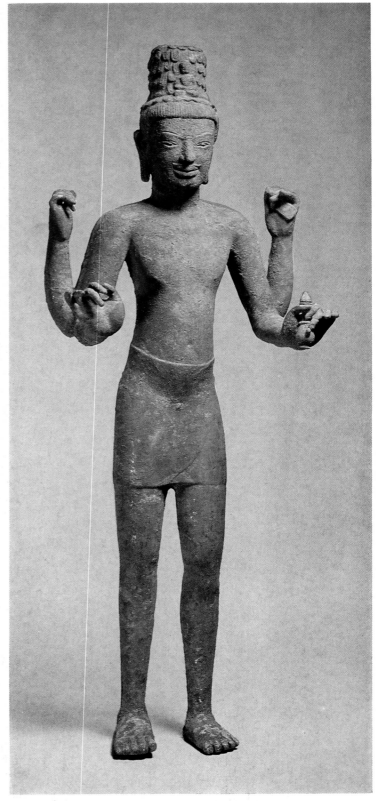

157, 158 Avalokiteshvaras, bronze, Thailand
(7th and 9th centuries A.D.*)*

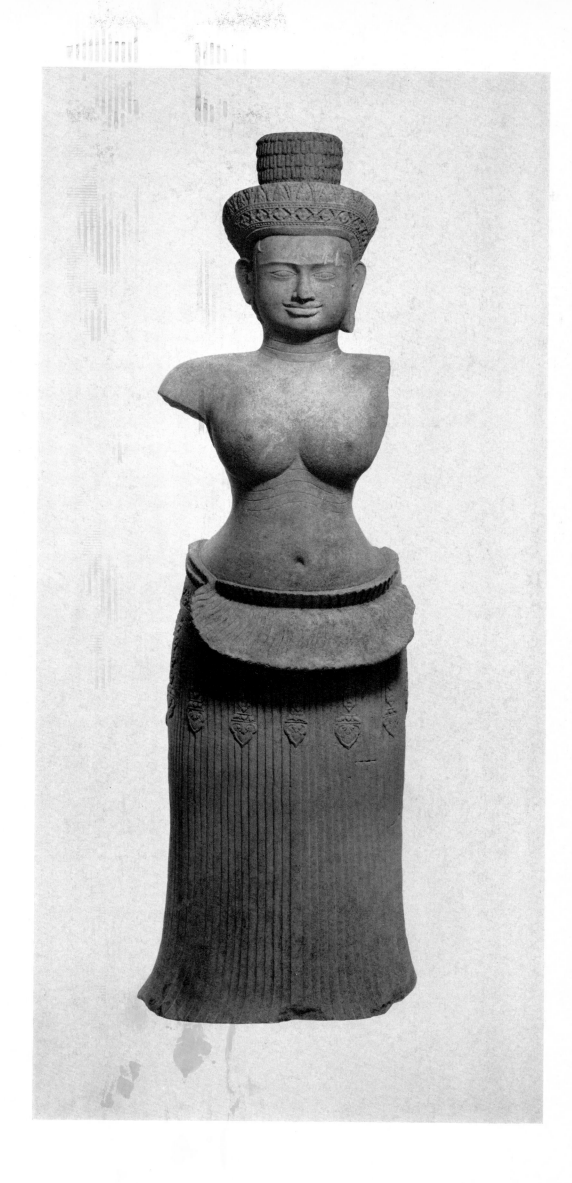

159 *Female deity, sandstone,*
 Khmer (10th century A.D.*)*

Following pages:
160 *Vishnu, sandstone,*
 Khmer (mid 10th century A.D.*)*

161 *Shiva and Devi (?), sandstone,*
 Khmer (late 11th century A.D.*)*

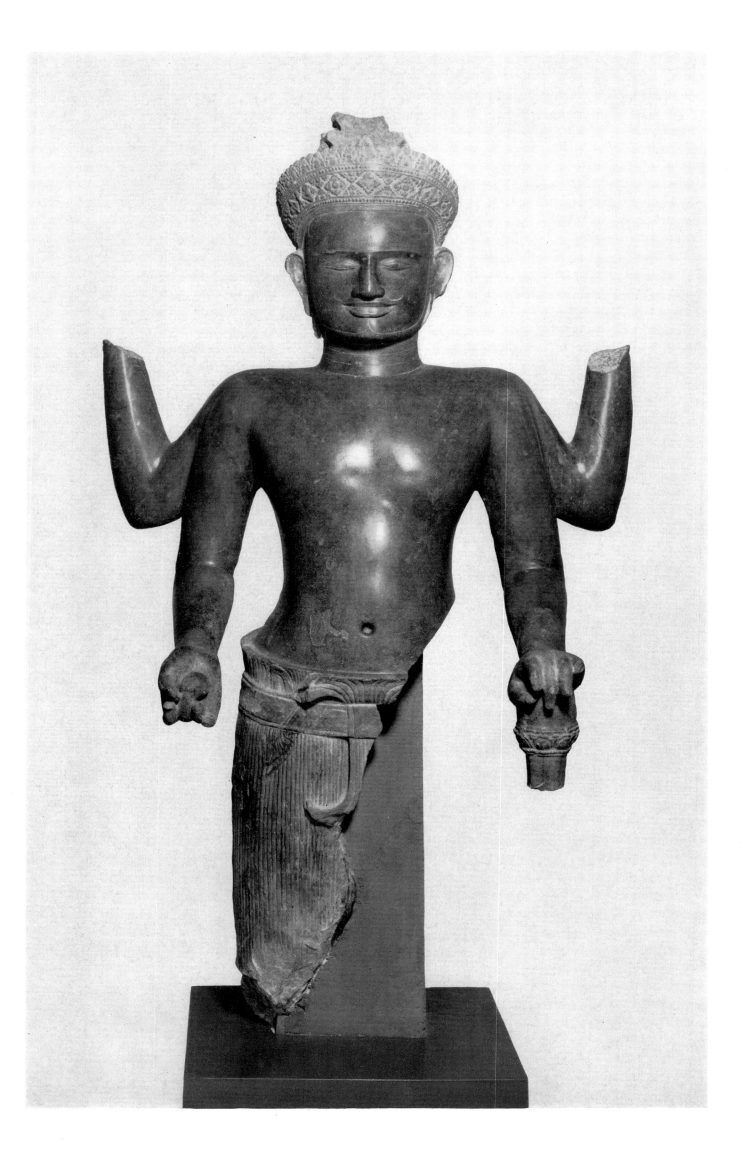

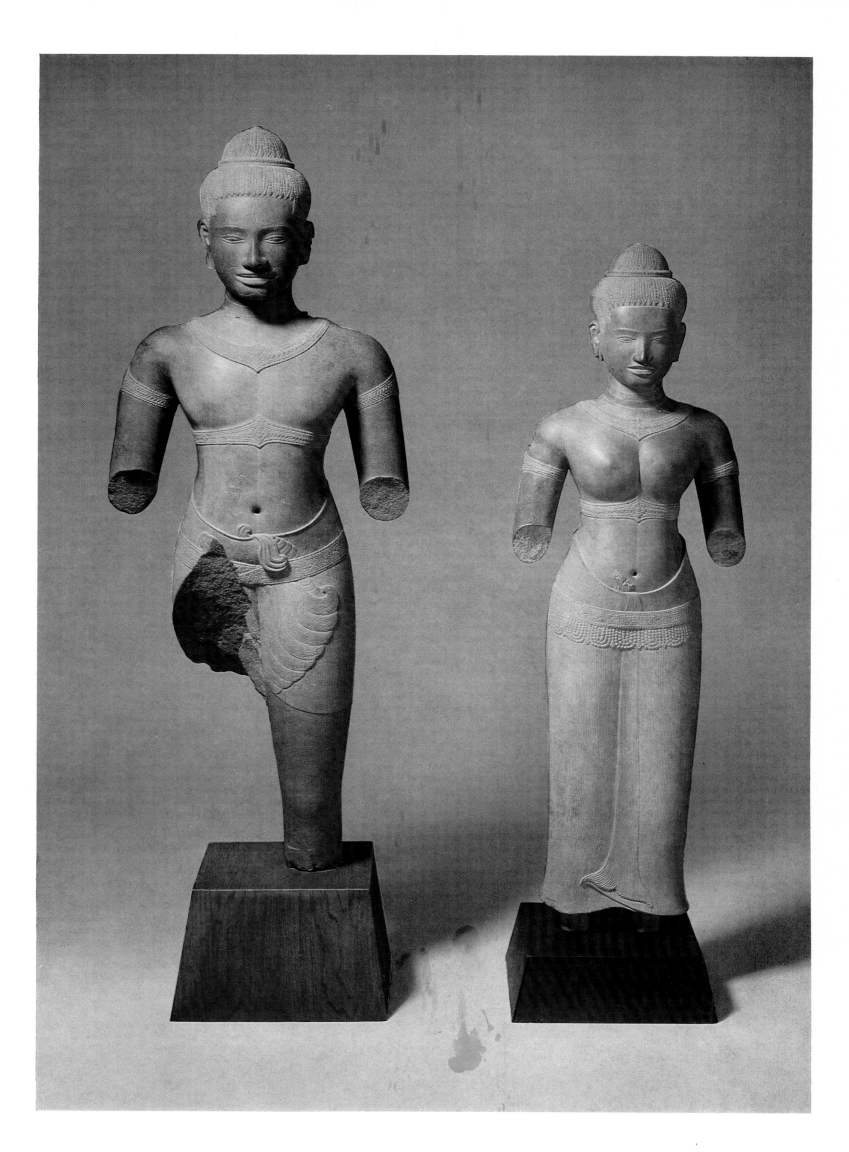

162 *Lintel, sandstone, Khmer (late 11th century* A.D.*)*

163 *Lintel, sandstone, Khmer (late 11th century* A.D.*)*

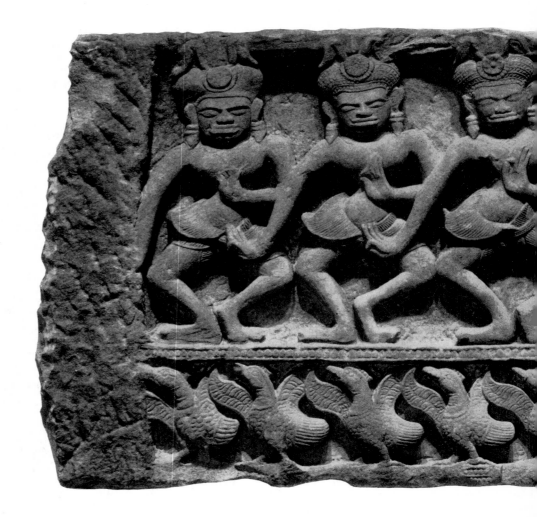

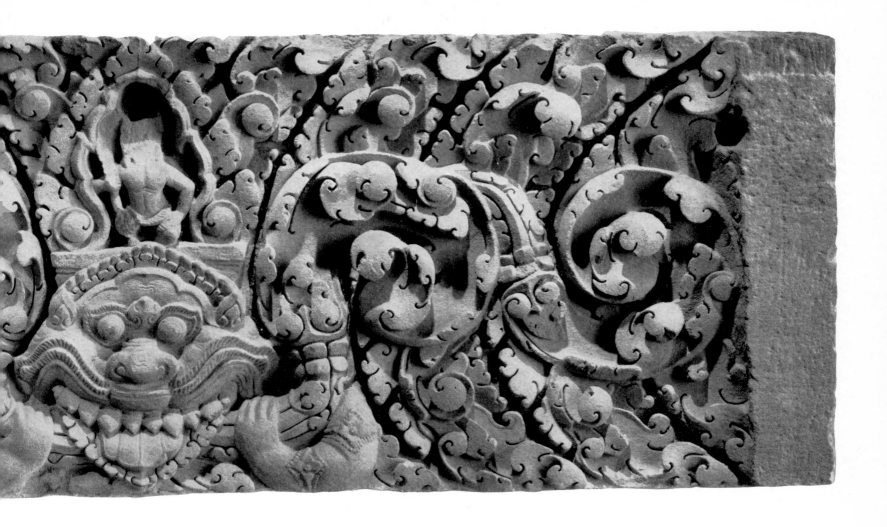

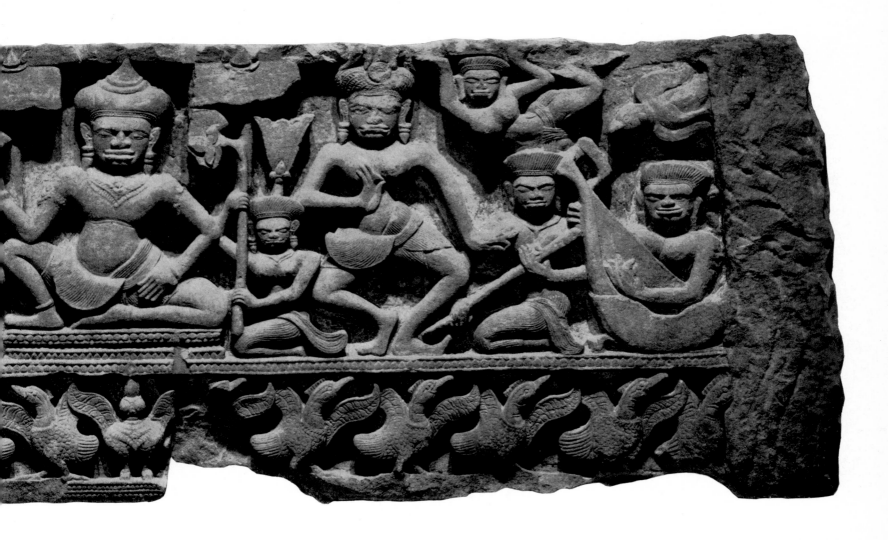

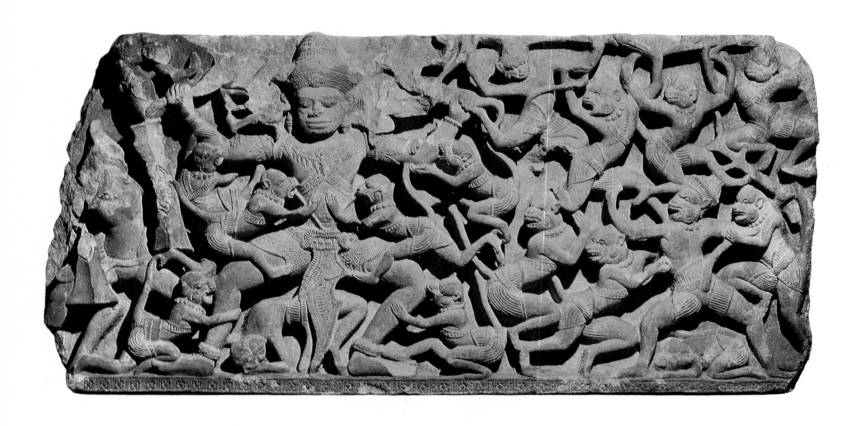

164 *Lintel, sandstone, Khmer (12th century* A.D.)

165 *Horse, sandstone, Khmer (12th century* A.D.)

166 *Buddha, sandstone, Khmer*
 (late 12th to early 13th century A.D.)

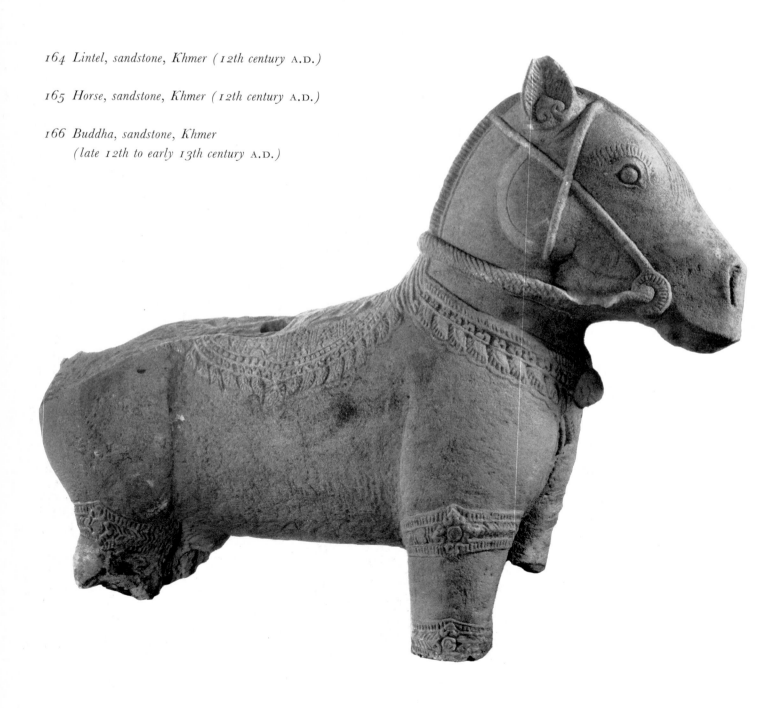

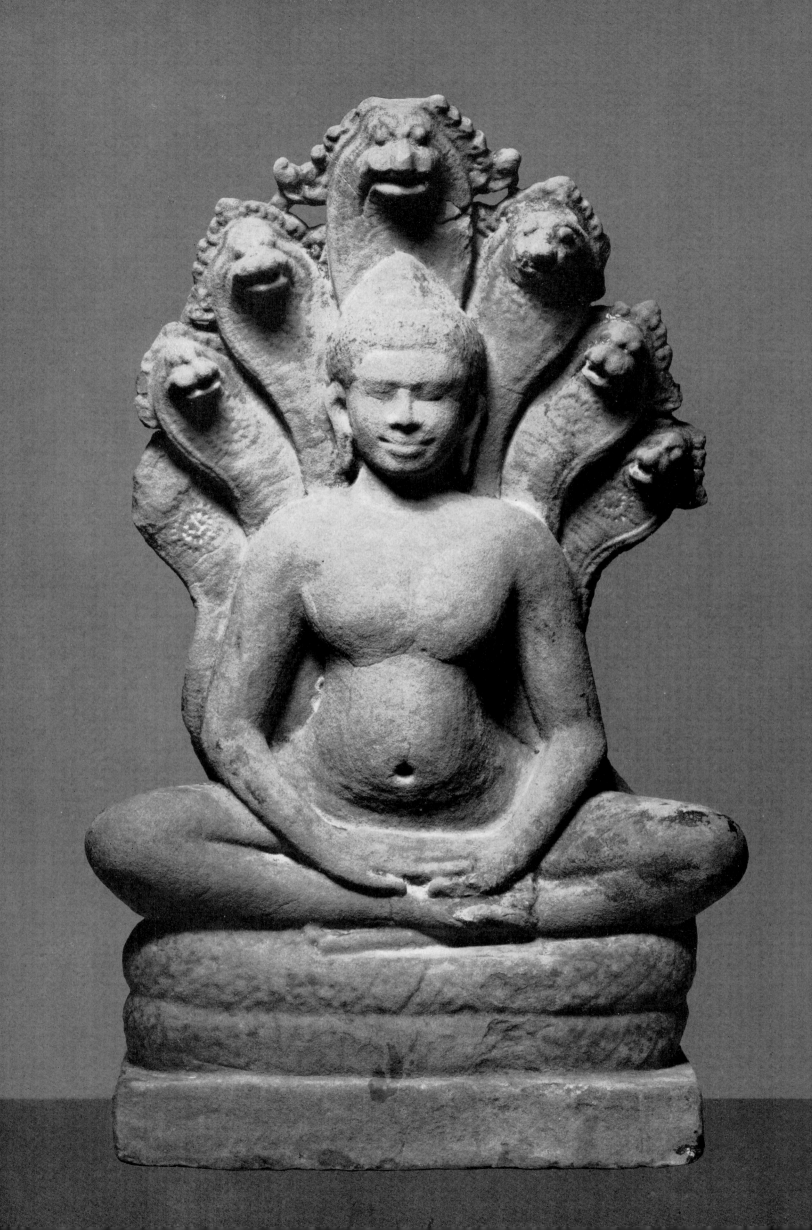

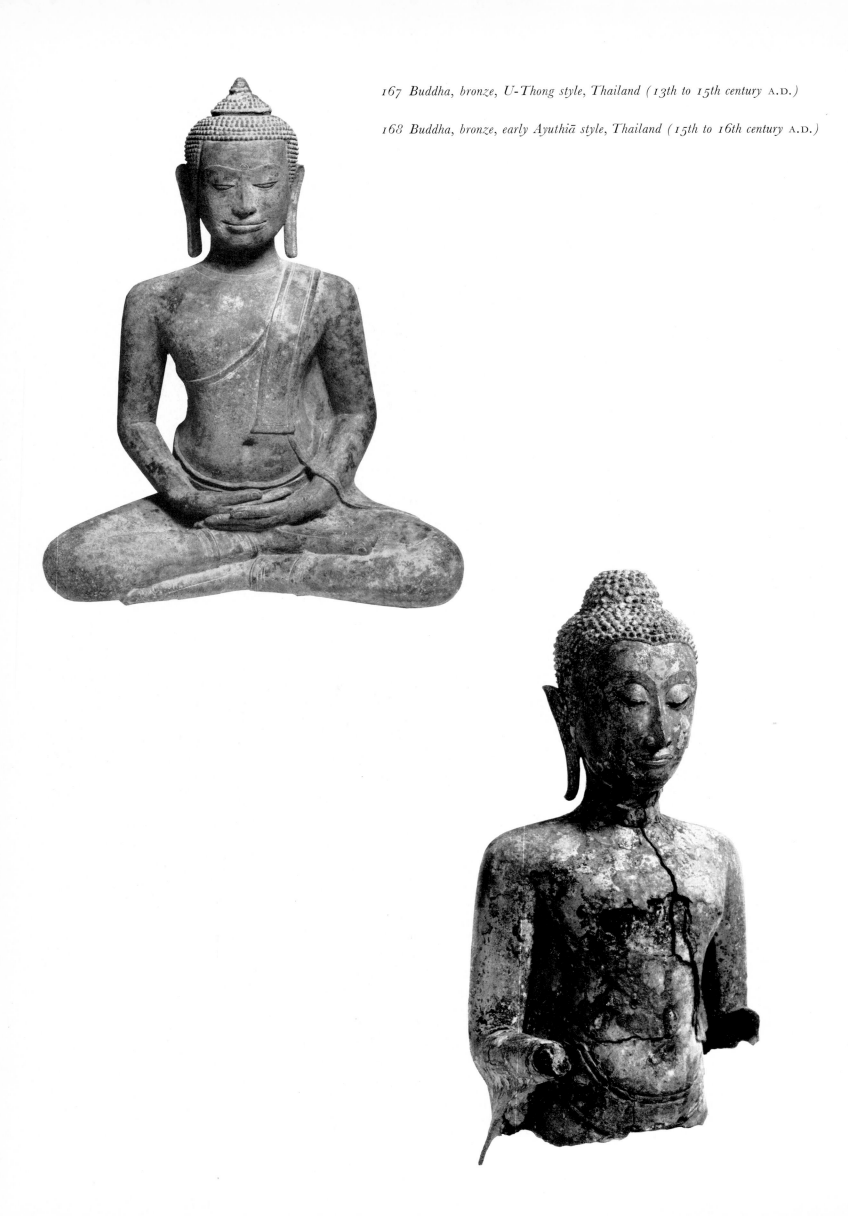

167 Buddha, bronze, U-Thong style, Thailand (13th to 15th century A.D.)

168 Buddha, bronze, early Ayuthiā style, Thailand (15th to 16th century A.D.)

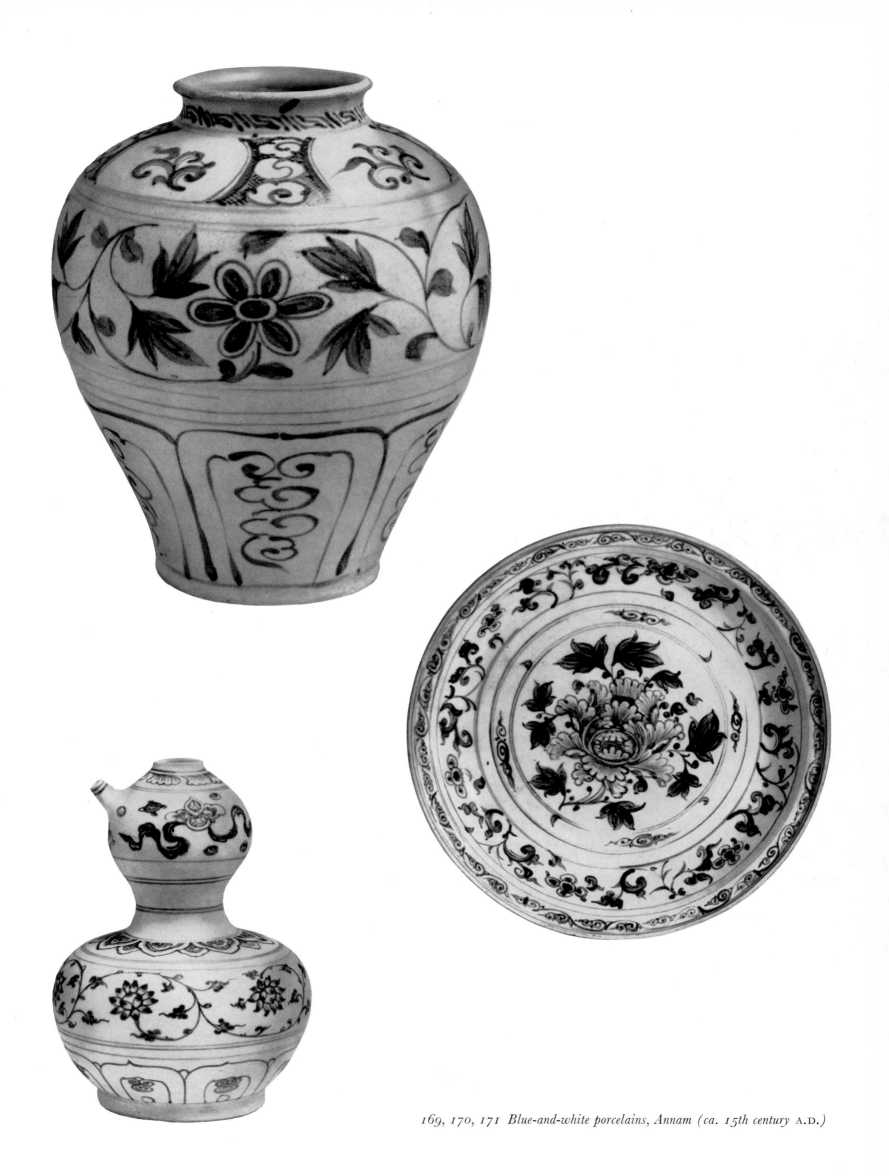

169, 170, 171 Blue-and-white porcelains, Annam (ca. 15th century A.D.)

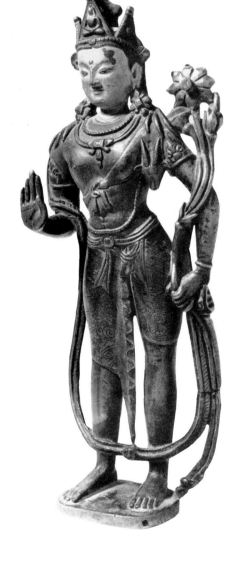

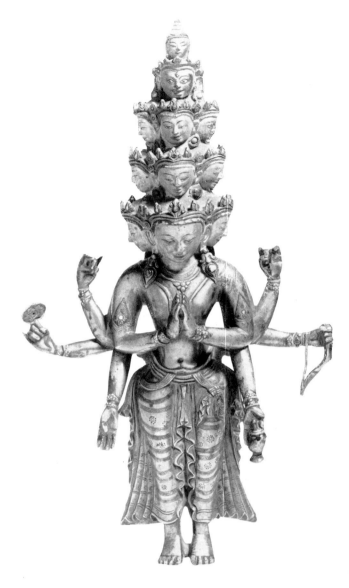

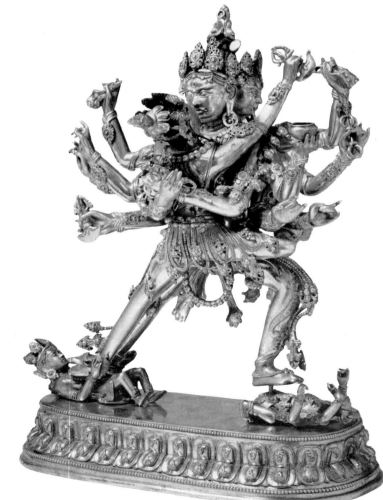

*172, 173 Bodhisattvas, gilt bronze, Western Tibet or Ladakh
(14th century* A.D.*)*

174 Samvara, gilt bronze, Tibet (17th century A.D.*)*

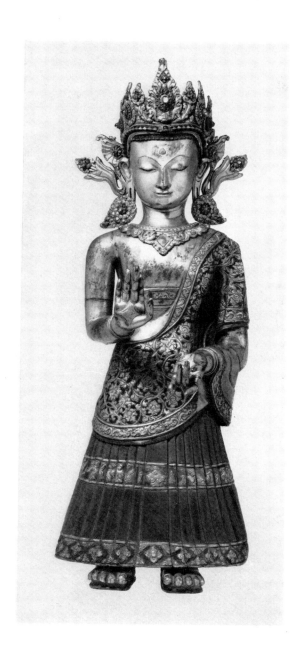

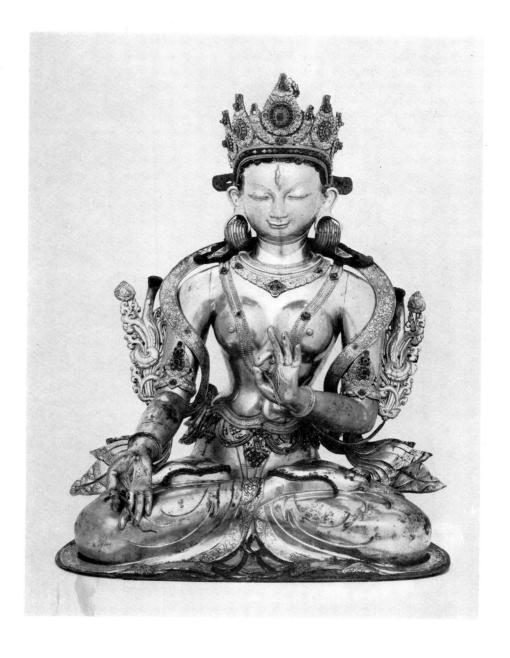

175 *Dīpankara Buddha, gilt copper repoussé, Nepal (17th century A.D.)*

176 *White Tārā, gilt copper repoussé, Nepal (18th century A.D.)*

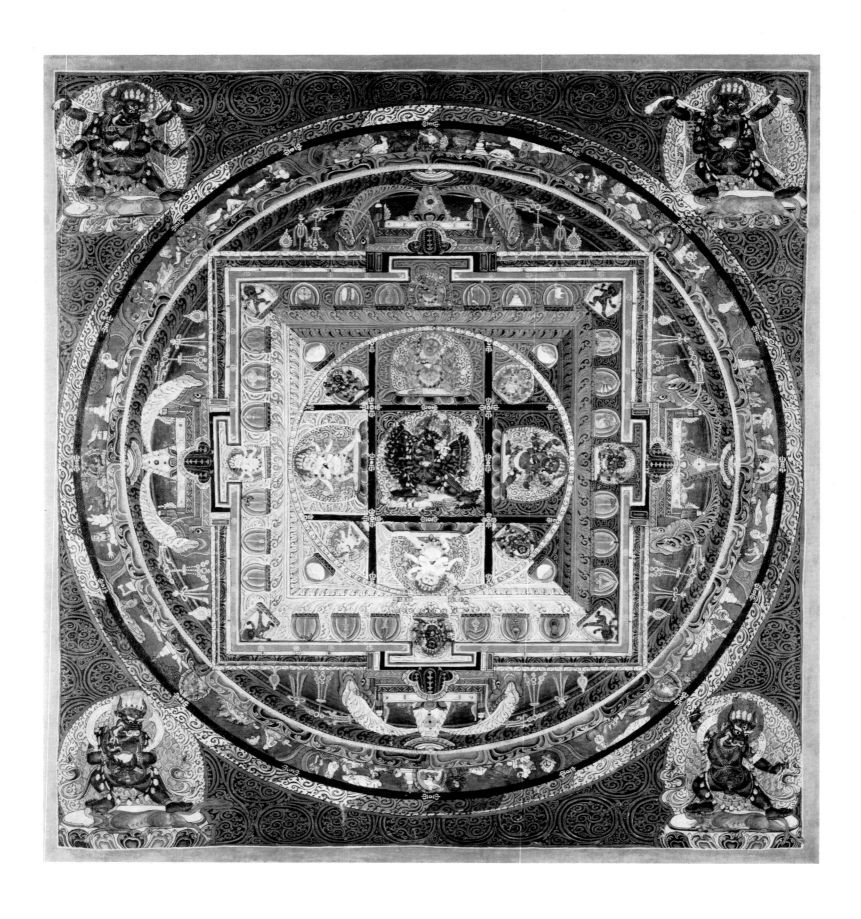

177 Yamāntaka-mandala, tanka, Tibet (late 17th to early 18th century A.D.*)*

178 Amitāyus, tanka, Tibet (18th century A.D.*)*

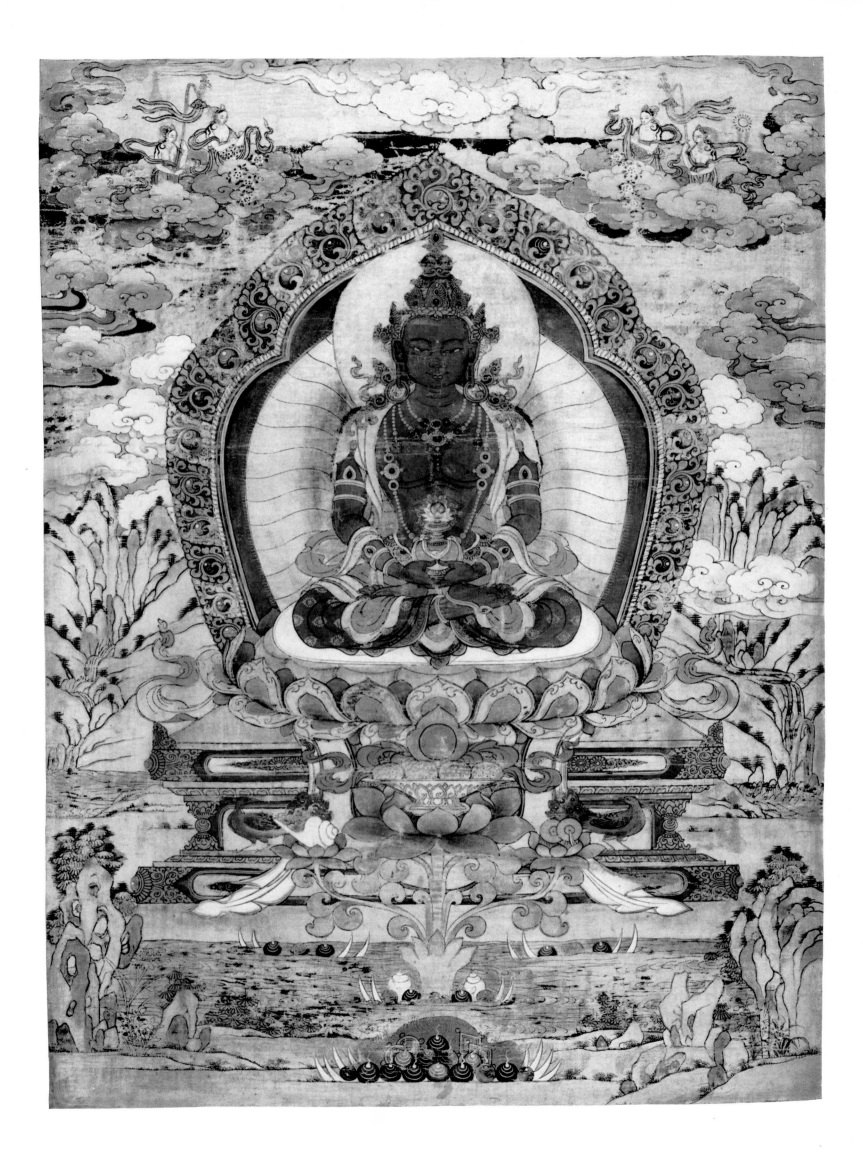

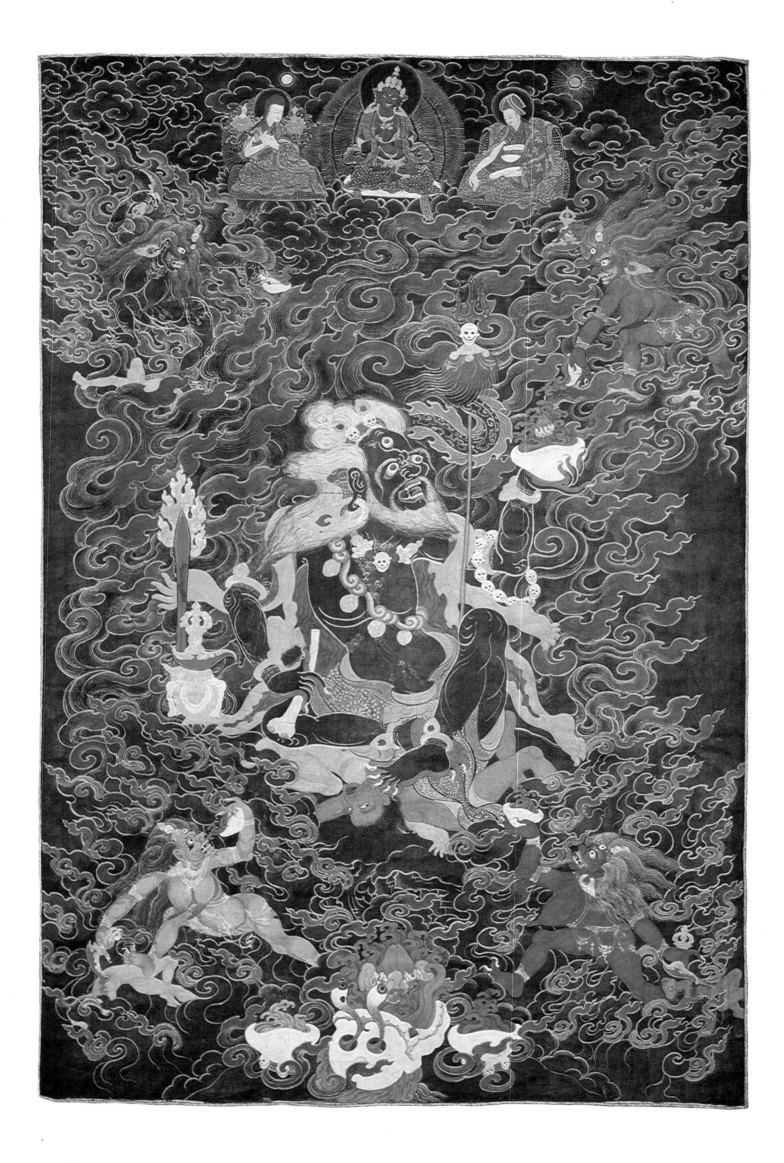

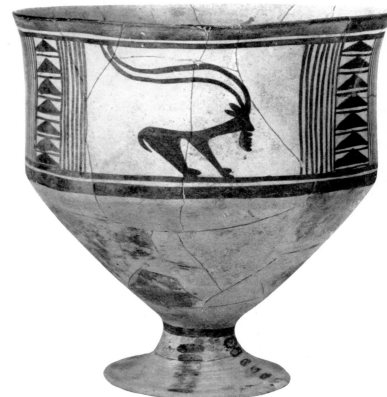

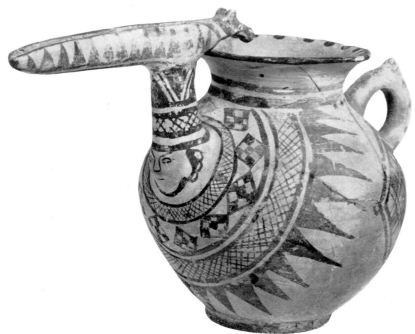

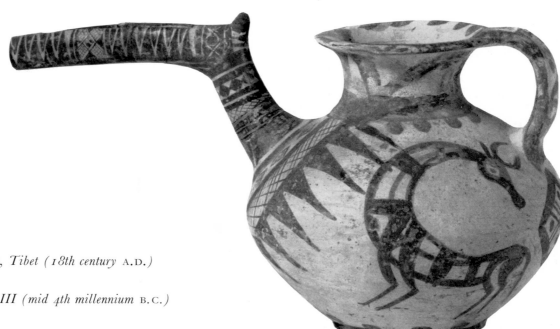

179 Mahākāla Brāhmanarūpa, tanka, Tibet (18th century A.D.)

180 Goblet, pottery, from Tepe Sialk III (mid 4th millennium B.C.)

181, 182 Pitchers, pottery, from Tepe Sialk VI (10th century B.C.)

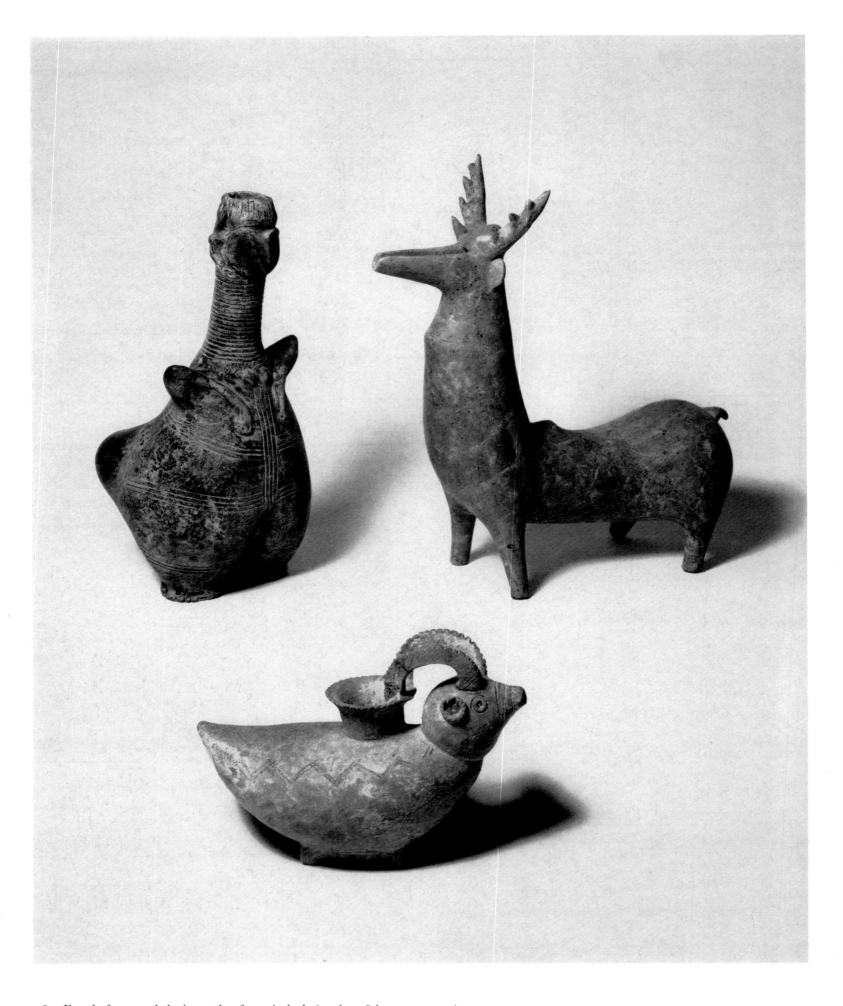

183 *Female figure and theriomorphs, from Amlash (10th to 8th century* B.C.*)*

184 *"Luristān" bronzes (late 2nd to 1st millennium* B.C.*)*

185 *Jar and bowls, pottery (12th to 13th century* A.D.*)*

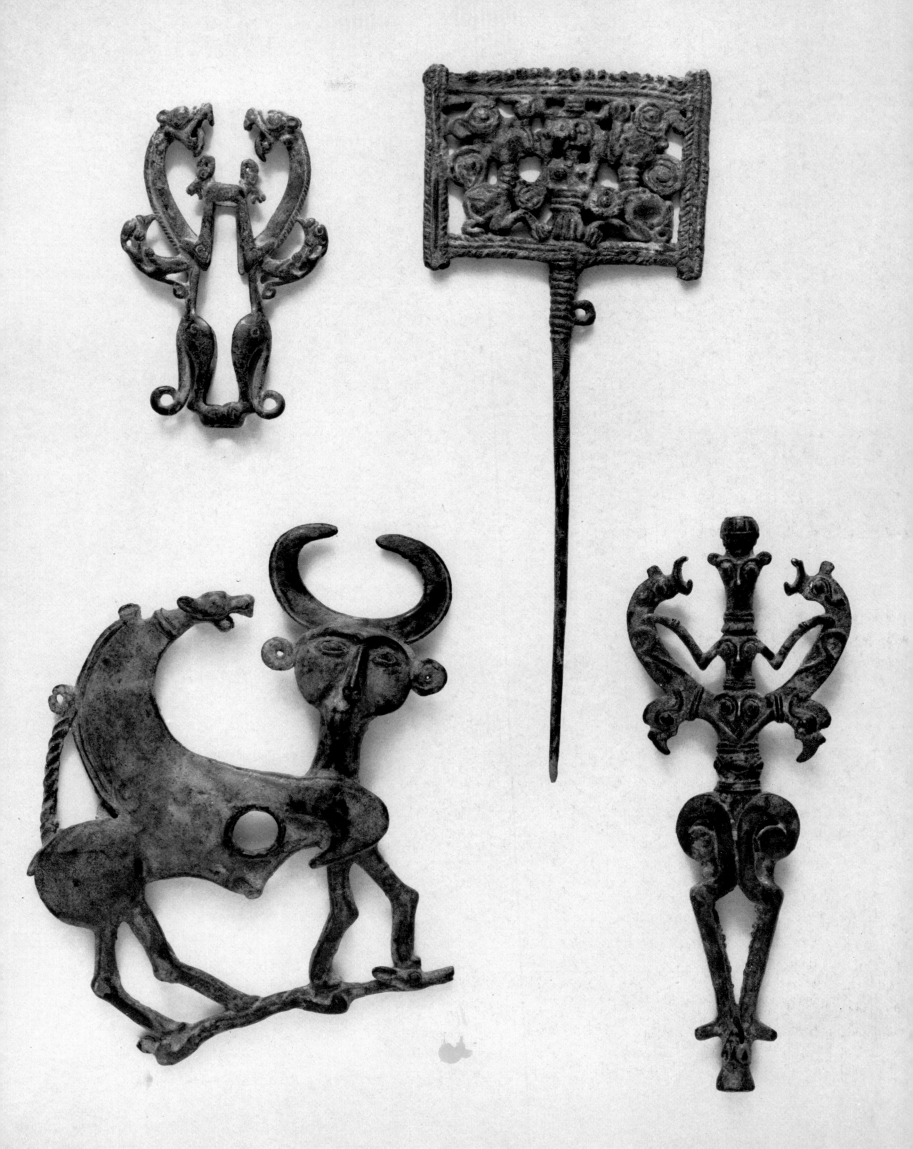

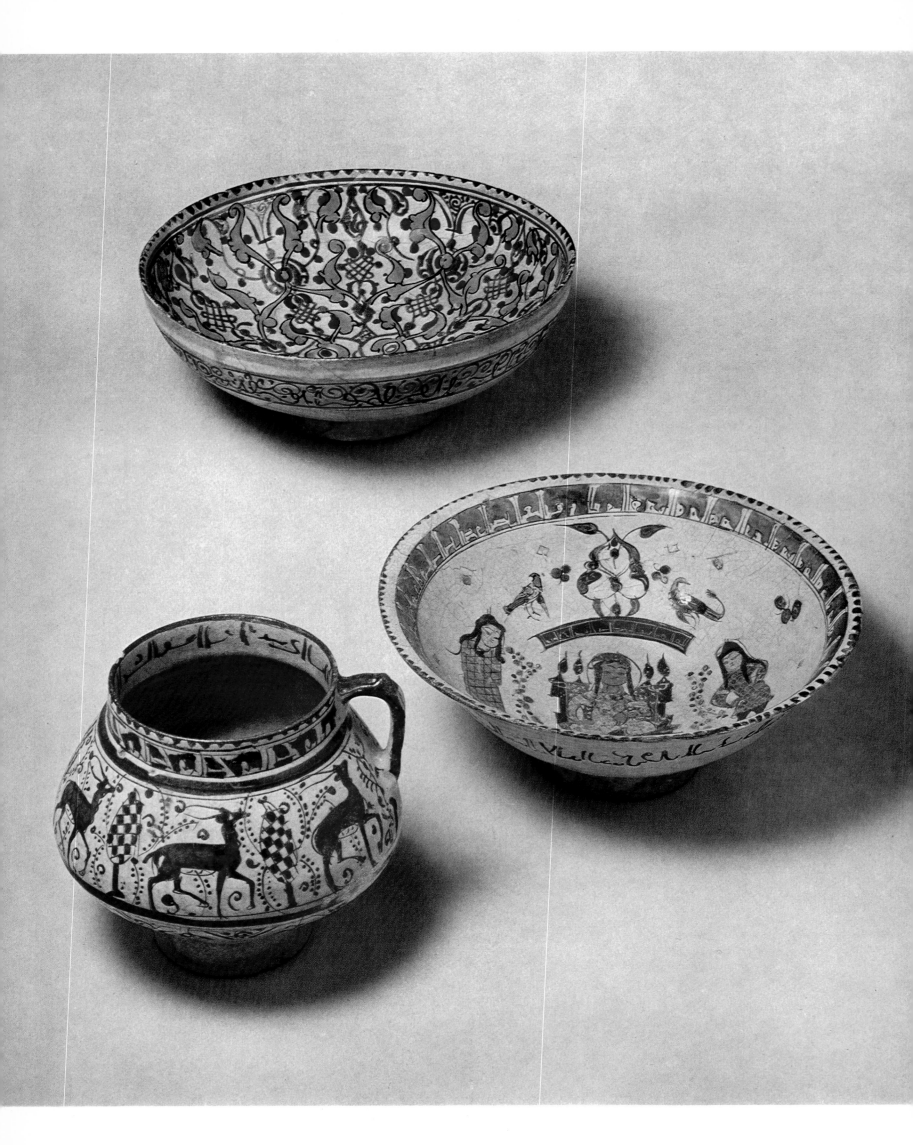

JAPANESE COLORED WOODBLOCK PRINTS IN THE ACHENBACH FOUNDATION FOR GRAPHIC ARTS

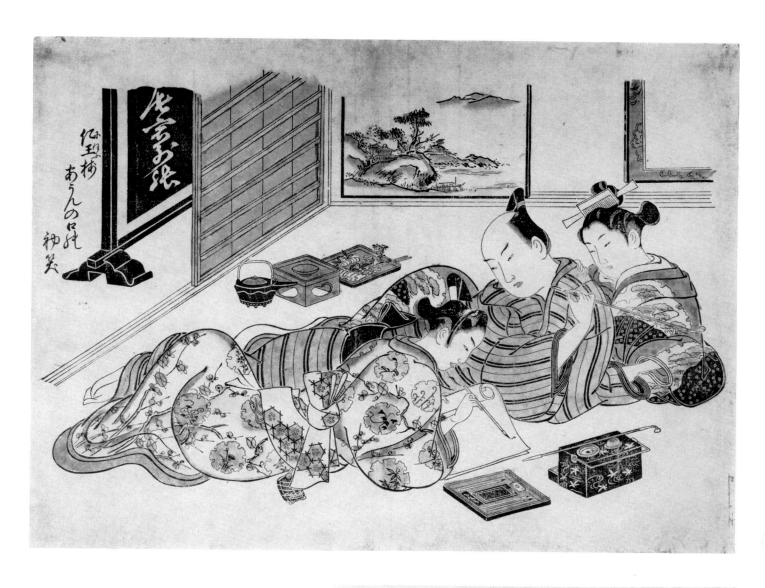

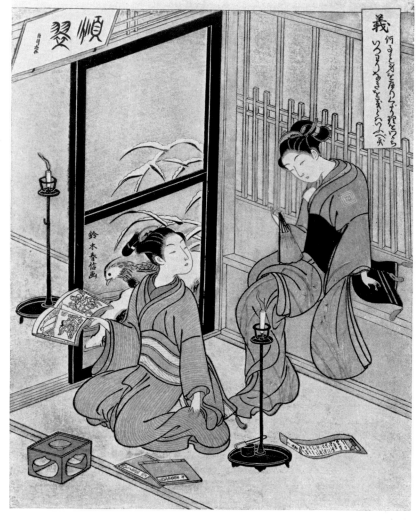

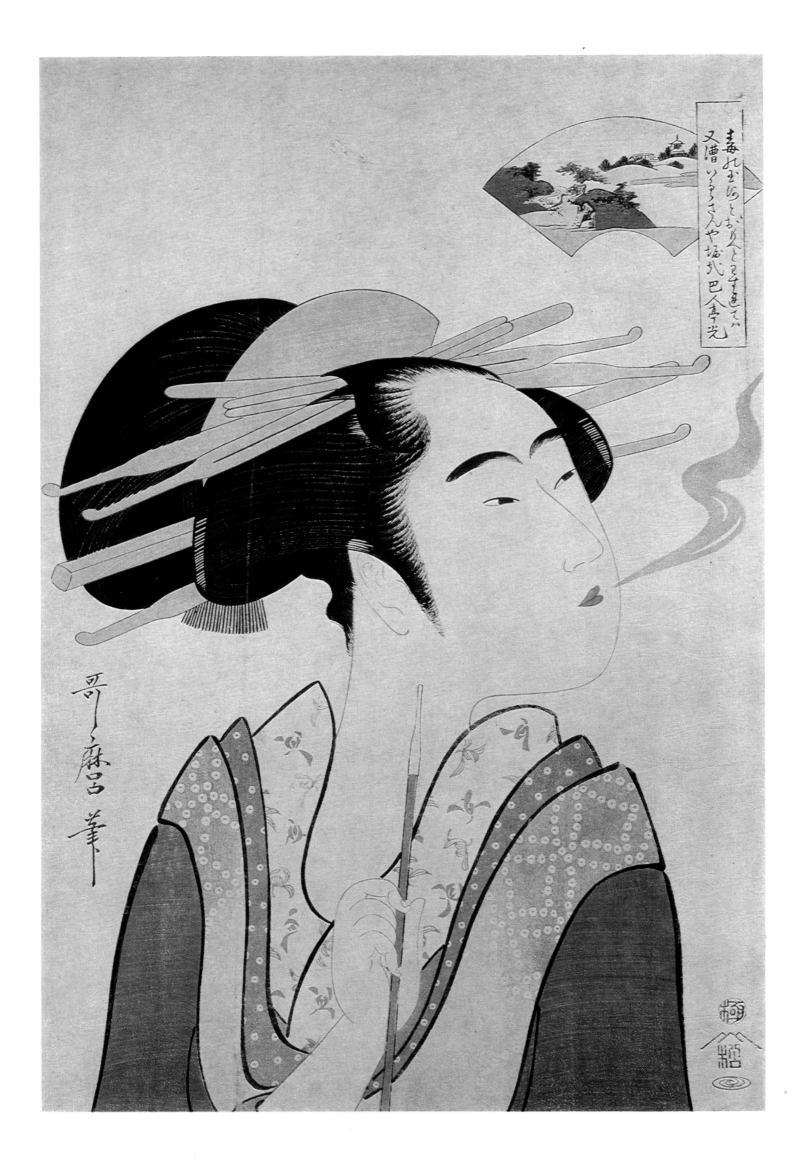

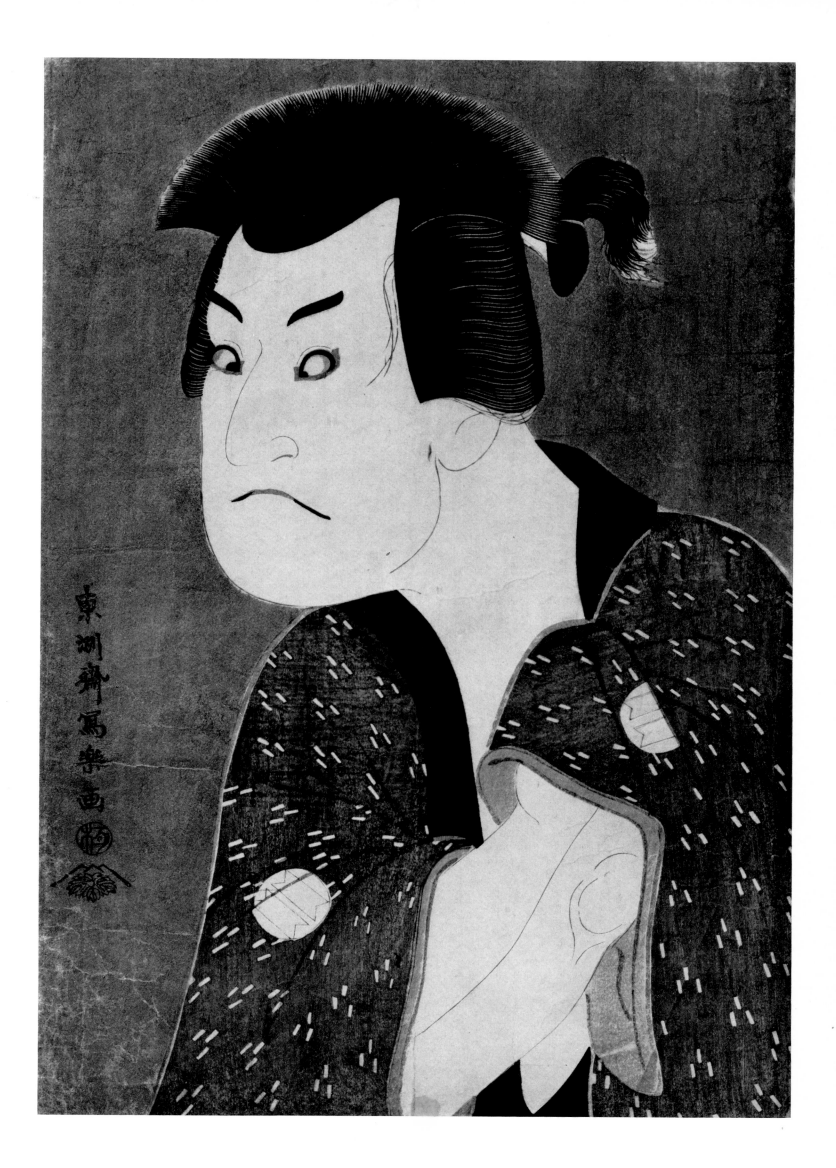

THE UNIVERSITY ART MUSEUM, BERKELEY

*192 Head of Buddha, schist,
Kushān period (late 3rd century* A.D.*)*

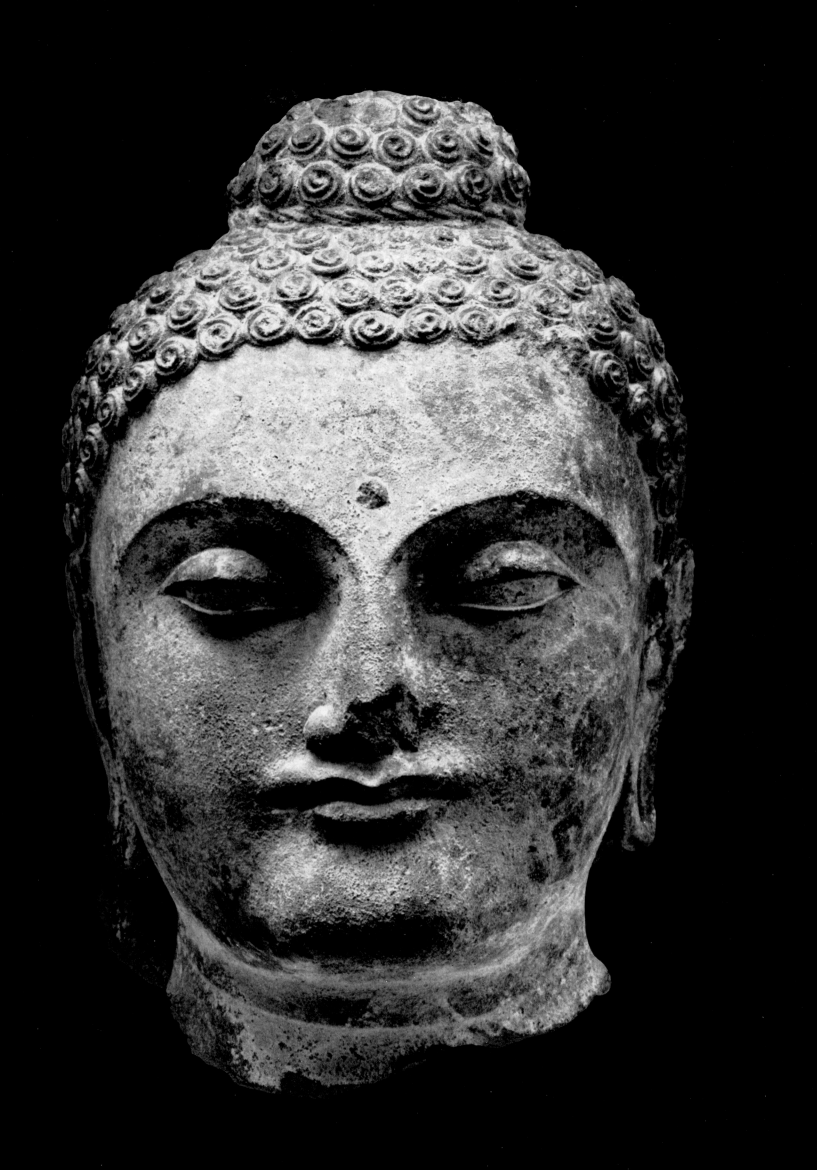

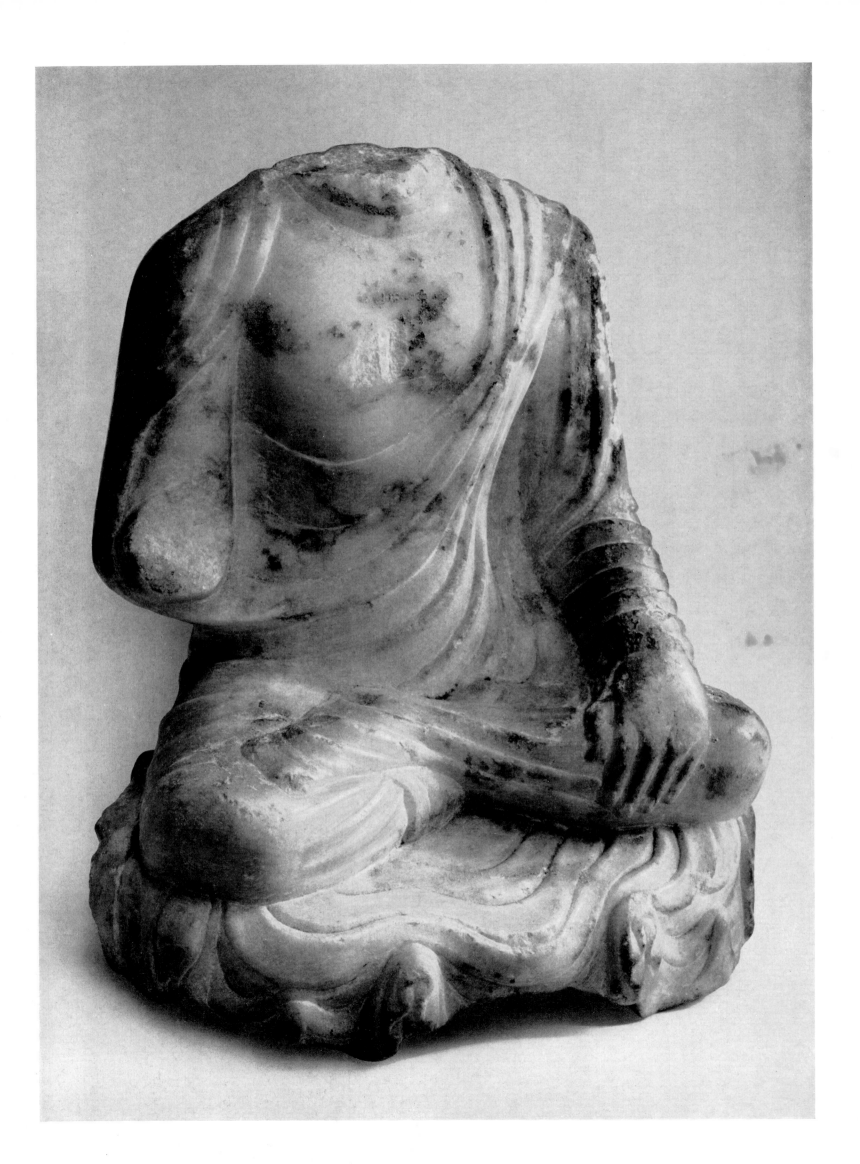

193 *Buddha, marble, T'ang dynasty*
 (late 7th to early 9th century A.D.*)*

194 *Weng Te-hung, hanging scroll, by Tseng Ch'ing,*
 dated 1639 A.D.

195 *"Scholar and Pupils," hanging scroll*
by Ch'en Hung-shou (1599—1652 A.D.*)*

196, 197 Landscapes, album leaves,
by Tao-chi, dated 1704 A.D.

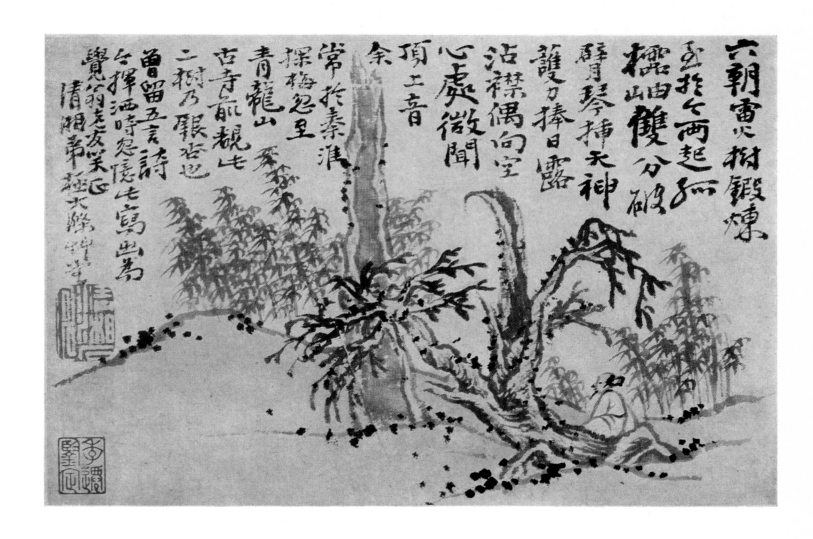

六朝靈火樹鍛鍊
盂括七兩起孤
襬岫雙分破
辟月琴揷天神
護刀捧日露
沾襟偶向空
心處微聞
頂工音
余
常於秦淮
探梅怨至
青龍山
古寺前覯七
二樹乃銀杏也
曾留五言詩
台擇酒時怨隱七寫出為
覺翁老友笑正
清湘弟輕大滌神浄

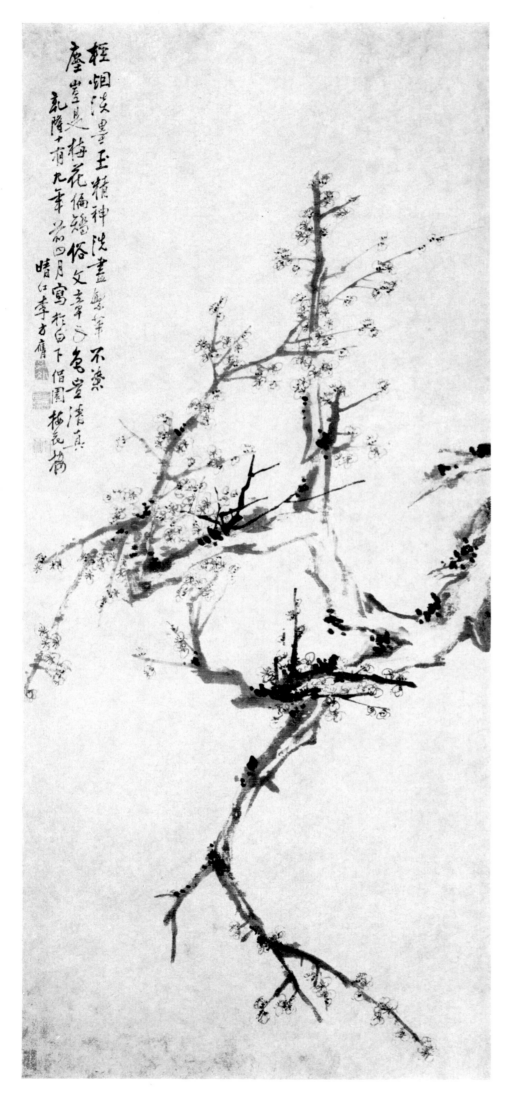

198 *Blossoming plum, hanging scroll,*
by Li Fang-ying, dated 1754 A.D.

THE STANFORD UNIVERSITY MUSEUM

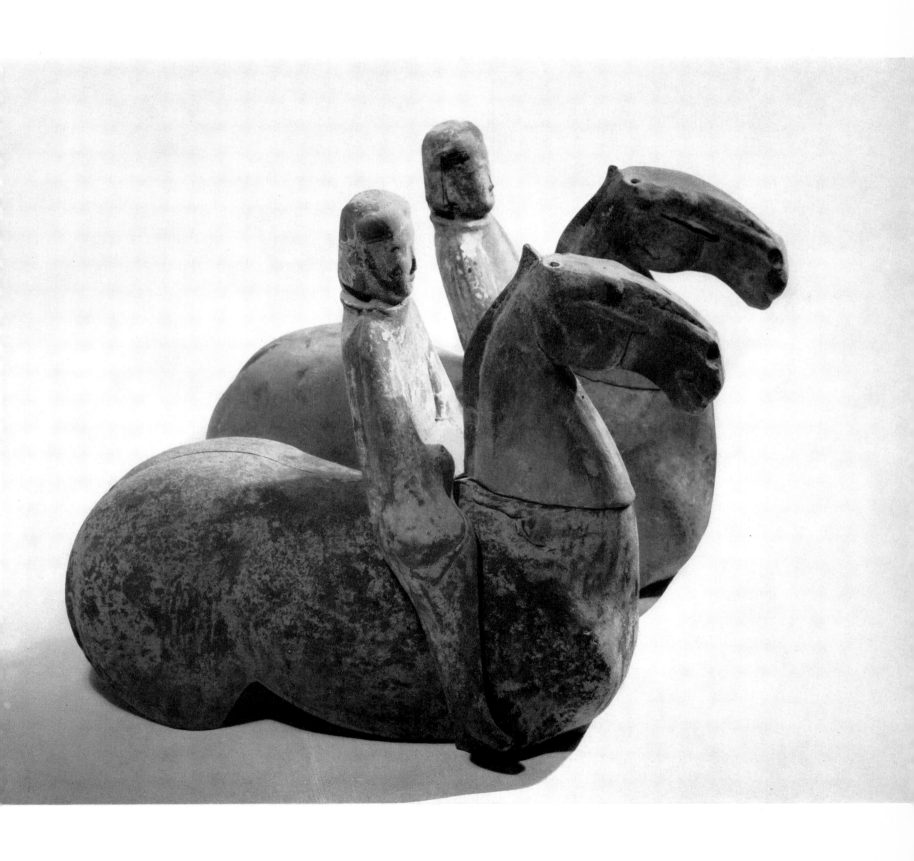

199 Horses and riders, pottery, Eastern Han dynasty (25—220 A.D.)

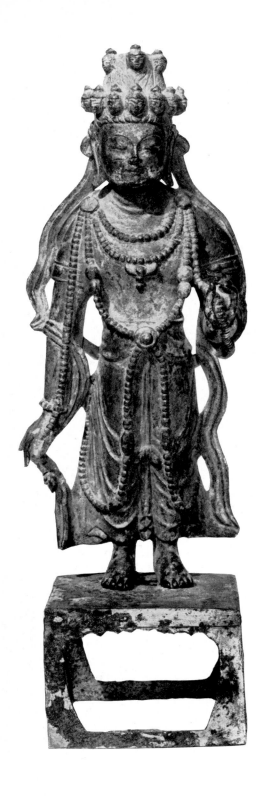

200 *Kuan-yin, gilt bronze, T'ang dynasty (618—906 A.D.)*

201 *Mirror, bronze, T'ang dynasty (618—906 A.D.)*

202 *Wen-shu, wood, Yüan dynasty (1279—1368 A.D.)*

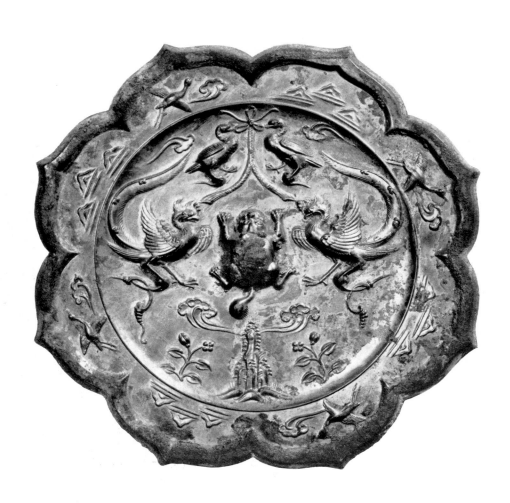

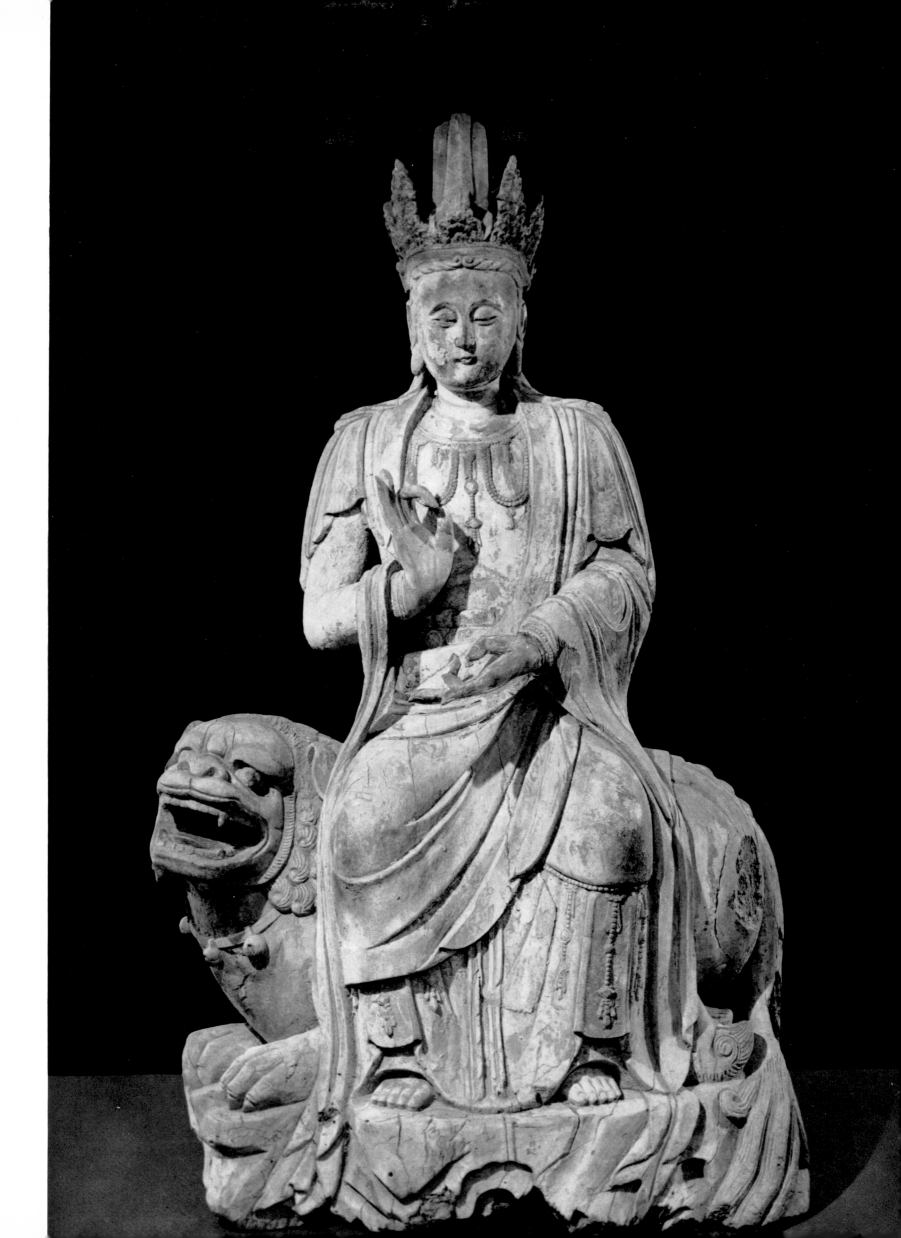

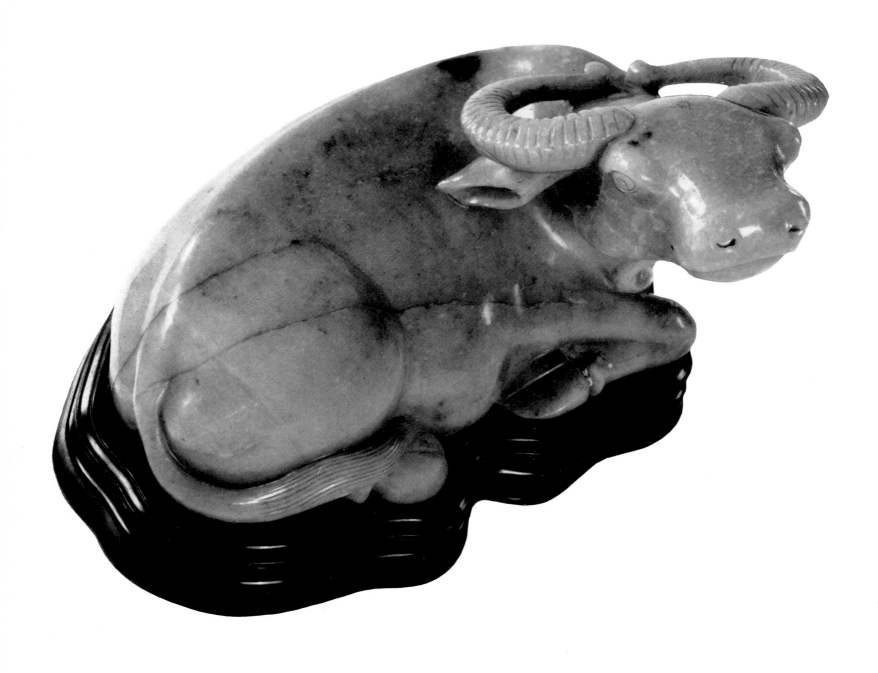

203 *Water buffalo, jade, Ming dynasty (1368–1644* A.D.*)*

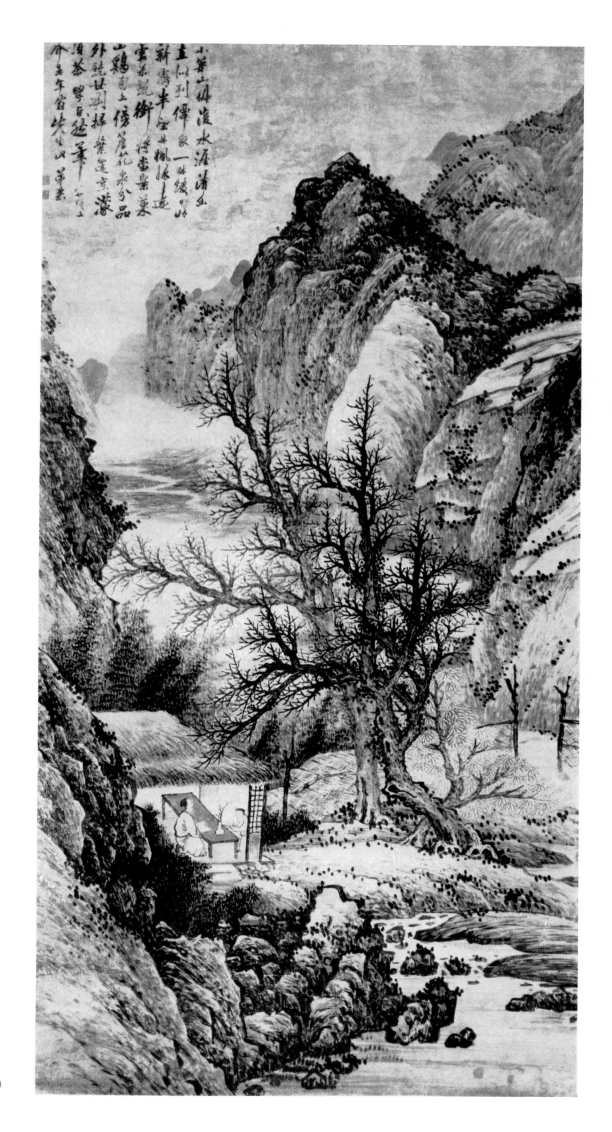

204 Landscape, hanging scroll,
by Wang Kai
(active ca. 1679—1705 A.D.)

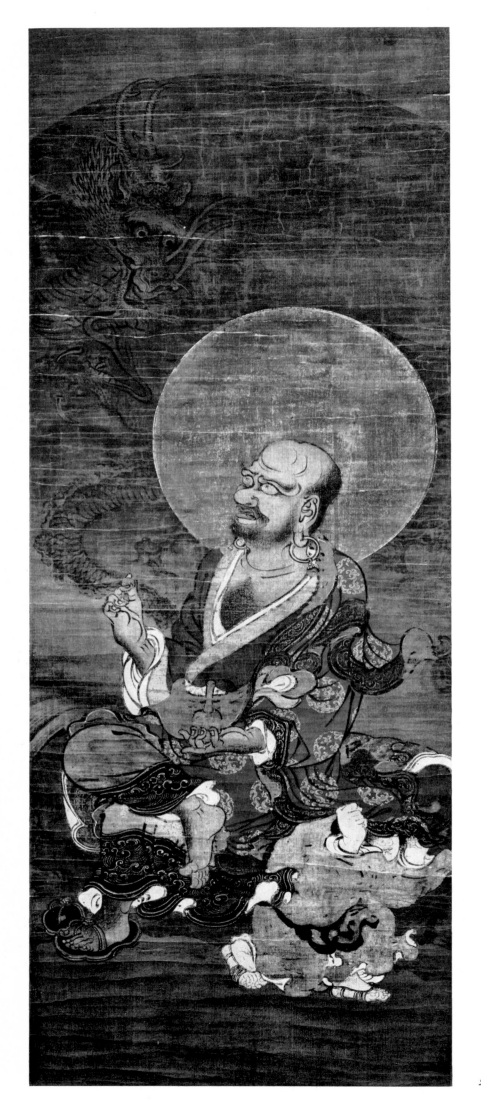

205 Rakan, hanging scroll, Kamakura period (1185—1334 A.D.)

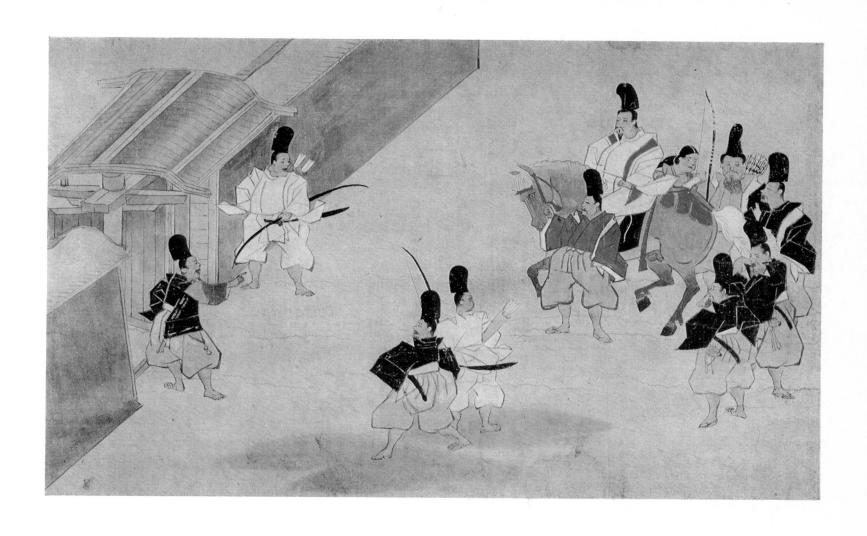

206 *Hōnen's biography, handscroll (section),*
Kamakura period (1185—1334 A.D.)

207 *Incense box, lacquer, Kamakura period*
(1185—1334 A.D.)

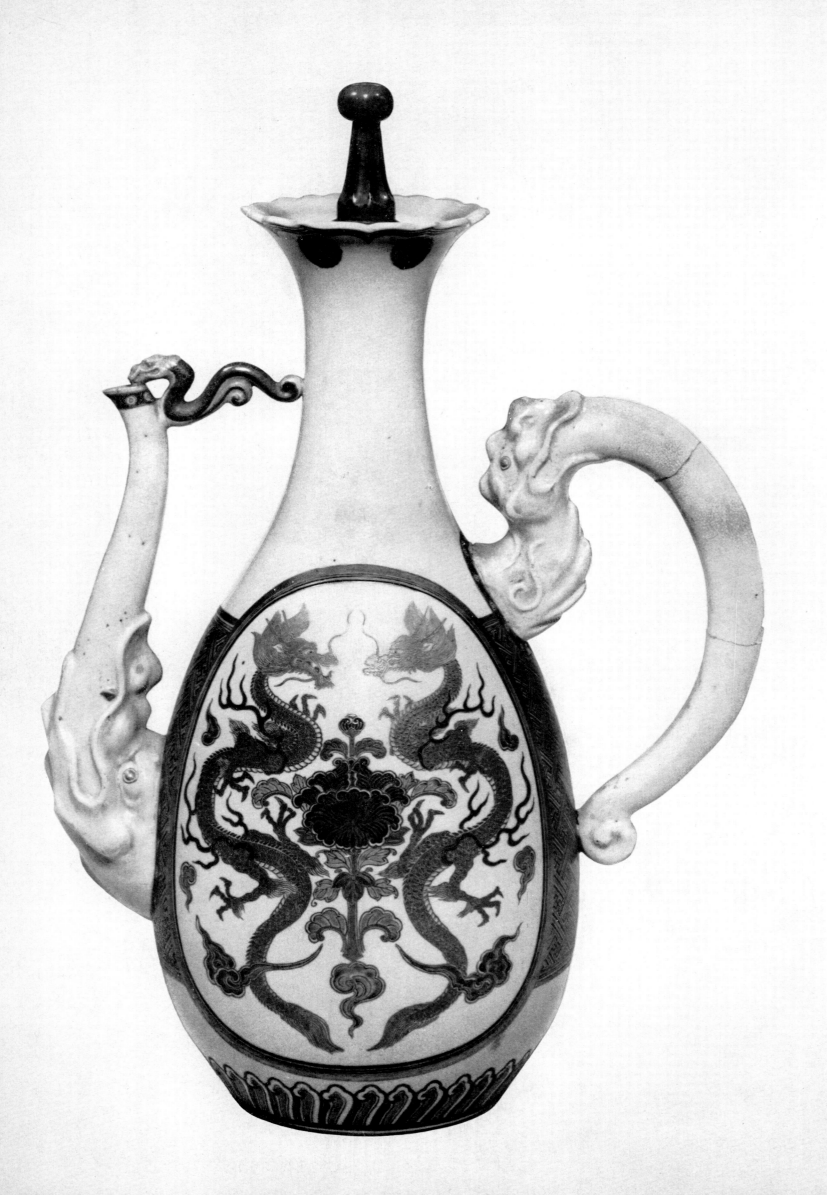

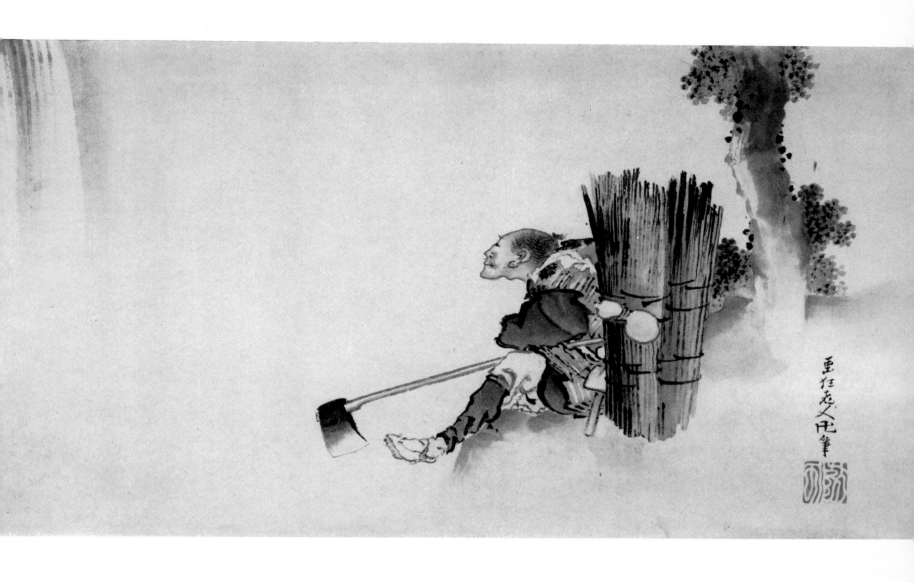

208 *Ewer, Satsuma ware, Edo period (1615—1868* A.D.*)*

209 *Painting, by Katsushika Hokusai (1760—1849* A.D.*)*

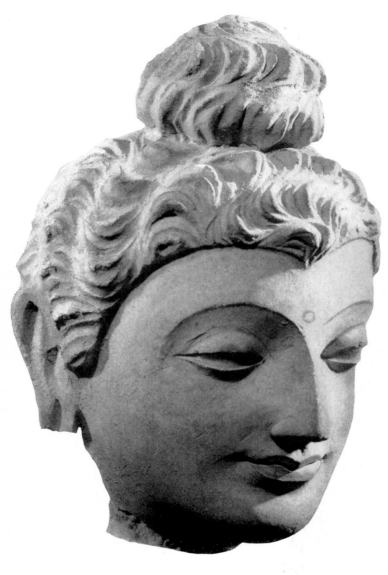

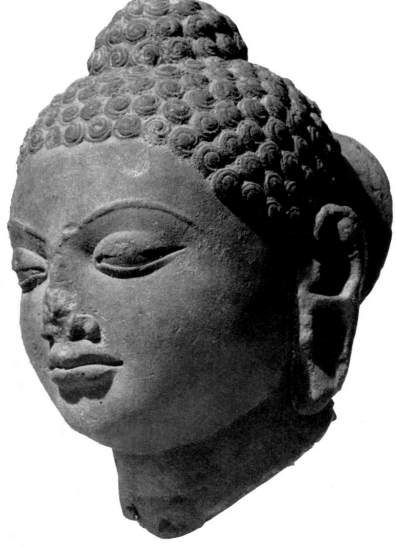

210 Head of Buddha, stucco, Kushān dynasty (ca. 50—320 A.D.)

211 Head of Buddha, sandstone, Gupta dynasty (320—600 A.D.)

212 Head of Buddha, bronze, Ayuthiā style (16th century A.D.)

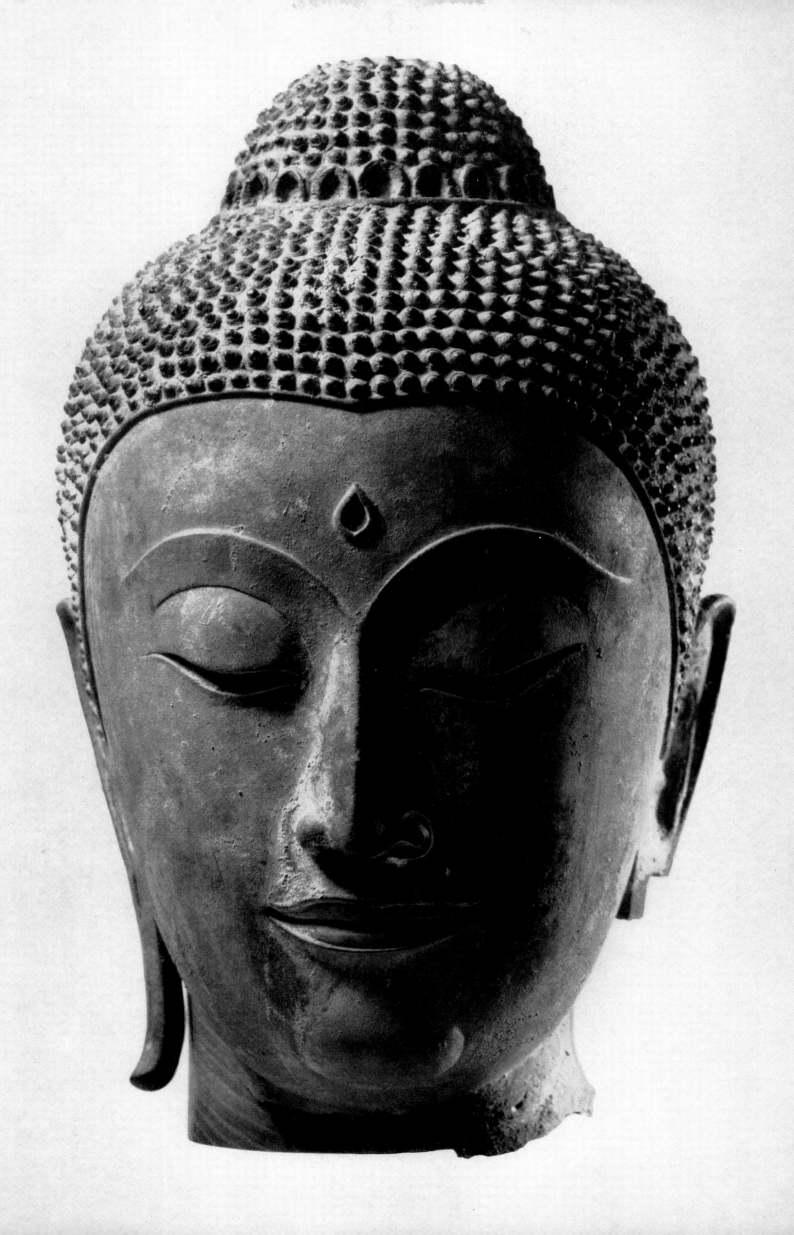

PHOTOGRAPH CREDITS

Asian Art Museum of San Francisco
Color photographs by James Medley, Asian Art Museum of
San Francisco except: William Abbenseth 9, 28, 50, 71;
Joe Schopplein 21 and Junkichi Mayuyama plate 89
Black-and-white photographs by James Medley, Asian Art
Museum of San Francisco except: William Abbenseth
1–3, 6–8, 10, 26, 27, 29, 36, 38, 39, 41, 46, 51, 60, 62,
64, 65, 78, 80, 87, 92, 109, 116, 118, 119, 121, 122, 132,
133–136, 147, 168, 173, 180; Joe Schopplein 4, 15,
22–25, 33, 35, 67, 70; Charles Davis 112, 113, 177;
Bruce Williams 178

Japanese Woodblock Prints in the
Achenbach Foundation for Graphic Arts
All photographs by Joe Schopplein

The University Art Museum, Berkeley
Black-and-white photographs by Ron Chamberlein
except: 194 by William Abbenseth
Color photographs by Colin McRae

The Stanford University Museum
Black-and-white photographs: Courtesy Stanford University

Endpapers: Details of a view of San Francisco (1860)
 (Courtesy of The Society of California
 Pioneers)